THE SECRET LANGUAGE of ART

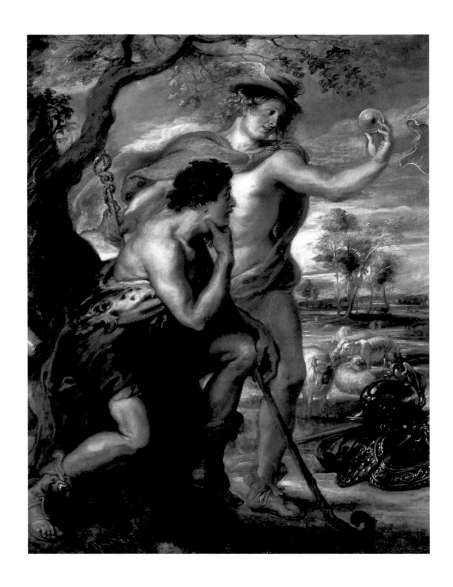

THE SECRET LANGUAGE of ART

SARAH CARR-GOMM

all pictures supplied by

THE BRIDGEMAN ART LIBRARY

DUNCAN BAIRD PUBLISHERS

LONDON

For Katherine-Mary Mathias

The Secret Language of Art
Sarah Carr-Gomm

First published in the United Kingdom and Ireland in 2001 by
Duncan Baird Publishers Ltd
Sixth Floor, Castle House
75–76 Wells Street
London W1T 3QH

Conceived, created and designed by Duncan Baird Publishers

Managing Editor: Hanna Bolus
Editors: Hanne Bewernick, Karen Frazer and James Hodgson
Editorial Assistant: Jessica Hughes
Managing Designer: Manisha Patel
Designer: Rachel Cross
Picture Researchers: Julia Brown and Amy Kent

British Library Cataloguing-in-Publication Data:
A catalogue record for this book is available from
the British Library

10 9 8 7 6 5 4 3 2 1

ISBN: 1-903296-31-5

Typeset in New Baskerville and Filosofia
Colour reproduction by Scanhouse, Malaysia
Printed by Imago, Singapore

NOTE
The abbreviations BCE and CE are used throughout this book:
BCE Before the Common Era (the equivalent of BC)
CE Common Era (the equivalent of AD)

CAPTION TO THE PAINTING SHOWN ON PAGE 2
Detail from *The Judgment of Paris* by Peter Paul Rubens
(see pages 38–39)

CONTENTS

CHAPTER 1:
CLASSICAL MYTH AND LEGEND

CHAPTER 2:
THE BIBLE AND THE LIFE OF CHRIST

CHAPTER 3:
SAINTS AND THEIR MIRACLES

CHAPTER 4:
HISTORY, LITERATURE, AND THE ARTS

CHAPTER 5:
SYMBOLS AND ALLEGORIES

FOREWORD by Sarah Carr-Gomm

The aim of this book is to serve as a useful introduction to the meanings of works of art. Most of the works covered date from the period of the late Middle Ages to the early twentieth century when figurative art predominated. It is the figures that often embody the principal message of a painting or sculpture: images and episodes from the lives of the saints, for example, were commissioned because their remarkable acts of faith and devotion were considered exemplary. Most of the entries in the book are, therefore, about individuals: religious, historical, and mythological. Literary characters and their authors are also included, as are themes of art-historical relevance, symbols, attributes, and personifications.

A symbol may be simply defined as an element, animate or inanimate, that stands for something else. The meaning of certain symbols, however, differs according to the context in which they appear – the dove, for example, represents the Holy Spirit in religious paintings, but when accompanied by

Detail from The Arnolfini Marriage *by Jan van Eyck (see pages 212–13).*

Venus is associated with love. Moreover, it cannot be assumed that the elements of a painting always carry symbolic significance – they may be included for aesthetic or naturalistic reasons.

Attributes are emblems that help the viewer to identify characters within a painting, such as the wheel of Saint Catherine or the shaggy tunic of Saint John the Baptist. They usually derive from an episode in the life of the figure concerned and often have no symbolic meaning. People, as well as objects, can serve this purpose; the apocryphal figure of Tobias, for example, may be seen as the attribute of the Archangel Raphael. There are also collective attributes, which identify a type: the crown of regents, the palm of martyrs or the cockle shell of pilgrims.

Many of the works featured in this book communicate important messages through personification – the embodiment of an abstract concept or quality in human form. From the Renaissance onwards, subjects drawn from classical antiquity became increasingly popular, especially figures from mythology. Classical deities were basically personifications of human qualities or natural phenomena, making them useful as allegorical references in paintings. In this book, their Roman titles, rather than Greek, are given because this was the norm in the Renaissance and Baroque periods.

It has been fashionable in art history to seek multiple levels of meaning and erudite solutions for particularly complex paintings. Recently, however, scholars have pointed out the potential pitfalls of this approach and have shown that when esoteric subjects were depicted they often carried an inscription to identify the subject or explain the message. Should you wish to delve deeper, many entries are accompanied by references to the literary, historical, and biblical sources with which artists would have been familiar. For the most part, these are readily available today. For example, the *Golden Legend* written in around 1260 by Jacobus de Voragine, which tells the lives of the Virgin and the saints, organized according to their feast days in the liturgical calendar, was translated into many languages and widely read throughout Western Europe.

Until the production of several books on iconography in the mid-sixteenth century, there was no authoritative dictionary to decipher visual symbols; moreover, symbols and attributes were not standardized. Even after this time, patrons, artists, and their advisers were not consistent in their choice of reference – more than one source might be used, and there was always room for invention. The student of iconography must, therefore, be cautious in the quest for meanings. Although ideas as to the original intention of a work of art can be formed from a knowledge of its subject-matter, there are many other factors to consider. These include artistic style and technique, social and political history, the original location of the work, and the intention of the artist's patron; such topics are, however, beyond the scope of this book.

Each chapter in this book explains the significance and meaning of key symbols and figures within a major subject area of Western art. The key paintings shown at the beginning of each chapter – 75 in all – are ones that are especially rich in symbolism or complex in their meaning. After each group of key paintings comes a thematic reference section for the subject area in question, with major symbols and figures clearly highlighted

and explained. A thorough cross-referencing system is followed, as explained below. You can use the book to look up a specific symbol or figure, or to explore the significance of the symbols in a particular painting.

With so many questions to answer, the study of art history is never-ending, and the subject is a delight because it involves looking at, and thinking about, the splendid products of the human imagination.

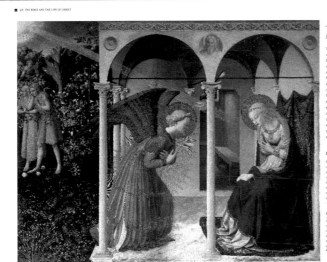

75 KEY PAINTINGS

Chapter symbol for quick reference.

A brief analysis of each painting provides artistic and historical background.

KEY ELEMENT: an explanation of the main subject(s) of the painting or its most striking symbol(s).

SEE ALSO: a list of page numbers to direct you to information about other key aspects of the painting or related themes.

THEMATIC DIRECTORY

Each chapter is divided into themes.

The main text provides detailed information, illustrated with details from relevant works of art. Key symbols and figures are highlighted in capital letters. The locations of the works cited are given, in most cases, in the index on pages 252–54.

Feature panels, illustrated with details from major works of art and covering especially important themes as well as general topics, are interspersed within the thematic entries.

Cross-references at the end of each themed section direct you to related entries elsewhere in the book. Footnotes refer to selected documentary sources.

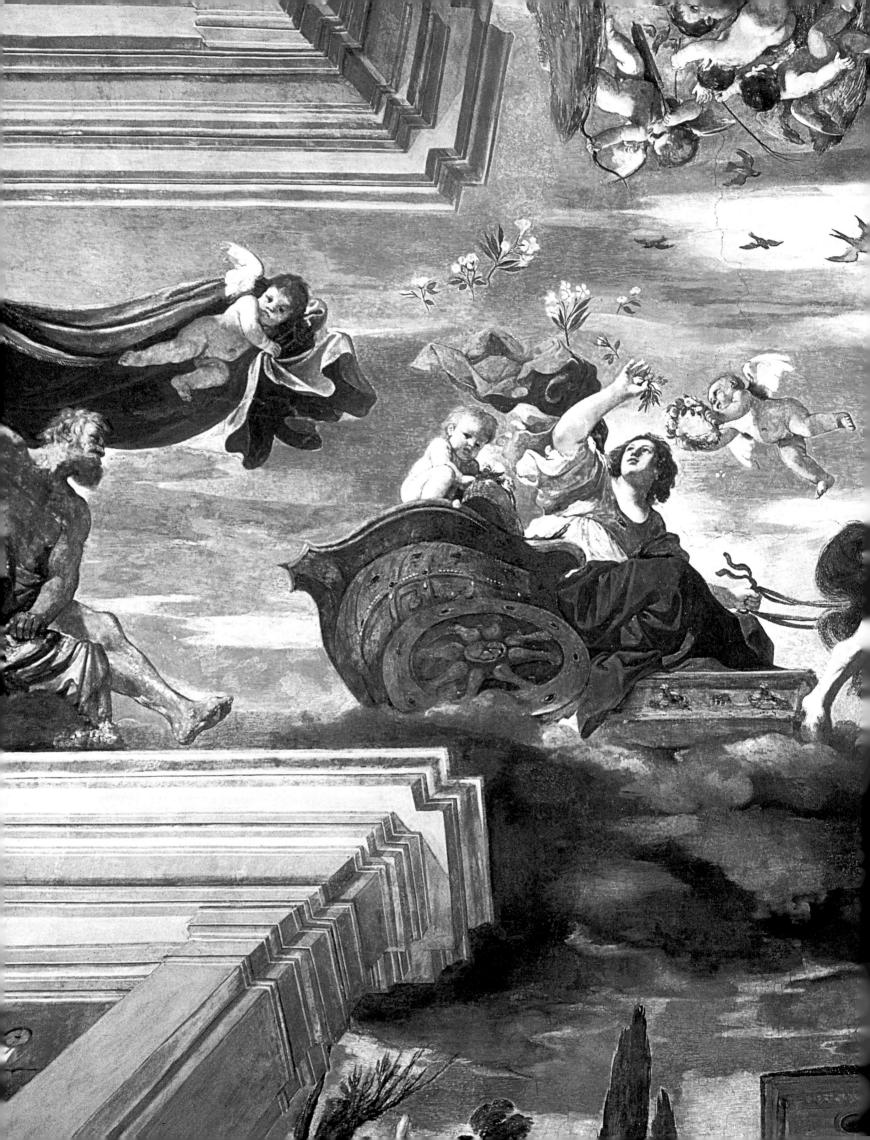

CHAPTER ONE

CLASSICAL MYTH AND LEGEND

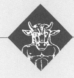

In the second half of the fifteenth century, the artists of the Renaissance began to turn increasingly to the traditions of classical antiquity for the subject matter of their paintings. The myths of the Greeks and Romans, as told in the works of poets such as Homer, Virgil, and Ovid, provided a vivid world of gods, monsters, and heroes whose lives, loves, and labors formed fictional models through which artists could express a new spirit of humanism and naturalism in painting – and whose popularity as subjects for artistic representation has endured to the present day.

Venus and Mars

Sandro Botticelli (1444/45–1510)

During the Renaissance, artists often chose the gods and goddesses of antiquity as subjects because of their beautiful figures and the settings in which they could be placed. As personifications, they could also be useful mediums for allegory. Here, Venus is shown reclining gracefully while Mars lies exhausted; as long as she can entertain the brutal god of war, there will be peace on Earth. Even the naughty little satyrs are unable to wake him as they play with his lance, helmet, and armor; and he is oblivious to the shell being blown in his ear and the wasps buzzing around his head.

Wasps – *vespe* in Italian – were the emblem of the Vespucci family, and it is thought that Botticelli painted this piece for them in 1483. The painting's shape suggests it may have been designed for a specific spot – perhaps above a door or fireplace or, more appropriately, as part of a piece of bedroom furniture.

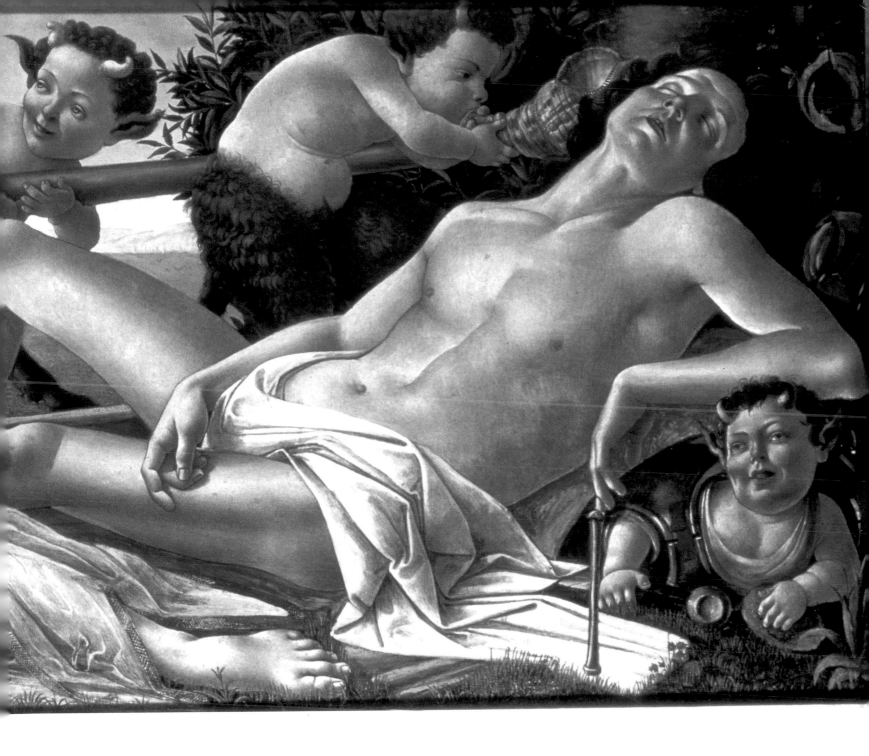

KEY ELEMENT

VENUS: Goddess of beauty and love, Venus was born as drops of Uranus's semen fell into the sea; Botticelli's *Birth of Venus* (1484–86) depicts her being blown ashore on a shell. She captivated men with the aid of a magical girdle, forged by her husband Vulcan, and was often pictured as the ideal of contemporary beauty. Painters of the female nude traditionally showed her reclining provocatively, a pose derived from Giorgione's *Sleeping Venus* (*c*.1508). Cupid was her special attribute – others were roses, myrtle, swans, doves, and Discord's apple.

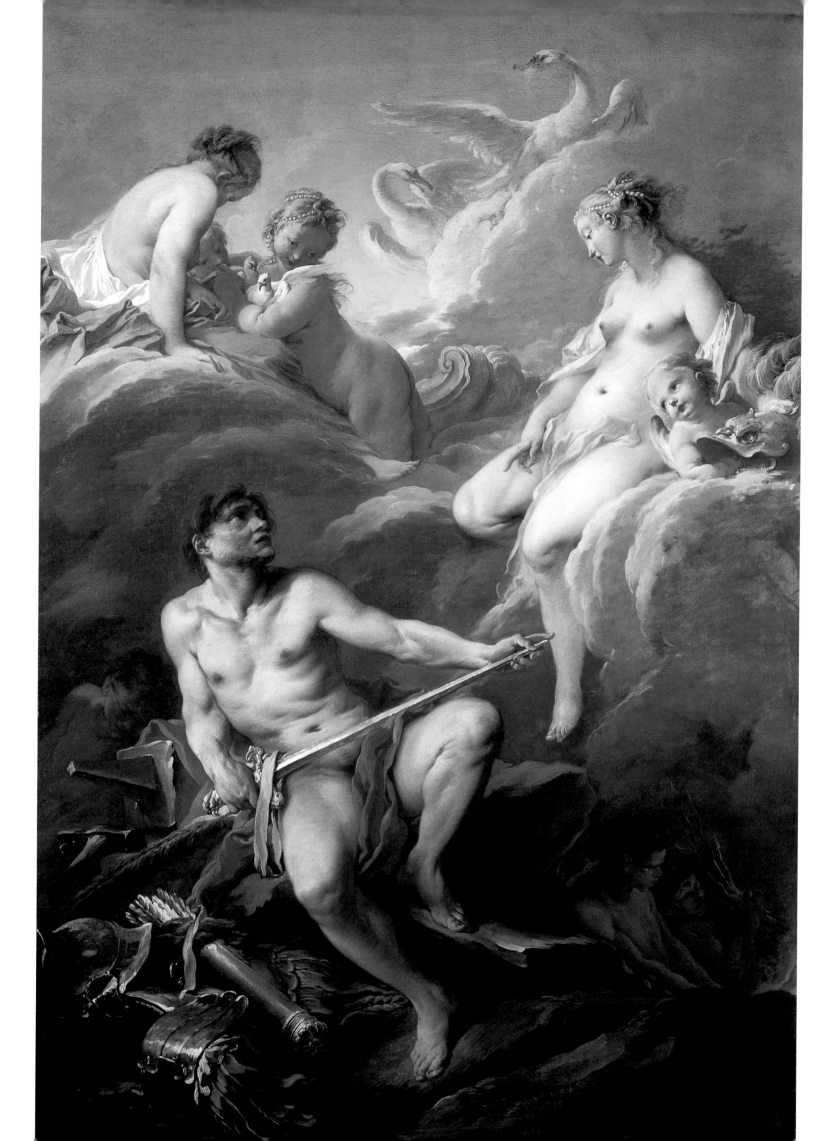

Venus Asking Vulcan for the Armor of Aeneas

François Boucher (1703–1770)

Aeneas, the hero of Virgil's poem *The Aeneid*, was destined to land in Italy and become the forefather of the Romans. On his arrival, he was engaged in a series of wars instigated by Juno, prompting his mother Venus to come to his aid. Boucher's painting (1732) shows a flirtatious and almost naked Venus, goddess of beauty and love, sitting on a cloud surrounded by swans and doves – two of her attributes. She looks down at her husband Vulcan and requests a special suit of armor for her son.

Boucher, chief painter to King Louis XV of France, was criticized for being too self-indulgent to paint anything more serious than *putti*, nymphs, and seminaked women. But his light-hearted, frivolous style, typical of the Rococo, was ideally suited to the paintings, decorations, tapestry, and stage-sets of the king's court.

KEY ELEMENT

VULCAN: God of the forge who presided over fire, Vulcan was the patron of metalworkers. He made thunderbolts for Jupiter, but was thrown off Mount Olympus when he tried to free his mother after Jupiter chained her up in punishment. Vulcan landed on the island of Lemnos in Greece, where he built a palace for himself and set up forges, said to be the Earth's volcanoes. The Cyclopes (one-eyed giants) were his attendants. Unfortunately, he broke his leg in the fall to Earth and became permanently lame.

Vulcan created many ingenious works of art, both for the gods and for mortals at the gods' request – including magnificently decorated shields for Achilles and Aeneas.[1] He also made a set of armor for Jupiter, who promised Vulcan anything he wanted as a reward. Vulcan asked for the chaste Minerva but, unable to ravish her, he spilled his seed on the Earth instead, and Erichthonius was born. Vulcan eventually married Venus, who was continually unfaithful. One story describes how he fashioned an invisible net to trap the frolicking Venus and Mars. When the pair were caught in a passionate embrace, Vulcan exposed them to the gods who, to his discomfort, were greatly amused. Mercury even taunted Vulcan by saying how much he would like to take Mars's place.[2]

In paintings, Vulcan's deformity is usually apparent, and he often appears half-naked and dishevelled at his forge. Sometimes he is shown striking at the anvil with a hammer or holding a thunderbolt with pincers, or he may be blowing the flames, his face black with smoke. Appropriately, he often appears above fireplaces, as in Peruzzi's *Vulcan at His Forge* (*c.*1515).

[1]Homer *Iliad* XVIII:428–617 [2]Ovid *Metamorphoses* IV:170–90 and Homer *Odyssey* VIII:265–346

The Young Bacchus
Michelangelo Merisi da Caravaggio (1571–1610)

The garland of grapes and vine leaves surrounding this boy's head identify him immediately as Bacchus, god of wine. Caravaggio's representation (*c.*1589) is, however, of his model, dressed up as the pagan god. The erotic content of the painting is explicit – the half-naked torso, flushed face, heavy eyelids, and pouting expression are sexually charged; and the provocative offering of the glass of wine to the spectator suggests that the invitation is for more than just a drink.

As well as establishing a style based on sharp contrasts of deep shadow and almost glaring light, Caravaggio was a master of still life. The glass and carafe are remarkably naturalistic, while the overripe, bruised quality of the fruit reflects the transience of life – indicating how this sensual body will soon wither and decay.

KEY ELEMENT

BACCHUS: Son of Jupiter and Semele, Bacchus was the god of wine who inspired music and poetry. Raised by Silenus, he had a blissful childhood and was often in the company of nymphs, satyrs, herdsmen, and vine-tenders. He was also frequently accompanied by Maenads or "mad women" (also known as Bacchants) – female followers who danced around him in a drunken frenzy.

Bacchus may be pictured with his rowdy throng or alone, and is sometimes shown wearing an animal skin, riding in a chariot drawn by wild animals. He is usually depicted as a beautiful youth, crowned with vines and grapes, and holding a cup or *thyrsus* (staff).

As a youth, Bacchus set out to teach the art of wine-growing, but the enterprise had a tragic ending. He fell in love with Erigone – daughter of his host, Icarios – and seduced her. But he had little time to enjoy his happiness, for Icarios was killed by drunken shepherds,[1] and when Erigone heard the news, she hanged herself.

When his divine nature was contested, Bacchus always emerged victorious. On one occasion, after he was kidnapped by Lydian pirates, he covered their oars and sails with ivy. Wild beasts then appeared on the scene, and when the sailors jumped overboard in madness or fear, they were turned into dolphins.

The Romans held the festival of the Bacchanalia in honor of Bacchus; and, from the Renaissance, this event inspired images of revelry, excess, and intoxication. Animals were consumed raw at these ceremonies, which usually turned into wild orgies. Francesco Zuccarelli's *Bacchanal* (*c.*1740) shows nymphs and satyrs dancing in an idyllic landscape while Silenus reclines on an urn. Other paintings depict the god's more lecherous aspect; for in the form of a goat, he was also worshipped as the god of fertility – hence his association with Pan, Silenus, and the satyrs.

[1]Apollodorus *The Library* III:xiv 7

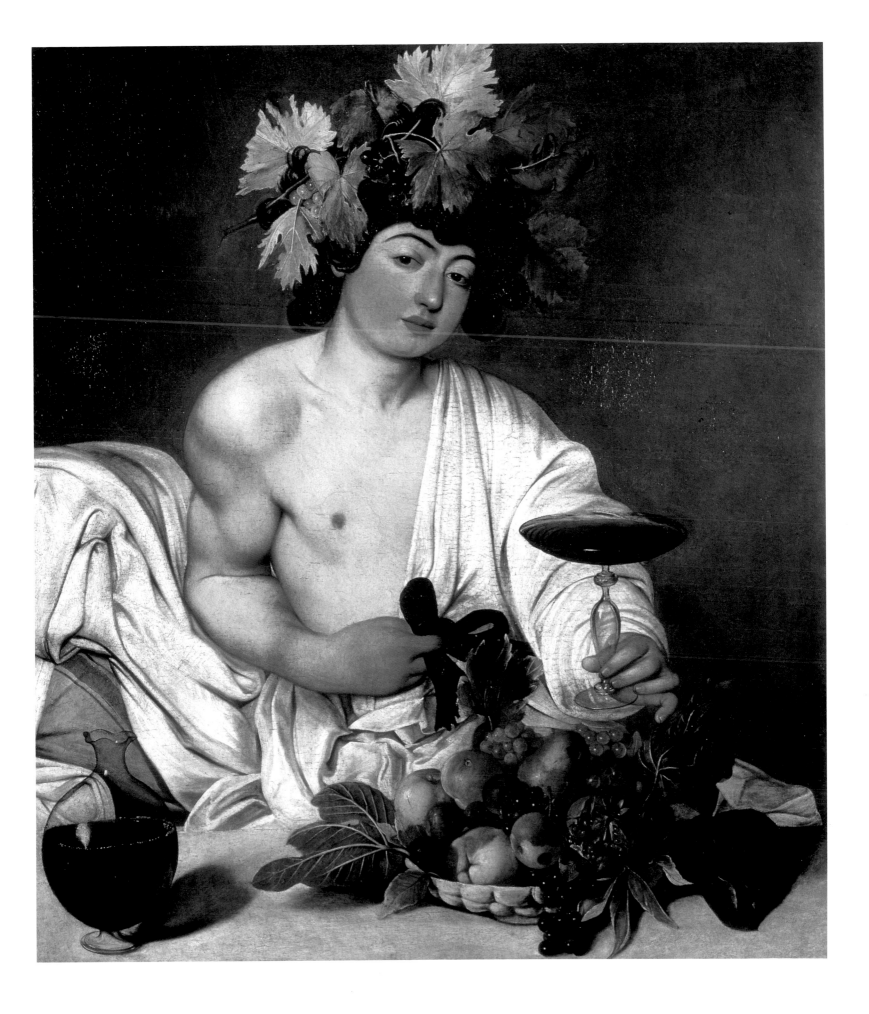

Juno and Mars
Giovanni Battista Carlone (1592–1677)

This painting of *c.*1650 is a "modello" – a drawing or painting of an intended composition, made for a patron in the hope that the work would be commissioned. As there was often considerable competition with other artists to win a commission, a modello was more fully executed than an ordinary sketch.

Carlone and his brother decorated vast areas of many churches in Genoa, and with this particular canvas, Carlone secured the commission to paint the ceiling of the gallery of the Palazzo Negrone. The episodes he depicted were taken from Virgil's epic account of Aeneas's journey from Troy to the shores of Italy, where he became the forefather of the Romans. In the tale, the gods and goddesses variously aid and thwart the hero as he continues on his travels. This ceiling painting, which invites the viewer to look up to the realm of the gods, shows a vengeful Juno (who hated the Trojans) seated with her peacock on the right, instructing Mars and his attendant Furies to impede Aeneas's path.

KEY ELEMENT

JUNO: Goddess of marriage and childbirth, Juno was the daughter of Saturn and Ops, sister and consort of Jupiter, and the mother of Vulcan, Juventas, and Mars. She was majestically beautiful, but after losing the prize for beauty to Venus in the Judgment of Paris (see pages 38–39), she sided with the Greeks in the ensuing Trojan War – against her husband's wishes.

Many legends tell of Juno's jealousy of her husband's mortal loves, and she is often depicted spying on him, as in Pieter Lastman's *Juno Discovering Jupiter and Io*

(1614). Enraged by his behavior, she took revenge on several innocent girls, notably Callisto, Io, and Semele.

Juno's attribute is a peacock, and a pair of the birds drew her chariot. It was she who put the eyes in the peacock's marvelous tail after Mercury slew Argus, the one-hundred-eyed monster guarding Io.[1] Antonio Balestra illustrated this scene in *Juno Placing the One Hundred Eyes of Argus in the Peacock's Tail* (*c.*1714).

[1]Ovid *Metamorphoses* I:568–746

Apollo's Chariot
Odilon Redon (1840–1916)

At the beginning of his career, Redon worked almost entirely in black and white, creating haunting images from his imagination. He was adopted by the Symbolist poets, and the Surrealists considered him one of the precursors of their movement. In about 1890, he began to work in color, producing decorative screens, flower paintings, and portraits. He favored pastel, which has similar properties to charcoal but produces vibrant color.

Redon's success with these subjects gave him the confidence to treat scenes from classical mythology, and several of his works illustrate the story of Apollo and the Python – a symbol of evil. Redon admired Delacroix's version of the theme on the ceiling of the Gallery of Apollo in the Louvre, and in this image (*c.*1905–1916) he borrowed Delacroix's idea of a chariot drawn by a team of horses rising to the heavens, which he described as "the joy of full daylight, in contrast to the sadness of night and shadows, like the happiness of feeling better after great pain." To Redon, the myth represented not only the triumph of good over evil and day over night but also the triumph of the creative spirit over base matter.

KEY ELEMENT

APOLLO: Son of Jupiter and Latona, and father of Aesculapius, Apollo was the god of light, healing (because his light nurtured plants), poetry, music (especially that of the lyre), and prophecy. A blaze of light shone over the island of Delos at his birth, and sacred swans flew around it seven times. Nourished on ambrosia and nectar after Latona abandoned him, he was dazzling in appearance and personified youth and beauty. He was also a hunter, acting as the protector of athletes and young men in war. His attributes include a lyre, a bow and arrow, a golden chariot drawn by four horses or rays of the sun, a laurel wreath or a crown.

In his role as god of prophecy, Apollo set out to find a suitable place to give truthful oracles to humans. He found it in the valley of Delphi in the heart of Greece. A monster of darkness known as the Python guarded the valley's entrance, so Apollo slew the creature with a thousand arrows.[1] In *Apollo and the Python* (1811), Turner shows him resting after his triumph.

See also page 60
[1] Ovid *Metamorphoses* I:416–51

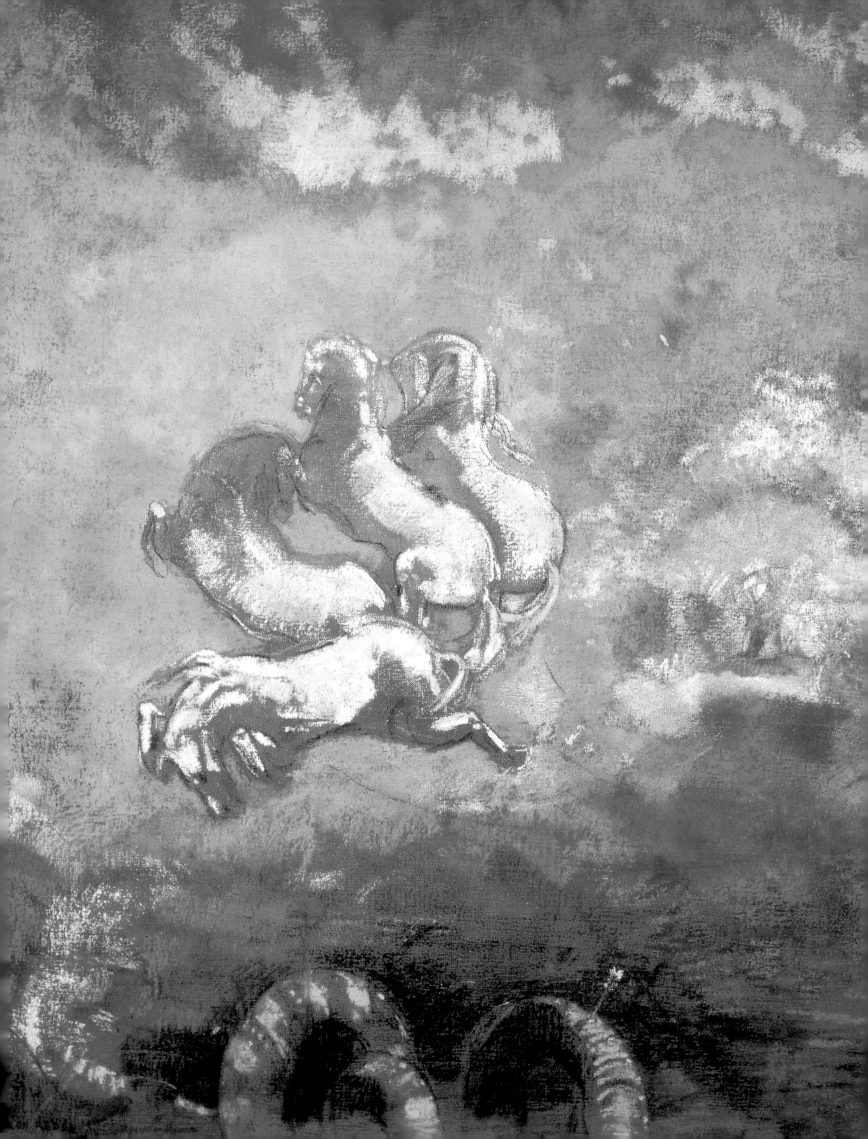

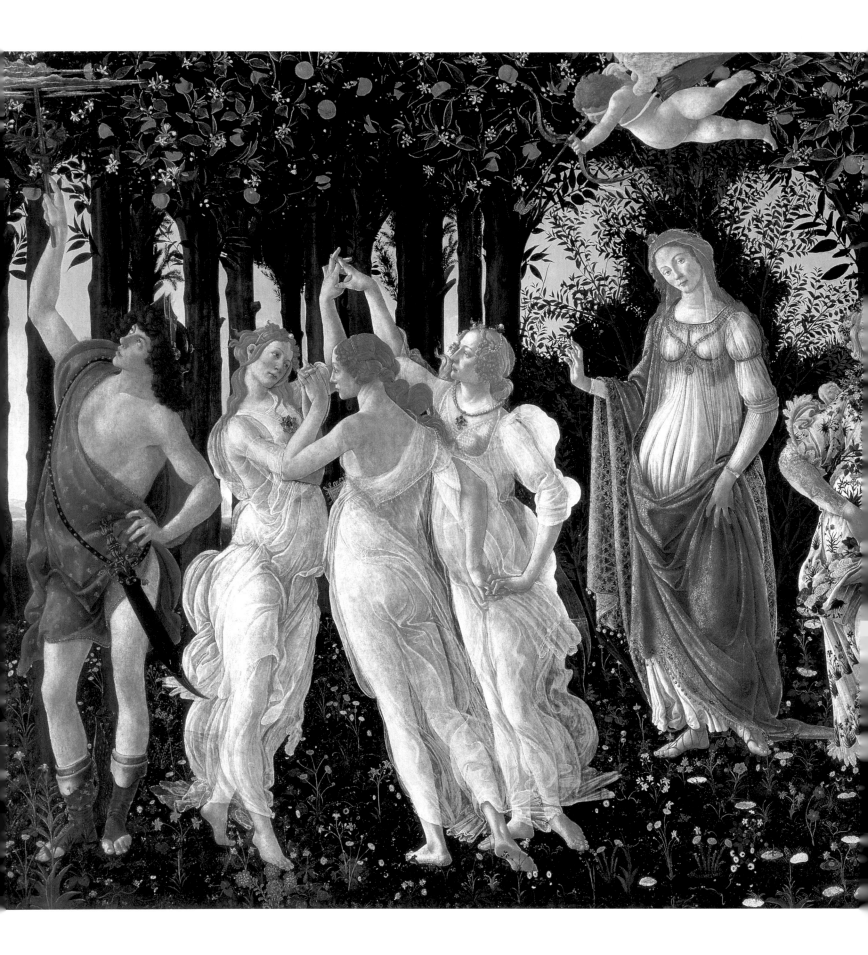

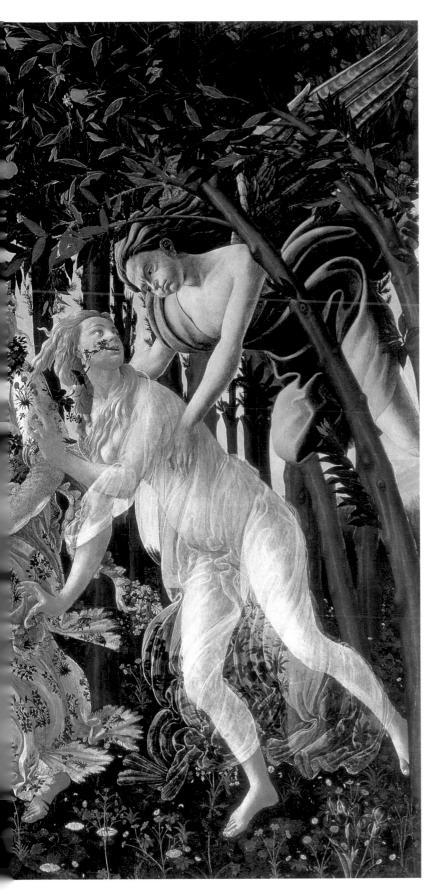

Primavera
Sandro Botticelli (1444/45–1510)

No satisfactory explanation has been given for the combination of characters in Botticelli's masterpiece (*c.*1478), which, unusually, reads from right to left. On the right, the west wind Zephyr chases Chloris. As he catches her, she exhales flowers and changes into Flora, goddess of spring, who strews the ground with blooms from her embroidered dress. In the center, Venus gestures to the Three Graces, who dance in an eternal circle; on the far left, Mercury disturbs a cloud with his caduceus. Cupid flies above the arch framing the central figure, suggesting that the overall theme may be love. The flowers and the forest are painted to imitate a tapestry – the most costly form of wall decoration.

KEY ELEMENT

THE THREE GRACES: Aglaia, Euphrosyne, and Thalia – the Three Graces – personified beauty and charm, and often attended Venus, goddess of love, whose attributes they adopted. They were popular subjects with artists, who turned to classical prototypes for inspiration; famous examples are the painting by Rubens (1639) and the sculpture by Canova (1813–16).

The "Sala di Aurora"
Giovanni Francesco Barbieri
Guercino (1591–1666)

Guercino lived in Rome from 1621 to 1623. During this period he produced some spectacular works, including the frescoes on two floors of the Casino Ludovisi, commissioned by Cardinal Ludovisi, nephew of the Pope. *Aurora* (1621–23) can be seen on the ceiling of the entrance hall, where the painting's ingenious *trompe l'oeil* architectural framework gives the impression that one is looking straight up into the open sky. Galloping across the morning sky in her chariot, Aurora scatters flowers and drives away the dark clouds of night, watched by her old husband Tithonos.

KEY ELEMENT

AURORA: Rosy-fingered and saffron-robed, Aurora was the goddess of dawn and sister of Apollo. Rising in the east each morning, she would set out to herald the coming of the day, either flying or driving her chariot. Her sons, the morning winds, were felt at her approach. The tears Aurora shed for Memnon, who died in the Trojan War, were said to be the dewdrops found at dawn.[1] She had several love affairs with mortals, including Cephalus, and when infatuated she neglected her duties. Struck by the beauty of Tithonos, she carried him off and secured his immortality, but forgot to ask for eternal youth. After they married, Tithonos grew slowly more decrepit until she could no longer bear to look at his withered body and locked him away.

[1] Ovid *Metamorphoses* XIII:576–622

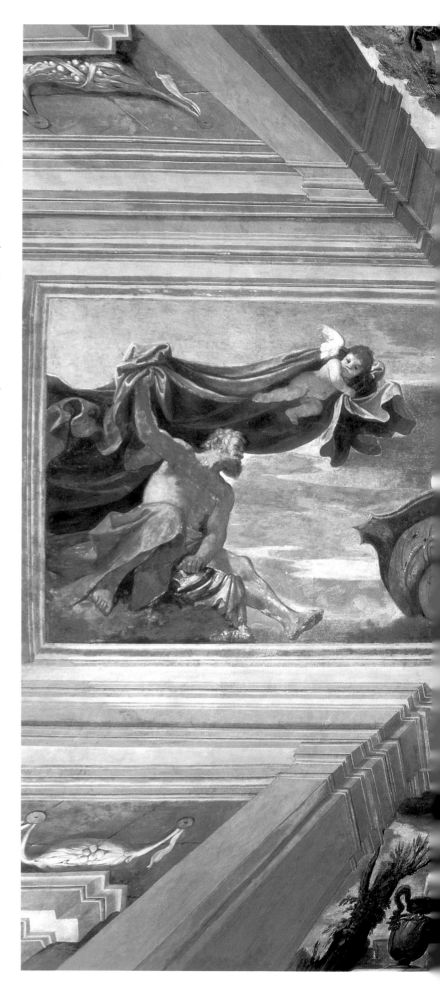

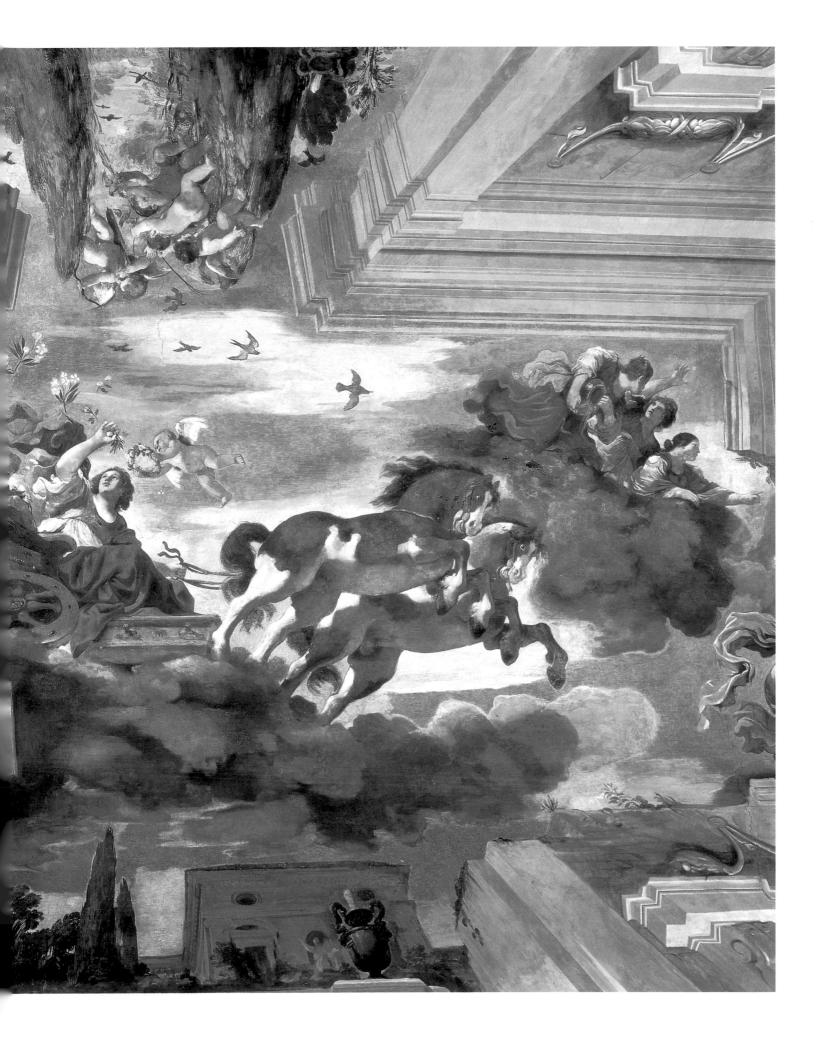

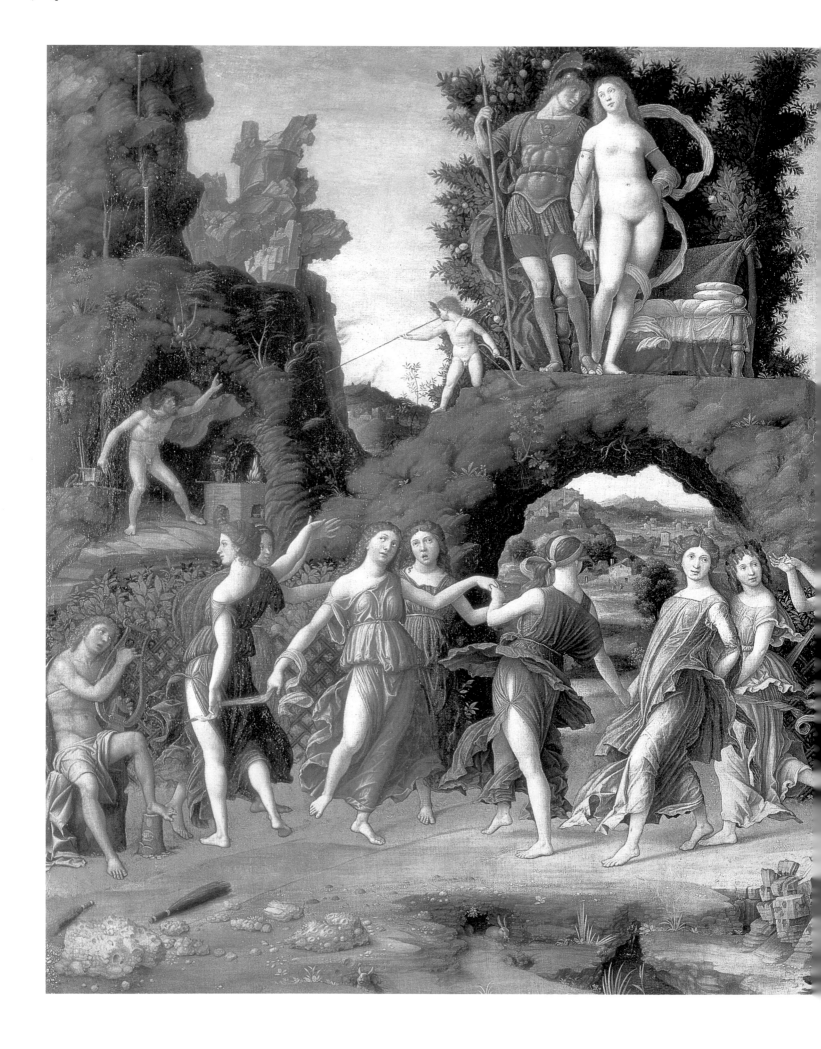

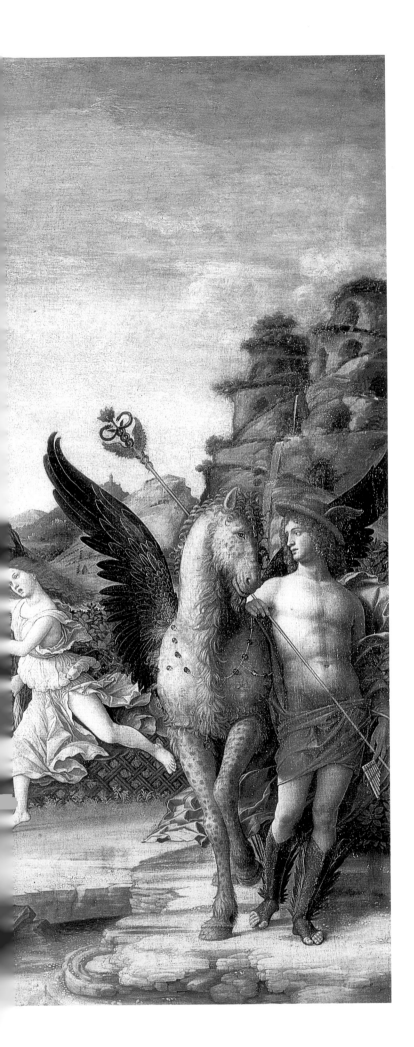

Parnassus

Andrea Mantegna (1431–1506)

Mantegna's *Parnassus* (1497) was commissioned by Isabella d'Este, wife of the Marquis of Mantua, to hang in her "studiolo" – a room set aside to display precious works of art. The painting reflects her classical education and her love of music. In the center, the nine Muses sing and dance to the sound of the lyre, played by Apollo on the left, while Mercury, the inventor of the lyre, stands on the right holding a syrinx (pan pipes). All is well on Mount Parnassus – the sacred land of Apollo and the Muses – as long as Mars the warmonger remains enchanted by Venus. The couple form the apex of the triangular composition, leaning together in harmony. But to their left, Cupid has just shot a dart at Venus's husband Vulcan to alert him to the adultery.

KEY ELEMENT

MUSES: Children of Jupiter and Mnemosyne (Memory), the nine Muses presided over and inspired music, poetry, dancing, and the Liberal Arts. They are often depicted as young and beautiful virgins, and may appear with their protector Apollo, perhaps holding books or musical instruments. They were also guardians of the Castilian Spring on Mount Parnassus, which was thought to be the source of poetic inspiration.

See also box, page 63

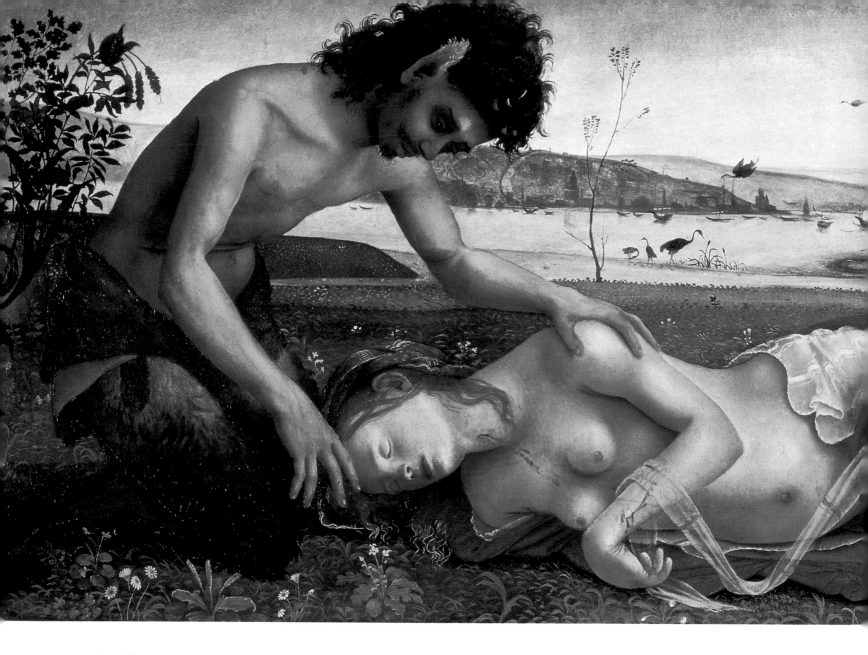

A Satyr Mourning Over a Nymph
Piero di Cosimo (c.1462–1521)

In the foreground, a partly naked woman lies on the ground with a wound in her neck. She is either dying or already dead – and the satyr at her head and the dog at her feet mourn her fate. The horizontal format of the painting (*c.*1495) – which suggests it was designed for a specific place or piece of furniture – allows for a panoramic view of an estuary with various animals wandering along the shore. The subject of the piece is unknown, although it has been linked to the classical tale where Cephalus accidentally kills his beloved wife Procris with his javelin. Others have seen it as an illustration of a Renaissance play by Niccolo da Correggio, who embellished the original story by introducing a faun who aroused the jealousy of Procris – although neither interpretation explains the absence of Cephalus. The subject remains unidentified and may illustrate a poem or play that is now lost.

KEY ELEMENT

SATYR: These mythical creatures were men with goat's horns, legs, and hooves. They inhabited the country-side as the carousing attendants of Bacchus, god of wine, and became associated with lust. A satyr appears in Jacob Jordaens' *Satyr and the Peasant* (1620), pointing out the incongruity of blowing on soup to make it cold and on hands to warm them.

Athene and the Centaur
Sandro Botticelli (1444/45–1510)

Athene (Minerva in Roman myth) was goddess of war and wisdom, and protector of the arts. In this painting (*c.*1480), Botticelli depicts her in a particularly provocative style, her curves emphasized by her revealing dress. She holds a halberd (axe) – her attribute as goddess of war – and can be futher identified by the olive branches decorating her hair and clothes (she created the olive tree when she competed with Neptune for the city of Athens, to which she gave her name). The centaur, half man and half beast, recoils from the goddess as she leans toward him and plays gently with his hair. He appears to be in some distress, perhaps because Athene's civilizing nature makes him aware of his baseness.

The interlocking rings embroidered on Athene's dress are an emblem of the Medici family of Florence – Pierfrancesco de Medici commissioned this painting, as well as two of Botticelli's other works: *Primavera* (see pages 20–21) and *The Birth of Venus* (1484–86).

KEY ELEMENT

CENTAUR: This mythological creature had the torso, arms, and head of a man, and the body and legs of a horse. Thought to represent the base or animal aspect of humanity, the centaurs were said to come from ancient Thessaly – probably because the inhabitants were known to be excellent horsemen. Their behavior was often wild and uncouth, and the centaur Nessus even tried to carry off the wife of Hercules – an encounter depicted by Piero di Cosimo in *Scenes of Primitive Man* (early sixteenth century).

The only civilized centaur was Chiron, whose hybrid form resulted from a union between the nymph Philyra and Saturn – who had turned himself into a horse in an attempt to conceal his illicit passion from his wife. Chiron was a wise teacher, especially of music and medicine, and educated many classical heroes, including Aesculapius, Achilles, and Jason. Hercules caused the centaur's death as Chiron entertained him; other centaurs smelled the feast and a battle ensued, in which Hercules accidentally shot a poisoned arrow into Chiron's knee.[1] In great pain, Chiron then begged the gods to take away his immortality and, with bow and arrow, became the constellation Sagittarius.

The renowned Battle of the Lapiths and the Centaurs occurred during the wedding of Pirithous and the lovely Hippodamia.[2] The Lapiths had invited the centaurs, but when the fiercest centaur Eurytus caught sight of the beautiful bride, he dragged her off by her hair; the other centaurs followed his example and carried off every girl they could lay their hands on. Theseus then attacked the centaurs on behalf of Pirithous, and a bloody fight ensued in which half the centaurs were slain and the rest driven away. The celebrated sculptures on the Parthenon in Athens depicted this violent struggle between civilization and barbarity.

[1]Ovid *Fasti* V:379–414 [2]Ovid *Metamorphoses* XII:210–535

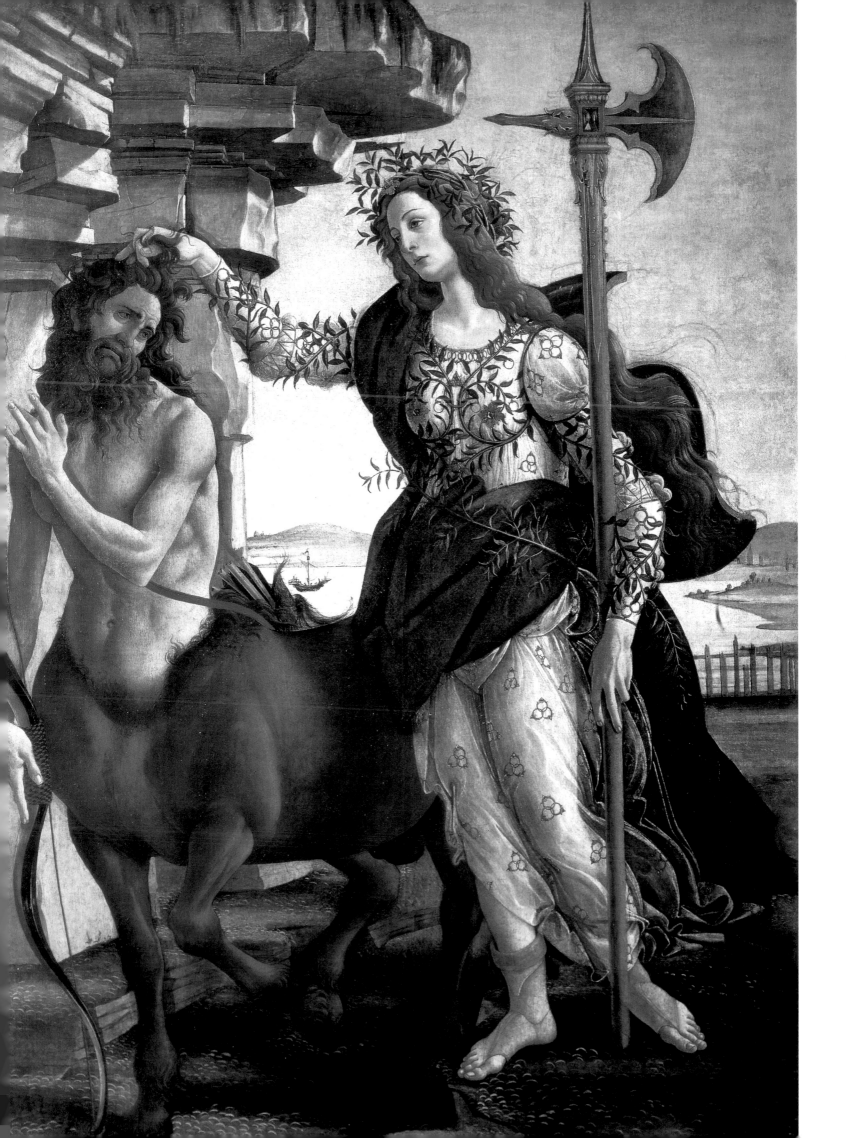

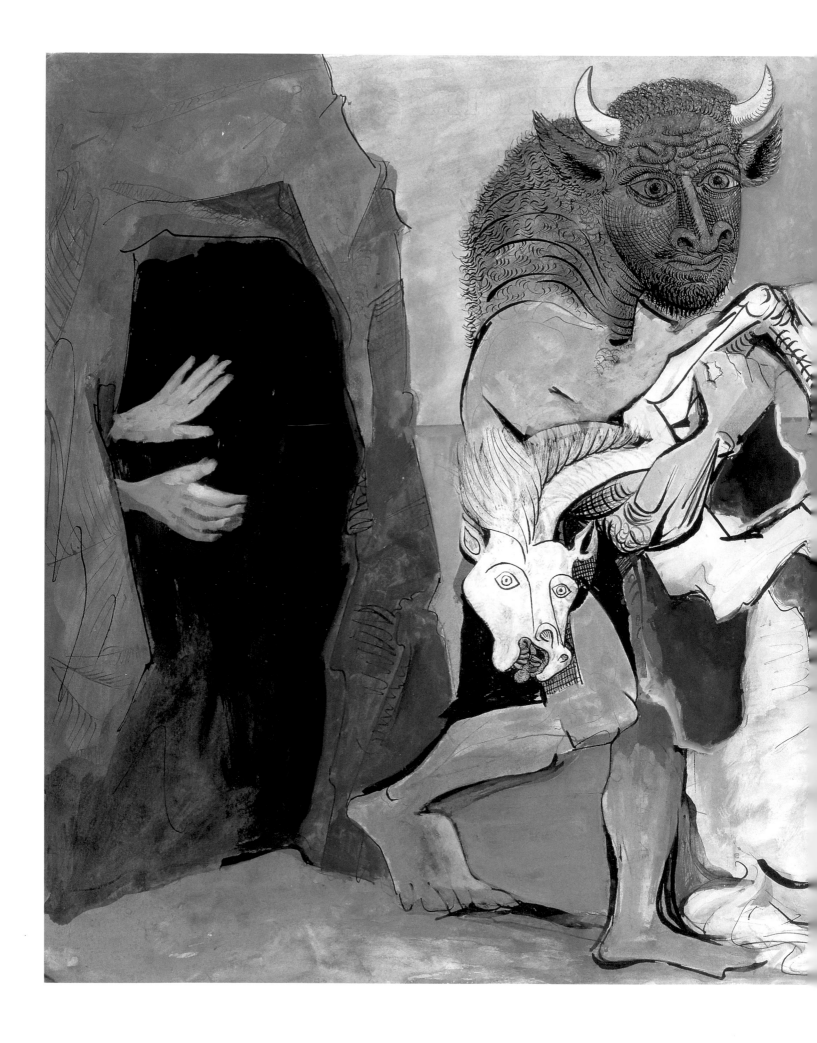

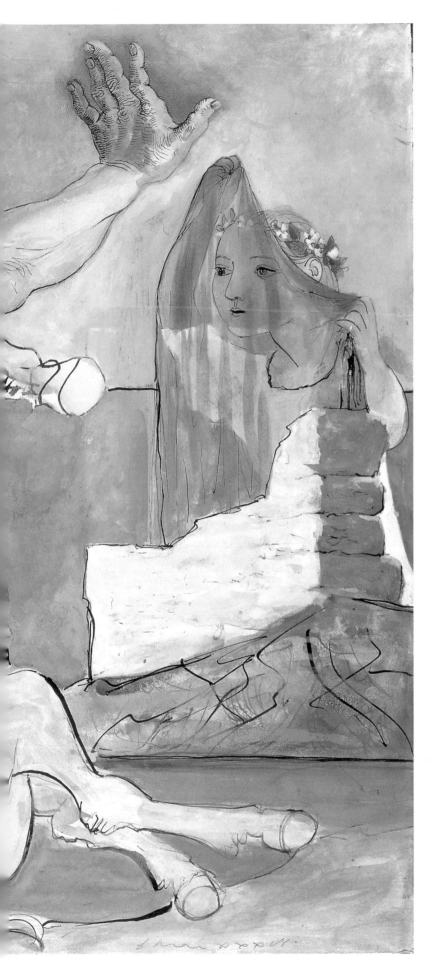

Minotaur and Dead Mare in Front of a Cave *Pablo Picasso* (1881–1973)

Picasso's work often related to his private life. After his wife Olga left him and he discovered that his lover was pregnant, he wrote surreal poetry for some nine months. Then, in March 1936, he visited Juan-les-Pins on the French Riviera, returning with drawings of fantastic scenes featuring Minotaurs. For Picasso, the bull-headed monster was a symbol of the dual nature of man and, here, it represents lust and brutality. Although the gentleness of its eyes and smile are oddly endearing, it holds a horse broken by its own hands and stretches a huge arm toward a girl with a veil – who stares, afraid. On the left, another pair of hands stretch imploringly from the darkness of a cave. Disturbed by events in Spain, which would later lead to the outbreak of civil war, this picture was a private allegory for the artist.

KEY ELEMENT

MINOTAUR: The ferocious Minotaur was conceived when Pasiphaë, wife of King Minos of Crete, mated with a bull. It had a man's body and a bull's head, and was kept in a labyrinth where, every nine years, seven youths and seven maidens were sent in sacrifice. Finally, the hero Theseus volunteered as a victim and killed the beast; he escaped with the aid of a ball of twine provided by Minos's daughter, Ariadne. In paintings, the creature represents base animal instincts such as lust.

Perseus Rescuing Andromeda

Piero di Cosimo (c.1462–1521)

Piero di Cosimo was a highly inventive artist, famed for the costumes and decorations that he created for masques and processions, and for his amusing mythological paintings, which were in great demand by private patrons in Florence. His life was as eccentric as his pictures – he hated fire so much that he was afraid to cook and lived on hard-boiled eggs, preparing them 50 at a time while boiling his glue. He also refused to allow his rooms to be swept or his fruit trees to be pruned, living more like a brute than a man.

Piero has represented several stages of a mythological narrative on this single panel (1490). In the top right, Perseus flies through the sky to rescue Andromeda, who is tied to a tree stump on the left – her mother had angered Neptune by declaring herself more beautiful than the nereids and she was about to be sacrificed to a sea monster. A moment later, Perseus lands on the back of the comical sea monster – placed prominently in the center of the composition – and starts to swipe at its neck. A bizarre mix of people in strange costumes or degrees of undress recoil from the scene in the foreground. Having slain the beast, Perseus marries Andromeda – the group on the right celebrates her liberation.

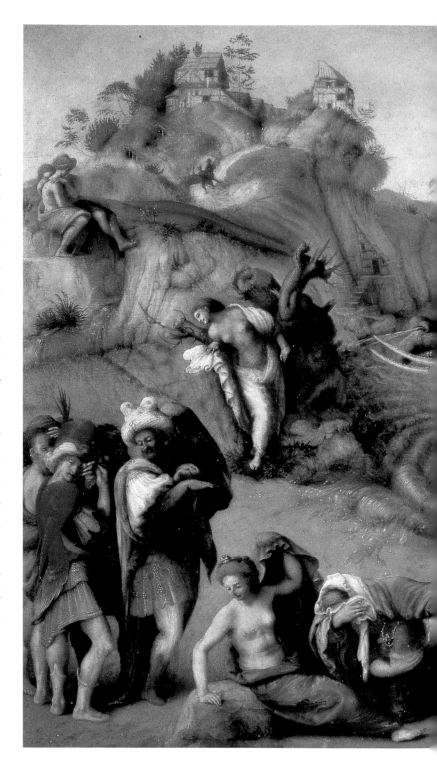

KEY ELEMENT

PERSEUS: Sent to get the head of Medusa,[1] a gorgon who turned all who looked on her to stone, Perseus was given armor by Minerva and winged boots by Mercury – a scene depicted in Paris Bordone's *Perseus Armed by Mercury and Minerva* (c.1540). Perseus beheaded Medusa by looking at her reflection in his shield, and on the way home rescued the Ethiopian

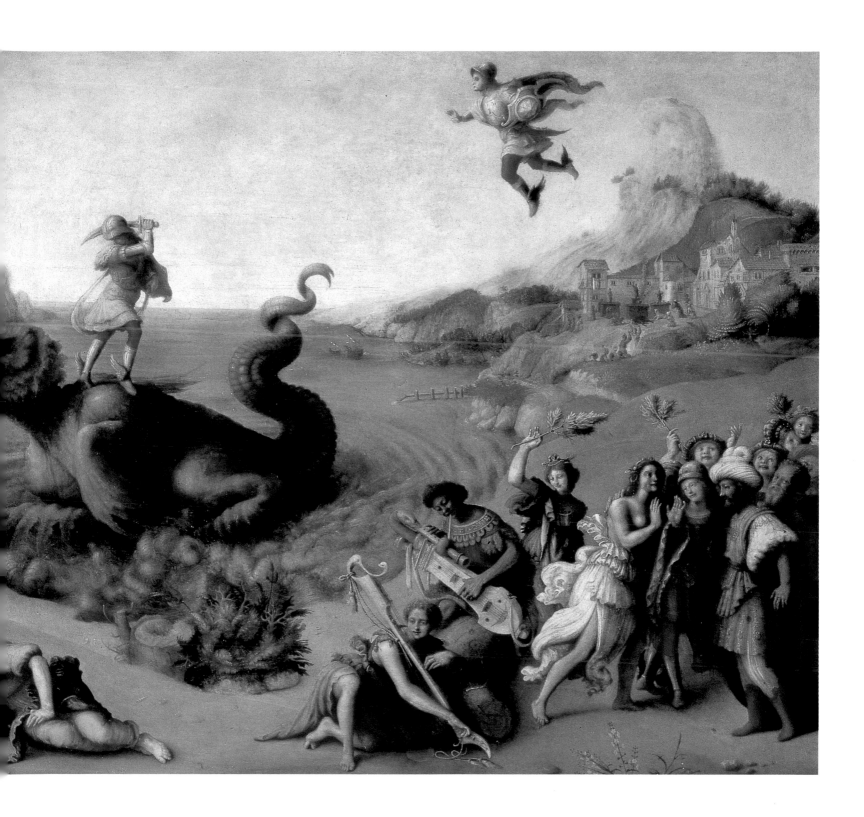

princess Andromeda, who was about to be eaten by a sea monster. When Andromeda's suitor Phineus interrupted the couple's wedding feast,[2] Perseus used Medusa's head to petrify him – as shown in *Phineus and His Followers Turned to Stone* by Giordano (1634–1705).

See also page 64

[1]Ovid *Metamorphoses* IV:604–803 [2]ibid. V:1–249

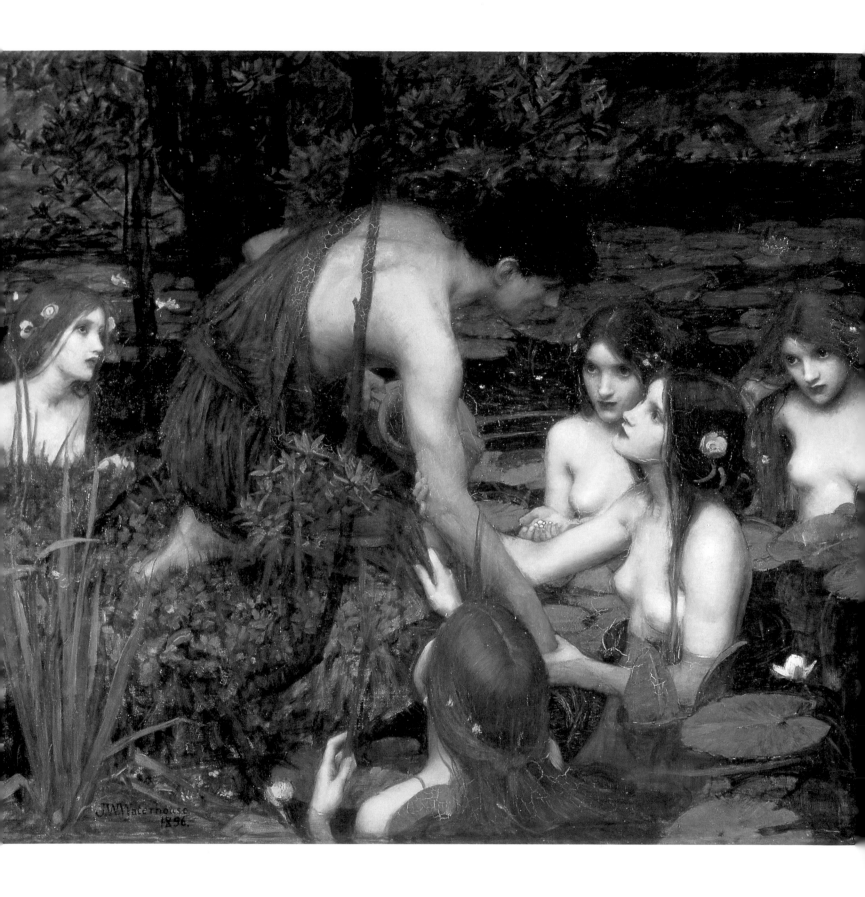

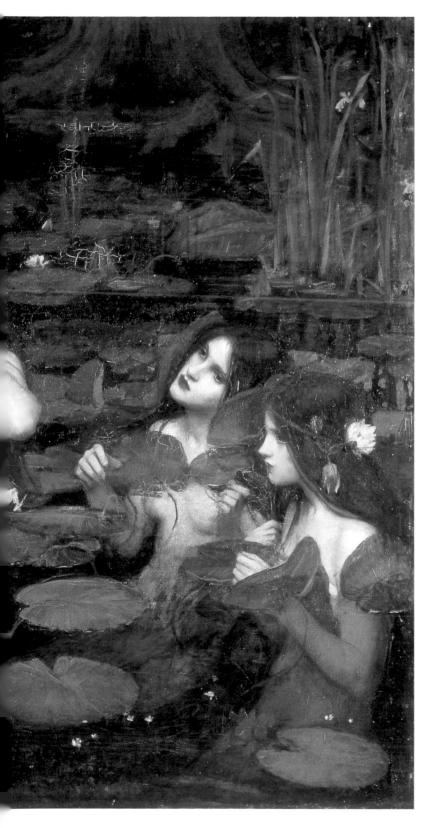

Hylas and the Nymphs
John William Waterhouse (1849–1917)

The English painter John Waterhouse was born in Rome and frequently painted genre scenes derived from ancient history and classical mythology. He was particularly fascinated by enchantresses and his paintings combine a Victorian narrative style with the dreamlike quality of the Pre-Raphaelites. A distinctive type of female beauty dominates his work – his models were chosen for their pale skin, reddish gold hair, and wistful looks. In this painting (1896), the nymphs form a ring around Hylas, while one of them looks mournfully at him as she draws him down.

KEY ELEMENT

HYLAS: The youth Hylas,[1] who accompanied Hercules on his adventures with Jason, was looking for water when he found a spring where naiads (nymphs of rivers, lakes or springs) danced. One nymph was captivated by Hylas's beauty and, as he filled his pitcher, she encircled his neck and pulled him underwater.

[1] Apollonius of Rhodes *Argonautica* I:1207–1240

Jupiter and Thetis
Jean Auguste Dominique Ingres (1780–1867)

This great canvas, painted in 1811, was the last work Ingres completed as a student in Rome and shows Jupiter, the supreme god of antiquity, sitting on his imperial throne in his kingdom of the sky. The god holds a scepter in his right hand, his left arm rests on a cloud, and an eagle watches attentively at his side. This powerful bird was Jupiter's attribute because of its great strength, speed, and soaring flight.

Jupiter ignores the ardent attentions of Thetis, a lovely nereid (sea nymph), as it had been prophesied that the offspring of their union would ultimately usurp him. To prevent this, Jupiter ordered her to marry a mortal man named Peleus. On the left, Jupiter's jealous wife Juno observes the scene suspiciously.

Ingres sent this work to Paris for review in 1811, where it was highly criticized for its lack of relief and for the curious proportions of its figures. Twenty-three years later this image of omnipotent authority was bought by the state.

KEY ELEMENT

THETIS: It was prophesied that Thetis, the loveliest of all the nereids, would bear a child who would surpass his father. When Jupiter ordered her to marry Peleus, she tried to avoid the union by changing shape into a bird, a tree, and a tiger, but Peleus held her by force.[1] At their wedding, Discord threw down a golden apple as a prize for the most beautiful of the major goddesses present: Venus, Minerva, and Juno. This act led to the Judgment of Paris (see pages 38–39), which ultimately caused the Trojan War.

Achilles, hero of the Trojan War, was the son of Thetis and Peleus. Homer's *Iliad* tells how the hero was insulted by the Greek king Agamemnon, and how Thetis rose from the depths of the sea to the gods' home on Mount Olympus and begged Jupiter to avenge her son.[2] Thetis also asked Vulcan, god of the forge, to make Achilles a magnificent suit of armor.[3]

[1]Ovid *Metamorphoses* XI:221–65 [2]Homer *Iliad* I:495–512
[3]Homer *Iliad* XVIII:428–617

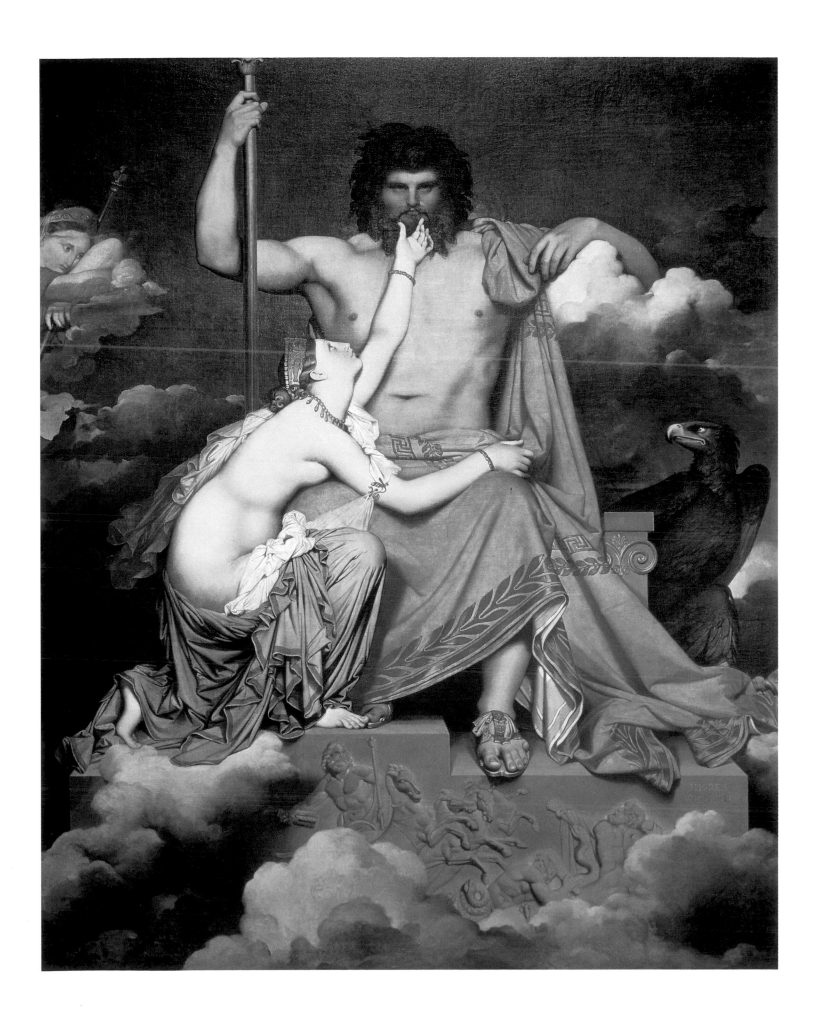

The Judgment of Paris
Peter Paul Rubens (1577–1640)

Rubens painted several versions of this subject, delighting in the story because it allowed him to depict three beautiful women in an idealized pastoral landscape where clothes were unnecessary. In one account of the Judgment of Paris, the Trojan prince had indeed asked the goddesses to take off their clothes to help him judge the divine beauty contest.

In this rendition (1639), Paris is shown in his shepherd's garb. He stares at the three magnificent nude goddesses, contemplating their side, front, and back views, while Mercury holds up the apple that was to be the prize. Minerva appears with her owl (her armor discarded behind her), Venus with her son Cupid, and Juno with her peacock. The goddesses' gentle expressions and graceful movements reveal nothing of the fateful consequences of Paris's decision, which gave rise to the Trojan War (see below).

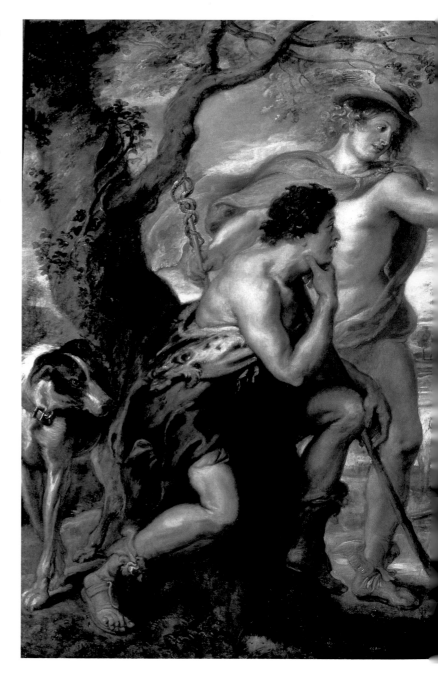

KEY ELEMENT

PARIS: Son of King Priam of Troy, Paris was destined at birth to be the ruin of his country. His father ordered his death, but the slave who had been entrusted with the task did not kill him, abandoning the boy on Mount Ida instead. He was found and brought up by shepherds, and he too became a tender of sheep. Later, the nymph Oenone fell in love with him.

In the portentous Judgment of Paris, he was charged with awarding Discord's golden apple to the goddess he deemed the fairest.[1] Juno offered him Asia if he chose

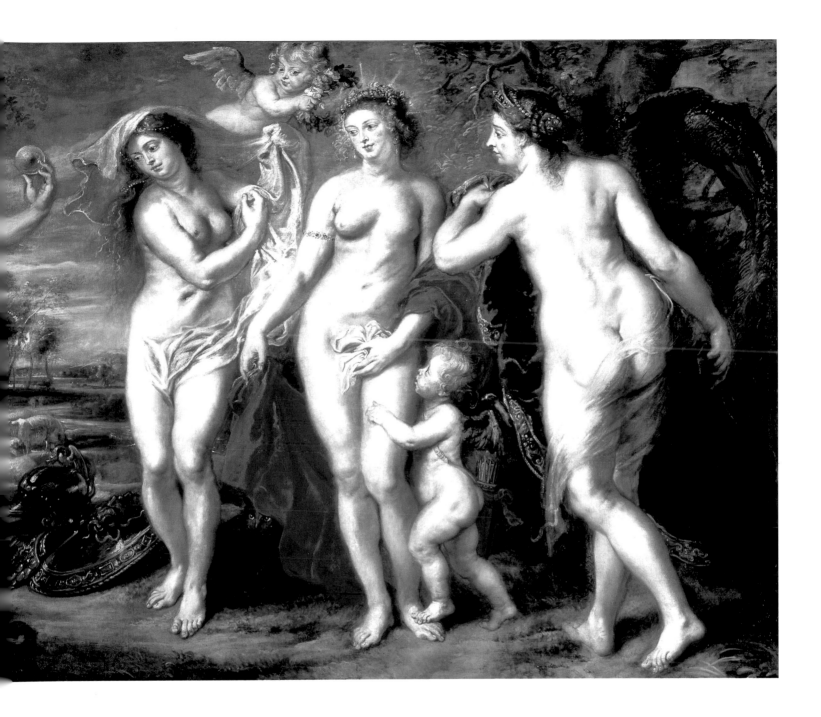

her; Minerva said she would make him a great warrior and conqueror; Venus promised him the beautiful Helen of Sparta, together with Love, Desire, the Three Graces, Passion, and Hymen. Venus won the apple but the decision incurred the resentment of Juno and Minerva. And when Paris abducted Helen he incited the Greeks to take up arms to retrieve her. He thus instigated the Trojan War, in which he fought without enthusiasm until it ended with the destruction of Troy.

[1]Hyginus *Fabulae* XCII

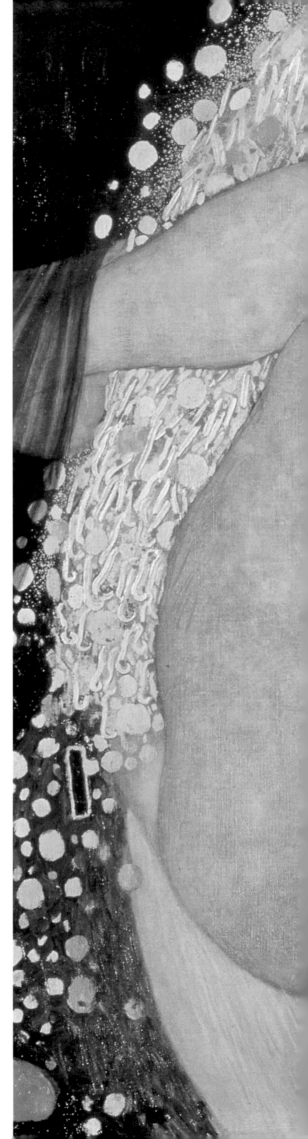

Danaë
Gustav Klimt (1862–1918)

Klimt's interpretation of the story of Danaë (1907–1908) is overtly sensuous; Jupiter descends as a shower of gold while Danaë lies in a fetal position, absorbed in an erotic dream as the gold falls between her legs. Klimt was a famous painter of murals and portraits, and founded the Vienna Secession in reaction to the conservatism of the state academy. Inspired by Byzantine mosaics, he had developed a style in which two-dimensional, abstract patterns surrounded three-dimensional, naturalistic figures. His works have a richness rarely equaled in twentieth-century art.

KEY ELEMENT

DANAË: After an oracle predicted that Acrisius, king of Argos, would be usurped by his grandson, he locked his daughter Danaë in a tower to stop her from conceiving a child. Jupiter spotted the lovely maiden from the skies and determined to ravish her; but unable to make love to her in his god-like form, he came down as a shower of gold.[1] As a result of their coupling, Danaë gave birth to the hero Perseus. In his painting *Danaë* (1545), Titian included an ugly nursemaid trying ignorantly to catch the gold – emphasizing Danaë's beauty and her higher understanding of her fate.

[1]Ovid *Metamorphoses* IV:611

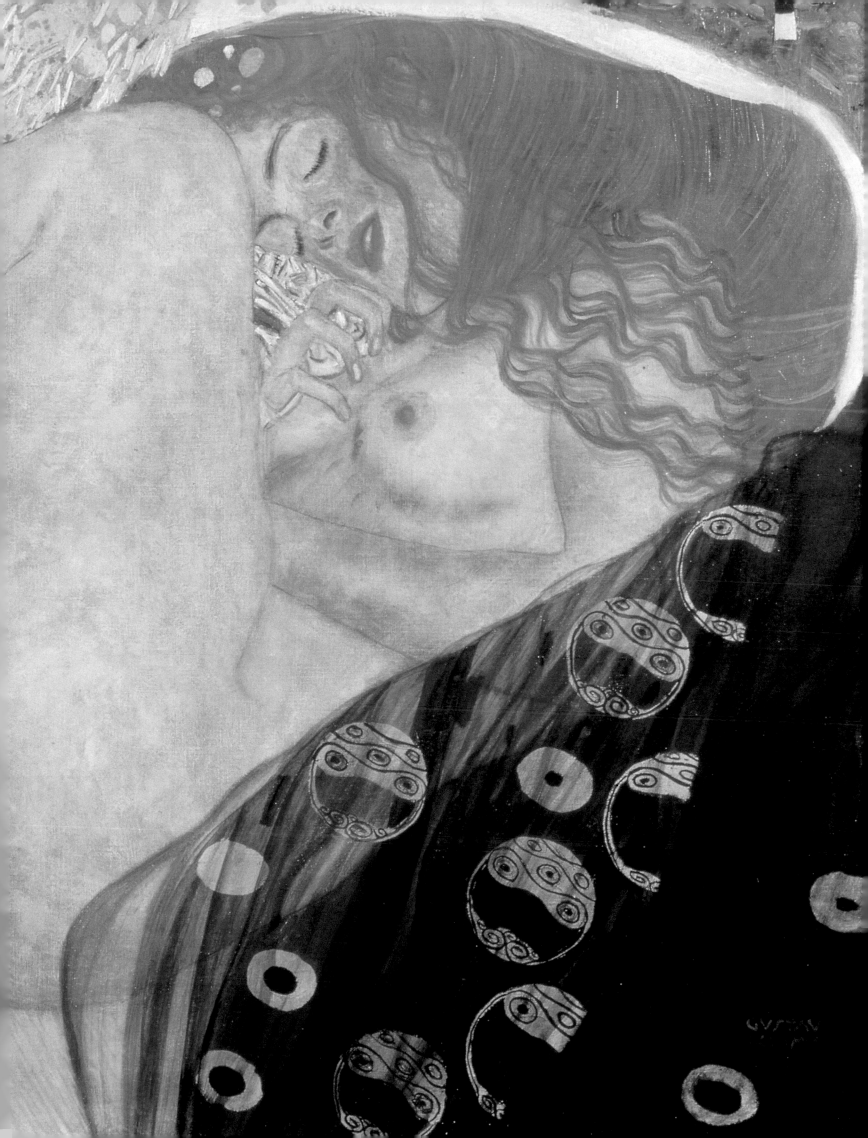

Jupiter and Semele

Gustave Moreau (1826–98)

Gustave Moreau was a major figure in the Symbolist movment, producing visionary and emotionally charged images. His sources varied from Italian Renaisssance painting to Byzantine art. By using thick layers of paint, he created an encrusted, almost jeweled, effect, depicting fantastic scenes filled with religious, historical, and mythological characters.

This canvas (1894–95) is typical of Moreau's elaborate style and shows a youthful Jupiter sitting impassively on a highly ornamental throne, indifferent to Semele who sprawls naked across his lap. Semele had asked to gaze on the god in all the brilliance of his divinity and, according to Moreau, was "struck down in a paroxysm of divine ecstacy" when she saw him. Jupiter is bedecked with jewels: a cluster of pearls adorn his forehead, and his hair, neck, and breast glitter with precious stones. He leans on a lyre, an unusual attribute for the god of the skies, while his most common attribute, the eagle, is somewhat lost at the bottom of the canvas. At the foot of the throne, Moreau painted figures representing Death and Sorrow, which he explained were the tragic base of human life. Not far from them, under the wings of Jupiter's eagle, the great god Pan (symbol of the Earth) bows his saddened brow. Shadow and Misery, the enigmas of darkness, are at Pan's feet.

KEY ELEMENT

SEMELE: Daughter of Cadmus, king of Thebes, Semele was loved by Jupiter.[1] But when Juno, Jupiter's wife, discovered her husband's infidelity, she persuaded Semele to ask Jupiter to appear to her in his full glory, as he did to Juno herself. Unfortunately, Semele's mortal frame could not endure the god's embrace, and his lightning turned her to ashes. Her child, Bacchus, was snatched from her womb before she died and was sewn into Jupiter's thigh until his birth.

[1]Ovid *Metamorphoses* III:253–315 and Philostratus the Elder I:14

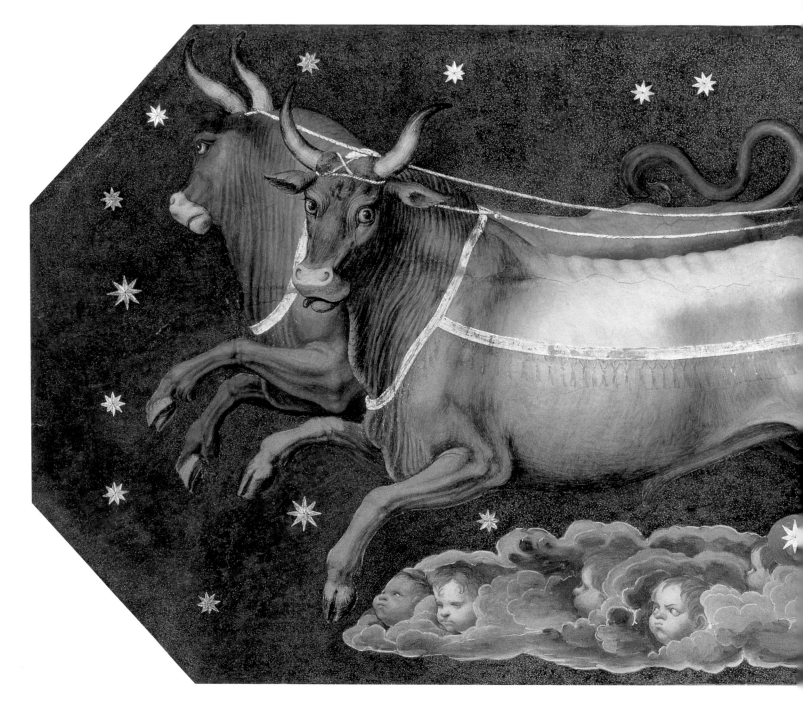

The Nymph Callisto on Jupiter's Chariot

Baldassarre Peruzzi (1481–1536)

This painting of 1511–12 is part of the decorated ceiling of what was originally an open-sided *loggia* in the Villa Farnesina in Rome. Peruzzi was also the architect of the villa, and designed the vault to accommodate several scenes: the fresco beneath is Raphael's *Triumph of Galatea* (see pages 46–47). This detail from Peruzzi's decoration shows Callisto riding in a golden chariot through a starry sky. Two bulls pull the chariot, and through the clouds, the heads of *putti* emerge, representing the winds. The painting is believed to have some astrological significance, with the bull, the sign of Taurus, rising through the constellation of the Great Bear, symbolized by Callisto (placed in the sky by Jupiter after Juno turned her into a bear). Other sections of the vault also depict complex astrological scenes, and together they are thought to represent the horoscope of Agostino Chigi, the villa's owner.

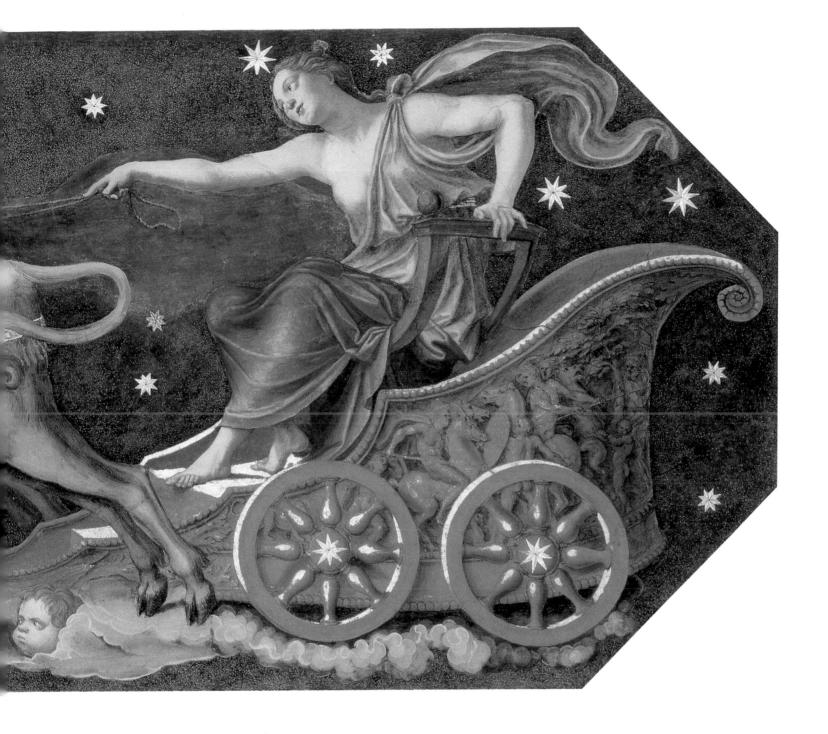

KEY ELEMENT

CALLISTO: Jupiter seduced Callisto, one of Diana's nymphs, by disguising himself as Diana. Later, as the nymphs were bathing in a stream, Callisto was reluctant to join them; and when the others undressed her they realized she was pregnant. Banished by Diana, Callisto was then changed into a bear by Juno. When Callisto's son Arcas was 15, he almost speared his mother while out hunting, but Jupiter swept them into the heavens to become the Great and Little Bear.[1]

[1]Ovid *Metamorphoses* II:401–530 and *Fasti* II:153–93

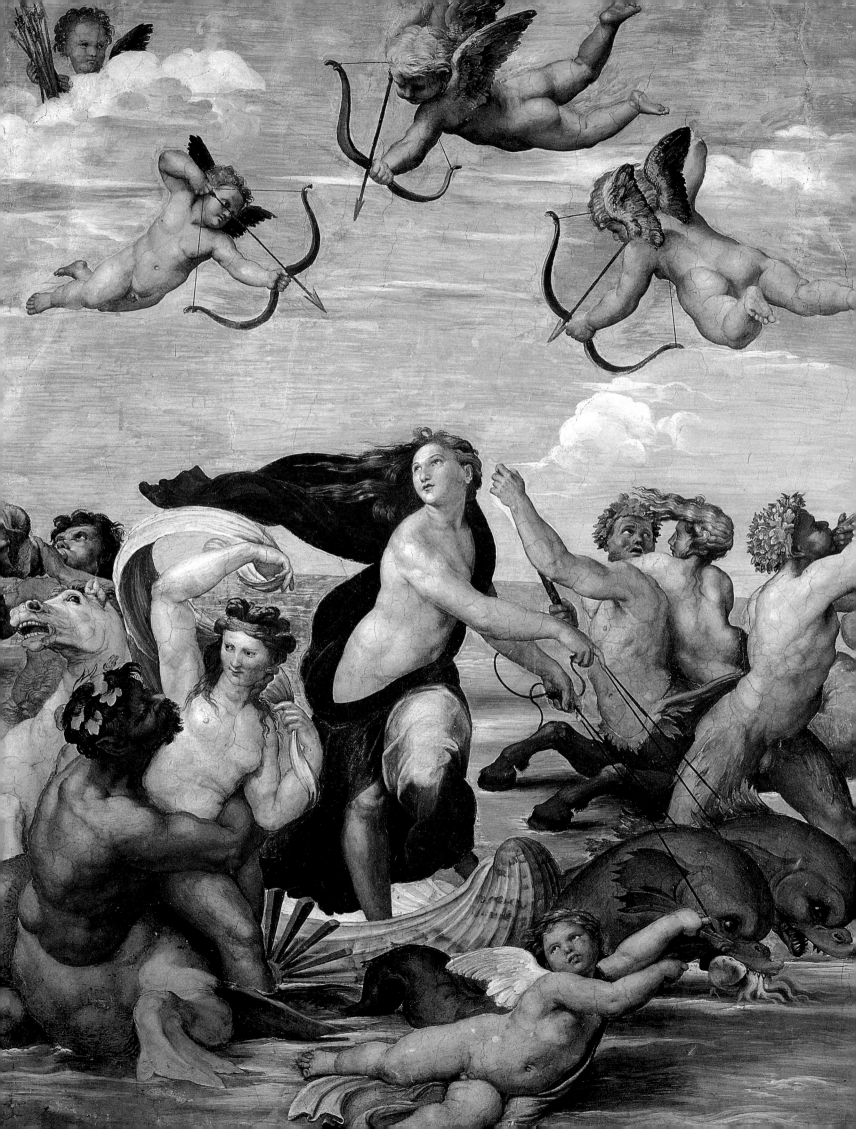

The Triumph of Galatea

Raphael (1483–1520)

In this painting of 1511, Galatea is shown fleeing from the monster Polyphemus (seen in a fresco to the left of this piece) on a giant cockle shell fitted with paddles and drawn by dolphins. Above her fly four *putti* and around her tritons and nereids (sea nymphs) play in the waves. This work was painted in an open *loggia* of the villa owned by the wealthy Papal banker Agostino Chigi, which overlooked the River Tiber in Rome. The scene in the picture is meant to reflect the view over the river from the *loggia*. The villa was also celebrated for its parties, and Raphael was usually among the guests. He had a great passion for women and apparently died following a bout of excessive indulgence. The figure of Galatea and other nudes painted in the villa are representations of his ideal female form.

KEY ELEMENTS

GALATEA: The sea nymph Galatea was in love with the handsome Acis, but was herself pursued by the one-eyed Cyclops Polyphemus – a savage monster who raised sheep on an island generally thought to be Sicily.[1] Climbing a hill overlooking the sea, Polyphemus played his pipe of a hundred reeds and sang a pastoral love song to Galatea. Later, the Cyclops saw her lying in Acis's arms, so he chased the youth and hurled a huge lump of the mountainside at him, whereupon Acis was turned into a river.

[1]Ovid *Metamorphoses* XIII 738–897

PUTTO: A *putto* (plural *putti*) is a young, winged boy, also known as an *amoretto* or "little Cupid." *Putti* may appear as angels or cherubs in religious paintings, or add a humorous note to secular paintings about love.

They often accompany Venus and may be seen worshipping her statue during the Feast of Venus. In Titian's painting of 1518–19, *The Worship of Venus*, countless *putti* gather apples (which were sacred to the goddess) from an orchard floor, or they fly up to pick them from the trees and tumble about playing ball.[1]

[1]Philostratus the Elder *Imagines* I:6

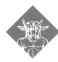

The Story of Cupid and Psyche

Jacopo del Sellaio (1441/42–93)

Jacopo del Sellaio, an artist working in the style of Botticelli, painted two panels depicting the love story of Psyche and Cupid. This one (*c.*1473) tells the first half of the tale.

In the villa on the left, we see the conception and birth of Apollo's daughter Psyche, who wears a white dress throughout the rest of the panel. Her beauty incurred the jealousy of Venus, who sent her son Cupid to make Psyche fall in love with someone ugly. As Psyche appears to a group of suitors, Cupid flies above, but he quicky falls in love with her and is unable to fulfil his mission. An oracle then tells Psyche to climb a high mountain, and at

the summit she is wafted down by the winds and falls asleep. On the right, she is led into a sumptuous palace provided by Cupid, where she is visited by her envious sisters. Although Cupid has forbidden Psyche to look at him, her sisters persuade her to take a peek and she falls in love. Unfortunately, a drop of hot oil falls from her lamp, and as an angry Cupid wakes and flies away, Psyche holds him by the ankle in an attempt to stop him leaving.

The artist's companion panel completes the story of Psyche's trials and eventual marriage. Together, the two pictures would have been an ideal decoration for a *cassone*, or bridal chest.

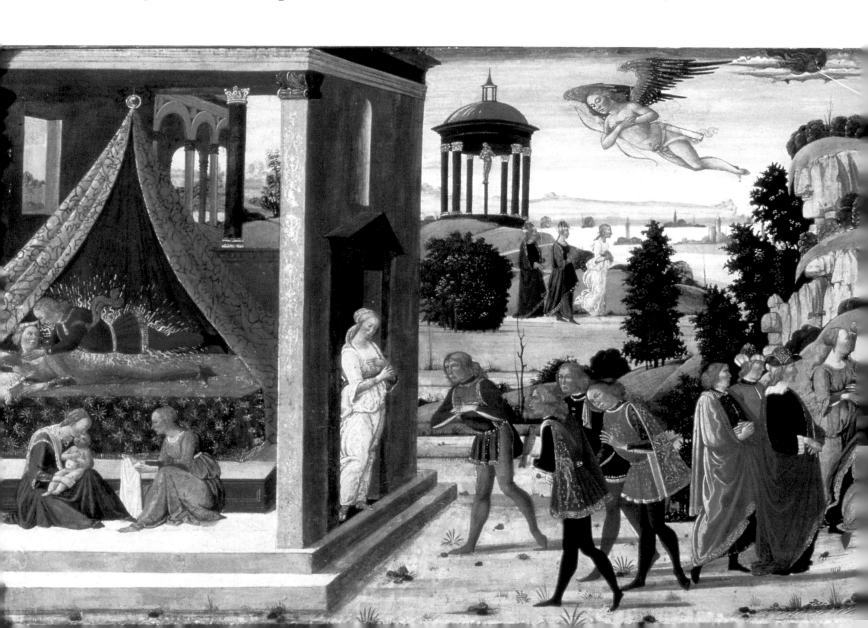

KEY ELEMENT

PSYCHE: In the second part of Psyche's story[1] (see opposite), the distraught girl roamed the Earth looking for Cupid – until she came to the house of Venus. Here, she became Venus's slave, and her mistress set her a series of near-impossible tasks. But Psyche was lucky: some ants helped her to separate a pile of mixed grain; a reed from the sacred waters told her how to obtain golden wool from dangerous sheep; Jupiter's eagle came to her aid when she went to get water from a stream guarded by dragons; and a tower guided her safely to the Underworld to collect some of Proserpina's beauty. At last, Cupid begged Jupiter to take pity on Psyche, so the gods held council and decided to give her a cup of nectar to make her immortal. A feast was arranged for the couple's wedding, and Psyche later bore Cupid a daughter, Pleasure.

The story of this beautiful couple was a popular romantic tale. Its numerous episodes and final wedding scene were sometimes used to cover large areas or to fill the many vaults of a ceiling.

[1]Apuleius *The Golden Ass* VII; VIII; IX

Venus and Adonis
Titian (c.1488–1576)

Titian chose the tragic love affair between Venus and Adonis as a subject for his patron King Philip II of Spain. He completed the painting in 1554 when the king was in London following his marriage to Mary I, Queen of England – although the picture was not in keeping with wedding celebrations, but accorded with the king's taste for naked women. Titian had previously sent Philip a painting of Danaë, seen naked from the front. In a letter to the king he explained that he had painted Venus from behind so the two pictures could hang together and his patron could admire the variety. Titian called the painting a *poesia* – a subject drawn from mythology but elaborated, taking the same artistic licence as a poet. He emphasized the tragic content of the story, showing a naked Venus clinging to the hunter, who ignores her pleas and sets off for the hunt at dawn. Cupid lies asleep under a tree as the sun's rays hail the fateful day.

KEY ELEMENT

ADONIS: When Myrrha tricked her father into an incestuous relationship, the gods turned her into a tree to protect her from his wrath – Adonis was born from the trunk. Venus fell madly in love with the beautiful youth after Cupid pierced her with his arrow. She was warned that Adonis would die while hunting but failed to dissuade him and, after his death, the rose sprang from his blood, and the anemone from her tears.

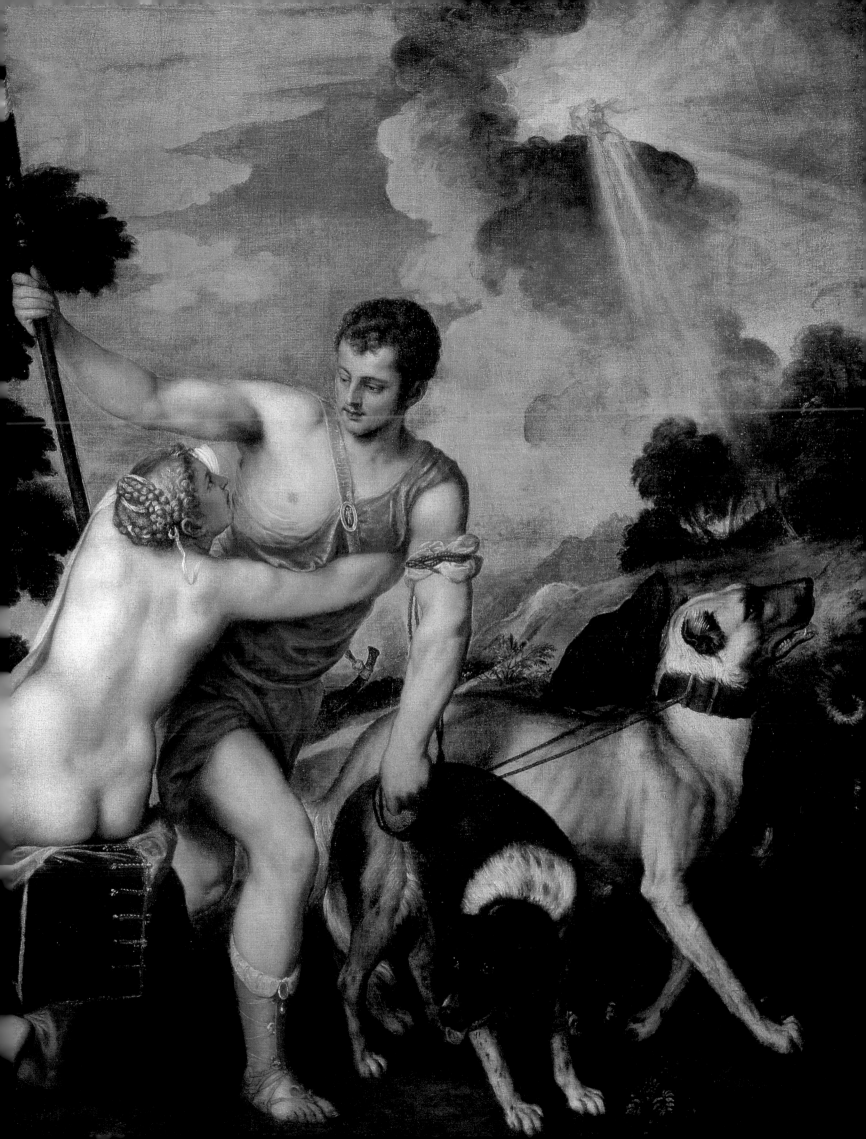

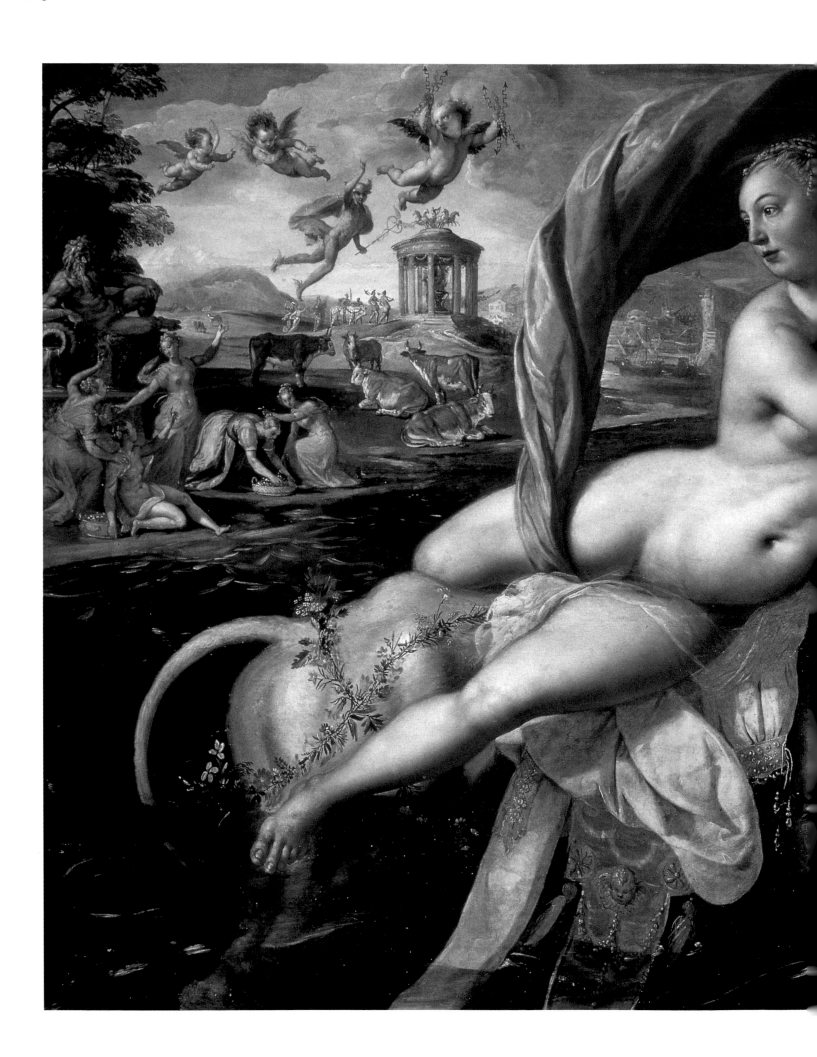

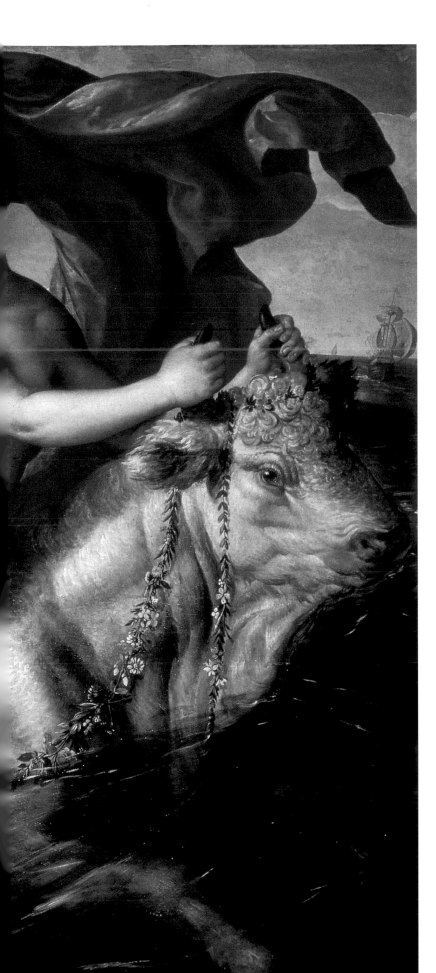

The Rape of Europa
Marten de Vos (1532–1603)

Marten de Vos was the master of a busy studio in Antwerp, an important artistic center in the late sixteenth century. *The Rape of Europa* (late sixteenth century) is a typical example of his graceful style and shows the naked Europa lying across the back of Jupiter, who is disguised as a bull, her billowing drapery forming an elegant arch behind her head as she clings to his horns. She looks back remorsefully at the shore where she had been playing with her companions before he whisked her away.

Like many painters of his day, de Vos had traveled to Italy, where he was greatly influenced by Venetian artists – Veronese and Titian had both treated the same subject.

KEY ELEMENT

EUROPA: Jupiter fell in love with Europa,[1] daughter of the king of Tyre, and disguised himself as a bull so he could mingle with the cattle on the sands where she played. In his painting in the Doge's Palace in Venice (1580), Veronese shows her admiring the handsome bull and holding out flowers so that he would kiss her hands. Jupiter frolicked and played until Europa lost her fear, hung garlands on his horns, and mounted him. He then sped across the ocean to Crete, where they made love; and as a result, she gave birth to three sons, one of whom was Minos, king of Crete. Another version says that one child was the continent of Europe, and that Europa was herself turned into a bull, becoming the constellation and zodiac sign of Taurus.

[1] Ovid *Metamorphoses* II:833–75

The Sabine Women
Jacques Louis David (1748–1825)

This canvas (1799) shows the Sabine women halting a fight between their Roman husbands and their fathers and brothers, and was a statement of David's support for the new Republic of France after the revolution in 1789. An ardent admirer of antique statuary, David arranged the composition as a frieze – the overlapping figures recalling classical relief sculpture, and the heroic poses contrasting masculine resolve with the women's emotional response. The soldiers on the right carry symbols of Rome such as the wolf, and the picture is littered with the women's children, who will form the future republic.

KEY ELEMENT

SABINE WOMEN: According to legend,[1] Romulus founded Rome in 753BCE. There were few women in the settlements, so, concerned about its future growth and greatness, he invited the neighboring Sabines to a festival. At a given signal, the Roman men seized and raped the unmarried Sabine women, intending to unite with their neighbors "by the greatest and surest bonds." Many sculptors and painters depicted this scene, including Pietro da Cortona and Giambologna.

Romulus refused to let the women return home, so their fathers and brothers marched on Rome. The women had married their violators in the meantime, and realizing the futility of this action they threw themselves between the armies, pleading with "tender and endearing words" until the men ended the fight.

[1]Plutarch *Lives* Romulus

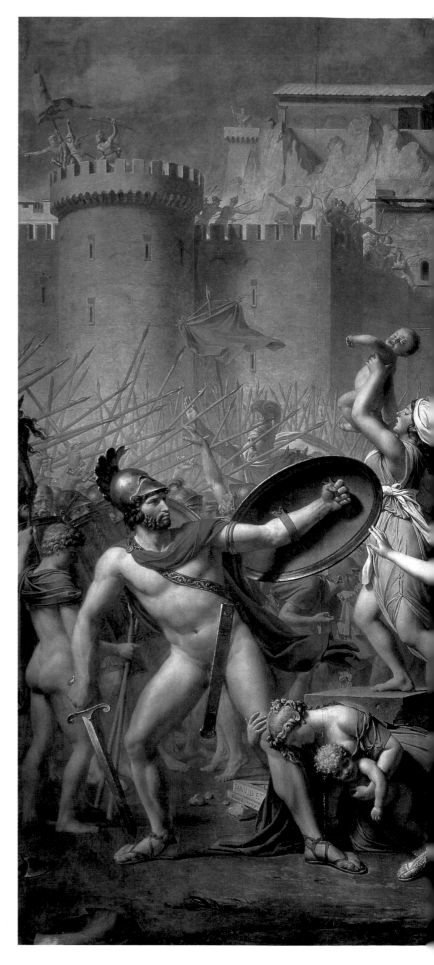

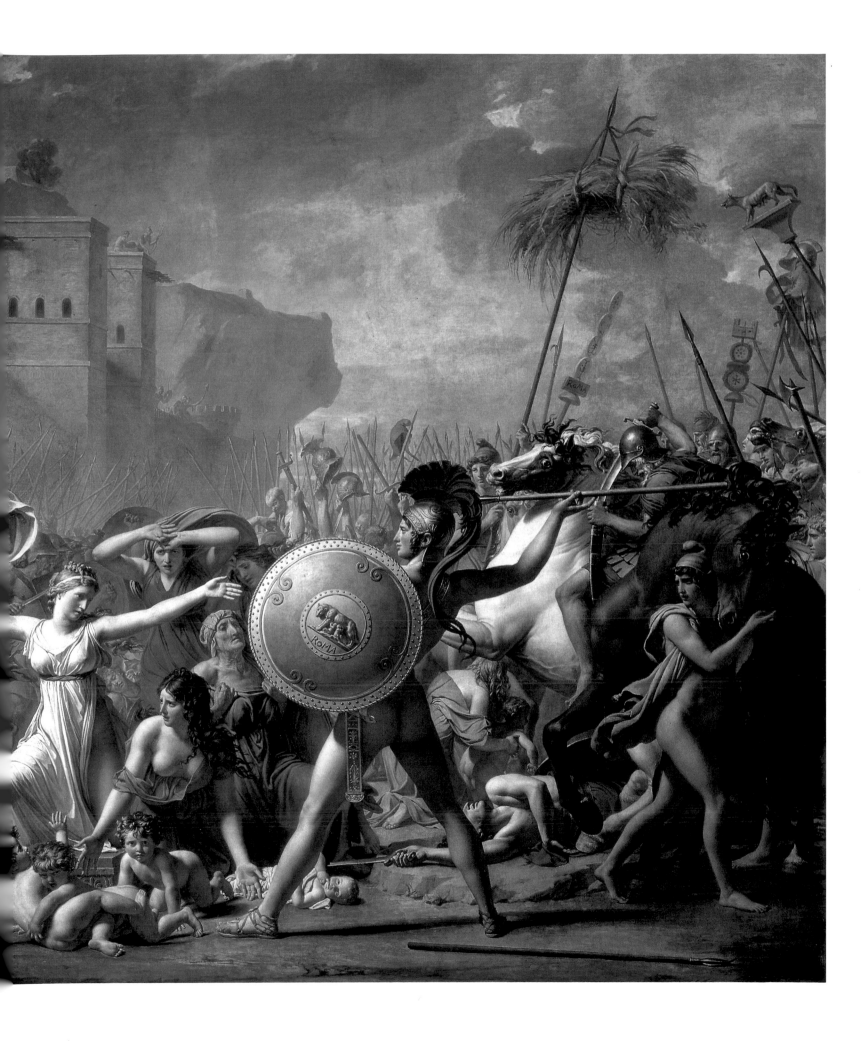

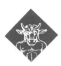
Gods and Goddesses

Episodes from the lives of the gods and goddesses of antiquity provided inspiration for many artists, challenging their imaginations. The stories describe a vast range of human emotions and, as personifications of human qualities, the gods played an important role in allegory. At the beginning of time, there was **GAEA**, the

The Olympians

In Greek and Roman mythology, the gods lived an idyllic life on Mount Olympus. Initially a family of 12, Bacchus is said to have replaced Vesta when she quit Olympus in protest at her fellow gods' bad behavior. Pluto was the only god who did not live on Olympus – his realm was the Underworld.

ROMAN NAME	GREEK NAME	ASSOCIATIONS
Jupiter	Zeus	Supreme deity; ruler of the skies
Juno	Hera	Queen of Heaven; marriage
Neptune	Poseidon	Ruler of the seas
Pluto	Hades	Ruler of the Underworld
Venus	Aphrodite	Love and beauty
Vulcan	Hephaestus	Forge and fire
Mars	Ares	War
Minerva	Athene	Wisdom
Apollo	Apollo	Light; the arts; healing
Diana	Artemis	Hunting; chastity; the moon
Ceres	Demeter	Agriculture
Mercury	Hermes	Communication
Vesta	Hestia	Home and hearth
Bacchus	Dionysos	Wine; ecstasy

Earth, and **URANUS**, ruler of the heavens, whose union produced the giant **TITANS**. There were usually said to be 12 Titans, six male and six female, all of whom were endowed with enormous size and strength. **SATURN**, the youngest, was the god of agriculture and was often represented as an old man with a scythe. He may also personify Time, although this allusion stemmed from a confusion between the god's Greek name, Cronos, and the Greek word for time, *chronos.*

Uranus also fathered the one-eyed **CYCLOPES** and the hideous, 100-handed giants, or **HEKATONCHEIRES**, but he couldn't stand the sight of these unfortunates and banished them to Tartarus. In response to Gaea's pleas, Saturn took revenge for this act by castrating his father with a sickle. The three serpent-headed **FURIES** were born as drops of Uranus's sperm fell on the Earth. Named Allecto (relentless), Megaira (resentful) and Tisiphone (avenger of murder), they breathed vengeance and pestilence, and administered revenge on behalf of wronged mothers and fathers.

The goddess **VENUS** (see page 11) was born as Uranus's sperm dripped into the sea – a subject chosen by Vasari for the ceiling of the room known as the *Four Elements* in the Palazzo Vecchio, Florence (*c.*1560). She came ashore on either Cyprus or the Ionian island of **CYTHERA**[1] (she was also known as the Cytheran); consequently, Cythera was thought of as an earthly paradise where sensual love prevailed and young girls found lovers or husbands. Watteau's *The Embarkation for Cythera* (see pages 218–19), seems to depict a departure from the island, and has a melancholic air appropriate to lovers returning to the everyday world. Venus is also associated with the ancient Syrian deity **ASTARTE**; and in *Astarte* (1877), Rossetti represents this mysterious goddess of love, whose realm lay between the Sun and the Moon.

Saturn inherited his father's kingdom, marrying his sister **OPS**, the goddess of the harvest. Ops was associated with **CYBELE**, "the Great Mother" and goddess of fertility. In allegory, Cybele represents the Earth, and is commonly shown with an abundance of fruit, as in Rubens' *The Union of Earth and Water* (1612–15), which

Corn: see Ceres

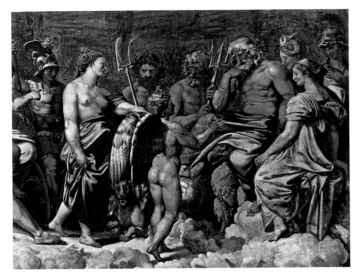

In Raphael's The Council of the Gods *(detail; 1509–1511), Jupiter and Juno converse with Venus and her son Cupid.*

invokes peace and prosperity. But Uranus had warned Saturn that he would be ousted by his son in turn, so he swallowed his offspring as fast as they were born – a monstrous act depicted by Goya in *Saturn Devouring One of His Children* (1821–23). Finally, Ops could no longer bear to see her children perish, so when **JUPITER** was born she gave Saturn a stone wrapped in swaddling and hid the baby in a cave on Mount Ida on Crete,[2] where Amalthea nurtured him on honey and goat's milk.

As predicted, Jupiter finally overthrew his father, presenting Saturn with an emetic that made him vomit up Jupiter's brothers and sisters, who emerged unharmed. Jupiter then became the supreme head of these new gods, and they lived on the summit of Mount Olympus in Greece, in a cloudless sea of limpid air, illuminated by white radiance. The Titans sought to overthrow their usurpers by piling two mountains on top of each other to reach Olympus, but Jupiter hurled thunderbolts to halt their attack. The subject was popular in Baroque times, and Giulio Romano's *trompe l'œil* frescoes in the Palazzo del Tè, Mantua (1530–32) showed later artists the dramatic possibilities of the

episode. Jupiter's image is usually majestic; he is portrayed as an athletic figure with a long, curly beard and hair. He may be enthroned or holding a scepter, and as the "aegis bearer," he may wear armor.

In ancient times, the transfer of power between gods was equated with four **AGES OF THE WORLD**: gold, silver, copper or bronze, and iron.[3] Saturn's benevolent and tranquil rule was linked to the Golden Age, a period free of fear and conflict, where the season was everlasting spring and animals lived in harmony. When Saturn was overthrown by Jupiter, he fled to Italy, where he taught agriculture and the Liberal Arts. In the Age of Silver, Jupiter introduced the four seasons, forcing humans to seek shelter. In the Age of Bronze, humans became fiercer and more inclined to conflict, but were still free from wickedness. The Age of Iron introduced treachery, violence, greed, and war. In frescoes in the Sala della Stufa (1637–47; Pitti Palace, Florence) Pietro da Cortona compared these ages to the ages of man: gold representing bounty and youth, silver the agrarian life, bronze reaping the rewards of middle age, while iron brought violence and death.

Jupiter married his sister **JUNO** (see pages 16–17), but his infidelities often provoked her fury. Among his lovers was his sister **CERES**, goddess of agriculture, corn, and the regenerative powers of nature. When Pluto abducted their daughter Proserpina, Jupiter promised to return her on condition that she had eaten no food in the Underworld. Proserpina innocently confessed that she had placed some pomegranate seeds in her mouth, so Jupiter resolved that she should spend equal parts of the year with her mother and her new husband Pluto.[4] He thus created the seasons, for Ceres made the world barren during Proserpina's stay in the Underworld, while her return home became spring and summer. Like Abundance, Ceres may carry sheaves or ears of corn, fruit, or a cornucopia, and hold agricultural tools. She was associated with Cybele, and in his

Ages of the World: see Ages of Man (page 245); **Ceres**: see Cornucopia (page 244), Pluto (page 78), Proserpina (page 78) **Jupiter**: see Amalthea (page 77), Liberal Arts (page 197)

[1]Ovid *Fasti* IV:286 [2]ibid. IV:197–206 [3]Ovid *Metamorphoses* I:89–150 [4]ibid. V:342–571

Forethought and Afterthought

The Titan **PROMETHEUS** (whose name means "forethought") predicted that the Olympians would overthrow the Titans, so he fought on Jupiter's side. Unfortunately, he enraged his new master by fashioning man from the freshly-made earth but in the image of the gods,[1] a story illustrated in two paintings by Piero di Cosimo (1490s). An angry Jupiter then deprived humankind of fire, so Prometheus climbed to the heavens and retrieved a spark from the chariot of the sun. In retribution for this defiant act, Jupiter chained Prometheus to a rock on Mount Caucasus. Each day an eagle came and devoured Prometheus's liver, and each night the organ was regenerated until, after many years, Hercules set him free.[2] Prometheus's torture was a popular theme in art, especially in the seventeenth century; Rubens shows his muscular body racked with pain in *Prometheus* (1611–14).

Jupiter's wrath extended to humans too, and he asked his son Vulcan to make **PANDORA** out of clay.[3] She came to life and the gods showered her with gifts: Venus gave

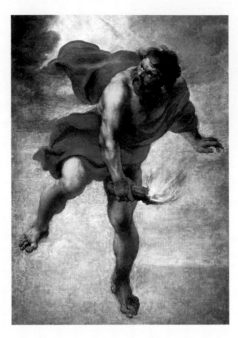

In Prometheus Carrying Fire *(detail) by Cossiers (1600–1671), the Titan glares up at Jupiter as he steals fire for humankind.*

her beauty and the art of pleasing, the Graces made her captivating, Apollo taught her to sing, Mercury instructed her in eloquence, and Minerva gave her rich jewelry. Jupiter's gift was a box, which he told her not to open but to give to her husband. Jupiter then sent her to Earth, where Prometheus's brother Epimetheus (whose name means "afterthought") ignored his sibling's warning and married her. Overcome with curiosity, Pandora opened the box: evils poured out and spread over the Earth to afflict mankind ceaselessly. Only Hope, the consoler of sorrow, remained inside. Pandora's story became the counterpart of Eve's temptation and the Fall of Man, and in *Eva Prima Pandora* (see pages 224–25) Jean Cousin painted her with an apple and an urn of troubles. Pandora was also portrayed in the nineteenth century – Rossetti depicted her several times as a troubled beauty holding her casket, from which an evil vapor escapes.

[1]Hesiod *Works and Days* 48–104 and Ovid *Metamorphoses* I:76–89
[2]Apollodorus *The Library* I vii 1 [3]Hesiod *Works and Days* 60–142

Statue of Ceres (*c.*1615), Rubens depicted her as a statue in a niche, with swags of fruit and *putti*.

The Titaness **LATONA**[1] was another of Jupiter's lovers. Fleeing Juno's anger, she gave birth to the twins Apollo and Diana on the island of Delos. When she stopped to drink from a lake, peasants gathering reeds harried and insulted her; and as a punishment for their malicious behavior she turned them into frogs, who continued to bicker underwater. Johann Koenig illustrated this in *Latona Changing the Lycian Peasants into Frogs* (*c.*1610). Jupiter also ravished Maia (daughter of the Titan, Atlas) and assumed various disguises to pursue the mortals Danaë, Io, Europa, Callisto, Antiope, and Leda.

Jupiter divided up the universe by drawing lots.[2] His brother Pluto won the Underworld, Jupiter became the ruler of Heaven, while **NEPTUNE** took control of the sea, the rivers, and fountains. Neptune was also responsible for earthquakes and could wreak havoc with the elements. His many loves included Caenis, Coronis, and

Sea Horse: see Neptune

Amymone. The sea nymph Amphitrite tried to escape his attentions by fleeing to the farthest limits of the sea, until a dolphin persuaded her to marry him; their son was the merman Triton. Neptune also fathered the Cyclops Polyphemus. In allegory, he may represent water, and he is often depicted as the god of the sea, appearing as a slightly disheveled but vigorous man with cascading locks. His attribute is a trident, which he used to rouse the winds and whip up tempests. He is also depicted riding in a chariot drawn by dolphins, or sea horses, accompanied by mermaids, mermen, nereids (sea nymphs), and naiads (water nymphs). His majestic figure sometimes decorates fountains.

MERCURY, son of Jupiter and Maia, was the athletic messenger of the gods. He acted as a guide and ambassador, was the protector of travelers, and led the souls of the dead down to the Underworld. He is usually shown wearing winged sandals "of untarnishable gold," and perhaps a winged petasus – a hat with a low crown and small brim. He was also the god of dreams and sleep, carrying a "wand which he could use at will to cast a spell upon our eyes or wake us from the soundest sleep."[3] His wand, or caduceus, often has snakes twined around it and may have wings. He was entrusted with Cupid's education, depicted by Correggio in *The Education of Cupid* (c.1528); Giambologna cast a potent image of Mercury in flight (1665).

On the day he was born, Mercury stole Apollo's cows, walking them backwards so they could not be traced.[4]

Mercury is depicted in his winged boots and petasus in Andrea Mantegna's Parnassus *(detail; see pages 24–25).*

He sacrificed two of the cows and made a lyre from a tortoise shell and some cow-gut. When Apollo discovered the theft, he was so enchanted by the sound of the lyre that he agreed to exchange his entire herd for the instrument. Mercury is thus seen as both inventive and light-fingered; he was the god of good luck, and of commerce, wealth, and thieves, and may be shown as a personification of diplomacy.

Son of Jupiter and Juno, **MARS** the god of war is depicted as a militant figure with a helmet and shield; he is usually armed with a spear, sword, and lance. He may be accompanied by the Furies or by his sisters Strife and Bellona (his female counterpart). Mars appears in allegories illustrating the triumph of love or wisdom over war. In his negative role, where war tramples on civilized pursuits, he may also emphasize the superior aim of peace. Mars' most famous affair – shown in numerous paintings – was with Venus; whenever he rested in her company, he took off his armor and the world was at peace. Painters followed the classical description of the couple together: "Mars potent in arms, rules the savage works of war, yet often casts himself back into your lap, vanquished by the ever-living wound of love."[5] The theme may also be treated humorously, with *putti* playing disrespectfully with Mars' discarded armor.

MINERVA was goddess of wisdom and war, but unlike Mars, she fought in defense of justice. She was born from Jupiter's head, because he had been told in a prophecy that his first wife Metis would give birth to

Latona: see Apollo (pages 18 and 60), Diana (page 61); **Mercury**: see Caduceus (page 247); **Neptune**: see Coronis (page 72), Polyphemus (page 66)

[1]Ovid *Metamorphoses* VI:313–81 [2]Homer *Illiad* XV:184–204
[3]Homer *Odyssey* V:47 [4]Ovid *Metamorphoses* II:676–706
[5]Lucretius *De Rerum Natura* I:32–40

Owl: see Minerva

one who would surpass him. When Metis became pregnant, Jupiter swallowed her, but he suffered so much pain that he had to beg **VULCAN** (see page 13) to split his head open – and Minerva issued forth. The owl of wisdom was sacred to Minerva and she often counseled her father. She possessed a noble beauty and is usually shown in armor, carrying a lance and a shield, which may bear the image of Medusa. She was also goddess of crafts, particularly spinning and weaving, and she invented the flute. She was invoked by those in pursuit of reason, learning, and the civilized arts.

Minerva once competed with Neptune for the region of Attica, which was promised as a prize to the one who gave the most useful present to its inhabitants. Neptune hit the ground with his trident and brought forth a spring or, in some accounts, a horse; Minerva created the olive tree, a symbol of peace – so the land was awarded to her. The tree was cultivated by Cecrops, who founded Attica's capital Athens, and Minerva became the city's patroness. Her temple – the Parthenon – was built on the Acropolis. She may be shown with an olive tree or branch, and olive leaves may decorate her dress.

As the god of light, **APOLLO** (see also page 18) inherited two distinct characteristics. First, he was the physical light of the sun god **SOL**, drawing a four-horse chariot across the sky each day, often preceded by the figure of Aurora. The subject lent itself to paintings on several Baroque ceilings, such as Guido Reni's *Aurora* (1614; Casino Rospigliosi, Rome) and Giambattista Tiepolo's *Course of the Chariot of the Sun* (1740; Palazzo Clerici, Milan), which shows Apollo blazing across the four continents. He is also seen rising or setting, as in the pair of tapestry designs by Boucher, *The Rising and Setting of the Sun* (1754), or with Phaethon, who asked to drive the god's chariot and foolishly flew too close to the ground, scorching some nations.

Communicating with the Gods

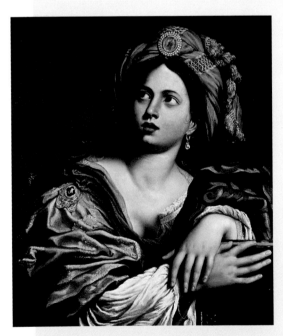

Domenichino's A Sibyl *(c.1620) represents the prophetess as a voluptuous woman in Eastern costume.*

In the classical world, the gods communicated with mortals through **ORACLES**, the most famous of which was that of Apollo at **DELPHI** in the heart of Greece. Here, Apollo's prophecies were uttered by a priestess, the **PYTHIA**, who sat on a sacred tripod of gold placed over a chasm in the rock. The hero Hercules contested Apollo's possession of the oracle when he did not receive the answer he required. He tried to carry the sacred tripod away but Apollo came to the priestess's defence, and Jupiter settled the quarrel by throwing a thunderbolt between his two sons.[1] Apollo had another oracle on Delos, the island of his birth. In *Landscape with Aeneas at Delos* (see pages 192–93) Claude Lorrain shows the picturesque landscape where Aeneas came to consult it.

Apollo also had a famous oracle at Cumae in Italy, where the **SIBYL** relayed his prophecies. She asked Apollo, who loved her, to grant her as many years of life as there were grains in a heap of dust. Salvator Rosa's *River Scene with Apollo and the Sibyl* (1650s) shows her holding the dust in her hand before the god. She scorned his love, and as she had forgotten to ask for eternal youth, Apollo condemned her to the misery of a protracted old age.[2]

[1] Apollodorus *The Library* II vi 2 [2] Ovid *Metamorphoses* XIV:130–53

Bear: see Diana

Secondly, Apollo represented the light of truth, knowledge, and reason. Artists such as Poussin and Anton Mengs were influenced by Raphael's painting *Parnassus* (*c.*1510), where Apollo sits surrounded by the Muses and the great poets. Together with Calliope, the muse of epic poetry, he provided inspiration to poets and bestowed on them his crown of laurel, a reference to his unrequited love for Daphne.

Apollo was also associated with the protection of flocks and herds. He often dressed as a shepherd with a crook, and in this bucolic guise may be seen with satyrs. As god of music, his supremacy was contested by the satyr Marsyas and by Pan. He could be cruel too, and as the archer-god, he rounded viciously on the Greeks in the Trojan War, his arrows killing ranks of men and his poisoned darts bringing disease. Usually, however, he is depicted as the god of the civilized arts.

The medicine god **AESCULAPIUS** was the son of Apollo and Coronis, and was brought up by the wise centaur Chiron, from whom he learned the art of healing. Aesculapius was introduced to Rome from Greece during a severe plague, arriving disguised as a snake. He resumed his appearance on the Tiber Island and the plague ceased. The caduceus, a serpent twined around a staff, is his attribute.

Apollo's twin sister **DIANA** was goddess of chastity and hunting. She is often depicted as an athletic figure dressed in a short tunic, and may carry a bow and arrow and be accompanied by hounds or stags. She was identified with the moon goddess Luna, and a crescent moon is her attribute. She is often surrounded by attendant nymphs, and perhaps a bear, because Juno turned her nymph Callisto into a bear. As Chastity, Diana may be paired with Venus or Cupid, who represent sensual love. She may also carry a shield to protect herself from Cupid's arrows.

VESTA was the goddess of the hearth and home. A fire burned constantly in her circular temple in Rome,

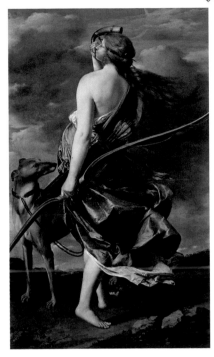

Orazio Gentileschi's Diana the Hunter (1625) *shows the goddess in naturalistic pose.*

which was guarded by the **VESTAL VIRGINS**. Vestals were selected at the age of six, performing their duties for 30 years before they were free to marry. Their most important task was to ensure that the sacred fire never died – they were whipped by the high priest when this happened – and if they broke their vow of chastity they were walled up alive. They wore white tunics with purple borders and purple mantles. Celebrated Vestals were Rhea Silvia (mother of Romulus and Remus), Tuccia, and Claudia. Vesta gave up her place on Olympus to the latecomer **BACCHUS** (see page 14), god of wine and drama.

Two wedding **FEASTS OF THE GODS** were popular subjects in art: the feast of Cupid and Psyche, and that of Thetis and Peleus. At the latter, the 12 deities of Olympus sat on their thrones, the Fates and Muses sang, Ganymede poured nectar, and 50 nereids danced on the sands. Unfortunately, the goddess of **DISCORD** Eris, who stirred up war by spreading rumor, had not been invited. As Juno, Minerva, and Venus chatted together, she threw down a golden apple dedicated to the fairest – an act that led to the Judgment of Paris and, ultimately, to the Trojan War. In *The Goddess of Discord* (1806), Turner shows her choosing the apple in the garden of the Hesperides. Artists also painted the feasts without reference to the weddings as great outdoor banquets set in the shade of trees.

Aesculapius: see Centaur (page 28), Coronis (page 72); **Apollo**: see Aurora (page 22), Daphne (page 76), Marsyas (page 79), Muses (pages 25 and 63), Phaethon (page 79), Pan (page 82)

Discord: see Judgment of Paris (page 69); **Feasts of the Gods**: see Apple (page 240), Ganymede (page 73), Psyche (page 49), Thetis (page 37); **Minerva**: see Medusa (page 64)

Nymphs, Satyrs, and Minor Gods

The opportunity to portray beautiful people in an Arcadian setting made the world of nymphs and mythical beings a favorite theme from the Renaissance onwards. **NYMPHS** were lovely women who possessed prophetic powers; they were associated with the woods, mountains, and dales. Naiads were nymphs of the rivers and lakes, and nereids were nymphs of the sea. They were often desired by **SATYRS** (see page 27).

FAUNUS, ancient chief of the fauns or satyrs, was often depicted in the company of Bacchus. Worshipped by farmers, shepherds, and country-dwellers, he was identified with the Greek god **PAN**, who lived in the mountains of Arcadia. Pan had a human torso and arms, and the legs, tail, hooves, and horns of a goat; he was thought to be the instigator of sudden, inexplicable "panic." Poussin's *Triumph of Pan* (1635–36) shows him as a garlanded herm (a double-faced bust).

Pan pursued the wood nymph **SYRINX** until she reached a river. She prayed to be transformed and, just as he thought he had caught her, he found he was clasping marsh reeds. As he sighed disappointedly, the reeds produced a delightful sound, so he cut unequal lengths, tied them together, and named his musical pipes the syrinx.[1]

Pan's son **SILENUS** was Bacchus's companion in revelry. He is usually depicted as a merry old man riding an ass, in varying degrees of drunkenness. Rubens' *Drunken Silenus Supported by Satyrs* (c.1620) shows him inebriated to the point of helplessness. **PRIAPUS**, god of licentiousness and fertility, was the son of Bacchus and Venus – who banished him to the mountains because of his huge genitals. When the nymph Lotis scorned his advances during one of his father's feasts[2] – a scene depicted by Giovanni Bellini in *Feast of the Gods* (1514) – he tried to ravish her as she slept, but she was woken

Waterhouse's Hylas and the Nymphs *(detail; see pages 34–35) reveals the artist's delight in the Arcadian world of heroes and nymphs.*

by an ass. She fled in terror until the gods turned her into a lotus tree.[3] **HYMEN**, the god of marriage, was also the son of Bacchus and Venus, and is usually portrayed as a boy crowned with flowers, holding a burning torch.

CASTOR AND POLLUX were the inseparable warrior twins of Jupiter and Leda, and rode horses whiter than snow. In Latin they were known as the *Dioscuri* or "sons of Jupiter." They rescued their sister Helen from Theseus, took part in the Calydonian Boar Hunt and in Jason's quest for the Golden Fleece; they also carried the daughters of Leucippus off to Sparta – a scene made famous by Rubens in the *Rape of the Daughter of Leucippus* (c.1618). Castor almost died in the ensuing fight, but Jupiter granted Pollux's prayer that he might share his immortality and allowed the twins to spend alternate days on Mount Olympus and in Hades.[4] He also placed them in the sky as the constellation Gemini, where they guided sailors, appearing as a glow of atmospheric electricity.

The **WINDS** were the sons of **AURORA**, goddess of the dawn (see page 22). They blew in times of strife, so their king Aeolus kept them in a cavern and tempered their fury.[5] The East wind came from Arabia and Persia, where the sun rose; the balmy West wind Zephyr blew from shores warmed by the setting sun; the South wind brought rain and clouds; while the North wind, old Boreas, whipped up storms of snow and hail. They may be shown as winged heads with puffed cheeks, or as personifications: the cold winds as old men with shaggy beards, the warm winds as youths. Zephyr pursued and raped the Greek maiden Chloris, then made her his bride.[6] Caught in his embrace, she turned into **FLORA**, goddess of flowers. Flora enjoyed perpetual spring in a garden of countless flowers and fruit, where the **THREE GRACES** (see page 21) twined garlands for their hair; she brought color to the earth

Panpipes: see Syrinx

by scattering seeds. In Poussin's *Kingdom of Flora* (1631), she appears with Hyacinthus, Narcissus, Crocus, Ajax, and Adonis – youths who were turned into flowers.

Other benign figures include Jupiter and Juno's daughter **JUVENTAS**, goddess of perpetual youth. In *Juventas with Jupiter in the Guise of an Eagle* (*c.*1820), Adolph Diez portrays her as Jupiter's cup-bearer. **IRIS** was goddess of the rainbow, descending to Earth to give mortals messages from the gods. She is also seen in the realm of the dream god Hypnos.

Many minor gods were personifications of abstract ideas or natural phenomena. A cornucopia may represent the favors that **FORTUNE** so unevenly meted out, while a spinning wheel or globe refers to her inconstancy. She may stand on gaming dice or have billowing "sails" of drapery, referring to the variable winds of chance. **VICTORY** usually flies down holding a palm branch and a laurel crown, which she places on the heads of those triumphant in war, athletics or poetry. She appears in Ingres's *Apotheosis of Homer* (1827). **HISTORY** is a female figure with books, tablets or scrolls, and in *An Allegory of History* (*c.*1770), Anton Mengs shows her with Fame, Time, and the double-headed **JANUS**, guardian of the threshold.[7] Janus had two faces so he could look ahead and behind. He gave his name to January and his knowledge of the past and the future meant he was associated with wisdom. Daughter of Chaos, **NIGHT** was the mother of **DAY**; together they represented passing time and death. Owls and bats draw Night's chariot, and she may wear a star-spangled cloak or a crown of poppies, and carry one black and one white child. In Michelangelo's *Night* (*c.*1530), she appears with a mask and a crescent moon. She was the mother of the Fates, of Death, and of **NEMESIS**, goddess of vengeance, who may stand on a wheel with a scourge hanging from her girdle. Dürer's *Nemesis* (1501–1502) holds a bridle for the undisciplined and a cup to reward the virtuous.

The Nine Muses

The **MUSES** lived on Mount Helicon near a miraculous fountain created by a blow from Pegasus's hoof. They brought artistic inspiration – thus a "museum" became an institution dedicated to literature, learning, and the arts – and still suggests a place where antiquities are housed. In *Parnassus* (*c.*1510), Raphael shows the Muses with ancient and modern poets.

NAME	MEANING	ASSOCIATION
Calliope	Beautiful voice	Epic poetry
Clio	Fame	History
Erato	Lovely	Lyric poetry
Euterpe	Joy	Music
Melpomene	Singing	Tragic drama
Polyhymnia	Many songs	Mime and sacred lyrics
Terpsichore	Joyful dance	Dance
Thalia	Good cheer/ Plenty	Comic drama
Urania	Celestial	Astronomy

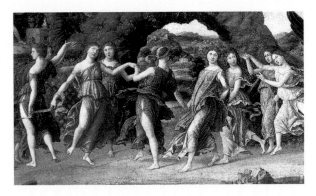

Andrea Mantegna's Parnassus *(detail; see pages 24–25) shows the Muses singing and dancing in a circle.*

Castor and Pollux: see Zodiac (page 209); **Faunus**: see Bacchus (page 14); **History**: see Time (page 244); **Iris**: see Rainbow (page 243); **Night**: see Death (page 245)

[1]Ovid *Metamorphoses* I:689–712 [2]Ovid *Fasti* I:393–441 [3]Ovid *Metamorphoses* IX:346–48 [4]Ovid *Fasti* V:693–720 [5]Virgil *Aeneid* I:50–65 [6]Ovid *Fasti* V:183–228 [7]ibid. I:89–145

Heroes and Monsters

Classical tales of quests and heroic trials have often been depicted in art, appearing both as narrative cycles and as allegorical references to virtuous qualities. The destruction of terrifying monsters is a recurring motif.

Apollo's oracle advised **CADMUS** to follow a heifer with a moon-shaped sign on her flank, for she would lead him to the place where he was to found Thebes. Obeying his instructions, Cadmus reached a forest where the dragon of Mars lived: a monster with "a golden crest, fire flashing from its eyes, its body all puffed up with poison, and ... its mouth set with a triple row of teeth."[1] Cadmus was unaware of the danger and sent his men into the forest to get water, where they soon met their fate – a scene depicted by Cornelis van Haärlem in *The Followers of Cadmus Devoured by a Dragon* (1588). In revenge, Cadmus fought a furious battle with the monster and killed it, at which point Minerva appeared and told him to plow the earth and sow the dragon's teeth as seeds. First spearheads appeared, then plumed helmets, then figures weighed down with weapons – one of whom warned Cadmus to "keep clear of family conflict." The warriors then fought each other until only five remained, and with these five *Sparti* (sown men) Cadmus founded the Greek city of Thebes.

Cadmus subsequently married Harmonia, daughter of Mars and Venus, and among his wedding presents from the gods was a beautiful but unlucky necklace made by Vulcan. Although the couple produced many children, the house of Cadmus was ill-fated: one of Jupiter's thunderbolts consumed their daughter Semele; Cadmus's grandson Actaeon was destroyed by his own hounds; and his descendant Oedipus blinded and banished himself (see box, opposite). Cadmus and Harmonia finally left Thebes bowed down with old age and sorrow, but as a reward for killing the dragon they were turned into snakes, disappearing into the shelter of a neighboring grove with their bodies entwined.

The hero **PERSEUS** (see pages 32–33) gained fame for killing **MEDUSA** and for rescuing **ANDROMEDA**. Medusa was one of three sisters renowned for their beauty and especially their lovely hair.[2] After Neptune robbed her of her virginity in one of Minerva's temples, the goddess punished Medusa by changing her into a hideous gorgon with a mass of snakes for hair. She then incised Medusa's image on her shield, as depicted by Caravaggio (*c*.1598). One glance at Medusa's face was enough to turn a human to stone, but Perseus managed to decapitate her and used her head to petrify his enemies. On his way home, he rescued Andromeda from Cetus the sea monster, turning the seaweed into **CORAL** when he laid down Medusa's head. Coral was thus thought to protect against evil, and Vasari depicted the scene on a cabinet door of the Studiolo of Francesco I in the Palazza Vecchio, Florence (*c*.1572) to indicate its precious contents.

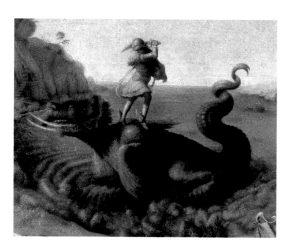

In Perseus Rescuing Andromeda *(detail; see pages 32–33), Piero di Cosimo portrays the sea monster Cetus in an unusually comical fashion.*

The winged horse **PEGASUS** sprang from Medusa's blood. It carried Perseus on his adventures and accompanied **BELLEROPHON** on various exploits. Queen Anteia of Argos loved Bellerophon and begged him to satisfy her passion – when he refused, she told her husband that he had tried to ravish her.[3] The king sent Bellerophon to the court of Lycia with a message requesting his death, and the hero was charged with the task of destroying the monstrous **CHIMERA**, which was devastating the country.[4] Foisted on humankind by the gods, it had a lion's head, a serpent's tail, and the body of a goat, while its breath came out in blasts of flame. Bellerophon managed to kill the beast with Pegasus's help. In subsequent tasks he fought and defeated the fierce tribe of the Solymi and the **AMAZONS**, a band of

Bow and Arrow: see Amazons

A Monstrous Riddler

The hero **OEDIPUS** was the son of Jocasta and King Laius of Thebes. After an oracle warned Laius that his son would kill him, the boy was abandoned on a hillside at birth, but was rescued by a shepherd and grew up in Corinth. Later, goaded by friends about his parentage, Oedipus asked the oracle of Delphi who his true parents were, and was told never to return home for he would kill his father and marry his mother. Fleeing from the only home he knew, Oedipus met Laius, who ordered the youth to make way for his chariot. A fight ensued and Oedipus killed him. Oedipus then entered Thebes, which was being terrorized by the **SPHINX**, a monster with a woman's head and a lion's body. She asked passers-by: "Which animal walks on four feet in the morning, on two at noon and on three in the evening?", eating anyone who failed to solve her riddle. Oedipus gave the right answer: a man – who crawls as a baby, stands upright in manhood, and walks with a stick in old age.[1] His rewards were the kingdom of Thebes and Jocasta's hand. When a plague broke out, an oracle predicted that it would not cease until Laius's killer was revealed. Finally, Oedipus discovered the truth about his parents and, tormented, put out his own eyes and banished himself to Attica. The Greeks adopted the Sphinx as a symbol of wisdom and, from the Renaissance, her image was used to embellish furniture.

[1]Apollodorus *The Library* III v 8

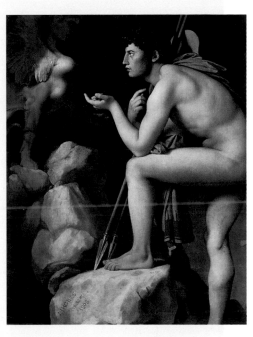

Ingres's Oedipus and the Sphinx *(detail; 1808) shows the hero in an inquisitive pose, his weapons lowered.*

female warriors who lived near the Black Sea. The Greek word *amazon* means "without breast," because the women cut off their right breasts so that they could draw their bows more easily. The Amazons invaded Athens but were driven back by **THESEUS** and Hercules.[5] Rubens' *Battle of the Amazons and Greeks* (*c.*1617) shows the violent battle of the sexes in which the women were overcome.

Theseus, son of King Aegeus of Athens, appears in art as a muscular figure similar to Hercules. He was mistakenly believed to be Neptune's son, but Aegeus had hidden a sword and sandals under a heavy rock to test his son's strength and prove his identity – a scene depicted by Poussin in *Theseus Finding His Father's Sword*

(1636–37). Theseus then set off for Athens, overcoming robbers and wild beasts on the way. He found Aegeus living with Medea, who attempted to destroy the youth before his identity became known. She told Aegeus that Theseus was an imposter who plotted to kill him, but the king recognized his sword just as he was about to hand his son a cup of poison.

In his most celebrated adventure, Theseus offered himself as a sacrifice to the dreaded **MINOTAUR** of Crete (see page 31). After killing the beast, he escaped from the labyrinth and sailed off with the king's daughter, Ariadne, later abandoning her on the island of Naxos. Reaching home, he forgot to hoist the sails of victory to notify his father of his safe return, causing

Cadmus: see Actaeon (page 76), Minerva (page 59), Semele (page 43), Vulcan (page 13); **Medusa**: see Neptune (page 58) **Theseus**: see Hercules (page 68), Medea (page 67)

[1]Ovid *Metamorphoses* III:1–137 and IV:563–603 [2]ibid. IV:774–803 [3]Homer *Iliad* VI:160–211 [4]Homer *Iliad* VI:180–85 [5]Plutarch *Lives* Theseus

Ulysses

Homer's epic poem the *Odyssey* tells the story of the hero-wanderer **ULYSSES** (Odysseus in the Greek). Son of King Laertes of Ithaca, Ulysses initially sought beautiful Helen as his bride, but finally relinquished his suit to Menelaus of Sparta and married faithful **PENELOPE**. Bound by oath to protect Helen, he initially feigned madness after Paris carried her off to Troy, but later fought to retrieve her in the Trojan War.

After the sack of Troy, Ulysses made an epic journey home, aided by Minerva. He came first to an island where **POLYPHEMUS** tended sheep.[1] This monstrous, one-eyed Cyclops was Neptune's son, and he sealed Ulysses and his crew in a cave and began to eat them. They escaped by giving Polyphemus wine until he fell down senseless, driving a burning stake into his eye, then clinging to his sheep as he let them out the next morning. Turner's *Ulysses Deriding Polyphemus* (1829) shows Ulysses' boat pulling away as nereids guide his ship; Polyphemus forms part of a mountain seen through the clouds. In revenge, Neptune made Ulysses' journey long and hazardous.

When Ulysses landed on the island of the sorceress **CIRCE**, some of his men fell prey to her potions and were turned into swine.[2] Fortified with an antidote from Mercury, Ulysses made her restore them, although Circe then persuaded him to stay for a year, feasting on meat and mellow wine. She fascinated painters such as Waterhouse, who in *Circe Invidiosa* (1892) shows her poisoning the sea in anger when Ulysses leaves.

After journeying to the land of the dead to learn his fate, Ulysses sailed past the **SIRENS**, whose sweet singing lured sailors to their deaths on the rocks. In *The Sirens* (1882), Gustave Moreau shows them as lovely maidens with crowns. Ulysses landed safely but his hungry crew ignored his command and killed the cattle of Helios; in punishment, Jupiter destroyed Ulysses' men and ship with a thunderbolt. The beautiful sea nymph Calypso detained him for another seven years and, after leaving her, he survived a storm with the help of the sea goddess Ino. Arriving in the land of the Phaeacians, he was then discovered by Princess Nausicaa, as seen in Rubens' *Landscape with Ulysses and Nausicaa* (c.1635).

Meanwhile, Ulysses' son **TELEMACHUS** had set off in search of his father, protected by Minerva in disguise as his guardian Mentor. Giambattista Tiepolo shows them striding out together in *Telemachus and Mentor* (1696–1770).

When Ulysses finally returned home laden with gifts from the Phaeacians, Minerva warned him that Penelope was being plagued by disreputable suitors who courted her as though he were dead. Penelope had no idea if Ulysses had survived and, to protect herself, had agreed to marry as soon as she had finished weaving a shroud for Laertes, which she spun by day and unpicked by night – fooling her suitors for three years. She is usually seen weaving, as in Giovanni Stradano's depiction in the Palazzo Vecchio, Florence (mid-sixteenth century). Ulysses was determined to reclaim his rightful position, so he disguised himself as a beggar and hatched a plot with Telemachus. Armed with his great bow, he joined an archery contest in which Penelope was the prize and, with Telemachus's help, slew all the suitors. He was thus reunited with both Penelope and Laertes.[3]

Scenes from Ulysses' life may occupy a narrative cycle, as in Pellegrino Tibaldi's frescoes (1550s), or form part of a decorative scheme, such as those of Pintoricchio from the Palazzo Petrucci (c.1509).

[1]Homer *Odyssey* IX 187–474 [2]ibid. X [3]ibid. XXI; XXII

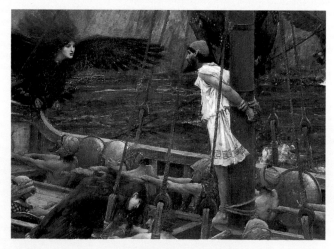

Waterhouse's Ulysses and the Sirens *(detail; 1891) shows Ulysses tied to his ship's mast. His crew have plugged their ears with wax so that they are unable to hear the Sirens' singing.*

Oak Tree: see Jason

Aegeus to throw himself into the sea in grief (which was subsequently called the Aegean Sea). Theseus thus succeeded to the throne of Athens, and was a liberal and popular monarch – but he was consistently unsuccessful in love. He married Ariadne's sister Phaedra, but she fell in love with **HIPPOLYTUS**, Theseus's son by the Amazon, Antiope. When the beautiful youth rejected her, she told Theseus that he had tried to seduce her, a scene depicted by Pierre-Narcisse Guérin in *Phaedra and Hippolytus* (nineteenth century). Theseus then sought Neptune's help in punishing the boy, and Hippolytus was trampled by his own horses.

Among his other adventures, Theseus fought off the **CENTAURS** (see page 28) who invaded the wedding of his friend Pirithous, king of the Lapiths. Theseus and Pirithous also descended into the Underworld to carry away Proserpina but were stopped by Pluto. In punishment, Pirithous was placed on his father Ixion's wheel, and Theseus was tied to a huge stone until he was rescued by Hercules.[1] On his return to Athens, Theseus discovered that Menestheus had usurped his throne, so he fled to the island of Scyros. Here, the king of the island pushed him down a steep precipice to his death, fearing that such a powerful hero would usurp him.

Theseus's father Aegeus had given santuary to Medea after she became estranged from an earlier hero, **JASON**, son of Aeson, king of Iolcus in Thessaly.[2] After Aeson's brother Pelias usurped the throne, he sent Jason away to be educated by the centaur Chiron, but when Jason reached maturity, he undertook a quest for the Golden Fleece in return for his rightful monarchy. This precious fleece hung in a grove in Colchis on the Black Sea, guarded by a dragon. Jason and his crew, the **ARGONAUTS**, who included Hercules and **HYLAS** (see page 35), sailed there in the *Argo*, passing through the dangerous Symplegades Straits with Minerva's help.

King Aeëtes of Colchis agreed to surrender the fleece if Jason carried out certain difficult tasks. Fortunately,

Cupid pierced the king's daughter **MEDEA** with his arrow; the sorceress fell in love with Jason immediately and helped him with her magic powers.[3] Jason completed all the tasks successfully and found the Golden Fleece hanging on a huge oak tree; he managed to remove his prize safely after Medea charmed the dragon with her sweet voice and sprinkled a potion in its eyes. Consumed with passion for Jason, Medea then accompanied him as he sailed for home. These stories appealed to Gustave Moreau, who painted *Jason and Medea* (1865) and *The Return of the Argonauts* (1897). When Jason reached Thessaly, he found Aeson on the brink of death, but Medea restored him with her spells. Pelias was by now bowed down with age, and seeking to avenge his usurpation of the throne, Medea convinced his daughters that he could be young again. In some tales she persuaded them to empty his veins of blood so she could fill them with youthful essence, in others she told them to cut Pelias up and boil him – either way, he died. His throne restored, the ungrateful Jason then abandoned Medea and married the daughter of the king of Corinth. The union was short-lived, for the furious Medea killed his bride, his father-in-law, and her own children.[4] Turner showed her practicing her black arts in his *Vision of Medea* (1828).

Medea was surpassed in horror by hybrid monsters of part-female form. These included the sphinx and the **HARPY** – a monster with a woman's face and breasts, and a bird's body and wings. Harpies defiled everything they touched and were thought to be the gods' grasping administrators; they also snatched the soul away at death. In his *Allegory of the Fall of Ignorant Humanity*, Mantegna (1431–1506) shows them supporting the fat figure of Ignorance, who sits on a globe flanked by Ingratitude and Avarice. They also appear as decorative motifs on furniture – the harpy table-leg in Cesare da Sesto's *Salome with the Head of John the Baptist* (1512–16) contributes to the painting's sinister atmosphere.

Harpy: see Avarice (page 250); **Jason**: see Centaur (page 28), Cupid (page 72), Minerva (page 59); **Theseus**: see Hercules (page 68), Ixion (page 78), Proserpina (page 78)

[1]Apollodorus II:v 12 [2]Apollonius of Rhodes *Argonautica*
[3]ibid. [4]Ovid *Metamorphoses* VII:1–403 and Euripides *Medea*

Hercules and his Labors

Cornucopia: see Achelous

Son of Jupiter and Alcmena, **HERCULES** was endowed with superhuman strength; Jupiter's wife Juno sent two snakes to kill him as a child but he strangled them with bare hands. She plagued him further as an adult and, driven mad by her, he threw his children into a fire.[1] As a punishment, he went to serve King Eurystheus, who set him 12 tasks, which he completed with Minerva's help.[2] Scenes from his labors often made reference to a patron's power, as in Vasari's *Labors of Hercules* (c.1560), painted for Duke Cosimo I. Hercules' story may also be treated as an allegory of good vanquishing evil, and he may personify strength, endurance, and courage. He is usually shown as a muscular figure with a lionskin and a club, and the statue known as the *Farnese Hercules* found in 1540, provided an excellent prototype.

For his first labor, Hercules trapped the **NEMEAN LION**. It was invulnerable to weapons, so he choked it, skinned it, and donned its protective pelt. Next, he tackled the monstrous **LERNEAN HYDRA**, which had nine, self-regenerating heads – including an immortal one. Hercules cut off its heads, cauterized the stumps, buried the immortal head, then dipped his arrows in its poisonous blood. Next, he spent a year hunting the **ARCADIAN STAG**, which was sacred to Diana. He then captured the **ERYMANTHIAN BOAR** by driving it into deep snow and trapping it in his net.

For his fifth task, Hercules diverted two rivers to clear a huge pile of dung in the **AUGEAN STABLES**, produced by the 3,000 cattle of King Elis. He then chased away the murderous **STYMPHALIAN BIRDS** by scaring them with

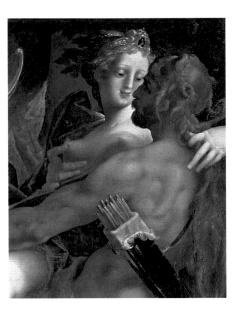

Spranger's Hercules, Deianeira and the Centaur Nessus *(detail; 1580) shows the hero rescuing his wife, clad in his lionskin.*

Minerva's golden castanets and shooting them with his poisoned arrows. After capturing the savage, fire-breathing **CRETAN BULL**, he tamed the man-eating **HORSES OF DIOMEDES** by killing King Diomedes and feeding his flesh to his mares.

For his ninth task, Hercules fought a pitched battle with the Amazons to win the **GIRDLE OF HIPPOLYTA**, their queen. He then slew the three-bodied monster Geryon, his two-headed dog and his giant herdsman, and shipped the **OXEN OF GERYON** to Greece, making the founding of Rome possible by killing the monster Cacus on the way.[3] Next, he obtained the **APPLES OF THE HESPERIDES** by killing a 100-headed dragon, and finally, he wrestled with Pluto's guard dog **CERBERUS**.

In later adventures, Hercules slew the centaur **EURYTION** after he found him raping a girl,[4] and rescued **HESIONE** of Troy from a sea monster.[5] He also fought the river god **ACHELOUS** for the hand of Princess Deianeira. Achelous turned into a snake, then into a bull – but Hercules flung himself around its neck and broke off a horn, which some say became the cornucopia.[6] After **NESSUS** tried to abduct Deianeira and Hercules shot him with one of his arrows, the dying centaur gave her a shirt soaked in his poisoned blood, pretending it was a love charm. Later, Deianeira sent Hercules the shirt to try and win him back from Princess Iole, causing him to go mad with the pain. Jupiter rescued him from his funeral pyre, and on Mount Olympus he was reconciled with Juno, marrying her daughter Juventas.[7]

Arcadian Stag: see Diana (page 61); **Cerberus**: see Pluto (page 78); **Eurytion**: see Centaur (page 28), **Girdle of Hippolyta**: see Amazons (page 64); **Hercules**: see Juno (pages 16–17), Minerva (page 59)

[1]Philostratus the Elder *Imagines* II:23 [2]Apollodorus *The Library* II:iv. 8–12 and II:v. 1–12 [3]Virgil *Aeneid* VIII:193–272 and Ovid *Fasti* II:543–87 [4]Hyginus *Fabulae* XXX [5]Apollodorus *The Library* II:v 9 [6]Ovid *Metamorphoses* IX:1–97 [7]ibid. IX:229–73

The Trojan War

Stag: see Iphigenia

The Trojan War began after **THE JUDGMENT OF PARIS** when **PARIS** judged Venus to be the most beautiful goddess and won **HELEN** as his prize, carrying her off to Troy. One of Fra Angelico's followers decorated a piece of furniture with *The Abduction of Helen* (*c*.1450), while Jacques Louis David shows her blinded by infatuation in *The Love of Paris and Helen* (1788). Unfortunately, Helen was already married to King **MENELAUS** of Sparta; and led by Menelaus and his brother King **AGAMEMNON**, the Greeks set out in their ships to follow the eloping pair. When the Greek ships were temporarily halted during their voyage, Agamemnon offered his daughter **IPHIGENIA** as a sacrifice to the gods at Aulis to induce them to bring wind to his fleet.[1] He brought her to the altar, surrounded by weeping priests, under the pretence that she was to marry **ACHILLES** – as shown in Bertholet Flémalle's *The Sacrifice of Iphigenia* (1646–47). Just as she was about to be killed, the goddess Diana mercifully cast a veil of cloud over the eyes of the assembled company and substituted a stag in her place.

Son of Peleus and **THETIS** (see page 36), Achilles had been educated by the centaur Chiron,[2] and in *The Education of Achilles* (1782) Regnault shows him learning how to draw a bow. Thetis knew her son's destiny was to die in war, so she dipped him in the river Styx to render him invulnerable,[3] but the heel she was holding remained dry and this was his one weak spot. Thetis even tried to stop Achilles from joining the war by disguising him as a girl and hiding him at the court of King Lycomedes, where he fell in love with the king's daughter Deidamia and fathered a son, Neoptolemus. The warrior Ulysses revealed Achilles' disguise and persuaded him to fight when, laying gifts before the court, he noticed Achilles' disregard for feminine luxuries and his fondness for weapons.[4] Rubens portrayed these scenes in the *Achilles Tapestries* (1630s), along with other tales of Achilles' exploits in the war.

When the Greeks finally landed near Troy, they laid siege to the city in a war that lasted 10 years. The gods played an active part in the hostilities: Juno, Minerva, and Neptune supporting the Greeks; Apollo, Mars, and Venus the Trojans. Jupiter incited and checked both sides, sending down thunderbolts and lightning, and intervening in the destinies of those involved.

At the outset, Achilles withdrew from battle after Agamemnon insulted him by appropriating his mistress Briseis.[5] Thetis begged Jupiter to avenge her son – a scene shown in Ingres's *Jupiter and Thetis* (see pages 36–37) – and the Greeks subsequently suffered a series of defeats, enabling the Trojan prince **HECTOR** to breach their defences and set fire to their encampment and one of their ships. Still sulking, Achilles agreed to

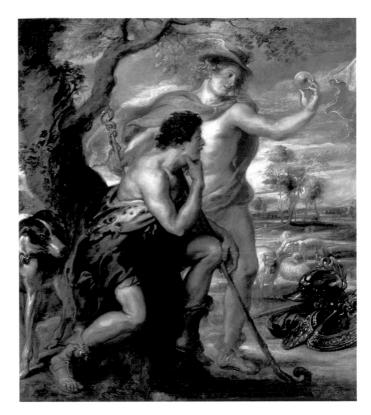

In The Judgment of Paris *(detail; see pages 38–39), Rubens depicts Paris as a shepherd as he considers his decision.*

Achilles: see Centaur (page 28), Diana (page 61); **Thetis**: see Styx (page 78)

[1]Ovid *Metamorphoses* XII:24–38 and Euripides *Iphigenia in Tauris* [2]Philostratus the Elder II:2 [3]Statius *Achilleid* I:269 and Hyginus *Fabulae* XCVI [4]ibid. [5]Homer *Iliad* I:172–87

Carnation: see Ajax

let his closest friend **PATROCLUS** take his place against the Trojans. But Patroclus fought too long and was killed by the hero Hector, son of King Priam of Troy. In art, Patroclus may be depicted escorting Briseis to Agamemnon, while images such as Jacques Louis David's *Funeral of Patroclus* (1780) show the enormous funeral pyre that Achilles built for him. Stirred into action again and wearing a magnificent suit of armor forged by Vulcan, Achilles rejoined the fighting and avenged Patroclus by killing Hector in single combat; he then drove around the walls of Troy in his chariot, dragging Hector's body by the ankles.[1] Paintings may show King Priam in Achilles' camp under Mercuy's protection, begging for Hector's body, or Hector's wife and son grieving over his corpse, which Apollo saved from damage and decay.

Hector had previously reproached Paris for failing to take part in the war, but Paris avenged Hector's death when he fired an arrow at Achilles' heel and killed him. The Greek warriors Ulysses and the greater **AJAX** (Achilles' cousin) then vied for the dead hero's armor until Minerva intervened and awarded the prize to Ulysses.[2] Furious, Ajax plotted to kill Ulysses' commanders in revenge, but Minerva thwarted his assault by driving him mad so that he slaughtered a flock of sheep. When his sanity returned, Ajax was so humiliated that he thrust his sword into his side. Hyacinths grew where his blood dripped on the earth – although Poussin shows a carnation in the *Kingdom of Flora* (1631).

The most famous and decisive incident of the war came when the Greeks built a hollow **WOODEN HORSE**; Domenico Tiepolo shows them constructing it in *The Building of the Trojan Horse* (1773–74). The Greeks pretended that the horse was an offering for the gods to ensure their safe homeward voyage, but in fact they installed their best men inside while the others hid from sight. King Priam's daughter **CASSANDRA** tried to warn the Trojans of their impending doom, for she had the power of prophecy – but she had previously refused Apollo, who made sure that no one believed her predictions. Tricked by the Greek captive Sinon into thinking that the horse was dedicated to Minerva and rejoicing

at the disappearance of their enemies, the Trojans flung open their gates and dragged the horse into Minerva's temple. That night, Sinon released the men inside and they killed the Trojan sentries, opened the city gates, and set Troy ablaze.

After this overwhelming defeat, the lesser Ajax raped Cassandra near an image of Minerva – an outrage depicted by Solomon Joseph Solomon in *Ajax Abducting Cassandra* (1886). Cassandra then became Agamemnon's concubine, until she was killed by his wife Clytemnestra. Achilles' ghost also requested that Cassandra's sister **POLYXENA** be sacrificed to honor his tomb, for although the couple had fallen in love during the war, Hector had refused to let her marry an enemy of the Trojans. In *The Sacrifice of Polyxena*, Giovanni Battista Pittoni (1687–1767) shows her being led with dignity to Achilles' tomb, where, preferring death to enslavement, she asked Neoptolemus to kill her.[3]

LAOCÖON, a Trojan priest, had also tried to warn his people about the wooden horse but he too had been ignored.[4] He died while sacrificing a bull to Neptune on the shore. Two giant sea snakes swam up, twining first around his sons before encircling the priest himself, and although Laocöon strove frantically to wrench the knots apart, the monsters crushed them all to death. The expressive marble rendition of this scene (second century CE) kept in the Vatican, Rome, has been greatly admired and copied since it was discovered in 1506.

Many scenes from the Trojan War were depicted in the eighteenth and early nineteenth centuries, and some of these can be seen in Giambattista Tiepolo's *Room of The Iliad* (*c*.1757). Popular episodes were the wrath of Achilles, in which Minerva holds the hero by his golden locks as he draws his sword against Agamemnon;[5] Briseis being taken from Achilles;[6] Diomedes wounding Venus as she tries to save Aeneas;[7] Achilles dragging Hector's body around the walls of Troy; Priam begging Achilles to return Hector's body;[8] and Andromache grieving over her husband's corpse. Paris and his fellow Trojans are sometimes shown wearing **PHRYGIAN HATS** – conical structures with the top turned over at the front – which were worn by natives of

Bull: see Laocöon

the ancient country of Phrygia in Asia Minor.

The Trojan hero **AENEAS**, son of Venus and Anchises, was destined to be the forefather of the Romans. After the sack of Troy, he led his family away from the burning city, carrying his father and the sacred relics and images of their household gods, and holding his son Ascanius by the hand.[9] Sculpted by Bernini, the subject was popular in Rome because it illustrated the noble values of family respect and piety. Aeneas was variously aided and thwarted by the gods during his journey – although the obstacles thrown in his way were often offset by Jupiter's guidance. His quest to find Italy led him over land and sea, through storms whipped up by Juno and calmed by Neptune, to the island of Delos. Here, the king and priest, Anius,[10] showed him the holy site where Apollo was born, as seen in Claude Lorrain's *Landscape with Aeneas at Delos* (see pages 192–93).

Later, the Trojans landed at Carthage, where Venus told Aeneas how Queen **DIDO** had founded the city.[11] Fearing an outbreak of war, Venus engaged Cupid to contrive a love affair between the pair;[12] Turner's *Dido and Aeneas* (1814) shows them setting out to hunt with a magnificent re-creation of Carthage in the distance, while a painting of the same title by Giovanni Romanelli (1610–62) depicts them running from a storm to shelter in a cave, where their love was consummated.[13] The blissful couple spent the whole winter together, but Jupiter sent Mercury to rebuke

In his Landscape with Aeneas at Delos *(detail; see pages 192–93), Claude shows Aeneas with his father and son grouped with Anius, wearing white.*

Aeneas and remind him of his destiny. Ignoring Dido's anguished pleas, Aeneas set sail, and the distraught queen built a funeral pyre and fell on the sword left by her heartless lover. Juno then took pity on Dido and sent Iris to release her spirit, and as she flew across the sky, Iris trailed a thousand colors sparkling like dew in the sun.[14] Aeneas looked back to see the city aglow with the flames of Dido's pyre.

After reaching Italy, Aeneas visited the Cumaean Sibyl and asked to see his deceased father one more time.[15] Bearing a golden bough for Proserpina, he descended into the shadows of the Underworld, passing Disease, Fear, Hunger, Evil, Poverty, Sin, and War. Crossing the River Styx, Aeneas found his father in the Fields of Elysium, where Anchises foretold how he would marry Lavinia, and how their son Silvius would fulfil Aeneas's destiny through his descendant Romulus – the founder of Rome.

Aeneas and his people then continued their journey to Latium, where they were welcomed by King Latinus, Lavinia's father. But at Juno's intervention hostilities began when Ascanius shot a stag from the royal herd – a scene painted by Claude Lorrain in *Landscape with Ascanius Shooting the Stag of Silvia* (1682). Aeneas was forced to engage in a series of wars, which he fought wearing a suit of armor fashioned by Vulcan (see pages 12–13) and carrying a shield embellished with images of the events that would shape the future of Rome.

Aeneas: see Furies (page 56), Proserpina (page 78), Romulus (page 202), Sibyl (page 60); **Ajax**: see Flora (page 62); **Dido**: see Iris (page 63); **Hector**: see Apollo (page 60), Vulcan (page 13)

[1]Homer *Iliad* XXII:395–515 [2]Ovid *Metamorphoses* XIII:1–398 [3]ibid. XIII:439–80 [4]Virgil *Aeneid* II [5]Homer *Iliad* I:190–99 [6]ibid. I:343–56 [7]ibid. V:311–362 [8]ibid. XXIV:469–804 [9]Virgil *Aeneid* II:705–730 [10]Ovid *Metamorphoses* XIII:625–35 [11]Virgil *Aeneid* I:335–70 [12]ibid. I:657–723 [13]ibid. IV:160–73 [14]ibid. IV:634–705 [15]ibid. VI

Love, Mortal and Divine

Tales of love and passion, triumph and defeat and the tenderness of both human and divine affections have provided some of the most memorable of the classical myths and have furnished artists throughout the ages with immensely powerful themes. Disguise and metamorphosis – or magical changes of form – often play a major part in the unfolding of these stirring episodes.

Many of the Olympian gods had mortal lovers, including the goddess of love herself, Venus, who fell in love with the mortal **ADONIS** (see page 50). Venus's son Cupid (see box, below) fell in love with the mortal **PSYCHE** (see page 49); and Diana, goddess of hunting and the moon, fell in love with Jupiter's son, **ENDYMION**, a supremely beautiful youth. Jupiter granted his son a wish, and he chose eternal sleep, remaining immortal and ageless.[1] Diana may be depicted gazing at him as she visited him by night (see opposite). Girodet's 1792 *The Sleep of Endymion* shows the idealized youth asleep, watched over by Cupid.

The mortal **CORONIS**,[2] beautiful daughter of King Coroneus, was strolling on the sand when the sea god Neptune saw her and fell in love. As she did not reciprocate, he resolved to take her by force, but she fled and prayed to the gods for help. Minerva, goddess of wisdom, took pity on her and turned her into a crow. In *Neptune Pursuing Coronis* (1665–70), Giulio Carpioni shows her with wings, flying away from Neptune's grasp. Mercury, the messenger god, fell similarly in love with the maiden **HERSE** as she was returning home with her sisters from a festival of Minerva. Mercury flew down to Earth, but Herse's envious sister Aglauros blocked the threshold of Herse's room. Mercury turned Aglauros into a blackened statue. In *Mercury, Herse, and Aglauros* (1767), Louis Lagrenée shows the lovers on a bed, while Aglauros peers around the curtain.

The sun god Apollo loved the Spartan youth **HYACINTHUS**[3] beyond all other mortals. They were competing at throwing the discus when Apollo's struck

The Winged Archer

CUPID (known to the Greeks as Eros) was the son of Venus; his father may have been Jupiter, Vulcan or Mars. He is usually shown as a winged archer or a beautiful young boy who, according to Ovid, carried two kinds of arrow – a golden one to kindle love and a lead one to put love to flight.[1] He is sometimes shown blindfolded – implying that love is blind – or tying a knot, symbolically bonding a pair of lovers. His role is frequently mischievous: he may be seen teasing one of Jupiter's many lovers or being chastised by Minerva, Diana or Venus, who once confiscated his arrows.

Correggio's *Education of Cupid*

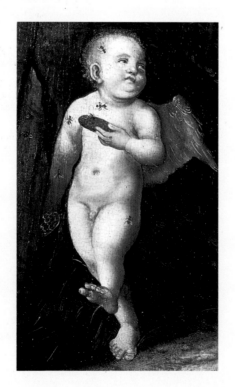

(1528) depicts Cupid engrossed in a book that is held out by Mercury, which suggests that, having discarded his bow and arrows, he has renounced sensual love in favor of learning.

Cupid was once stung by a bee as he was pilfering honey from a hive; when he asked Venus how such a tiny creature could cause such pain, she replied that he too was tiny yet inflicted far worse wounds.[2]

[1]Ovid *Metamorphoses* I:468
[2]Theocritus *Idylls* XIX

Cupid sports a swollen left cheek in Lucas Cranach's Venus with Cupid the Honey Thief *(detail; 1540).*

Swan: see Leda

Harp: see Antiope

Hyacinthus, killing him. In an alternative version,[4] jealous Zephyr, the wind who loved Hyacinthus, blew the discus at his head. Apollo transformed the youth's blood into the purple hyacinth, which returns to life every year. In Poussin's *Kingdom of Flora* (1631) Hyacinthus stares at the flower that bears his name.

The most amorous of the gods was Jupiter who visited the objects of his desire in a variety of disguises in order to fool his jealous wife Juno. His disguises often took animal form, as in the story of **EUROPA** (see page 53) whom he bore away disguised as a bull.

Jupiter appeared to **LEDA**, the wife of Tyndareus, king of Sparta, in the form of a swan. Leda subsequently laid two eggs – from one hatched Clytemnestra and Castor,

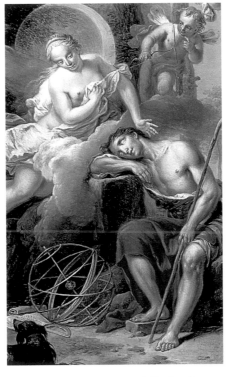

In Janneck's Diana and Endymion *(detail; 18th century) a dog symbolizes the devotion of the goddess to her beloved.*

and from the other, Helen of Troy and Pollux. Accounts vary as to the paternity of these children, as Leda is said to have slept with her husband on the same night as with Jupiter; most often the latter pair are said to have been the offspring of the god. Michelangelo's cartoon and lost painting of 1530 showing Leda erotically embracing the swan provided the basis for several paintings. Correggio's picture of *c*.1534 similarly emphasizes the sexual nature of the encounter. Leonardo da Vinci's slightly earlier treatment of the theme, which is now lost but exists in copies by other artists, shows Leda standing with the swan while her infants play on the ground, hatched from eggs.

When Jupiter fell in love with the shepherd boy

GANYMEDE,[5] he again chose the form of a bird, swooping down as an eagle in order to snatch the youth up into the air. Jupiter then flew with Ganymede to Mount Olympus, where the boy became his cupbearer. In his painting of the event, Rembrandt (1606–69) humorously depicted the young boy as a squealing and incontinent baby.

ANTIOPE, daughter of the king of Thebes,[6] was ravished by Jupiter in the form of a satyr – Amphion and Zethus were born from the union. Antiope fled to avoid the rage of her father, who killed himself in despair. She was then imprisoned by her uncle and tormented by his wife, Dirce. Following her eventual escape, her grown-up sons took revenge by deposing her uncle and having Dirce torn apart on the horns of a bull. The twins ruled Thebes and built its walls – Amphion played the harp so beautifully that the stones fell into place on their own.[7] This scene was captured by Giambattista Tiepolo in *Amphion Building the Walls of Thebes with His Song* (*c*.1720).

A master of devious strategies, Jupiter even used inanimate forms to steal an embrace from the victims of his passion: to possess **DANAË** (see page 40), Jupiter became a shower of gold; with **SEMELE** (see page 43) he appeared in his true form – as fire; and with the unfortunate **IO**, he spread dark clouds over himself to rob her of her virginity. To hide the deed Jupiter turned Io into a sleek heifer. Juno admired the creature and asked Jupiter if she could have it. Jupiter agreed and

Adonis: see Venus (page 11); **Danaë**: see Jupiter (page 57), Perseus (page 32); **Endymion**: see Diana (page 61); **Europa**: see Continents (page 229); **Leda**: see Castor and Pollux (page 62), Helen (page 69)

[1]Apollodorus *The Library* I:vii 5 [2]Ovid *Metamorphoses* II 569–587 [3]ibid. X:162–219 and Philostratus the Elder *Imagines* I:24 [4]Lucian *Dialogue of the Gods* 16 [5]Ovid *Metamorphoses* X:155–161 [6]Hyginus *Fabulae* VIII and Ovid *Metamorphoses* VI:111 [7]Philostratus the Elder *Imagines* I:10

Peacock: see Io

Juno instructed the monster Argus, who had 100 eyes, to guard the beast. When he could no longer bear Io's suffering, the god Mercury lulled the vigilant Argus to sleep and cut off his head. Juno set the monster's 100 eyes in the peacock's tail and forgave her husband. Io resumed her human form and bore Jupiter a son. Isolated incidents from the story have been depicted in art, including Mercury sending Argus to sleep, and Io being embraced by a black cloud, as in Correggio's painting of 1531 (see opposite).

Love's tragic and painful consequences did not necessarily require immortal involvement. Even purely human love stories often ended in sadness – none more acutely than that of **ORPHEUS AND EURYDICE.** Orpheus,[1] whose wonderful lyre-playing could charm animals and inanimate objects, fell in love with the wood nymph Eurydice. In *Orpheus Charming the Beasts* (1628) Roelandt Savery shows Orpheus playing to animals in the shade of trees. At the pair's wedding, omens foretold an unhappy outcome. As the innocent new bride wandered in the meadows, a serpent bit her ankle and she died. Poussin captured the ill-fated wedding in *Landscape with Orpheus and Eurydice* (1650).

Following Orpheus's repeated pleas – which were accompanied by him singing and playing his lyre – the king and queen of the Underworld restored Eurydice to him, charging him not to look back at her until the pair had reached the upper realms. Just before they emerged into daylight, however, Orpheus did look back. Eurydice immediately slipped back down into the depths.

Another tragic tale is that of **PYRAMUS AND THISBE,** who grew up next door to each other and fell in love.[2] Their parents forbade their marriage, however, and the lovers communicated through a slender chink in the wall between their houses, cursing the wall for preventing their embrace. They determined to escape at night and planned to meet outside the city, near a mulberry tree by a tomb. Thisbe slipped out first, but, near the appointed tree, was frightened by a bloodied lion arriving from a recent kill. As she fled to a cave, her veil slipped from her shoulders and the lion tore it to

shreds. Pyramus came upon the blood-stained garment and, thinking his beloved dead, plunged a sword into his side. Thisbe found him dying and took her own life. Their blood turned the fruit of the mulberry tree red for evermore. In *Landscape with Pyramus and Thisbe* (1651) Poussin shows Thisbe rushing to the fatally wounded Pyramus against a stormy landscape.

When the divinity of the goddess of love, Venus, was denied by the race of Propoetides, the infuriated goddess turned all their women into prostitutes.[3] On seeing their wicked lives, **PYGMALION** vowed to remain celibate. He carved a snowy ivory statue, more beautiful than any living woman, and fell deeply in love with his own creation. He would stroke and embrace it, and woo it as if it were alive. At the Festival of Venus, he prayed to the goddess to bring his statue to life; she consented and was present at their marriage. The subject was of tremendous interest to eighteenth- and nineteenth-century painters: François Boucher, for example, painted *Pygmalion* (1742); in *Pygmalion and Galatea* (1870), Jean-Léon Gérôme shows Pygmalion embracing his statue; and Edward Burne-Jones painted the series *Pygmalion and the Image* (1868–70).

ARIADNE,[4] daughter of King Minos of Crete, was let down by a mortal lover, only to be rescued by a god. She fell in love with Theseus, who dared to encounter the savage Minotaur, risking death for the reward of glory. He slew the monster in the heart of its labyrinth and was able to retrace his steps with Ariadne's help: she had given him a ball of thread to unwind as he entered the maze and then follow back to its source on his return journey. They sailed to the island of Naxos, where the god Bacchus was worshipped, but Theseus cruelly abandoned Ariadne on the shore. Accounts differ about her first meeting with Bacchus. One describes her asleep when he appeared; another recounts that she was lamenting her fate, incredulous at Theseus's empty vows. Bacchus, afire with love, greeted her with his companions.[5] He turned Ariadne's crown into a circle of stars, which brought her eternal glory, and in some accounts they were wed. In *Bacchus and Ariadne* (1518–23) Titian has the god leaping down

Lion: see Pyramus and Thisbe

from his chariot to claim her, followed by his rowdy throng; while in Sebastiano Ricci's *Bacchus and Ariadne* (*c.*1716), the goddess Hymen presides over their marriage as Bacchus gently takes Ariadne by the hand.

Pastoral and bucolic settings are common in classical tales of love and loss. **POMONA**[6] was a wood nymph who was devoted to the cultivation of fruit trees, from which she derived her name (*poma* means "fruit" in Latin). To keep satyrs out she fenced herself inside her orchards, but **VERTUMNUS** (a satyr, though he may not be depicted as such) fell in love with her and adopted various disguises to approach her: a rough harvester, a soldier, a vineyard worker, and a fisherman. Dressed as an old woman, he entered her garden, lavishly praised her fruit trees then tried to persuade her to court Vertumnus, likening marriage to a tree that supports a vine – but to no avail. Finally, he threw off his disguise and the nymph, entranced by his beauty, was smitten with a passion equal to his own. This bucolic subject was chosen for the decoration of villas: for example, the Villa Medici at Poggio a Caiano, which was decorated by Pontormo; the scene of the disguised Vertumnus wooing Pomona was chosen by other artists, including Domenico Fetti in his *Vertumnus and Pomona* (*c.*1621–23).

The nymph **DAPHNIS**, son of Mercury, was a cowherd among the woods and sweet springs of Sicily. A gifted musician, he pleased the goddess Diana with his shepherd's pipe,

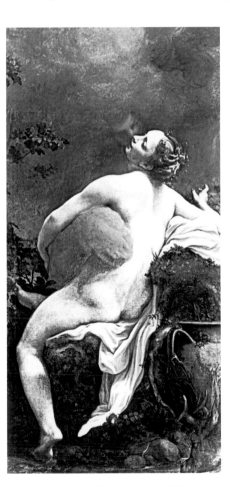

In Correggio's Io *(detail; 1531), the maiden succumbs to the embrace of the black cloud that disguises Jupiter.*

which he had been taught to play by Pan; Daphnis is also credited with inventing the bucolic or pastoral poem. In one pastoral romance,[7] the nymph **CHLOE** fell in love with Daphnis and they married. In *Daphnis and Chloe* (1545–50) Paris Bordone shows the young couple with Cupid.

The theme of **NARCISSUS** is one that has attracted artists since the Renaissance. The young man was so beautiful that many nymphs fell in love with him, yet he scorned them all. One of them placed a curse on him so that, by falling in love with himself, Narcissus would suffer the same torment as they had. One day, as Narcissus leaned down to drink water from a clear, shining pool, he became enchanted by his own reflection. Nothing would draw him from the spot, so he wasted away. Nymphs mourned his death, but when they searched for his body they found in its place the flower that bears his name. Narcissus is often depicted gazing into the pool – Salvador Dali created a memorable image in which his body is transformed into the flower.

ECHO was one of the nymphs who fell in love with Narcissus. She had been punished by Juno for detaining her with chatter when she could have caught her husband Jupiter being unfaithful. As punishment, Echo could only repeat the last words of what was said to her. Unable to converse with her loved-one, she wasted away until only her voice remained. In paintings, she often gazes wistfully at Narcissus.

Ariadne: see Bacchus (page 14), Minotaur (page 31), Theseus (page 65); **Pomona and Vertumnus**: see Satyr (page 27)

[1]Ovid *Metamorphoses* X:1–85 [2]ibid. IV:55–166 [3]ibid. X:243–97 [4]Catullus *Poems* LXIV and Philostratus the Elder *Imagines* I:15 [5]Ovid *Heroides* X [6]Ovid *Metamorphoses* XIV:623–771 [7]Longus *Daphnis and Chloe*

Tales of Transformation

Metamorphosis – a change in nature and appearance – was used by the gods either to punish or reward mortals. A major theme in classical myth, famously explored by the Roman poet Ovid in his *Metamorphoses*, divinely instigated transformation provided the artists of the Renaissance and later ages with dynamic subjects.

Transformation was often used by the gods in their own rivalries. The nymph **ARETHUSA** was cooling herself in clear waters when her beauty attracted the river god Alpheus.[1] He chased her and as she cried for help she was rescued by the goddess Diana, who hid her in a cloud. Alpheus waited for the nymph to reappear, but to thwart him Diana turned Arethusa into an underground stream.

The nymph **DAPHNE** was also saved from an amorous god by metamorphosis. Cupid pierced her with a lead arrow, which puts love to flight, but struck the god Apollo with the golden arrow of new love.[2] Daphne fled to evade the god's advances and as she called for help, her breasts became enclosed in bark, her hair turned into leaves and her feet became rooted in the ground (see right). Daphne had turned into a laurel tree. Yet still Apollo loved her; he made a crown from her branches and wound twigs around his quivers and lyre. The tale was popular in Renaissance and Baroque art and inspired Bernini to sculpt *Apollo and Daphne* (1622–25).

The goddess Juno, always eager to foil the amorous adventures of her husband Jupiter, changed the nymph **CALLISTO** (see pages 44–45) into a bear. But in some cases, metamorphosis occurs as a release from earthly troubles. **CLYTIE** loved Apollo but he scorned her in favor of another. Clytie made the affair known to her rival's father, who buried his daughter alive.[3]

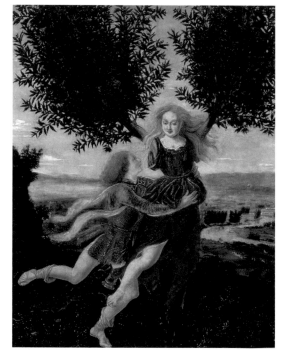

As Apollo tries to seize Daphne in Pollaiuolo's Daphne and Apollo (c.1470–80), *leaves sprout from the nymph's arms as they turn into branches.*

Unfortunately, Apollo continued to ignore Clytie, who turned into a sunflower which adoringly turned its head to follow the sun. Frederic, Lord Leighton depicts her in *Clytie* (1890–92) stretching her arms to the rising sun.

Similar release was granted to **CAENIS** who was famous for her beauty but refused to marry. As she wandered on a lonely shore, she was ravished by Neptune, who then granted her any request. Determined never to endure such injury again, Caenis asked to become a man and was transformed into **CAENEUS**. Caeneus attended the wedding at which the centaurs fought the Lapiths. He killed many centaurs until he was finally overwhelmed and miraculously escaped as a bird.

Named after his parents Aphrodite and Hermes (Venus and Mercury in Roman myth) **HERMAPHRODITUS** bathed in a remote pool where the nymph **SALMACIS** dwelled. She immediately longed to possess him[4] and as Hermaphroditus stepped into the water, she wound herself around him and prayed never to be separated from her love. Their bodies fused, joining male and female as a hermaphrodite. Spranger shows a voluptuous Salmacis watching the young god undress in *Salmacis and Hermaphroditus* (c.1590).

The use of metamorphosis as a punishment for pride or other impiety displayed the gods' most vindictive behavior. **ACTAEON** was the grandson of Cadmus, founder of Thebes. Straying deep into the woods while hunting one day, he spied Diana bathing in a pool with her nymphs; she was outraged that he had seen her naked and turned him into a stag.[5] Actaeon fled, amazed by his own speed, but as he paused to look at his reflection, his hounds caught him and gorged on his flesh. In *Diana and Actaeon* (1556–59) Titian shows

 Goose: see Philemon and Baucis

 Spider: see Arachne

him astounded by Diana's beauty, and in *The Death of Actaeon* (*c*.1565) he flees from the vengeful huntress.

ARACHNE's sin was to deny the superiority of a god. She was famous for her spinning skills[6] and even gained the praise of her teacher, the goddess Minerva. But Arachne denied that she had ever been taught to spin and challenged Minerva to a contest. In *Minerva and Arachne* (1579) Tintoretto shows Minerva watching the mortal Arachne's flawless work. Furious at her rival's success, Minerva beat Arachne until she tried to hang herself. She then took pity on the girl, turning her into a spider so that she could spin eternally.

The goddess Aurora, snubbed by the mortal **CEPHALUS**, whom she had abducted,[7] gained her revenge by changing his appearance and planting doubt in his mind. When Cephalus returned home to his wife **PROCRIS**, he offered her a bribe to become his mistress. When Procris hesitated, Cephalus revealed his identity and she fled in shame, but he soon begged for her forgiveness. Later, Cephalus spoke endearingly to the cooling winds while hunting and was thought to be wooing a nymph. Procris refused to believe the rumor without proof. The next day, as Cephalus called to the winds again, he heard a moan from a bush. Thinking it was an animal, he hurled his javelin and speared the hidden Procris. She died in his arms – a scene painted by Veronese (*c*.1528–88) in *Cephalus and Procris*.

The beautiful **ATALANTA** could run faster than any man, but Apollo warned her that her husband would be her downfall.[8] She devised a competition for her many suitors, declaring that she would marry the man who could outrun her and that those who failed would die. Neptune's great-grandson Hippomenes took up the challenge. He asked Venus for help and she gave him three golden apples with which to distract Atalanta. Atalanta could not resist fetching the apples and she lost the race, as seen in *Atalanta and Hippomenes* (*c*.1612) by Guido Reni. Unfortunately, Hippomenes

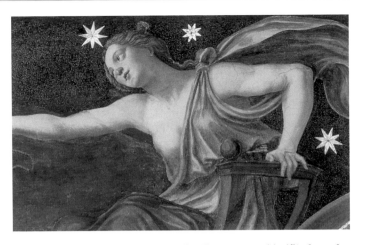

Peruzzi's The Nymph Callisto *(detail; see pages 44–45) shows her racing across the sky in a chariot, where she was placed by Jupiter after her own son almost killed her in her guise as a bear.*

forgot to thank Venus, whose sympathy quickly turned to anger. She induced the lovers to defile a spot sacred to the goddess Cybele, who promptly turned the couple into lions and harnessed them to her chariot.

But metamorphosis could be a gift, as well as a punishment, from the gods. When Jupiter and Mercury disguised themselves as mortals to observe mankind, they were turned away from 1,000 homes.[9] Finally, they arrived at the cottage of the elderly **PHILEMON** and his wife **BAUCIS**, who offered to kill their only goose in honor of their guests. After turning the cottage into a temple, the gods destroyed the inhospitable land with marshy waters. The couple asked to serve the gods as priests and to die together; both wishes were granted, and when they died, they were turned into trees growing side by side. Artists focused on the couple's hospitality, and in *Jupiter and Mercury with Philemon and Baucis* (1620–25), a painter of the school of Rubens showed the gods sitting at the table with the goose nearby. Jupiter also rewarded the nymph **AMALTHEA**, who fed him as an infant on the milk of a she-goat. He gave her a goat's horn as the cornucopia, claiming it would give her all she desired, and later turned her into a star.

Actaeon: see Cadmus (page 64); **Arachne**: see Minerva (page 59); **Atalanta**: see Cybele (page 56); **Caeneus**: see Centaur (page 28); **Cephalus**: see Aurora (page 22)

[1]Ovid *Metamorphoses* V:572–641 [2]ibid. I:452–567 [3]ibid. IV:190–273 [4]ibid. IV:274–388 [5]ibid. III:138–252 [6]ibid. VI:1–145 [7]ibid. VII:661–865 [8]ibid. X:560–707 [9]ibid. VIII:611–724

The Underworld

Pomegranate: see Proserpina

HADES was the Greek god of the Underworld, his Roman equivalent being Pluto or Dis. Later, Hades became the name of the Underworld itself – a gloomy, subterranean region inhabited by departed souls. Situated on the far shore of the River **STYX** (or hate), it was reached through natural chasms. Minos judged the dead souls, sending most to the dreary Plain of Asphodel. The virtuous ended up in the Fields of Elysium, while Tartarus, place of unbearable torments, was the destiny of those who had outraged the gods – the equivalent of the Christian perception of Hell.

PLUTO ruled the Underworld but was unable to find a bride until he saw **PROSERPINA** (Persephone) gathering flowers and dragged her off to be his queen.[1] Bernini's statue *Rape of Proserpine* (1622) captures the horror of the abduction, while Pieter Brueghel the Younger shows her in Tartarus in the *Rape of Persephone* (sixteenth century). Her mother Ceres sought her over land and sea until, angered by her vain search, she caused the Earth to lie barren. Eventually, a nymph revealed that her daughter was now Pluto's sad consort, at which point Proserpina's father Jupiter took pity on

Ceres and promised to return her daughter if she had eaten nothing in the Underworld. Unfortunately, Pluto's queen had tasted a few pomegranate seeds and was condemned to spend half of each year in Hades.

CHARON the ferryman rowed the dead across the River Styx. He was "a ragged figure ... with eyes which were stark points of flame and a dirty garment knotted and hanging from his shoulders."[2] He also appears in Christian paintings such as Michelangelo's *Last Judgment* (1536–41). Cerberus, a gigantic, multiheaded dog, guarded the entrance to Hades; he is Pluto's attribute and may be shown with a serpent's tail.

TITYUS, son of the Earth, whose body stretched over nine acres, was sent to Tartarus for assaulting Latona; there, vultures plucked continually at his liver, while he was powerless to drive them off.[3] **TANTALUS** was accused of feeding his son to the gods, stealing their nectar, and giving away their secrets; his punishment was to stand chin-deep in a pool, "tantalized" by the waters that receded when he stooped to drink and by the fruit dangling above his head.[4] **SISYPHUS**, the devious king of Corinth, was condemned to push a boulder eternally up a hill,[5] as portrayed by Titian in *Sisyphus* (*c.*1548–49), while **IXION** was tied to a wheel turned by a strong wind[6] after he tried to seduce Juno[7] – a scene painted by van Couenbergh and Rubens.

The goddess **HECATE** was associated with the Underworld and black magic. At night she was believed to hold burning torches at crossroads, accompanied by ghosts and hell-hounds. Later, she was depicted as having three bodies, which stood back-to-back looking in different directions. She is mentioned in Shakespeare's *Macbeth* and was illustrated by William Blake in his engravings of the play.

Patenier's Charon *(detail; 1515–24) depicts the repellent oarsman punting his boat across the River Styx; after he had ferried his passengers to the other side, he would demand a coin for his services.*

Hades: see Hell (page 120); **Ixion**: see Juno (pages 16–17);
Proserpina: see Ceres (page 57), Pomegranate (page 240);
Tityus: see Latona (page 58)

[1]Ovid *Metamorphoses* V:346–571 [2]Virgil *Aeneid* VI:300–305
[3]ibid. VI:595–600 [4]Homer *Odyssey* XI:582–93 [5]ibid. XI:593–600
[6]Ovid *Metamorphoses* IV:461 [7]Hyginus *Fabulae* LXII

Crimes and Transgressions

Tales of pride and folly were recurring themes in classical mythology, and the fates meted out to those guilty of such sins provided inspiration for many paintings. **NIOBE** boasted that her children were more beautiful than Apollo and Diana, so the gods killed them one by one.[1] When Niobe implored the gods to save her youngest, Jupiter took pity and turned her into a statue that wept unending tears. Richard Wilson depicted Apollo and Diana shooting Niobe's children from the clouds in *The Destruction of Niobe's Children* (*c.*1760).

Covetousness was the downfall of **DAMOCLES** who praised King Dionysius's wealth, pronouncing him the happiest of men. The king thought this presumptuous and invited Damocles to experience such happiness for himself, placing him on the throne with a sword above his head, held by a single hair, to illustrate the worries of a man in a position of power. Folly was also severely punished as in the cases of Midas and Icarus. Granted a wish by Bacchus, King **MIDAS** asked that everything he touched be turned to gold,[2] not realizing that his food and wine would also be transformed. In *Midas Washing at the Source of the Pactolus* (*c.*1628), Poussin depicts him washing away folly in the River Pactolus, turning its sands to gold dust. Later, Apollo gave Midas an ass's ears after he objected to the god's musical victory over Pan, as seen in Domenichino's *The Judgment of Midas* (*c.*1616–18), one of a series of rural scenes that often show Apollo in a vengeful mood. **DAEDALUS** built the Labyrinth for King Minos but was imprisoned inside it for helping Theseus to escape.[3] He made himself and his son **ICARUS** wings from wax and feathers, warning Icarus not to fly too close to the sun. But as they flew to freedom, the boy foolishly soared too high, the sun melted the wax, and he fell into the sea below. In *Landscape with the Fall of Icarus* (*c.*1560), Pieter Bruegel the Elder shows a shepherd and a plowman on a cliff, oblivious to the tiny figure hurtling from the sky.

Unnatural crimes angered the gods and were punished appropriately. Danaus agreed that his 50 daughters, the **DANAÏDS**, should marry the sons of his estranged brother Egyptus. He gave each a dagger and, on their wedding night, all but one slew their spouses. In Tartarus, they were condemned to fill vessels full of holes.[4] Rodin's sculpture *Danaïds* (1885) shows a Danaïd collapsed in despair. **ORESTES** killed his mother and her lover to avenge the murder of his father, Agamemnon.[5] Tormented by grief, he was pursued by the Furies until he was acquitted. Academic painters favored key events in these tragedies, and in *The Dispute Between Orestes and Pylades* (1614), Pieter Lastman depicts Orestes and his friend arguing over who should sacrifice himself to the gods.

Offending a god was the most dangerous transgression, often incurring hideous punishments. When Neptune was angered by mankind's transgressions and flooded the land, **DEUCALION AND PYRRHA** escaped in an ark, floating for nine days.[6] An oracle advised them after the water subsided and, descending with veiled heads, they threw stones behind them, which took human form and repopulated the Earth. The satyr **MARSYAS** competed in flute-playing with the god Apollo. He lost and was flayed alive for his presumption. A Hellenistic image (third century BCE) shows Marsyas hanging from a tree, while Titian's gruesome painting *The Flaying of Marsyas* (*c.*1570) shows him being flayed upside down. In an unfortunate incident, Apollo reluctantly agreed to let his son **PHAETHON** drive his chariot for one day, even though only he could control its fiery steeds.[7] Phaethon was so frightened by Scorpio's menacing tail that he dropped the reins, causing the horses to plunge so close to the Earth that the forests caught fire. Hurling a thunderbolt, Jupiter dashed Phaethon into a river, where he was buried by nymphs; his mourning mother and sisters were transformed into trees and their tears turned into amber in the sun. The tale was popular in Baroque art.

Daedalus: see Minotaur (page 65); **Midas**: see Bacchus (page 14), Pan (page 62); **Marsyas**: see Satyr (page 27); **Orestes**: see Agamemnon (page 69), Furies (page 56)

[1]Ovid *Metamorphoses* VI:146–312 [2]ibid. XI:85–193 [3]ibid. VIII:183–235 [4]Apollodorus I.iv.2 [5]Aeschylus *Orestia* [6]Ovid *Metamorphoses* I:313–415 [7]ibid. II:1–400

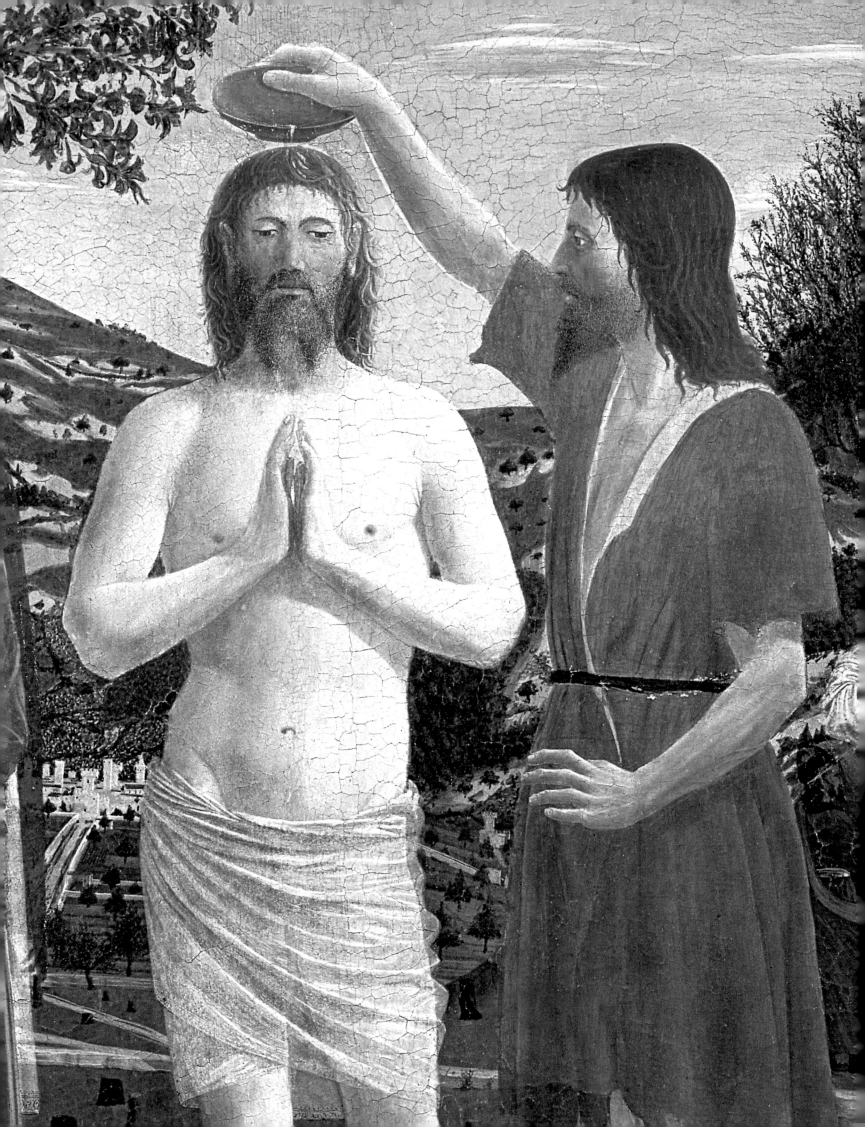

CHAPTER TWO

THE BIBLE AND THE LIFE OF CHRIST

Religious imagery dominated medieval art, with biblical stories continuing to be a major subject of painting through the Renaissance and Baroque periods. The Old Testament was a rich source of epic narratives – from the Creation to the Exodus – and the deeds and fantastic visions of the great prophets were often understood to prefigure Christ. Fresco cycles of the events of the New Testament – especially the Life and Passion of Christ – were originally intended to help educate the illiterate. The biblical lives and stories retold in this chapter explicate the imagery of some of the world's greatest art.

The Wilton Diptych
Anonymous (14th century)

The *Wilton Diptych* takes its name from Wilton House, England, where it was kept until 1929. It shows King Richard II of England being presented by his patrons – Saints Edmund, Edward the Confessor, and John the Baptist – to the Virgin and Christ Child, who are surrounded by their heavenly entourage of angels. The strong likelihood is that the painting, on two small, easily portable oak panels, was commissioned by Richard himself some time around 1395 for his personal use (hence the emphasis on symbols of kingship). The king's portrait shows him as he would have looked at the time of his coronation in 1377. Prominence is given to his personal symbol of the white hart (stag), while the tiny globe that tops the pole with the red cross pennant contains a stylized miniature island realm.

KEY ELEMENT

ANGELS: Angels and archangels are said to be divine messengers, the Greek word for angel meaning "bringer of news." They appear frequently throughout the Old and New Testaments, and not only bring God's word to humankind but also deliver his protection or punishment. They are often depicted as young men with wings and haloes; young winged boys are called *putti*.

See also page 118

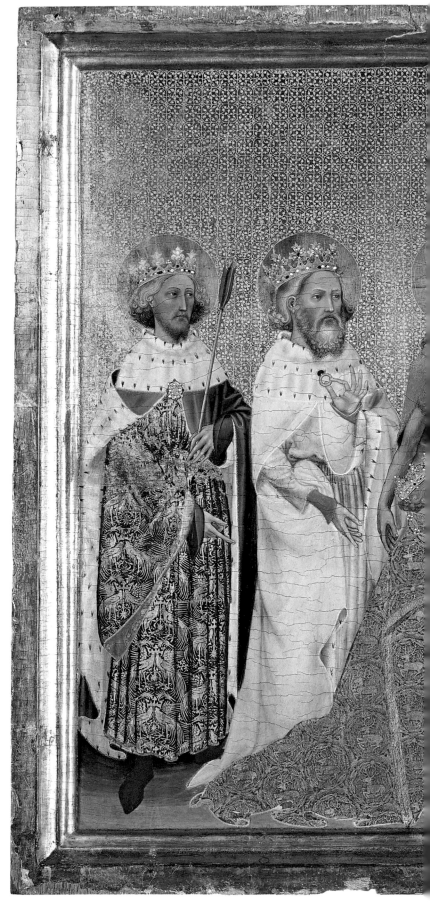

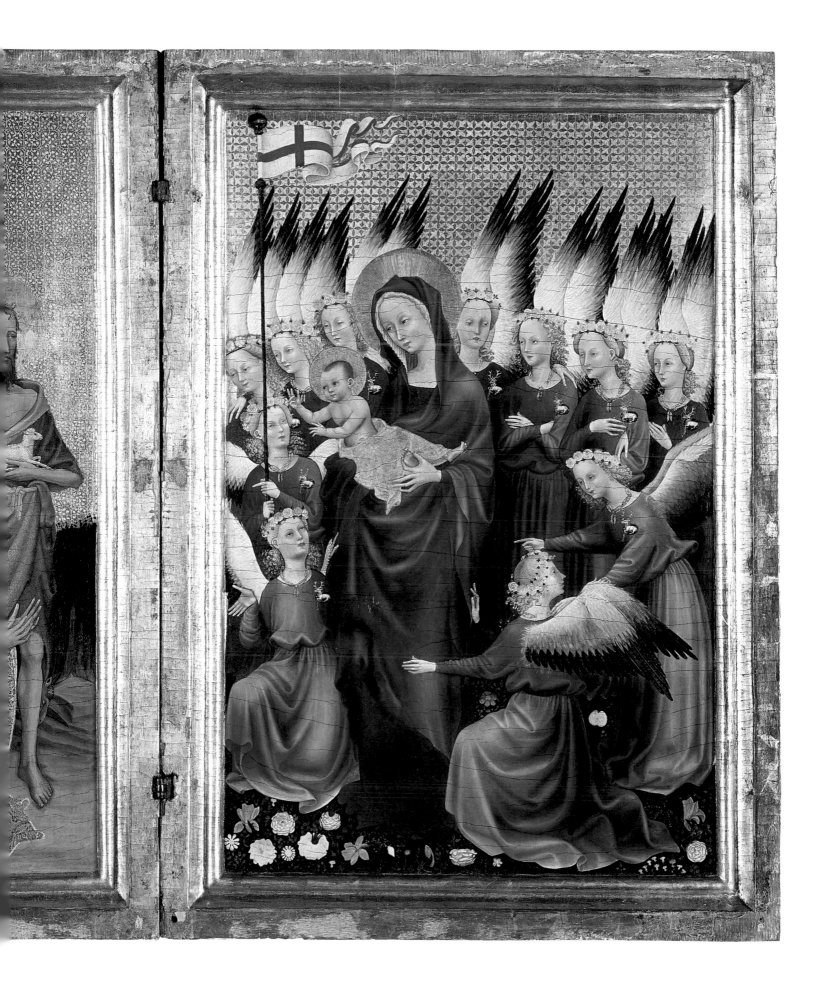

The Fall of the Rebel Angels

Pieter Bruegel the Elder (1525/30–69)

This panel, painted in 1562, has at its center the armored figure of the Archangel Michael. Wielding his long sword and a shield marked with the red cross of the Resurrection (a symbol of Christ's final triumph over evil), Michael beats down Satan and the host of angels who in their pride had rebelled against God. The rebels' precipitous fall from Heaven is emphasized by the figures tumbling as if in a vortex from the light at the top of the picture and by the swirling, buoyant figures of Michael's victorious white-robed angels. The fallen angels are metamorphosing into grotesque demonic forms, with Satan himself as the dragon trampled under Michael's feet.

KEY ELEMENT

MICHAEL: The Archangel Michael is often depicted dressed in armor, fighting Satan, who is in the form of a dragon – for example, by Dürer – or as a beautiful young man with wings, by artists such as Piero della Francesca. In scenes of the Last Judgment he is shown holding scales on which he weighs the souls of the dead.

See also page 118

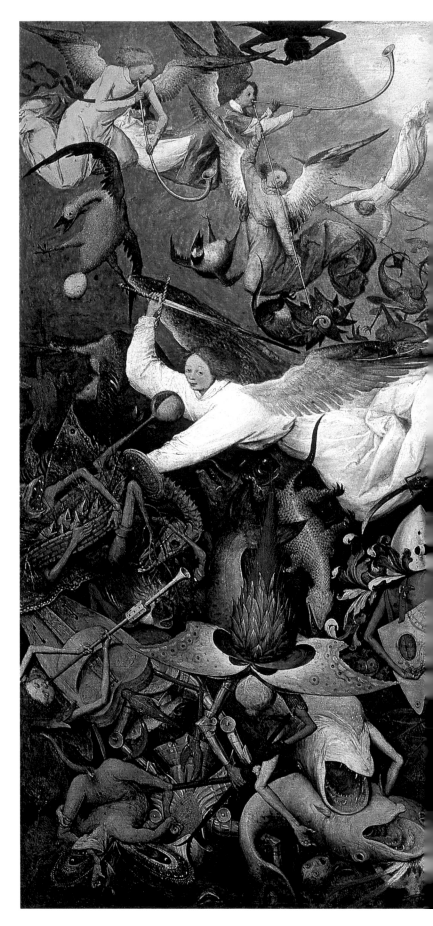

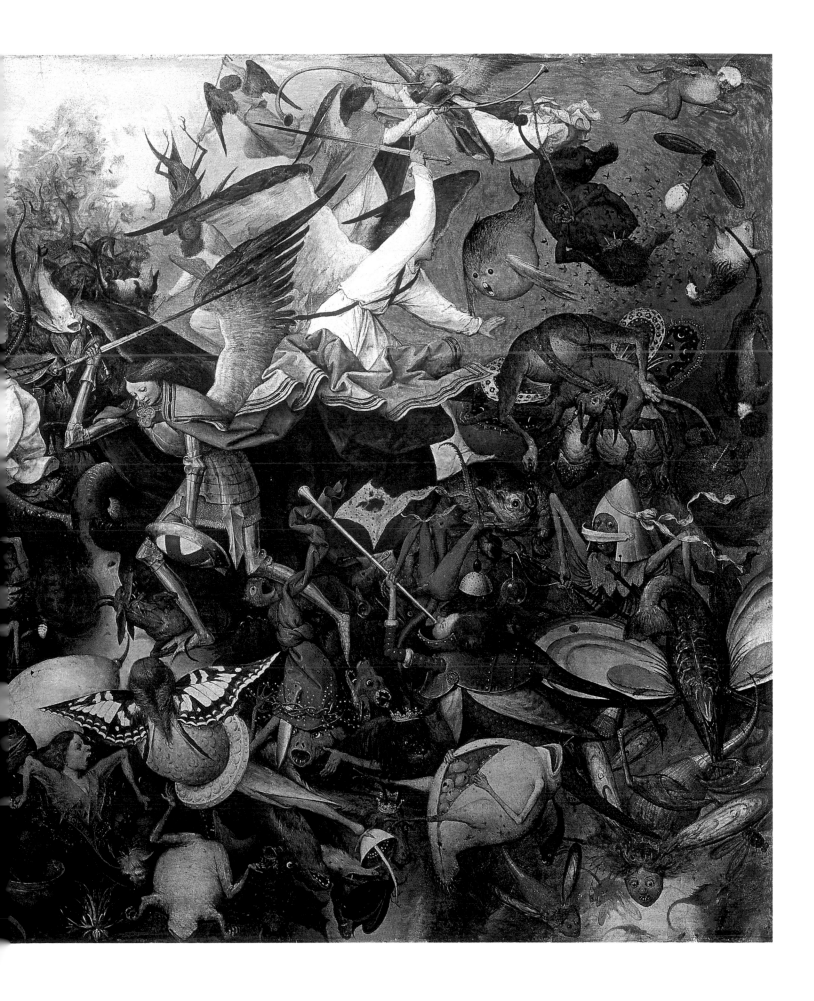

The Adoration of the Lamb

Jan van Eyck (c.1390–1441)

The great altarpiece for the cathedral of Saint Bavo, Ghent, said to have been begun by Hubert van Eyck (died 1426), was completed in 1432 by Hubert's younger brother Jan. Its central panel depicts a vast and varied multitude of the blessed assembled under the rays of the Holy Spirit to worship Christ, who appears in the form of the Mystic Lamb standing on the central altar, flanked by angels and the Instruments of the Passion. The fountain shown in the foreground of the painting alludes to the promise made in the Book of Revelation that all those who thirst will be given water from the well of life.

Jan van Eyck was associated with the high culture that flourished at the court of the dukes of Burgundy in the early 1400s; his minute attention to detail in this vast painting recalls the miniatures in the Burgundian Books of Hours which were painted in the so-called International Style at around this time. However, the landscape that appears in the background, with its solid rocks and trees and distant blue hills, is a precursor of the realism and perspective of later Renaissance art.

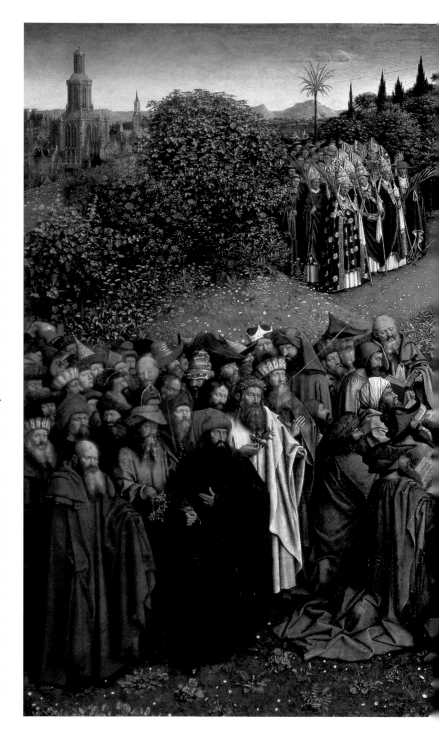

KEY ELEMENT

LAMB: In the Old Testament, a lamb or ram was frequently sacrificed to God and was used in early Christian and medieval art to represent both the Passion of Christ and Christ of the Resurrection. In depictions of the former theme, the lamb's blood may be shown flowing into a chalice; in the latter, it may hold a triumphant banner with a red cross on a white background. The attribute of John the Baptist is a lamb

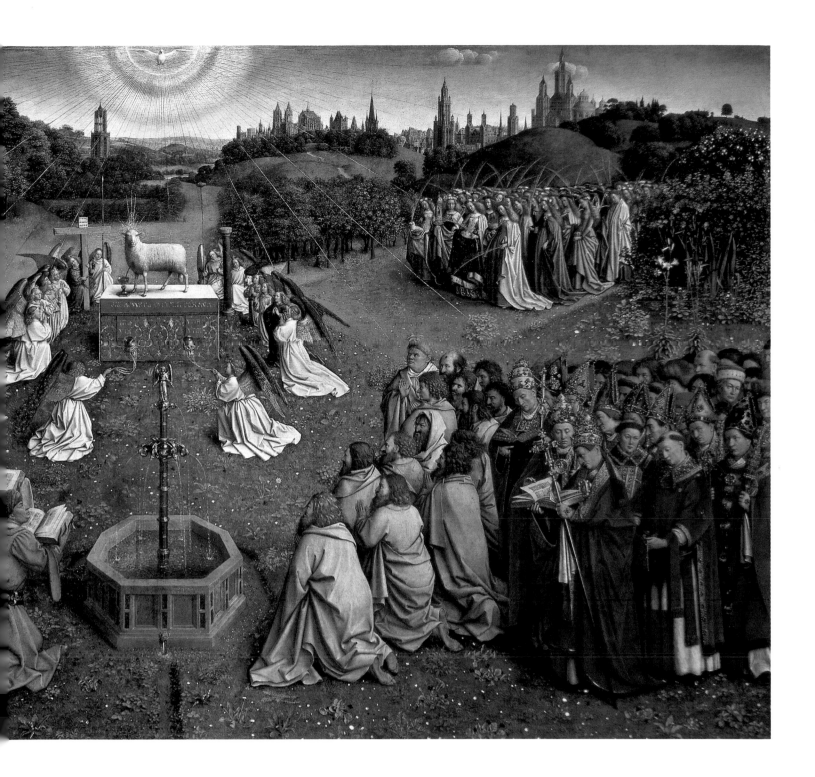

– a reference to his calling Christ the "Lamb of God," destroyer of sin.[1]

A lamb may also symbolize one of Christ's flock of followers, under the protection of the Good Shepherd,[2] as illustrated in the early Christian mosaics of the Mausoleum of Galla Placida, Ravenna.

[1]John 1:29 [2]John 10:11

The Fall
Hugo van der Goes (c.1440–82)

Van der Goes's interpretation of the Fall of Adam and Eve is one panel of a diptych probably painted after 1479; the second panel depicts the Lamentation over the dead Christ – together, they invite the viewer to meditate on the subject of human sin and the sacrifice necessary to reverse it.

The Garden of Eden around the luscious-looking Tree of the Knowledge of Good and Evil is a traditional verdant paradise. However, the iris and columbine shown growing in front of Adam and Eve are the flowers that are associated with the Virgin Mary and the Holy Spirit respectively, thus hinting at the future role of these two in redeeming fallen humanity from the consequences of eating the forbidden fruit. Van der Goes also included these flowers in the *Portinari Altarpiece* (see pages 104–05). The serpent, following a misogynistic medieval representation of Deceit, is given the head of a woman on the body of a lizard. Its elaborate hairstyle (a feature associated with prostitutes) contrasts with the flowing hair of Eve.

KEY ELEMENT

ADAM AND EVE: In the Old Testament, God created Adam from the dust of the Earth[1] in his own likeness and breathed life into him; He then placed Adam in the Garden of Eden, and forbade him to eat of the Tree of Knowledge. God created Eve from Adam's rib, to be his companion.[2] The serpent tempted Eve to know good and evil by eating the forbidden fruit, and she in turn persuaded Adam to taste it. At once their eyes were opened and, ashamed, they took fig leaves to hide their nakedness. In punishment for their Original Sin, God expelled Adam and Eve from the Garden of Eden.

The Creation, the Temptation, and the Fall of Adam and Eve were popular in medieval and Renaissance art because they represented mankind's need for redemption through Christ. These themes were illustrated on their own or as a cycle.

The Temptation and the Expulsion from Paradise introduce the fresco cycle by Masolino and Masaccio, *The Life of Saint Peter* (1426–27; Brancacci Chapel, Santa Maria del Carmine, Florence). The Fall may also be seen in an Annunciation where it refers to Christ's mission to redeem humankind; Adam's skull may appear in a Crucifixion scene.

[1]Genesis 1:26 [2]Genesis 2:7–22

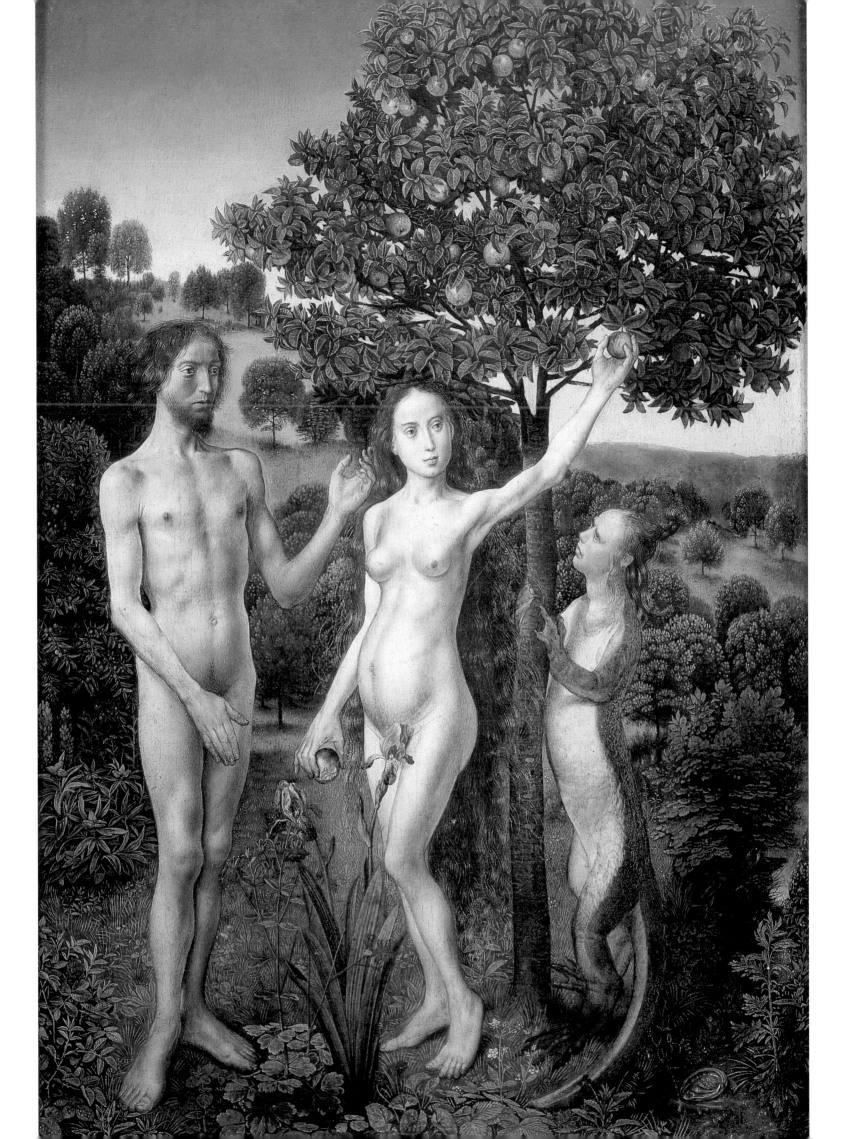

Vision of Ezekiel
Raphael (1483–1520)

This small oil was painted by Raphael for a private patron around 1518. The setting of the vision takes its cue from the Book of Ezekiel: "... behold, a whirlwind came out of the north, a great cloud, and a fire infolding itself, and a brightness was about it." (Ezekiel 1:4). God is shown riding through the air supported by the "four living creatures" of Ezekiel's vision. Christian tradition equates these with the four winged creatures (man or angel, lion, ox, and eagle) that symbolize the Evangelists in art; and this, rather than the description in Ezekiel itself, is the tradition that Raphael follows in this painting.

Although white-haired like the Hebraic Ancient of Days (Daniel 7:9), the half-naked figure of God the Father, with the body of a man in his prime, is a thoroughly Renaissance concept, more closely akin to Jupiter, king of the gods of pagan antiquity. The stupendous power of the vision is conveyed by comparison with the scale of the landscape beneath, in one corner of which the tiny figure of Ezekiel himself can be seen caught in a shaft of light.

KEY ELEMENT

GOD: In the New Testament, Christ told his disciples to "teach all nations, baptizing them in the name of the Father, and of the Son, and of the Holy Ghost,"[1] from which the doctrine of the Holy Trinity derives.

In artistic representations of the Trinity, the One God is shown as Three Persons: God the Father; God the Son – usually displaying his wounds; and God the Holy Ghost – most commonly represented by shafts of light or by a dove.

In the Renaissance, God the Father came to be depicted as a static, paternal figure with long white hair and a beard, as in Masaccio's *Trinity* (1427–28). Michelangelo's representation of God the Father creating the world (1509–1512; Sistine Chapel, Rome) has affinities with depictions of Jupiter.

The attributes of God may be a triangular halo representing the Trinity, a globe in order to represent his capacity as the creator of the world, or an alpha and omega to signify his position as the beginning and the end of all things.

[1]Matthew 28:19

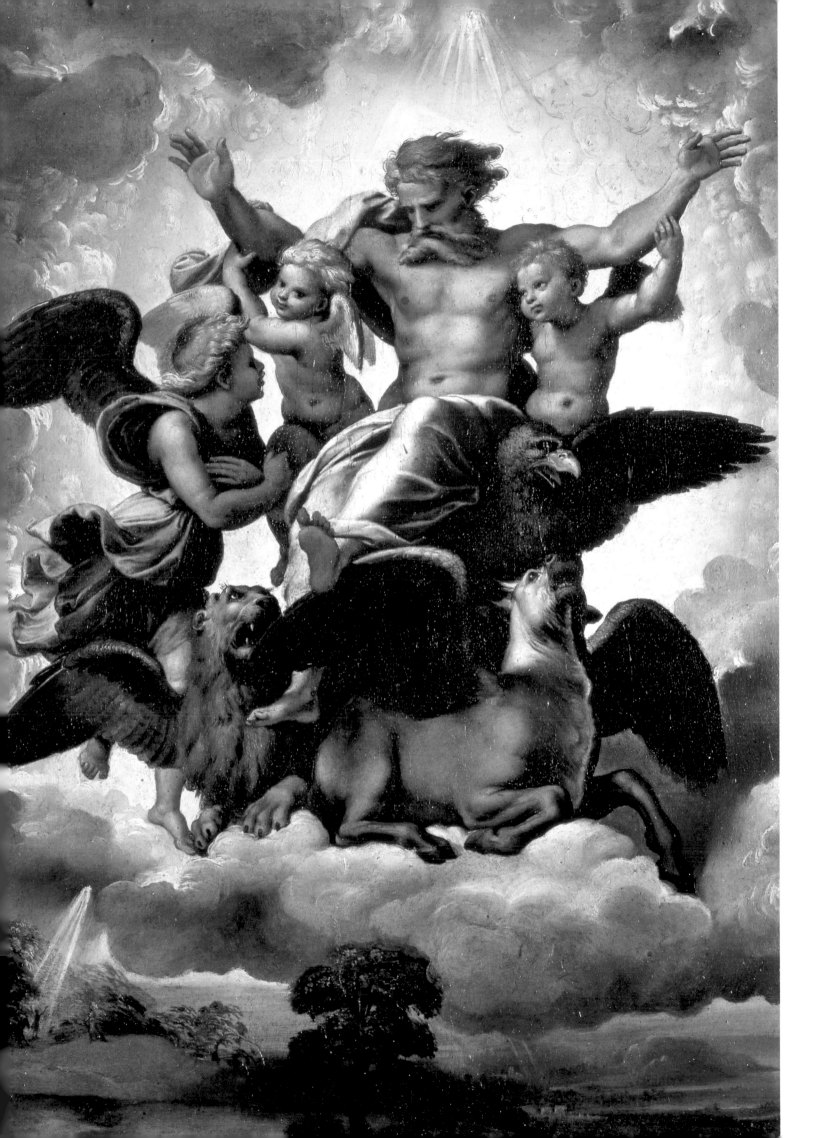

The Last Judgment

Fra Angelico (c.1400–1455)

This striking vision of the Last Judgment was painted in the early 1430s for the church of Santa Maria degli Angeli, Florence. The perspective of the twin rows of vacant tombs, ending in the dark and empty sky, creates a dramatic sense of space and foreboding. At the center, surrounded by a ring of angels, is Christ in his role as judge, with the Virgin and Saint John in their traditional positions to either side of him. Below them, the division of the blessed and the damned has already taken place. Angels come to lead the blessed souls away to the bliss of Heaven, here symbolized by the circular dance in a paradisal landscape. On the opposite side, the damned gesticulate with terror as devils drive them toward the torments of Hell.

KEY ELEMENT

LAST JUDGMENT: The Gospels prophesied that all nations would come before Christ, and "He shall separate them one from another, as a shepherd divideth his sheep [the faithful] from the goats [nonbelievers]. And he shall set the sheep on his right hand, but the goats on the left."[1] In late medieval and Renaissance churches, the Last Judgment was traditionally depicted on or near the wall of the west entrance as a

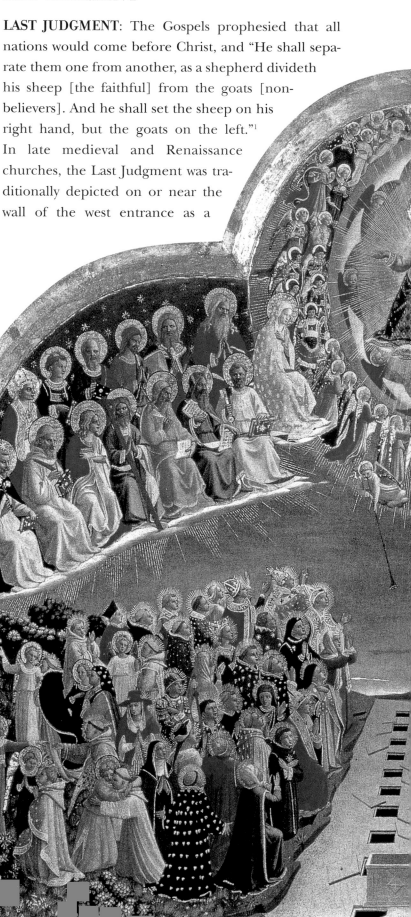

reminder to departing congregations. Christ presides as judge, seated on a throne with the Apostles flanking him. Near him may be the Virgin as intercessor, Saint Peter with the keys to Heaven, and angels bearing the Instruments of the Passion. Above Christ may appear ranks of angels or saints and, below him, Michael holds the scales in which souls are weighed. Angels sound trumpets to call up the dead. At the bottom of such compositions graves may open to release souls and the blessed may soar up in a clockwise direction toward Christ's right. On his left the damned are sent to Hell. Here, Satan may devour and excrete sinners, while those suffering specific tortures may be grouped according to their punishment.

Michelangelo's *Last Judgment* (1508–1512; Sistine Chapel, Rome) is unusual in being placed behind the altar. This may have been to warn those who questioned the supremacy of the Pope after the Reformation. Christ is no longer passive but seems to storm out of the fresco with a condemning gesture.

[1] Matthew 25:32–33

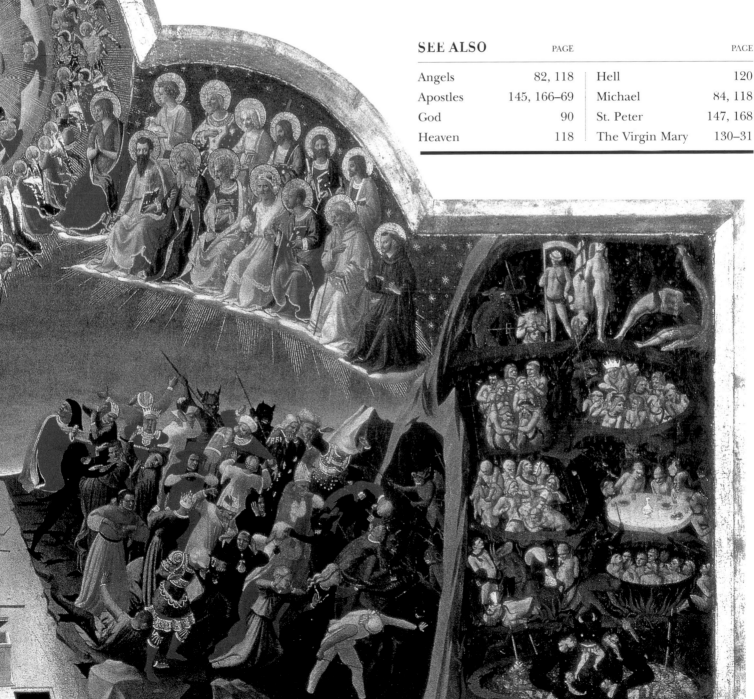

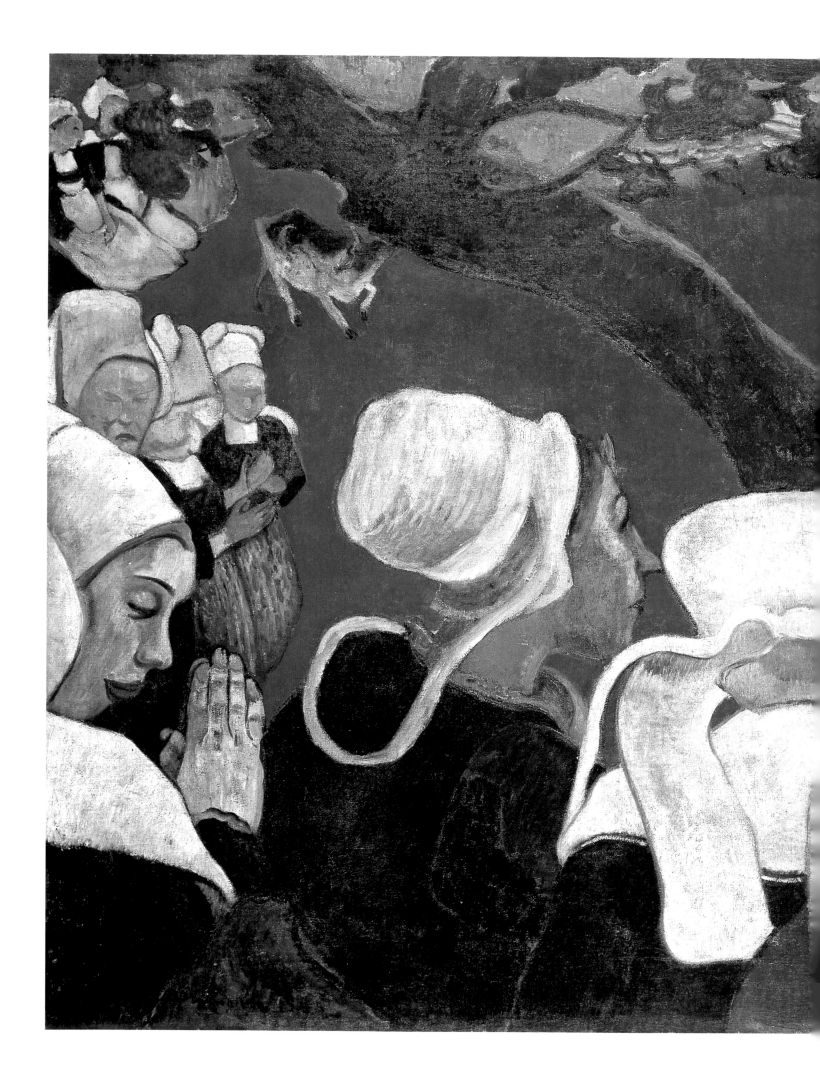

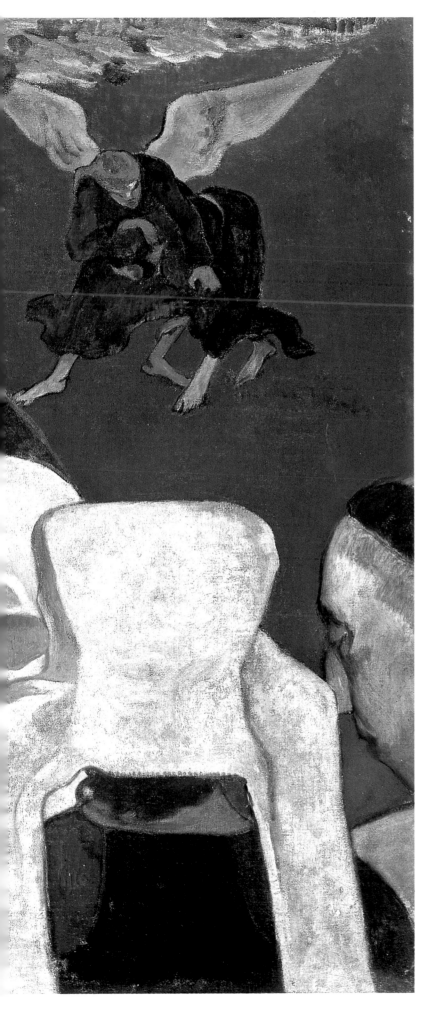

The Vision after the Sermon

Paul Gauguin (1848–1903)

Gauguin's mysterious masterpiece, depicting a Breton religious festival, was painted in the summer of 1888. The subject of the vision is the wrestling match described in Genesis between Jacob and the angel. The praying girl in the left foreground and the priest with bowed head on the right have their eyes closed, so perceive the vision inwardly and profoundly (unlike the other onlookers and the intruding cow). Jacob's struggle with the angel was interpreted in various ways by nine-teenth-century French writers and artists, who saw it as an allegory either of the growth of secularism and religious doubt or of human-ity's relationship with the divine. Gauguin's treatment may reflect his concept of the artist's hard-won acquisition of hermetic knowledge inaccessible to ordinary people.

KEY ELEMENT

JACOB: In the Old Testament,[1] Jacob and Esau were the twin sons of Isaac and Rebecca. In one episode, alone by a brook at night, Jacob wrestled with an angel until daybreak. Unable to throw him, the angel refused to tell him his name, but said that Jacob would hence-forth be called Israel. Jacob then understood that he had been wrestling with God.

See also page 123
[1]Genesis 25:20–34

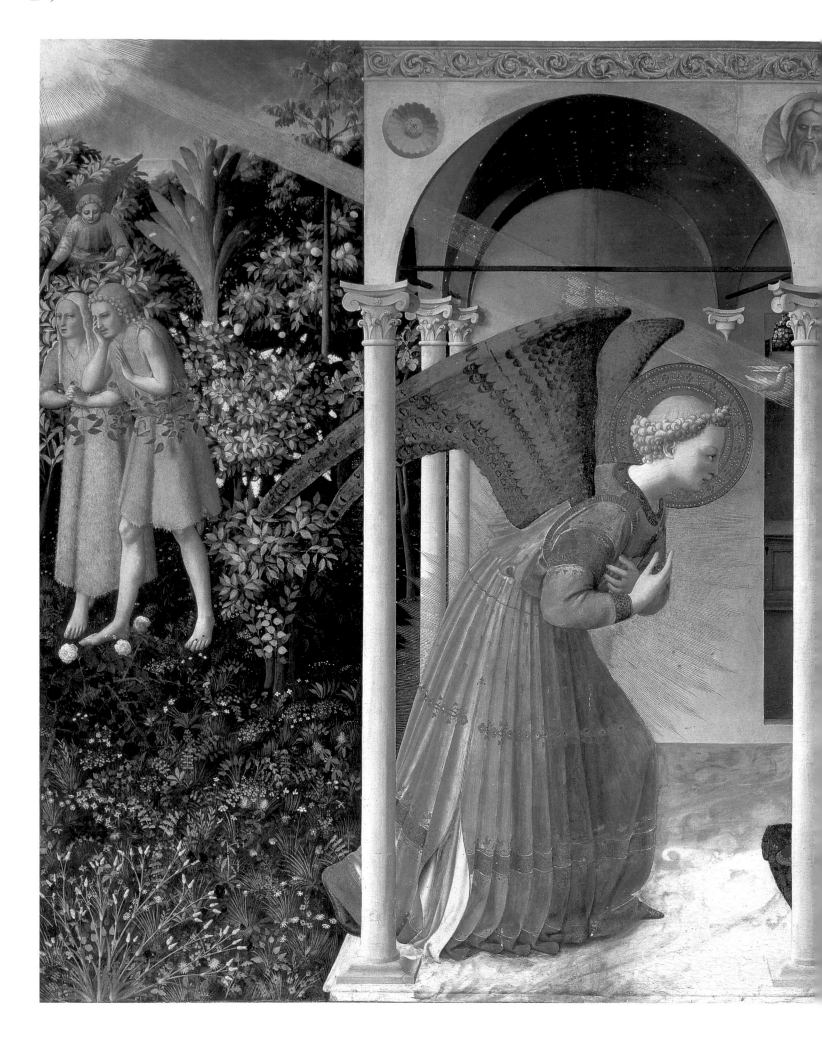

The Annunciation
Fra Angelico (c.1400–1455)

The architectural setting of this panel painting of *c.*1435–45 has strong similarities with the artist's famous *Annunciation* fresco of the late 1430s for the convent of San Marco, Florence. The fiery-robed angel stoops in humility as he greets the Virgin whose blue cloak symbolizes the heavenly role that she is to assume. Despite the interposing column of the *loggia*, the crossed hands of the Virgin and Gabriel mirror each other to create a sense of harmony. On the left, another angel oversees the expulsion of Adam and Eve from Eden after the Fall – the catastrophe that Christ's incarnation was to remedy. The theme of Mary as the second Eve, regaining what the first had lost, was common in medieval literature. The swallow appears as herald of spring and hence new life.

KEY ELEMENT

ANNUNCIATION: The moment in which the Incarnation of Christ was made known to Mary[1] is one of the most frequently depicted scenes in Christian art. Often with the lily of purity nearby, Mary is usually seated or kneeling in meditation, or reading a holy book, thought to be the Old Testament prophecy, "Behold, a virgin shall conceive, and bear a son."[2] God's hand may be seen dispatching rays of light and the dove of the Holy Ghost.

[1]Luke 1:31–35 [2]Isaiah 7:14

Madonna and Child with Saints
Giovanni Bellini (c.1430–1516)

Bellini's large altarpiece for a chapel in the north aisle of the church of San Zaccaria, Venice, is dated 1505. This type of composition, showing the Virgin with the Child on her lap and saints (usually four or six) on either side, is known as a *Sacra Conversazione*; altogether more intimate than the *Maestà* (see pages 144–45), it was a favorite with Venetian Renaissance artists.

Bathed in clear golden light and distanced from the viewer by the elaborate architectural surround, the Virgin on her high throne is absorbed in her own thoughts, holding, but not looking at, the Child. The Child's hand is raised in blessing but the gesture is not directed at the viewer; and although Saints Peter and Jerome face forward, their heads are bowed and their eyes cast down in private meditation. The two female saints, Catherine of Alexandria (her wheel is just visible to the left of the throne) and Lucy, are similarly absorbed. Only the more outward-directed gaze of the musician angel invites the viewer to enter into the scene of quiet adoration.

KEY ELEMENT

IMAGES OF THE VIRGIN: The Virgin as the mother of God is a central doctrine of the Church and images of her frequently stress her motherhood. This was apparent in the Tree of Jesse, which emphasized Christ's descent from the father of David, via the Virgin rather than Joseph. A most maternal image was the Virgin Suckling the Christ Child, depicted until the Council of Trent (1545–63) registered its disapproval of the Virgin's nudity. The Franciscans emphasized human tenderness, and during the Renaissance many artists portrayed the Virgin in domestic settings or a naturalistic landscape, perhaps even wearing fashionable contemporary clothes.

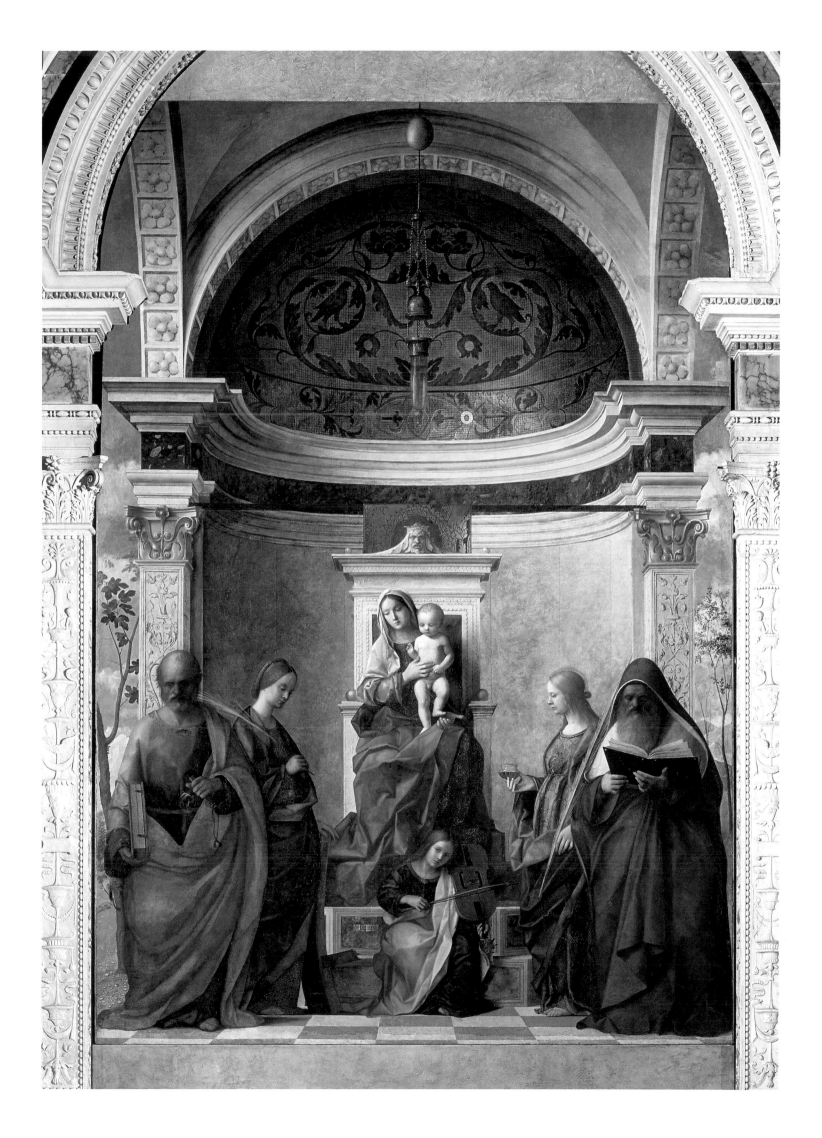

Virgin and Child with Saint Anne

Leonardo da Vinci (1452–1519)

Leonardo's painting (*c*.1510) of the popular subject of the Virgin and Christ Child with the Virgin's mother, Saint Anne, is far removed from earlier stiff, frontal arrangements of the family group. Leonardo worked on versions of this subject in the first years of the sixteenth century: a somewhat different treatment that includes Saint John the Baptist as an infant survives as a drawing in the National Gallery, London, and a now-lost cartoon caused a sensation when it was exhibited in the Annunziata Convent, Florence, in 1501.

Although Saint Anne is shown in her usual place at the rear, with the Virgin in front of her, the three figures are lively and naturalistic. In a distinct departure from the tradition of presenting Anne as an elderly matron, Leonardo shows her as surprisingly youthful and attractive. The hapless lamb in the Child's grasp hints at his own future role as the Lamb of God, the blameless sacrifice for sin; but apart from this reference, the playful and intimate trio in the dreamy landscape wear the symbolic significance lightly.

KEY ELEMENT

SAINT ANNE (ANNA): The cult of Anna (first century CE), mother of the Virgin, first came to the West with Christian refugees fleeing from Muslim conquests, and an early image of her (*c*.650CE) appears in Santa Maria Antiqua, Rome, where she is shown with the Virgin. By the fourteenth century she was a popular figure, partly because her motherhood at an advanced age confirmed the doctrine of the Immaculate Conception of the Virgin. She usually appears with her daughter. Legend[1] claims that she was married three times and had three daughters, and she is depicted in the late Middle Ages with her extended family, known as the

Holy Kinship, by artists such as the Master of Saint Veronica. In 1479 the Carmelites in Frankfurt formed a brotherhood of Saint Anne and commissioned an altarpiece devoted to her, illustrating scenes from her life.

[1] *Golden Legend, The Birth of the Blessed Virgin*

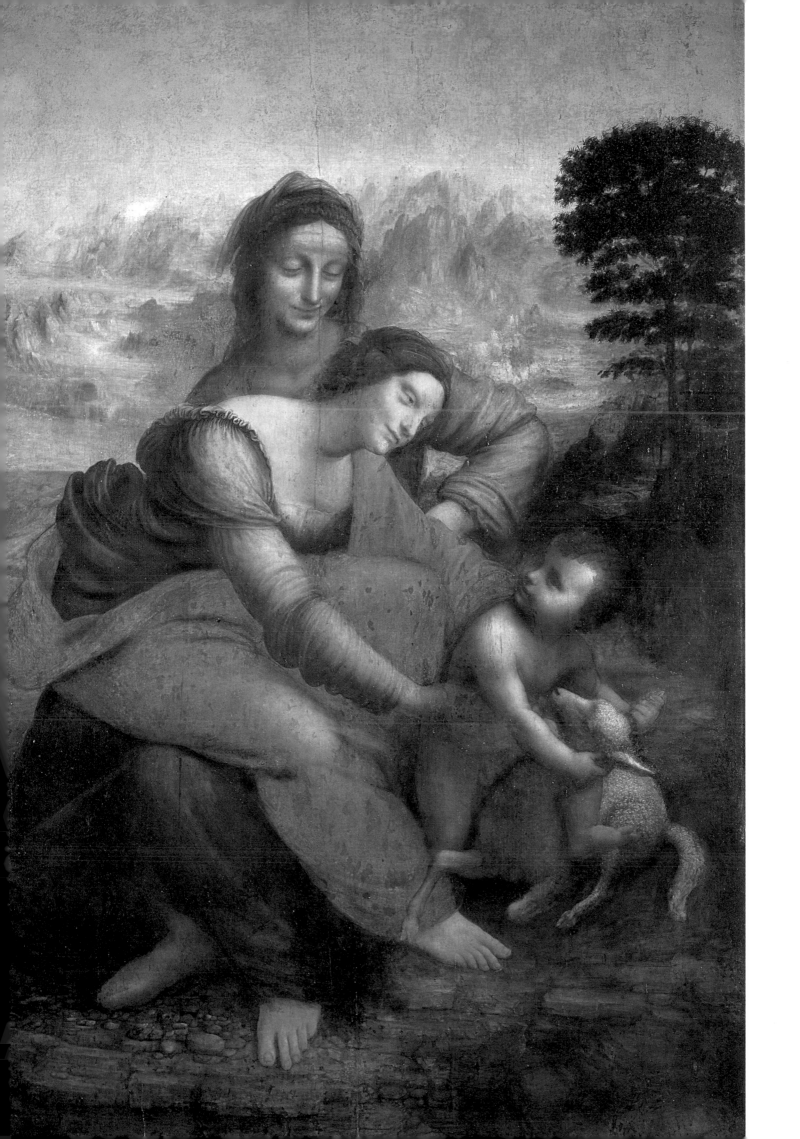

Coronation of the Virgin
Enguerrand Quarton (c.1410–66)

Quarton's elaborate treatment of the Coronation of the Virgin as Queen of Heaven (1453–54) follows a medieval symmetrical formula with the Virgin between God the Father and God the Son (shown identical) who are placing the crown upon her head, with the dove of the Holy Spirit hovering above and angels and the ranks of heavenly witnesses to either side. Although the focus is upon the Virgin's bliss in Heaven, the small-scale scenes below (the Crucifixion, the cityscapes, and the scenes from purgatory and Hell) set her in the context of God's grand redemptive scheme. All the picture's elements were minutely specified by Jean de Montagnac (depicted praying by the Cross), who commissioned the painting.

KEY ELEMENT

CORONATION OF THE VIRGIN: The subject of the Coronation of the Virgin appeared in late medieval art. In this, the last scene of the cycle of the Virgin, she is received into Heaven by Christ where he crowns her as the Queen of Heaven. Episodes from the last days of the Virgin on Earth, including her deathbed, the tomb, and the Apostles, may appear in narrative pictures of the Coronation. The Virgin is often shown as the intercessor between humankind and God.

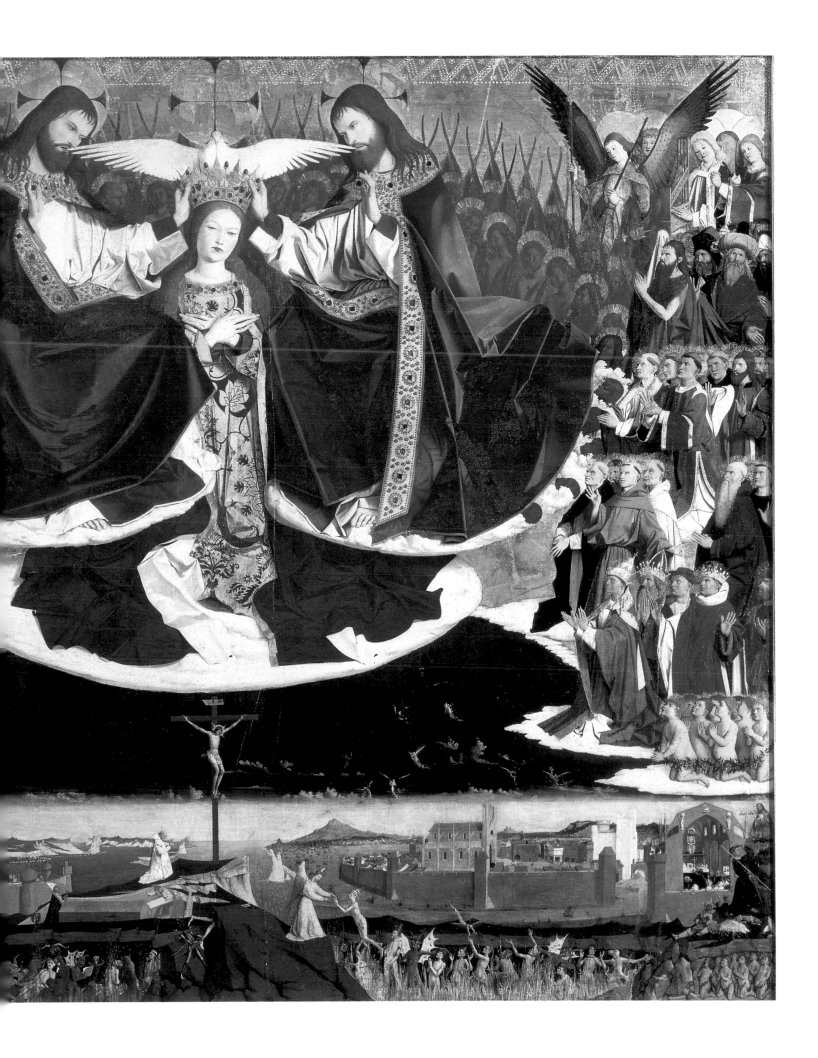

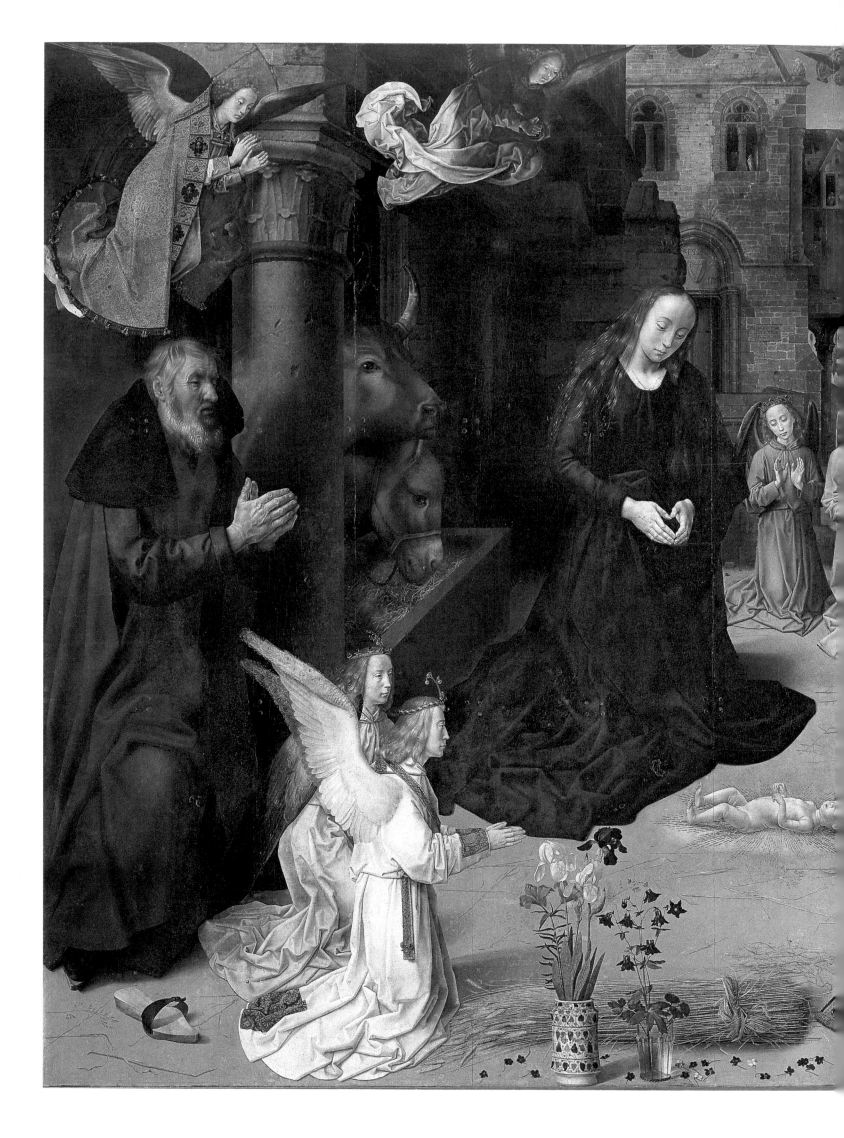

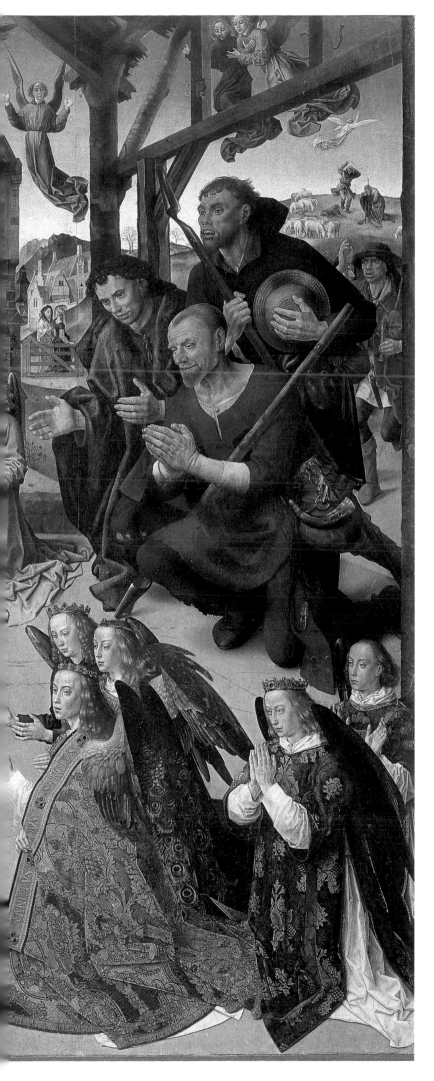

Christ Child Adored by Angels

Hugo van der Goes (c.1440–82)

The enormous triptych, known as the *Portinari Altarpiece*, of which this is the central panel was painted in Bruges around 1475 for the high altar of the church of Sant' Egidio, Florence. Amid the animation of the rich-robed angels and bumpkin-like shepherds thronging into the stable, the Virgin contemplates the Christ Child, who lies in naked humility on the bare floor, his divinity indicated only by the rays of light emanating from his body. Saint Joseph stands to one side, a little detached from the central group of Virgin and baby. The iris and columbine (the flowers of the Virgin and the Holy Spirit respectively) in the exquisite still life in the foreground symbolize the roles of the Virgin and the Holy Spirit in Christ's Nativity. They also appear in van der Goes' *The Fall* (see pages 88–89).

KEY ELEMENT

NATIVITY: The birth of Christ, or Nativity, took place in Bethlehem in Judea. The Virgin Mary "brought forth her firstborn son, and wrapped him in swaddling clothes, and laid him in a manger; because there was no room for them in the inn."[1] The Infant is usually shown in a humble crib with an ox and ass looking on, as prophesied by Isaiah. An angel appeared to shepherds that night and told them of the Savior's birth.

See also page 132 [1]Luke 2:7

SEE ALSO

The Isenheim Altarpiece
Matthias Grünewald (c.1470–1528)

Grünewald's massive limewood altarpiece was painted between 1510 and 1515 for the high altar of the church of the monastery at Isenheim, Alsace. The tortured and disfigured body of Christ on the Cross dwarfs the mourning group of Saint John, the Virgin, and Mary Magdalene. Contrasting with the moment of agony and death, the stolid figure of Saint John the Baptist invites the viewer to meditate on Christ's sacrifice and its implications with the words attributed to him in the Bible: "He must increase, but I must decrease" (John 3:30). In the panel below, the three Marys prepare Christ's body for the tomb. On the wings are Saints Sebastian and Anthony.

KEY ELEMENT

CRUCIFIXION: Christ's Crucifixion took place at Golgotha ("a place of a skull"), and was watched by a crowd including his mother and Mary Magdalene. As the soldiers crucified him, Christ said "Father, forgive them; for they know not what they do."[1] Just before he died, a sponge soaked in wine and water was offered to Christ. Afterwards a soldier pierced his side; blood and water flowed from the wound.

See also page 134 [1]Luke 23:34

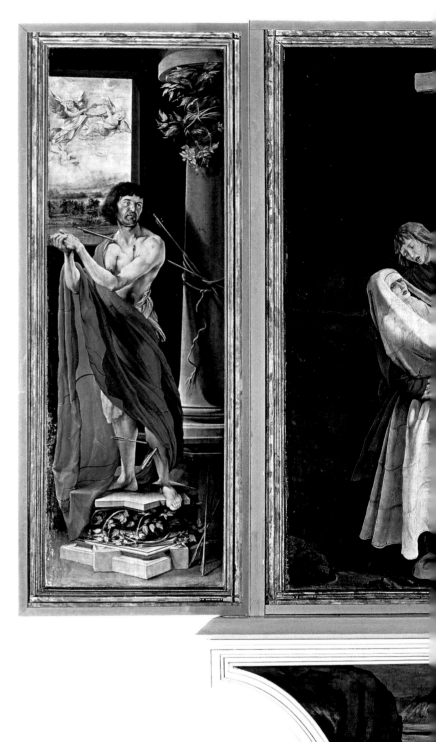

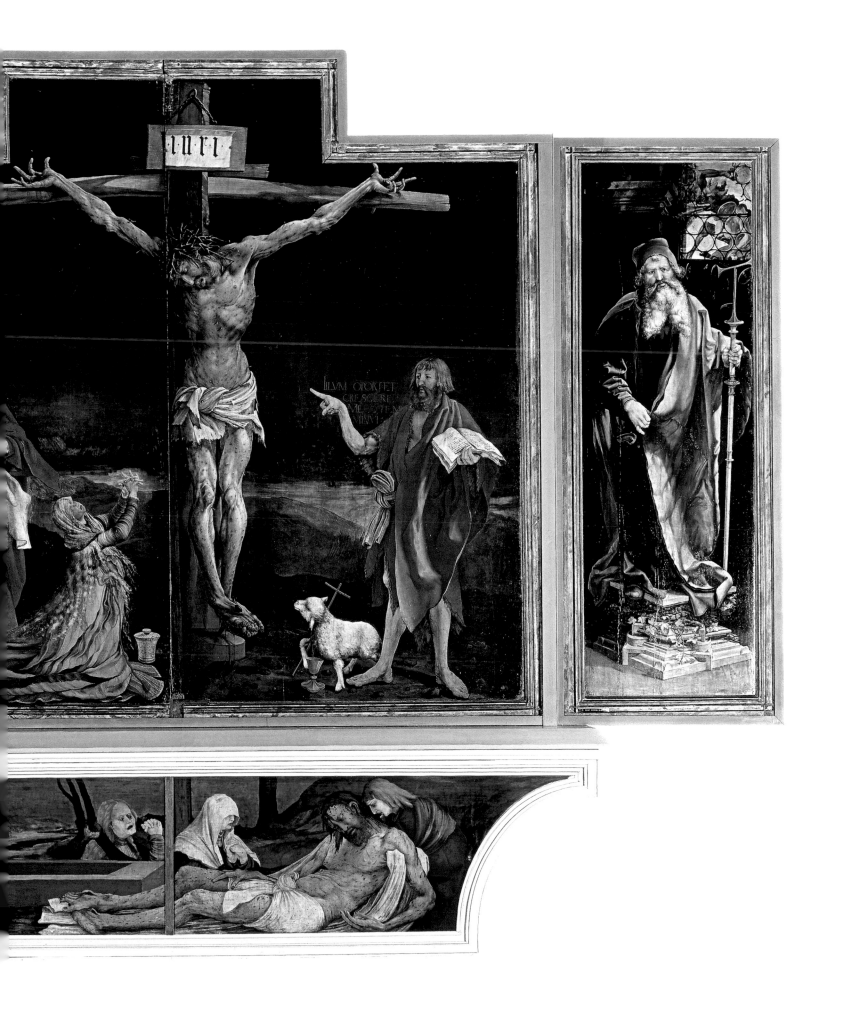

Christ in the House of His Parents

John Everett Millais (1829–96)

Millais's canvas evoked massive hostility when it was exhibited in London in 1850 and was denounced by *The Times* newspaper as "revolting." As a leading member of the pre-Raphaelite Brotherhood, the artist was exemplifying pre-Raphaelite tenets of painstaking realism and directness of emotional appeal when he painted the Holy Family as poor English laborers at work in Joseph's carpenter's shop. But the thin, care-worn Virgin was particularly offensive to eyes accustomed to attractive young blondes modeling this role. The boy Christ has injured his hand on a nail and his cousin John (later the Baptist) brings water for the wound. The blood dripping on Christ's foot foreshadows the Crucifixion, as does the ladder on the wall behind.

KEY ELEMENT

HOLY FAMILY: During the Renaissance, paintings of Mary, Joseph, and the Infant Jesus grew out of maternal images of the Virgin and Child. Michelangelo's *Doni Tondo* (*c.*1504) is an example of this development. The subject emphasizes the human aspect of the Incarnation, as the Holy Family are seen doing domestic tasks. In Correggio's *Madonna of the Basket* (*c.*1524), for example, the Virgin has her sewing beside her, while Joseph is busily at work.

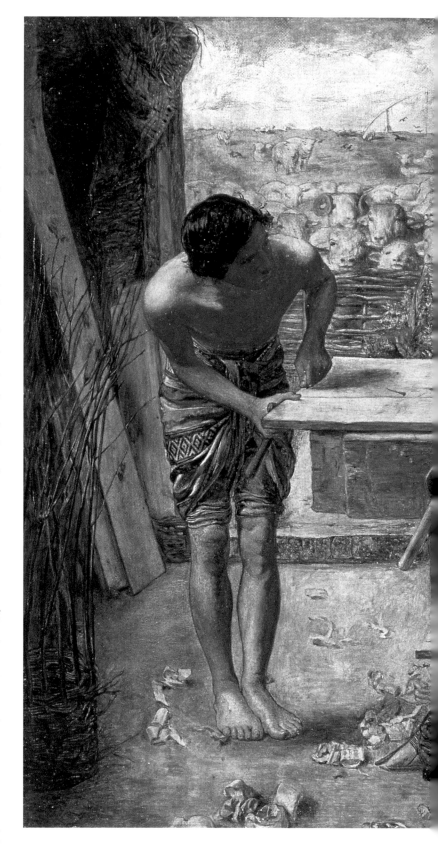

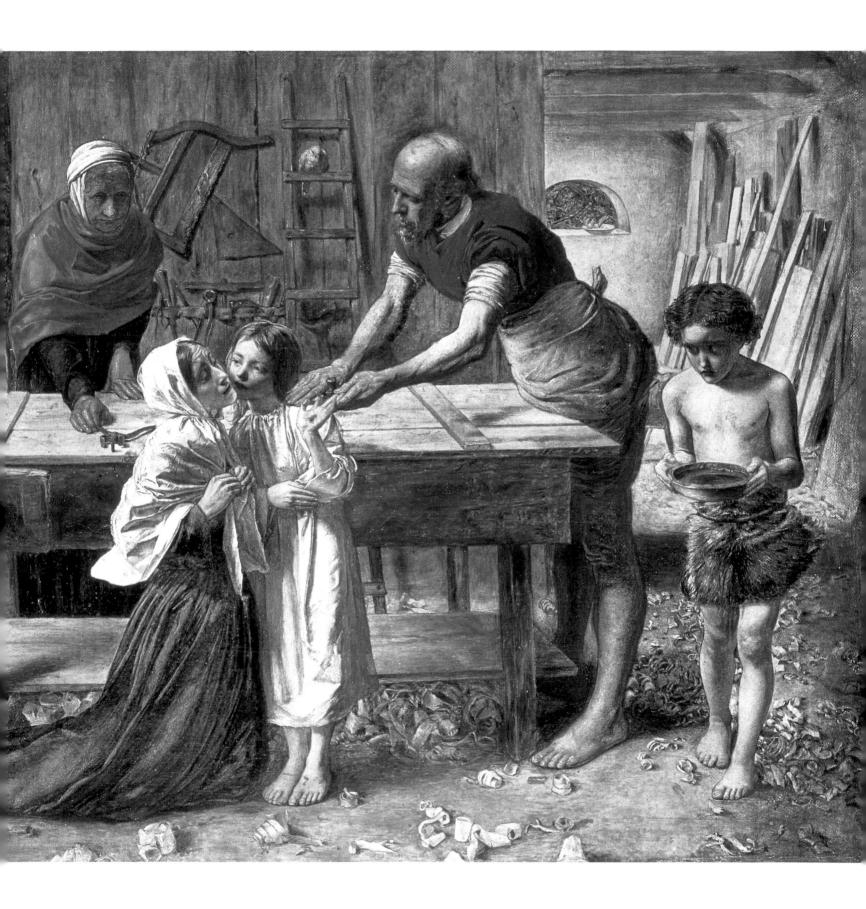

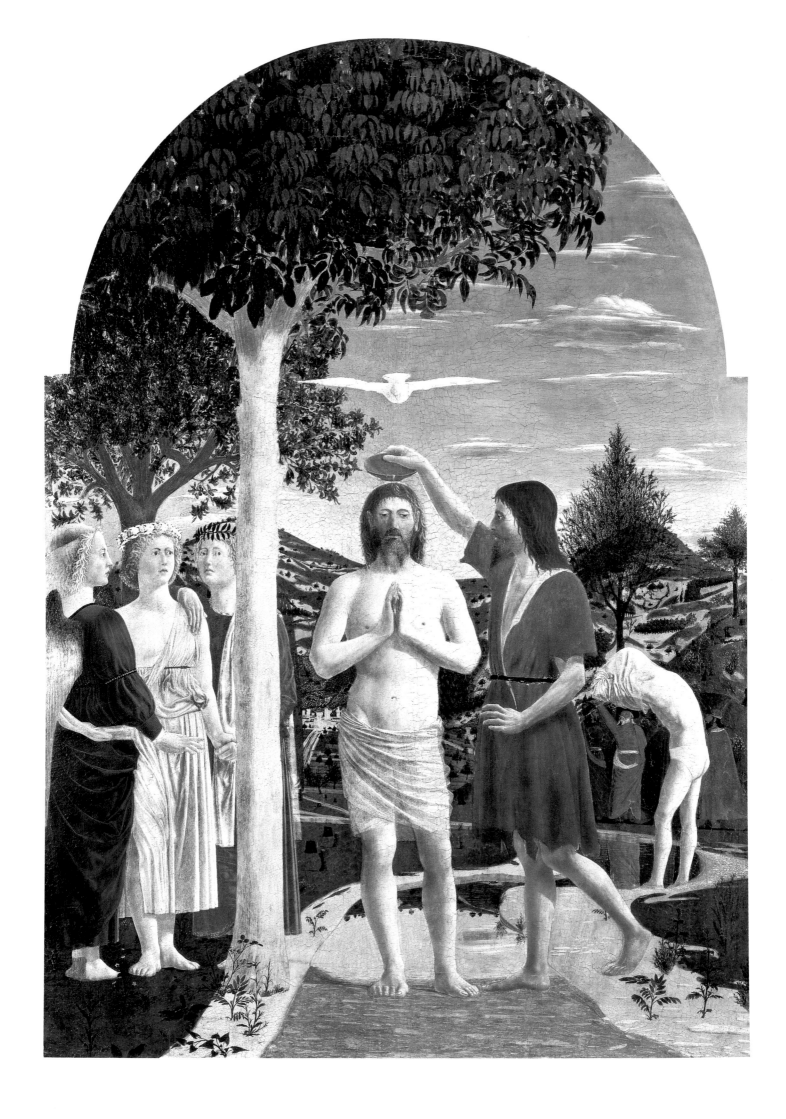

Baptism of Christ

Piero della Francesca (c.1415/20–92)

This baptismal scene was painted for the priory of San Giovanni Battista in Piero della Francesca's native town of Borgo San Sepolcro, Umbria, probably around 1450. The two central figures of Christ and John the Baptist stand out from the rest of the picture under the level wings of the dove of the Holy Spirit; their stillness and the fact that, alone of all the figures in the painting, they neither touch nor overlap one another emphasize the extraordinary import of what is taking place.

The artist's characteristic preoccupation with geometric proportions, light clear colors and solid, monumental figures is seen in the trio of watching angels, who in more traditional treatments of the subject often hold Christ's garments as he steps into the River Jordan. Contrasting with the angels is the frieze-like group of Jewish priests dressed in fall colors behind the startlingly pale figure of another baptismal candidate who is in the act of pulling off his shirt. The reflection of the sky in the untroubled water of the river adds to the harmonious quality of the scene.

KEY ELEMENTS

BAPTISM: At the age of about 30, Christ was baptized by Saint John in the River Jordan. At his Baptism "the heavens were opened unto him [John] and he saw the Spirit of God descending like a dove. And lo a voice from heaven, saying, 'This is my beloved Son, in whom I am well pleased.'"[1]

SAINT JOHN THE BAPTIST: John was the cousin of Jesus and son of the priest Zacharias and his wife Elizabeth. The details of his miraculous birth and his life are told in the Gospel of Saint Luke. When he grew up, John preached in the wilderness that the Kingdom of Heaven was at hand. For food he ate wild honey and locusts. He baptized many people, proclaiming: "He that cometh after me is mightier than I."[2] John the Baptist is one of the most frequently represented saints in Renaissance painting.

See also box, page 126
[1]Matthew 3:13–17 [2]Luke 3:15–17

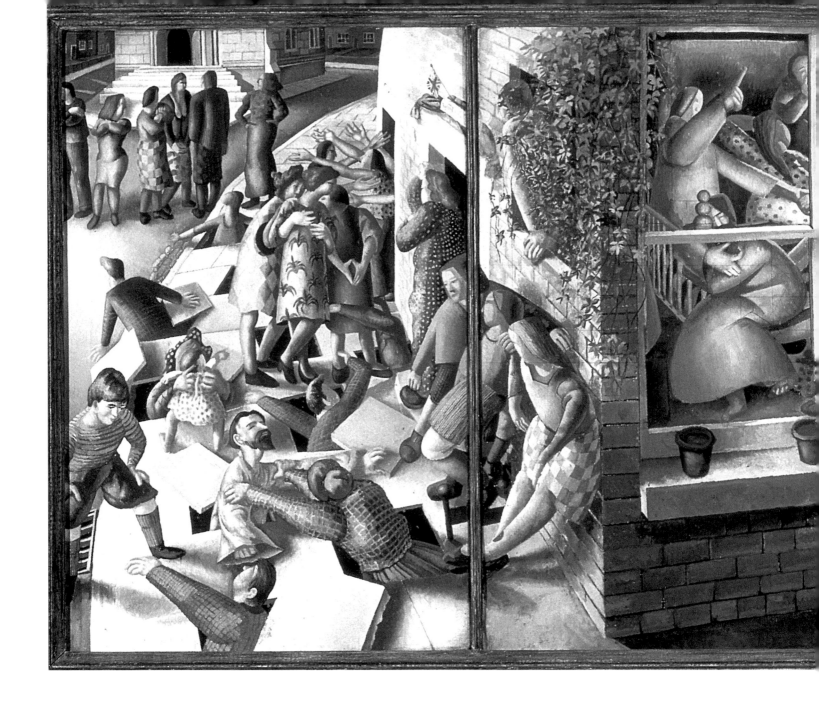

Resurrection with the Raising of Jairus's Daughter

Stanley Spencer (1891–1959)

This oil, dating from 1947, is typical of Spencer's vision of the most profound religious mysteries taking place in the very ordinary surroundings of contemporary suburban or small-town England. Through the window, Christ can be glimpsed raising the dead daughter of Jairus from her bed. The window bars form a cross, at which Christ's hand and the girl's intersect, symbolizing the

transition from death to life that the Cross of Christ effects. To one side, the dead rise from underneath the paving stones of the village street; on the other, they hasten out of the grassy churchyard through the railings to greet their friends. The numerous embracing figures convey the great joy of the Resurrection, without the terrors of the Last Judgment that accompany it in more traditional treatments.

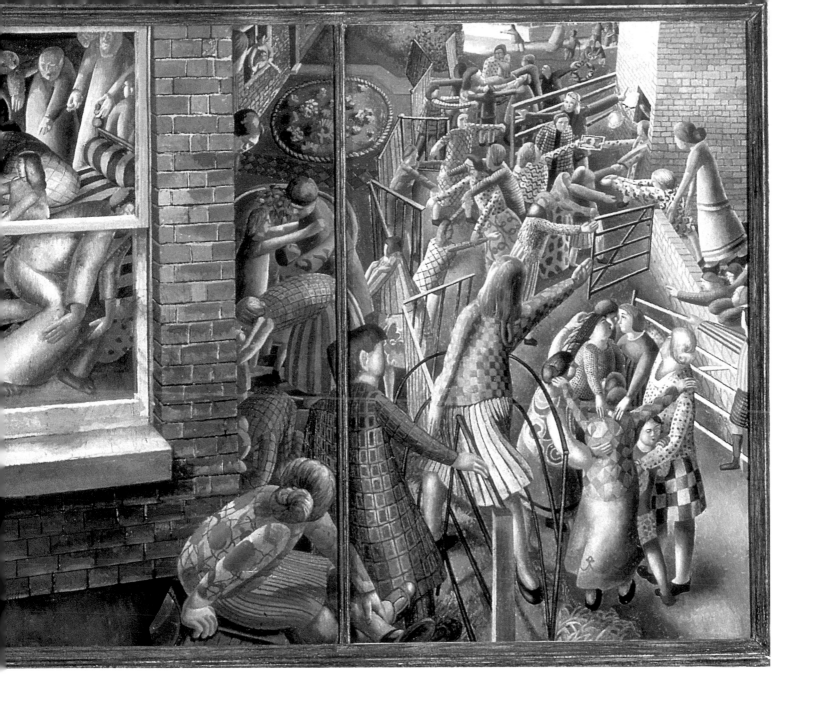

KEY ELEMENT

MIRACLES: Christ healed many people and he also brought the dead to life, as in the Raising of the Widow of Nain's Son[1] and the Raising of the Daughter of Jairus.[2] Better known is his Raising of Lazarus who had been entombed for four days in a cave with a stone at its entrance. Christ ordered the stone to be removed: at this, Lazarus came forth, bound in a shroud.[3] Christ also exorcised those possessed by the Devil – for example, the Daughter of the Woman of Canaan.[4] In the miracle of the Gadarene Swine, he cast devils out of two men into a herd of pigs which then rushed into the sea.[5]

See also page 133 [1]Luke 7:11–15 [2]Mark 5:22–24 [3]John 11:1–44
[4]Matthew 15:32–38 [5]Matthew 8:28–32

Christ in the House of Martha and Mary
Diego Velázquez (1599–1660)

In this painting of about 1618, the closely observed figures of the two women in the foreground and the still life on the kitchen table are typical of the young Velázquez's style and subject-matter. Unusually, the religious component of the composition – Christ comfortably seated in a chair, with Mary and another listener absorbed in his words – is placed in the background, and the small, bright scene glimpsed through the opening in the dark kitchen wall, seems remote and dream-like, although both the old woman's pointing finger and the curve of Martha's arm lead the viewer's eye to it. Martha's somewhat sullen expression suggests that the old woman is either stirring her to envy of her sister (Envy is often personified in art as an ugly old woman) or else conveying to her the unwelcome message that Mary was not to be deprived of her opportunity to hear Christ's teachings.

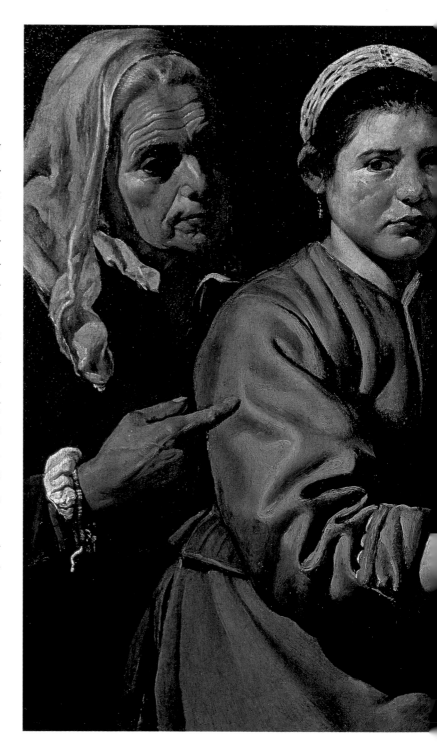

KEY ELEMENT

MARTHA: The sister of Christ's friends Mary Magdalene and Lazarus, Martha represents the practical housewife. Luke's Gospel describes how she hospitably received Christ into her house and busied herself serving him while Mary listened to his words. When she reproached him for not sending Mary to help her, Christ replied that Mary had chosen the better path.[1] Martha is usually shown either at work or

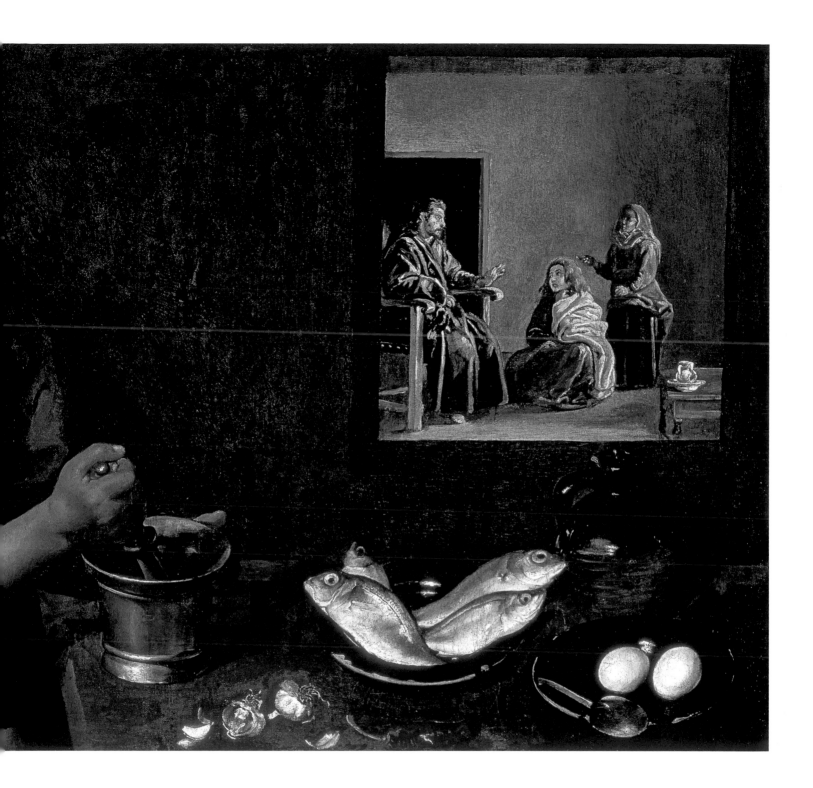

with items appropriate to her role as a housewife: perhaps a ladle and pot or a bunch of household keys. Martha, Mary, and Lazarus were later set adrift on rafts without food, but they landed safely near Marseilles.[2] At that time a ferocious dragon was terrorizing the neighboring community of Tarascon, but Martha subdued the beast with holy water and a cross.

See also box, page 135 [1]*Luke 10:38–42* [2]*Golden Legend, St. Martha*

SEE ALSO

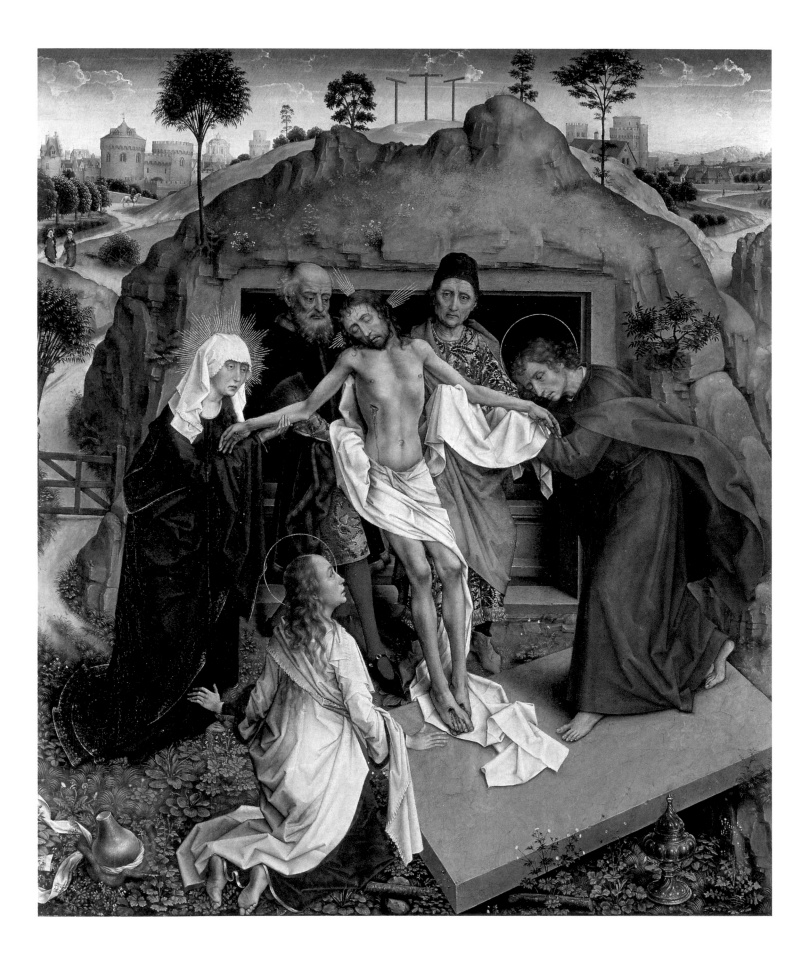

The Entombment

Rogier van der Weyden (1399/1400–1464)

Van der Weyden is believed to have painted this Entombment of Christ while visiting Italy in 1450. The painting depicts the moment between the Deposition or Descent from the Cross and the actual laying in the tomb: the mourners are the same as those shown in a Deposition scene, but the group has moved from Calvary (the three crosses are visible on the distant skyline) to the garden location of the rock-cut tomb which Joseph of Arimathea had made available for Christ's burial.

Lying on the ground, the stone slab to seal the tomb suggests an altar on which Christ is the sacrifice, with the sarcophagus itself just visible inside the tomb behind the group. Joseph of Arimathea and Nicodemus support the dead body while the Virgin and Saint John the Evangelist bend over his hands and Saint Mary Magdalene kneels in the foreground, her pot of ointment prominently placed in front of the tomb slab. The two distant figures who can be seen on the path leading to the garden gate are the other holy women coming to anoint the body for the grave.

KEY ELEMENTS

DEPOSITION AND ENTOMBMENT: In scenes of the Deposition or Descent from the Cross, Joseph of Arimathea and the Pharisee Nicodemus are present and minister to Christ. They are also seen at the Entombment, placing his wrapped and anointed body in the sepulchre. After Joseph and Nicodemus had left, Mary Magdalene and Mary, the mother of Joseph and John, remained outside the tomb keeping vigil.

JOSEPH OF ARIMATHEA: The wealthy Joseph of Arimathea was a follower of Christ and appears in the Gospels as the man who asked Pilate's permission to remove Christ's body after the Crucifixion. Joseph wrapped Christ in clean linen and laid the body in his own tomb, which had been "hewn out in the rock." He rolled a stone over the entrance and then departed.[1]

[1]Matthew 27:57–60

In the Beginning

Rose: see Angels

In European paintings **HEAVEN**, where **GOD** (see page 90) abides with the angels and saints, is often represented as a vast blue arch with stars or clouds, or a heavenly garden. It may also be indicated by gates through which divine light shines. In Nardo di Cione and Andrea Orcagna's *Paradise* (1357) Heaven consists of a huge crowd of saints and angels.

In Christian theology, **ANGELS** (see also page 83) are grouped in three hierarchical orders, each of three

The Tower of Babel

The story of the Tower of Babel has been interpreted as a means of explaining the existence of different languages and nations. The Bible states that humanity originally shared a common language, but when the Babylonians tried to build a tower in order to reach the heavens God disrupted this presumptuous project by making the workers speak in many tongues so that they might not understand each other.[1] He then scattered them abroad, so the tower was left unfinished. Pieter Bruegel the Elder painted *The Tower of Babel* as an image of the folly and overweening ambition of man.

[1]Genesis 11:1–9

Pieter Bruegel the Elder's The Tower of Babel *(detail; 1563) presents a fantastic structure not unlike the Colosseum in Rome.*

types.[1] *The Assumption of the Virgin* (*c*.1474) by Botticini, part of the *Palmieri Altarpiece*, shows the three orders of angels, each with its three ranks.

In the first hierarchy, Seraphim surround the throne of God and are often red in color; Cherubim know and worship God, and are depicted as gold or blue; and Thrones, wearing judges' robes, support his seat and represent divine justice. The second hierarchy governs the stars and the elements. It consists of Dominions, depicted with crowns, scepters or orbs; Virtues that have white lilies or red roses, themselves symbols of the Passion of Christ; and Powers, militant figures who fight ubiquitous devils. The third hierarchy maintains contact between Heaven and Earth and executes God's will. Princedoms oversee territories; archangels – the independent figures Michael, Gabriel, Raphael, and Uriel – and angels bring God's messages to humankind.

The Archangel **GABRIEL** brings news of birth. In the Old Testament he explains the visions of Daniel;[2] in the New Testament he is identified with the angel who announced the birth of John the Baptist to Zacharias, and of Christ to the Virgin Mary. Gabriel often presents the Virgin with the lily of purity, which may, therefore, be considered his attribute.

Depictions of **MICHAEL** (see also page 84) may show him as a young man with wings (often in white or in armor, with lance and shield) standing over a dragon. He was the prince of angels and the military leader who threw the Devil from Heaven. Domenico Beccafumi's *Archangel Michael and the Fall of the Rebel Angels* (*c*.1524) shows Lucifer and his cohorts vanquished by Michael and metamorphosing into demons as they tumble down to Hell.

Like the other archangels, **RAPHAEL** is often shown as a winged youth. His name means "God heals" – he acts as a guardian angel and is traditionally a protector of the young and of travelers. He served as a guide for Tobias, in whose company he is usually seen. Tobias may hold a fish and Raphael a jar containing the fish gall with which he restored Tobias' father's sight. He is shown with these attributes in Botticini's *The Three Archangels and Tobias* (pre-1470).

Lamb: see Cain and Abel

Olive Branch: see Noah

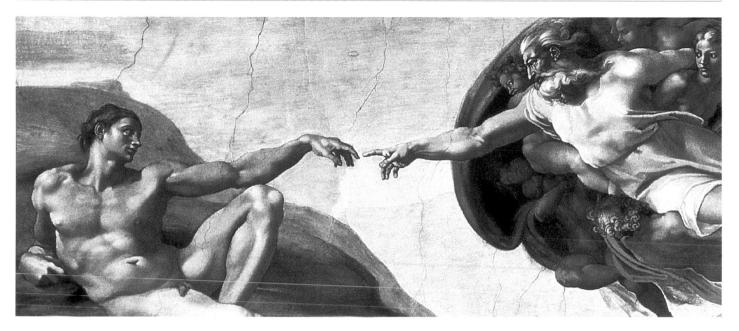

According to the Bible, the **CREATION** took seven days.[3] Michelangelo chose this story for the central section of the Sistine Chapel ceiling (Vatican, Rome) because it gave him the opportunity for dramatic narrative and potent images (see detail, above). These opening passages from Genesis were illustrated relatively rarely compared to the themes of the Creation of **ADAM AND EVE** (see page 88) and the Fall.

The sons of Adam and Eve, **CAIN AND ABEL**, both made offerings to God; but Abel's sacrificial lamb was favored above Cain's crops, and in a jealous rage Cain slew his brother. For his crime God cursed him and sent him to a land east of Eden. The Italian sculptor Lorenzo Ghiberti (1378–1455) used episodes from their story for a gilded bronze panel of the doors of the Baptistery in Florence. Titian painted a violent interpretation: *Cain Slaying Abel* (*c.*1540).

Other stories from Genesis which have been widely portrayed are those of Noah and Job. A blameless and upright man, **JOB** became the subject of an experiment devised by God and the Devil to test the strength of his faith. His afflictions were illustrated by William Blake in

Michelangelo's Creation of Adam *(detail), painted in 1510 for the ceiling of the Sistine Chapel in Rome, accompanies scenes depicting the other stages of the Creation, the Fall, and the Flood.*

1828. An Old Testament patriarch descended from Adam and Eve, **NOAH** alone won God's favor when he regretted that he had made humankind and resolved to destroy the race in a great flood. But he instructed Noah to build an ark to house his family, and a male and female of every living creature.[4] When Noah entered the ark he was in his 600th year, and he has been consistently portrayed as an elderly man with a white beard. In late medieval and Renaissance art, scenes from the story of Noah appear in cycles of the Old Testament illustrated by Ghiberti and by Michelangelo. Isolated scenes were also painted, particularly the animals entering the ark, as in Jan Brueghel the Elder's *The Entry of the Animals into Noah's Ark* (1613). The dove returning with the olive leaf, a sign of peace and reconciliation between humankind and God, was painted by John Everett Millais in *The Return of the Dove to the Ark* (1851).

Noah: see Dove (page 239), Olive (page 241)
Michael: see Satan (page 120)
Raphael: see Tobias (page 129)

[1]Pseudo Dionysius *Celestial Hierarchy* [2]Daniel 8:16
[3]Genesis 1 and 2:1–3 [4]Genesis 6:5–19

Heroes and Heroines of Israel

Throughout the Old Testament and Apocrypha there are countless stories featuring the courage, determination, and ingenuity of individual Israelite men and women. Their deeds helped to protect their fellow Israelites from persecution by oppressors, both in their homeland and abroad, and have provided artists with vivid subject matter for paintings that show heroism in its different forms.

The Philistines had ruled the Israelites for 40 years when an angel told Manoah and his wife that they would conceive a son, instructing them to name the boy **SAMSON** and warning that his hair must never be cut. Samson was endowed with great physical strength: as a youngster he slew a lion with his bare hands, and when the Philistines captured him, he killed 1,000 men with a donkey's jawbone. Samson fell in love with Delilah who, bribed by the Philistine kings, sought to discover the secret of his strength. After Samson finally revealed the truth about his hair, Delilah lulled him to sleep and called upon the Philistines to shave his head. This done, they put out his eyes, chained him and put him to work at a prison mill, where his hair began to grow again. Later, the Philistine lords brought Samson out to entertain an audience, including their five kings, placing him between the pillars of the building. Samson brought down the pillars and the building, killing himself and a multitude of Philistines.[1] He is usually represented as a muscular figure with long hair and the attribute of a broken pillar, and may be shown betrayed by Delilah. Rembrandt painted a gory image of *The Blinding of Samson* (1636); the annunciation of Samson's birth and the angel ascending in the flames of Manoah's offering were also sometimes chosen as subjects for paintings.

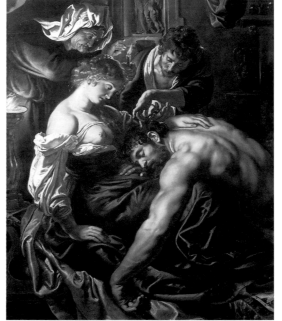

Rubens' Samson and Delilah *(detail; c.1609) shows Samson's betrayal, illustrating how even the strong can be rendered powerless by deception.*

The story of **ESTHER** shows that in the face of adversity powerful rhetoric can be as effective as physical strength. When Ahasuerus, king of Persia, dismissed his queen after she refused to appear at a feast in his sumptuous palace (which boasted marble pillars and beds of gold and silver), he chose Esther as his new wife. Esther had been brought up by her cousin, Mordecai, who told her to keep the secret of their Jewish faith.[2] Mordecai soon discovered that the king's favorite attendant, Haman, had obtained permission to kill all the Jews, so he sat outside the king's gate until he could warn Esther of their impending fate. The penalty for entering the inner court for an unsolicited audience with the king was death, but Esther dared to do so. When the king lowered his scepter as a sign of acceptance, she invited him to a banquet where she made an impassioned speech on behalf of the Jews. As a result, Haman was hanged, Mordecai received high office and wealth, and the enemies of the Jews were put to death.[3]

Esther is shown both as a richly dressed queen and as an example of virtuous womanhood; Veronese used her story to depict sumptuous costumes and settings.

Less opulent than Esther, but blessed with great loyalty and determination, **RUTH** was a non-Jew from the land of Moab, but married into a Jewish family. After her husband and father-in-law died, she accompanied her mother-in-law, Naomi, to Bethlehem, steadfastly refusing to abandon her.[4] Ruth asked the Israelite Boaz if she might glean in his fields, and he told his reapers to leave her extra corn. Poussin used the scene to illustrate summer in *The Meeting Between Ruth and Boaz* (1660–64). Eventually, they married, and the line of David evolved from their union.

Sparrow: see Tobias

In the Apocrypha, **TOBIAS** was the son of Tobit, who lived in the Assyrian capital of Nineveh and defied the law by helping his fellow Jews in exile. One night Tobit gave a Jew a proper burial. Afterwards, as he slept, sparrow droppings fell into his eyes and blinded him.[5] Fearing death, he sent Tobias to get the money he had left in Media – accompanied by the Archangel Raphael in disguise and his dog. When Tobias went to wash in the River Tigris, "a fish leaped out ... and would have devoured him;" Raphael told Tobias to catch the fish and conserve the heart, liver, and gall. Arriving at the house of his cousin Raguel and Raguel's daughter Sarah, Tobias burned the heart and liver, banishing the demon that had caused the death of Sarah's seven previous husbands. Raphael brought the money, Tobias and Sarah married, and they returned to Nineveh, curing Tobit's blindness with the fish's gall.[6]

Tobias and his protector were popular subjects in fifteenth-century Florence. The archangel is often the main figure, and in *Tobias and the Angel* by a follower of Verrocchio (1460s), Raphael (with a dog and a pot containing the fish's gall) leads Tobias, who holds a fish. Rembrandt painted *The Angel Leaving Tobias* (1637).

Another apocryphal figure, **JUDITH** was seen as the female counterpart of David (the shepherd who became king of Israel). Holofernes, captain of the Assyrians, was ordered to go west with a huge army, killing anyone who did not yield to his king's command – and in Judea he prepared to make war with the people of Israel. Hearing of her people's plight, Judith bathed and put on her finest clothes and jewels, then entered the enemy's camp carrying wine and food.[7] She pretended that she had come to betray her people; seduced by her beauty, Holofernes gave a feast in her honor. Unfortunately for him, he drank too much wine, at which point Judith smote his head from his body and triumphantly bore it back to her people as the terrified Assyrians fled.[8] She was a popular subject in the

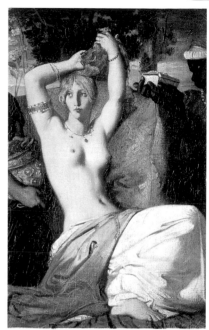

Chassériau's The Toilet of Esther *(detail; 1841) shows Esther preparing herself for her meeting with King Ahasuerus.*

Renaissance and Baroque periods; and Artemisia Gentileschi and Christofano Allori both painted famous interpretations. She is usually shown holding Holofernes's head – sometimes erotically.

Similarly bloody, the story of **JAEL** in the Book of Judges is sometimes confused with that of Judith. When Jabin, king of Canaan, ruled over the Israelites, Sisera was the captain of his armies. Jael invited Sisera into her tent, gave him drink, and let him rest, then "took a nail of the tent, and took a hammer in her hand ... and smote the nail into his temples."[9] Although not a Jew, she was seen as a heroic liberator of the Israelites.

Unlike many of the other Israelite heroes and heroines, **SUSANNAH**'s courage was in the face of sexual, rather than religious, oppression. She was married to the honorable Joachim, who often entertained two judges in his house. Lusting after Susannah, they conspired to watch her bathing in her garden.[10] When she was alone, the judges threatened to accuse her of adultery unless she lay with them; Susannah replied that she would prefer to be falsely accused than sin in the eyes of the Lord. At her ensuing trial she was condemned to death, but God sent Daniel to expose the truth, and the elders were sentenced and Susannah set free. From the Renaissance onwards, artists often painted her bathing as an opportunity to show a beautiful female nude, as in Tintoretto's *Susannah and the Elders* (1557).

Ruth: see David (pages 124–25)
Susannah: see Daniel (pages 126–27)
Tobias: see Raphael (page 118)

[1]Judges 16:1–30 [2]Esther 2:2–10 [3]Esther 7:1–10 [4]Ruth 1:16–17 [5]Apocrypha, Tobit 2:9–10 [6]ibid. 11:11–13 [7]Apocrypha, Judith 10:3–5 [8]ibid. 13 [9]Judges 4:21 [10]Apocrypha, Story of Susannah

The Virgin Mary

Western art abounds with richly varied **IMAGES OF THE VIRGIN** (see page 98) or Madonna, the mother of Christ. In certain respects the Christ Child may be seen as her attribute. She was depicted in large fresco cycles and altarpieces, as well as in small devotional works. Her popularity as a subject is partly explained by the Church doctrine that emphasized her virginity as a foil to the sin of lust. Mary's virginity may be reflected in a symbolic walled garden, the *Hortus Conclusus*, presented as an example for saints and martyrs. She may be seen standing on a serpent or dragon, whereby she vanquishes sin. The **SACRA CONVERSAZIONE**, or "holy conversation," is a type of devotional altarpiece that was developed *c.*1440, in which various saints flank the Madonna and Child, with the Madonna often shown enthroned, in the same pictorial space, rather than in separate panels. An example is Domenico Veneziano's *Saint Lucy Altarpiece* or *Madonna and Child with Saints* (1445). In the early 1700s Pope Paul V proclaimed a new interpretation of Mary, derived from the Book of Revelation: "And there appeared a great wonder in heaven; a woman clothed with the Sun, and the Moon under her feet, and upon her head a crown of 12 stars."[1] This became a highly popular devotional image, especially with the Jesuits.

The Virgin was believed to have important powers of intercession, which partly accounts for the popularity of her image and for the number of churches dedicated to her. She may be present with Saint John the Baptist in the Last Judgment, and in private commissions the donors may be shown being presented to her by saints. She was also a protector: artists painted her in thanksgiving for deliverance from the plague or after a military victory, and she is sometimes depicted as the Virgin of Mercy opening her cloak, under which the

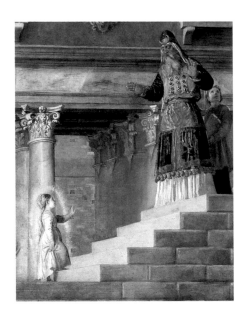

In The Presentation of the Virgin in the Temple *(detail; c.1538) Titian depicts the child Mary as a tiny, yet intrepid, figure.*

chosen or faithful can shelter. This image was often painted for lay confraternities of *misericordia*, or compassion, which gave aid to the sick.

The **MATER DOLOROSA**, or Virgin Mourning, shows her weeping alone or over the dead body of Christ. The **SEVEN SORROWS OF THE VIRGIN** are often presented as vignettes around her grieving figure. They are: the prophecy of Simeon that "This child is set for the fall and rising again of many in Israel and for a sign that is spoken against and a sword will pierce through your own soul also;"[2] the Flight into Egypt; the Loss of the Holy Child in the Temple; the Meeting on the Road to Calvary; the Crucifixion; the Deposition; and the Entombment.

The **PIETA** developed out of the Lamentation over Christ's body, and is prefigured in images of the Christ Child lying in his mother's lap, seemingly dead.

According to legend[3] Mary was born to **JOACHIM** and **ANNA** (see page 100), as a result of Immaculate Conception, which meant that she was protected from all stain of original sin. From the age of three Mary behaved like an adult, dedicating herself to prayer and weaving. She was taken to the Temple to be brought up by priests and walked up the flight of stairs to the altar unaided. She made a vow to God that she would remain a virgin, and when she was about 12 years old the perplexed priests held a council to decide how to find her a suitable spouse. Under instruction from an angel, **JOSEPH** and other suitors came to lay rods on an altar; the suitor whose rod flowered would marry her. Miraculously, Joseph's rod flowered and brought down the Holy Ghost in the form of a dove. In painting, the rejected suitors may be seen angrily breaking their rods over their knees. Joseph and Mary celebrated their betrothal, and Mary returned to her parents.

House: see Loretto

Dragon: see Images of the Virgin

Joseph appears in fresco cycles of the Life of the Virgin and Christ, and in individual scenes of the Flight into Egypt and the Holy Family. He is usually depicted as a kindly old man concerned only for his family's welfare. The idea that Joseph was an elderly man may have come from an Apocryphal Gospel which claims that he had been married previously, had six children and died aged 111.[4] His attribute is often the flowering rod.

Scenes from the Virgin's early life were illustrated in cycles of mosaics, panels, and frescoes, most notably by Giotto (Arena Chapel, Padua). Isolated scenes were also chosen, such as the *Presentation of the Virgin in the Temple* (see detail, opposite) by Titian, or the *Sposalizio* (or *Marriage of the Virgin to Joseph*; 1504) by Raphael.

The most frequently depicted scene from the Virgin's adult life is the **ANNUNCIATION** (see page 97). She may also be depicted in devotional images or in cycles of her own or Christ's life, including the Nativity, the Adoration, and the Flight into Egypt. Another scene sometimes illustrated is the **DORMITION** – in which Mary's body was placed by the Apostles in the innermost of three caves near the Mount of Olives where angels appeared with Moses, Elijah, Enoch, and Christ, and the Virgin's body and soul were carried to Paradise. At the **ASSUMPTION** of the Virgin – a popular subject, gloriously depicted by Titian (*c.*1518) – she rose to become the Queen of Heaven. This image of her in glory derives from Byzantine prototypes, where she is seen enthroned as a monumental figure. The Italian *Maestà* or Virgin and Child in Majesty, might include saints and angels shown smaller than the Virgin to reflect the hierarchy of importance; and the **CORONATION OF THE VIRGIN** (see page 102) shows Mary being received into Heaven by her divine son who crowns her as Queen of Heaven.

Other, more obscure, episodes from the Virgin's life are infrequently depicted. One story tells of Joseph bringing two midwives to Mary, only to find Christ already born. One of the midwives, Salome, doubted the miracle of the Virgin Birth and asked to examine her. When she touched Mary, her hand withered up. She repented and, touching the infant Christ, her hand was restored. Salome holds her hand over Christ in the Master of Flémalle's *Nativity* (*c.*1425); and the Virgin may be attended by the midwives in pictures of the Adoration of the Magi. Another story tells how, during the Flight into Egypt, Christ tamed the beasts of the desert and commanded the branches of a palm tree to bend down so that Mary could eat, while a stream sprang from its roots to quench her thirst. This is shown in Correggio's *Madonna della Scodella* (1530).

Later medieval legend tells of an emotional scene when Christ and his mother part. This subject was particularly popular in Germany; in Altdorfer's *Christ Taking Leave of his Mother* (*c.*1520), Saint John the Evangelist stands nearby and the Virgin faints at the moment of separation.

LORETTO, on the Adriatic coast of Italy, was a major place of pilgrimage because, according to legend, the house of the Virgin's birth was miraculously transported there from the Holy Land in 1291. Caravaggio's *Madonna of the Pilgrims* (1604–1605) was commissioned to imitate a statue known as the Madonna of Loretto. Tiepolo's *Holy House of Loretto* (*c.*1742) shows the house with the Virgin on its roof being carried through the air by angels.

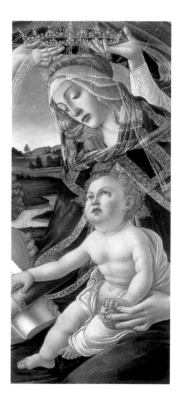

In Botticelli's Madonna of the Magnificat *(detail; 1482) Mary and the Christ Child hold a pomegranate, symbolizing the Resurrection.*

Seven Sorrows of the Virgin: see Life of Christ (pages 132–37)

[1]Revelation 12:1 [2]Luke 2:34–35 [3]Apocrypha, Gospel of Pseudo Matthew and *Golden Legend, The Birth of the Virgin*
[4]Apocrypha, History of Joseph the Carpenter

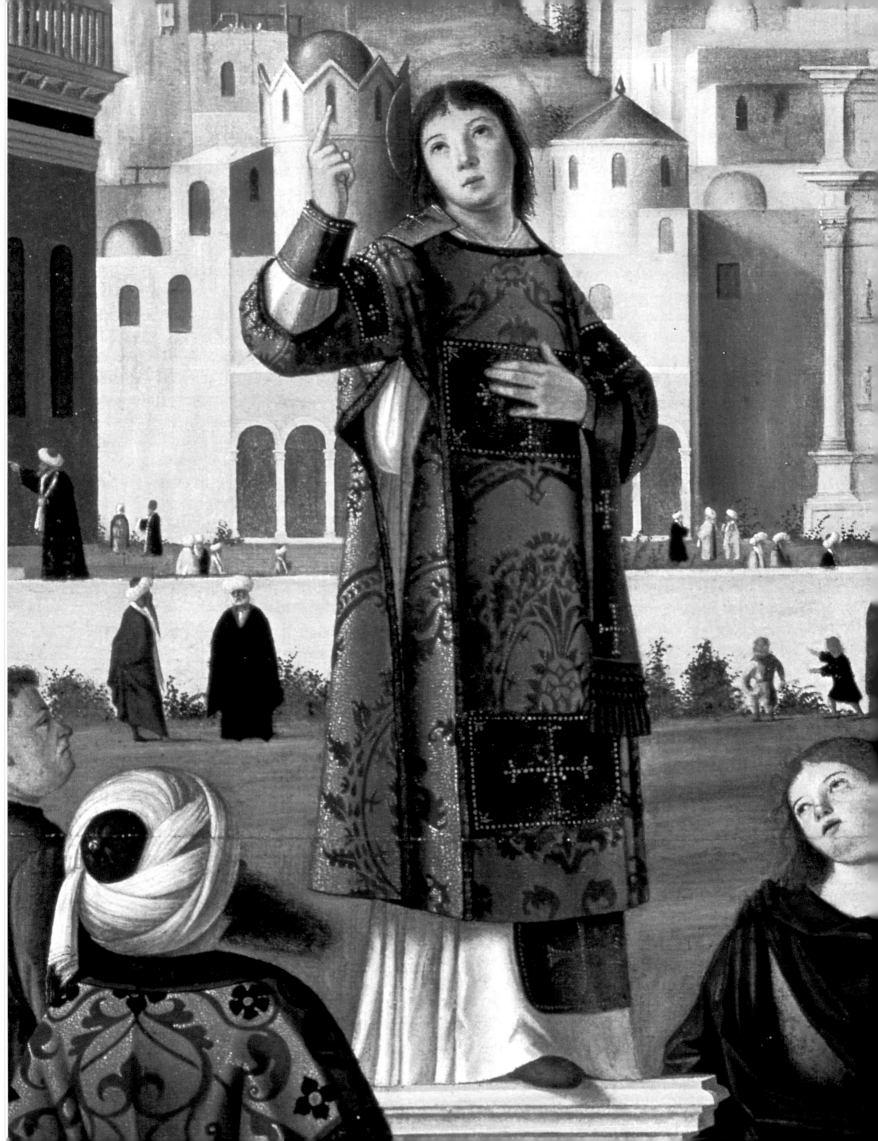

CHAPTER THREE

SAINTS AND THEIR MIRACLES

Christian art drew many of its heroes and heroines from a mid-thirteenth-century book called the *Golden Legend* by Jacobus de Voragine, which recounted the lives and deeds of the early saints. Its tales of voyages, miracles, martyrdoms, and wonder-working relics remained hugely popular for the next 300 years. But the saints who populate thousands of paintings are often confusing figures today – how, for example, did Saint Nicholas come to be the model for Father Christmas? This chapter identifies the major saints in art and gives succinct information on their lives, works, and attributes.

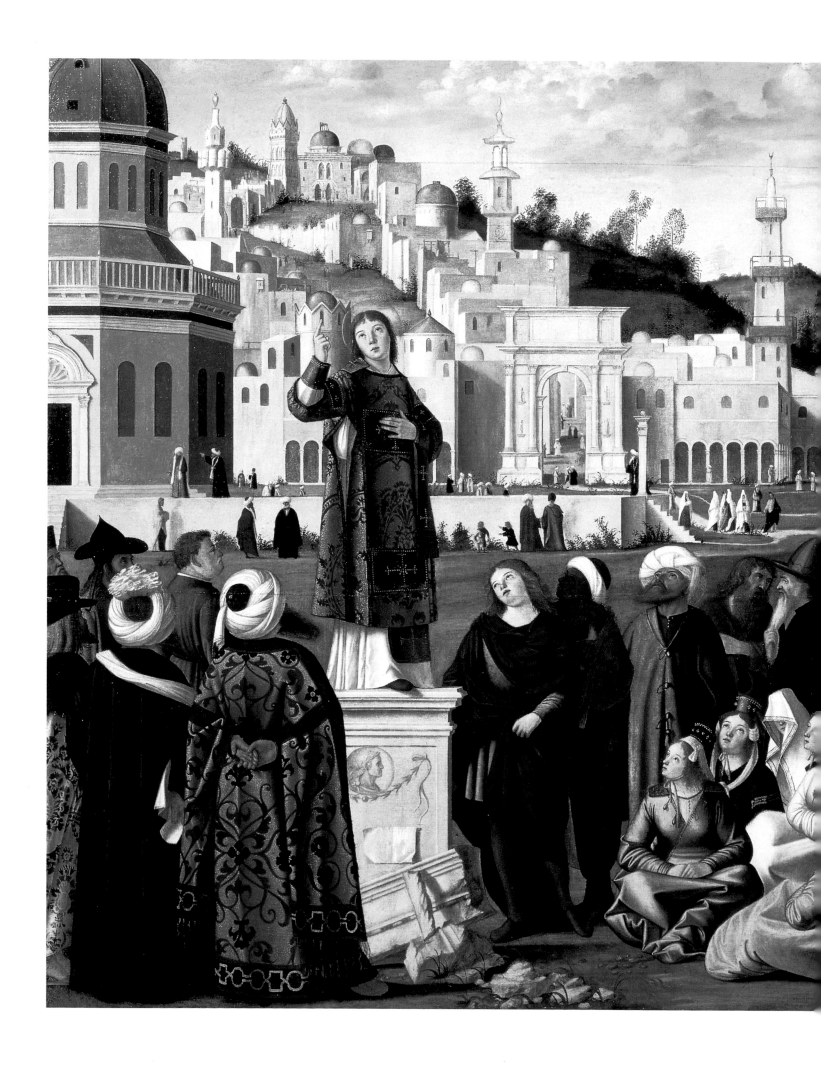

Saint Stephen Preaching
Vittore Carpaccio *(1460/65–1525/26)*

Carpaccio's cycle of paintings on the life of Saint Stephen for the Scuola di San Stefano, Venice, was begun in 1511. Carpaccio shows Stephen dressed in the robes of a contemporary deacon preaching to a gathering of attentive listeners. He stands on the base of an antique statue, symbolizing the overthrow of paganism by Christianity. The veiled figure at the back of the cluster of seated women alludes to the presentation of the synagogue in Christian allegory as a blindfolded woman, deaf and blind to the message of the Gospels; the men behind her are probably to be identified as the Jewish council members who accused Stephen of blasphemy. Behind Stephen the octagonal baptistery alludes to the imminent triumph of Christianity.

KEY ELEMENT

SAINT STEPHEN: Stephen (died *c.*35CE) was venerated as the first Christian deacon and martyr. Legend tells that when his relics were brought to Rome, they were placed in the tomb of Saint Laurence in the church dedicated to him. Apparently, when the tomb was opened, Laurence moved to make room for Stephen. In Italian and French Renaissance art, Stephen can be seen as a young deacon with his attribute of a stone, the instrument of his martyrdom. In Fra Angelico's narrative cycle in the Nicholas V chapel, Rome, he is paired with Saint Laurence.

The Maestà
Duccio di Buoninsegna (c.1260–c.1318)

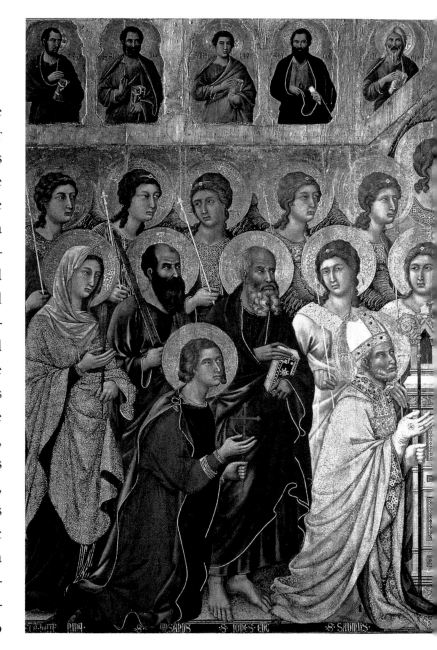

Duccio painted his great masterpiece of the Virgin in Majesty as the reredos (screen) for the high altar of Siena cathedral, where it was installed in 1311 amidst the acclaim of the city's populace. The subject of the *Maestà* – the Virgin and Child enthroned in the midst of a heavenly retinue – was very popular in thirteenth- and fourteenth-century Italy, and Duccio's renowned painting was instrumental in setting the trend. While the golden background, the formal pose of the Virgin and Child, the elaborate throne, and the full-face paintings of 10 of the 12 Apostles in the niches along the top all record the early Sienese painters' debt to their Byzantine predecessors, the grouping and individuality of the angels and saints around the throne reveal a fresher, less hieratic approach. Duccio's *Maestà* was conceived very much as an expression of civic identity: the four patron saints of Siena – Ansano, Savino, Crescenzio, and Vittore – kneel in the foreground and the Latin inscription below the throne requests the Virgin to grant peace to Siena and life to the painter.

Behind the row of kneeling saints, the second row contains three saints and two angels (nearest to the throne) on each side. The saints shown here are (from left to right) Catherine of Alexandria, Paul, John the Evangelist (to the right of the throne), John the Baptist, Peter, and Agnes, each one recognizable by his or her attribute. The 10 Apostles shown at the top of the composition are (from left to right) Jude, Simon, Philip, James the Great, Andrew (right side), Matthew, James the Less, Bartholomew, Thomas, and Matthias. Each Apostle's name appears in abbreviated form.

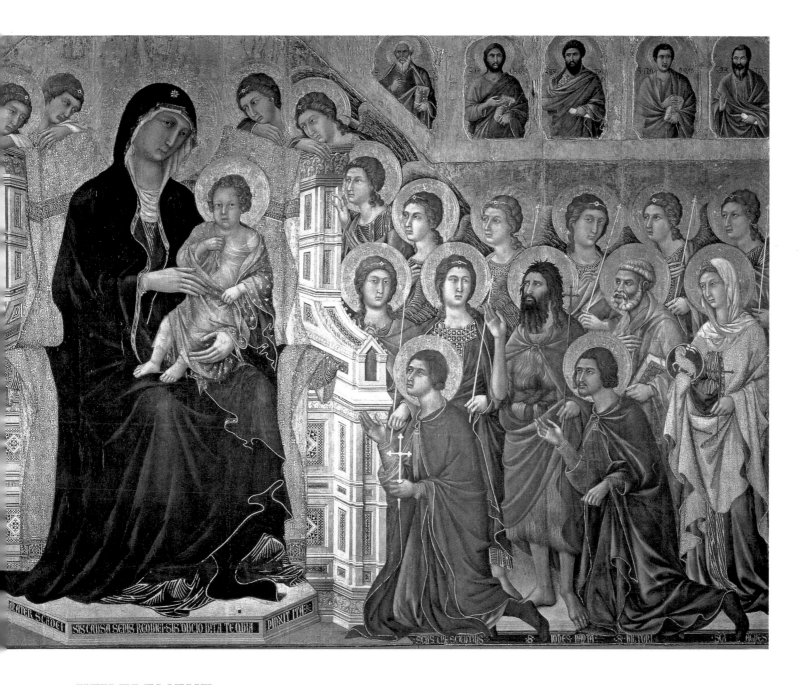

KEY ELEMENT

APOSTLES: Following Christ's Resurrection, 11 of the 12 disciples became the Apostles, or messengers of his gospel: Andrew, Bartholomew, James the Great, James the Less, John, Jude, Matthew, Peter, Philip, Simon, and Thomas. The twelfth Apostle was Matthias, who replaced Judas Iscariot. The early missionaries Paul and Barnabas may also be included in the group.

See also pages 166–69

The Raising of the Son of Theophilus
Masaccio (1401–1428) and Filippino Lippi (1457/58–1504)

Masaccio was commissioned to paint a fresco cycle depicting the life of Saint Peter for the Brancacci Chapel in the Church of Santa Maria del Carmine, Florence, in the mid-1420s. Saint Peter appears twice in this scene which combines two incidents that took place when the Apostle was on a missionary journey in Antioch: his bringing back to life of the son of the sceptical governor, Theophilus (seated in the niche on the left), and the citizens'

subsequent enthronement of Peter as their bishop. Masaccio's fresco probably included portraits of Brancacci family members among the witnesses to the miracle. However, it was reworked by Lippi in the 1480s, and many of the original figures were replaced by portraits of Lippi's own contemporaries. The bones around the kneeling boy (one of Lippi's figures) suggest that he had been dead for a long time before Peter raised him.

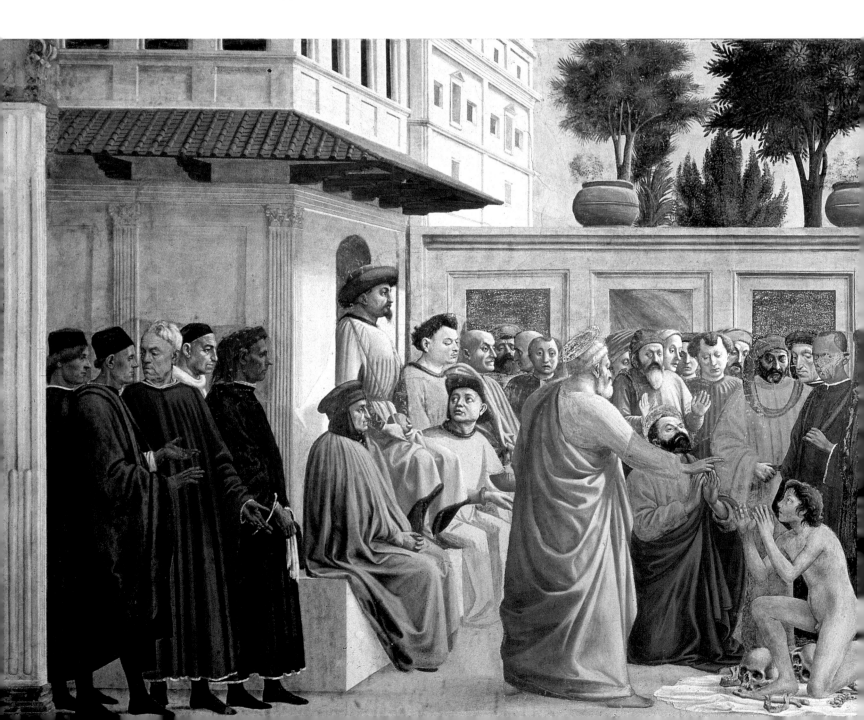

KEY ELEMENT

SAINT PETER: Peter, the Prince of the Apostles, held a unique position among the disciples of Christ, and in painting he stands in the favored place on Christ's right. His significance was demonstrated on numerous occasions in the Gospels – for example, when Christ agreed to let him walk upon the water. After the Resurrection, Christ appeared to Peter and instructed him to "feed my sheep."[1] He became missionary to the Jews, as Saint Paul was to the Gentiles, and he is considered to have been the first Bishop of Rome.

Peter is shown as a vigorous old man with curly white hair and a beard; he often wears a yellow cloak over green or blue. His usual attribute is a pair of keys.

See also box, page 168 [1]John 21:16

SEE ALSO	PAGE		PAGE
Architecture	206	Miracles	113, 133
Halo	248	Religious Orders	249

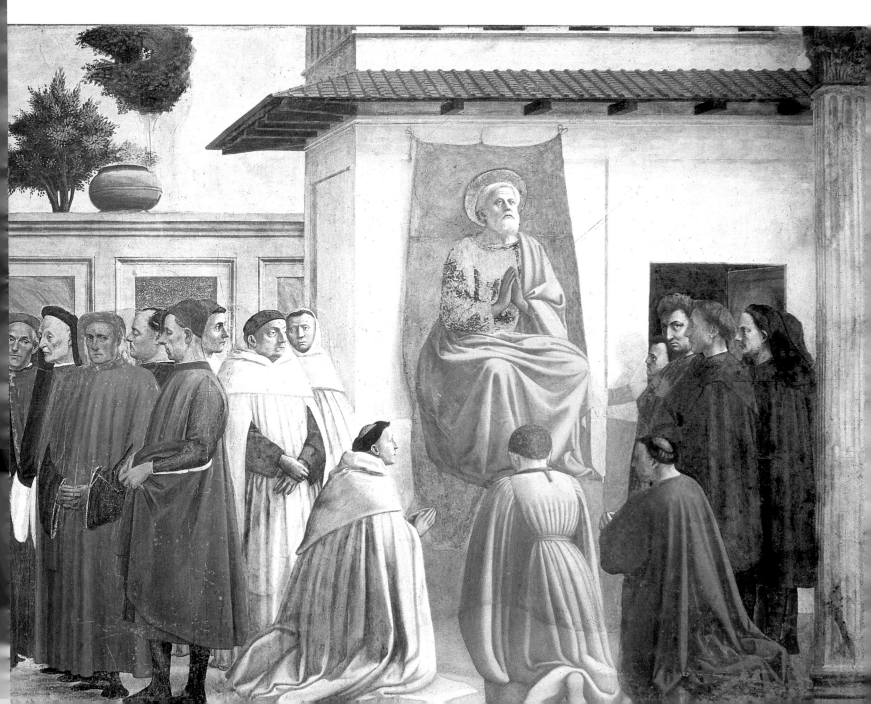

Saint Jerome and the Lion in the Monastery

Vittore Carpaccio (1460/65–1525/26)

Carpaccio painted two incidents from the legend of Saint Jerome in about 1502 as part of his decorative scheme for the Scuola di San Giorgio degli Schiavoni in Venice. This picture shows the episode in which a lion came into Saint Jerome's monastery, limping from a thorn in its foot – Carpaccio depicts it grimacing with pain, standing on three legs. The monks fled from it in panic, but Jerome welcomed the creature, healed it, and set it to performing useful tasks. The sanctity and safety of the monastery is conveyed by the presence of timid and harmless creatures such as deer and pheasant. The turbaned figures are probably an allusion to Venice's wars with the Ottoman Turks; like the savage lion, the Turks could be pacified and brought within civilized bounds by the power of the Christian faith.

KEY ELEMENT

SAINT JEROME: Jerome was one of the Latin Doctors of the Church, with Saints Ambrose, Augustine, and Gregory the Great. In the fifteenth century a popular image was that of Jerome as an old hermit in the wilderness praying in front of a crucifix or beating his breast with a stone, wearing a cardinal's hat, with a lion nearby, as shown by Cosimo Tura (died 1495).

See also page 170

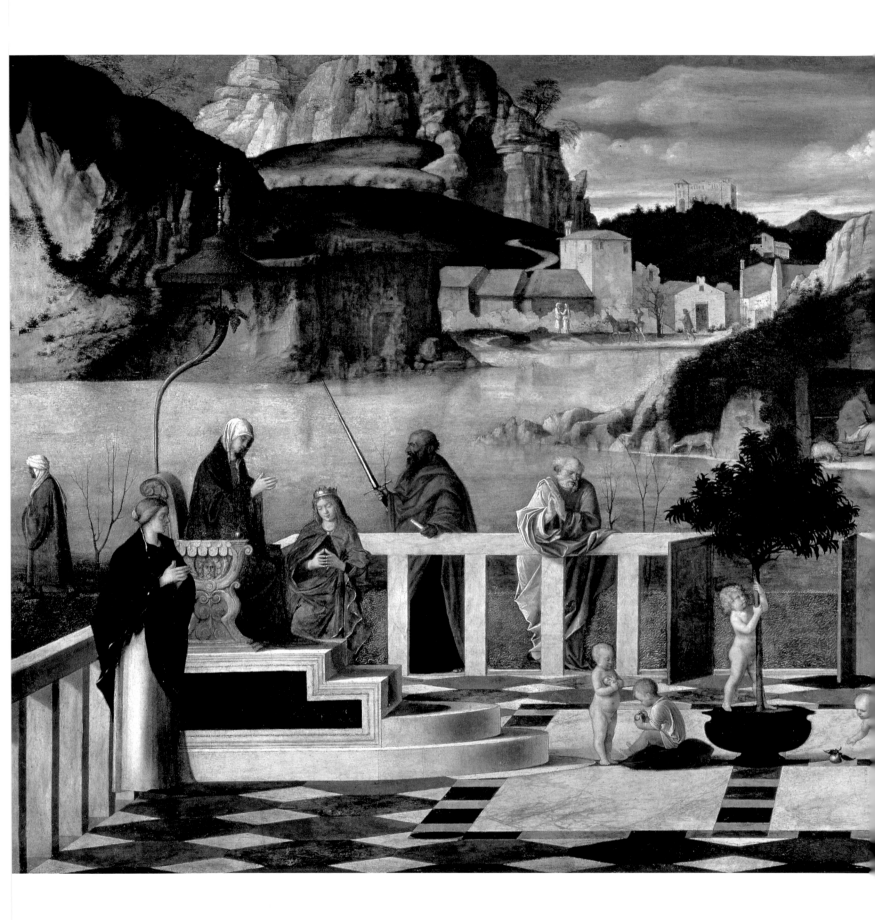

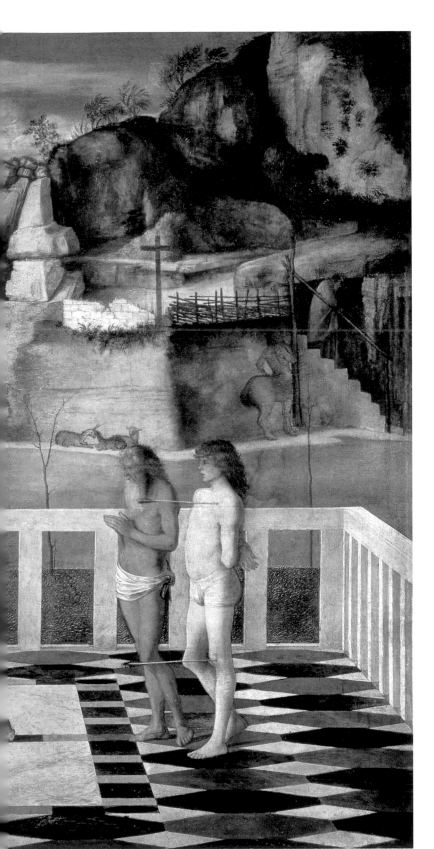

Sacred Allegory
Giovanni Bellini (c.1430–1516)

Although its true meaning is uncertain, Bellini's *Allegory* (*c.*1487) has been interpreted variously as a debate on the four daughters of God (Mercy, Truth, Justice, and Peace) or a meditation on the Redemption. The apples shaken from the tree may represent innocence before the Fall. On the left of the heavenly courtyard the Virgin sits on a throne, over which hang the Eucharistic grapes. Leaning on the balustrade are Saint Peter, and Saint Paul, who brandishes his sword at the retreating figure of a turbaned infidel. On the right stand Job, representing the righteous of the Old Testament, and Saint Sebastian, who is pierced by an arrow. Over the water Saint Anthony Abbot descends the stairs from the Cross to the centaur who directed him to Saint Paul the Hermit.

KEY ELEMENT

SAINT SEBASTIAN: According to legend, Sebastian (third century CE) was a Christian officer in the Roman Praetorian Guard who persuaded two fellow officers to die rather than renounce Christ. Sebastian was invoked against plague because at his martyrdom he survived the wounds inflicted by a large number of arrows. He is often portrayed as a handsome naked youth, riddled with arrows, looking heavenward for inspiration.

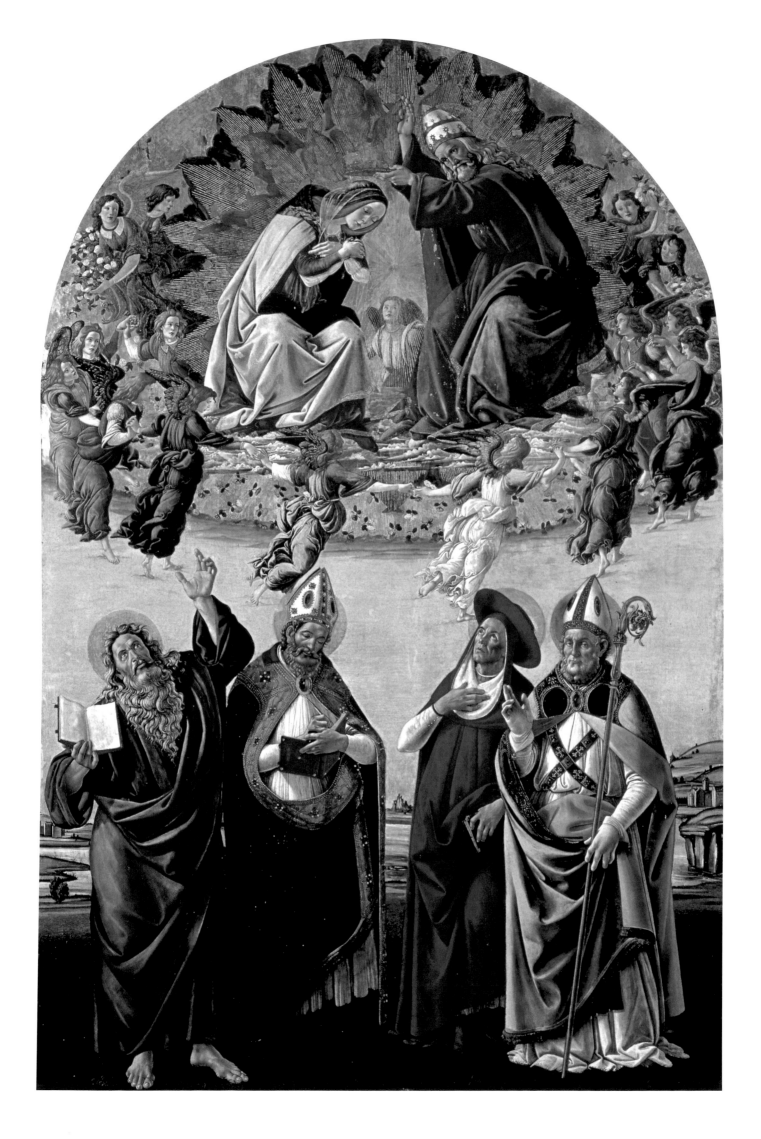

San Marco Altarpiece

Sandro Botticelli (1444/45–1510)

The Florentine goldsmiths' guild commissioned Botticelli in about 1480 to paint this altarpiece for their chapel in San Marco, dedicated to their patron Saint Eligius. The saint, dressed in bishop's robes and holding a crosier, stands on the right in the group of four saints, looking directly out of the picture with his right hand raised in blessing. By contrast, Saint John the Evangelist gestures energetically toward the scene overhead, at the same time holding up a little book with blank pages, indicating that he is about to make his prophecy of the woman crowned with stars (Revelation 12:1), which foretells the Coronation of the Virgin.

Behind these two figures stand two Fathers of the Church: Saint Augustine, also in bishop's robes, absorbed in writing in his book, and Saint Jerome, wearing the red hat and robe of a cardinal, who gazes upward with an expression of wonder. Ringed by cherubim and seraphim and dancing, rose-strewing angels, the Virgin receives her crown from God the Father, who wears the three-tiered papal mitre. The golden rays of Heaven allude to Botticelli's goldsmith patrons.

KEY ELEMENT

SAINT ELIGIUS: Eligius, or Eloi (*c.*588–660CE), the patron saint of metalworkers, was trained at a mint in Limoges and became a talented engraver. He founded a monastery at Solignac and a convent in Paris. In 641CE he became Bishop of Noyon and Tournai. His attributes are an anvil, or the tongs with which he is said to have held the Devil by the nose when the fiend visited his workshop disguised as a young woman. Nanni di Banco's sculpture of around 1411 in the niche belonging to smiths on the exterior of Orsanmichele, Florence, shows Eligius as a bishop. The relief below the sculpture depicts the legend of how he sawed the legs off a horse in order to shoe it more easily. After he had completed his work, he miraculously restored the legs to the horse's body.

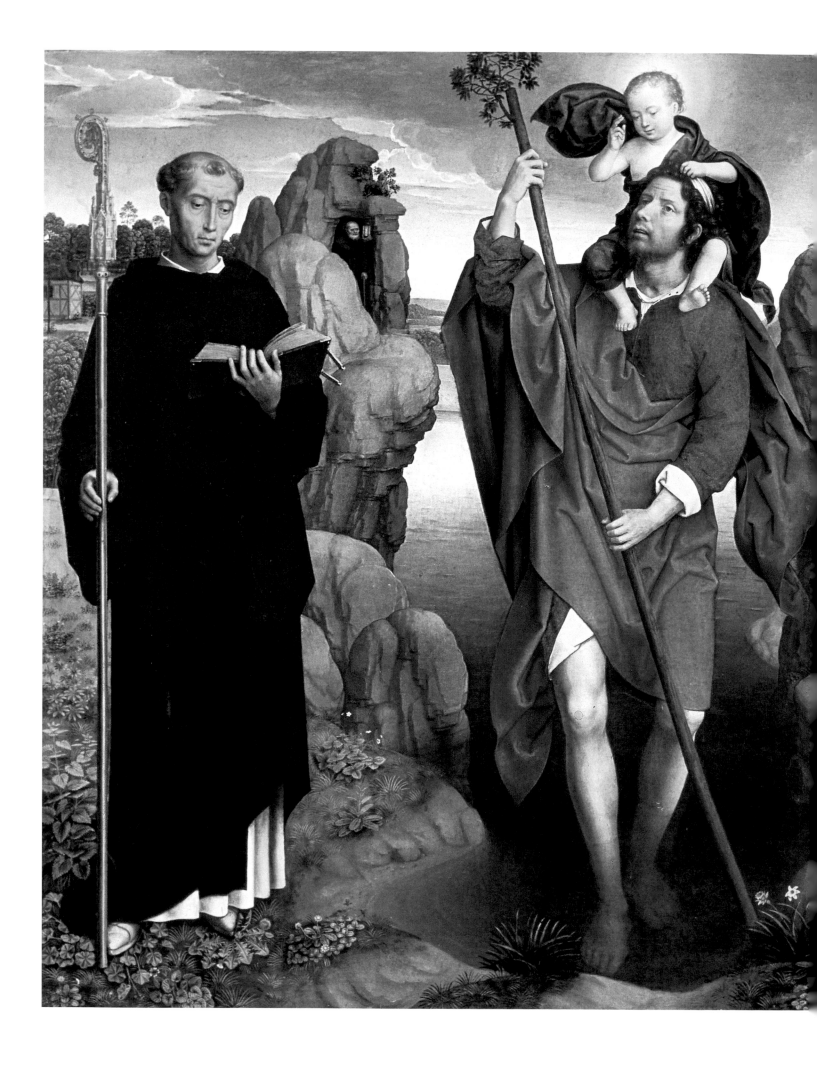

Saint Christopher
Hans Memling (c.1440–94)

In 1484 Willem Moreel commissioned a trip-tych from Memling as the altarpiece for a chantry chapel in the church of Saint James, Bruges. The central panel depicts Saint Maur (as a Benedictine monk) and Saint Giles (with a tame deer), with Christopher between them carrying the Christ Child. In a cave in the rock a hermit holds up a lantern to guide travelers over the perilous ford. The tiny Child on the saint's shoulders lifts his right hand in bless-ing. Christopher's raised eyes express his real-ization of the identity of his burden at the same moment as his staff miraculously sprouts green leaves. Memling conveys Christopher's giant stature by showing his legs underwater on a lower level than the surrounding ground.

KEY ELEMENT

SAINT CHRISTOPHER: A Canaanite of prodigious size and strength, Saint Christopher converted to Christianity in order to serve the mightiest sovereign. A hermit told him to help those who wished to cross a dangerous river. One day a child begged to be taken over the river, so Christopher lifted him onto his shoul-ders and strode into the water. The water became more and more turbulent and the child became as heavy as lead. Upon reaching the other bank the child revealed himself as Christ, who was carrying the weight of the whole world. He told Christopher to plant his staff, and the next morning it bore leaves and fruit.

See also page 176

The Heavy Stone

Spinello Aretino (c.1346–1410)

In 1387 Spinello Aretino painted a series of frescoes on the subject of the life of Saint Benedict in the sacristy of the church of San Miniato al Monte, overlooking Florence. As the founder of the West's first great monastic Order, Benedict was frequently depicted in his role of a builder of monasteries; the fresco cycle in the cloister at Monte Oliveto Maggiore, near Siena, for example, has later, more sophisticated treatments of the theme. On the basis of the legends told about him in the sixth-century *Dialogues* of Saint Gregory the Great, he also enjoyed a great reputation as a miracle-worker and exorcist.

Spinello's scene here depicts an incident in the building of Benedict's first monastery at Monte Cassino. The white-robed monks are frustrated by the heaviness of a stone they are using in the construction, because the Devil (shown in traditional style with tail, black bat-like wings, and claw-feet) is sitting on the slab, making it impossible to move. Saint Benedict raises his hand to drive off the fiend, who is shown hurrying away.

KEY ELEMENT

SAINT BENEDICT: Benedict (*c.*480–547CE)[1] was born in Umbria and sent to Rome to study, but abandoned the dissolute life of the city to become a hermit. In about 529CE he founded his Order, the first in Europe, at Monte Cassino. His reputation spread, and his advice was sought by King Totila the Ostrogoth. He was buried in the same grave as his sister, Saint Scholastica.

Little more is recorded about his life, but there are numerous legends. Benedict's nurse followed him to Rome, where she borrowed a sieve – when it broke into pieces Benedict miraculously restored it. As a hermit, he was fed by a monk who let him know whenever food had been left for him by ringing a bell on the end of a string. He asked a community to observe a stricter life, and so they apparently tried to poison him, whereupon Benedict blessed the glass containing the poison, which shattered as if struck by a stone. Maurus and Placidus were young men in his care. When Placidus fell into a fast-flowing river, Benedict enabled Maurus to rescue his friend by walking on the surface of the water, pulling him out by the hair. A malicious priest tried to feed Benedict with a poisoned loaf of bread, but the saint ordered a raven to fly off with it, and a building collapsed on the priest. Benedict threatened two nuns with prompt excommunication if they would not stop gossiping. They died a few days later without having heeded his threat, and were buried in the church. At Mass the deacon ordered all to leave who were not in communion, and the two nuns were seen to come out of their tombs and depart.

Benedict exorcized those who were possessed by the Devil and cured those inflicted with diseases. He is usually shown as elderly with a white beard. He may wear the black habit of his original Order or the white of the reformed Order. He may be seen with a raven or crow, or a broken tray.

[1]*Golden Legend, St. Benedict*

SEE ALSO	PAGE		PAGE
Halo	248	Satan	120
Religious Orders	249		

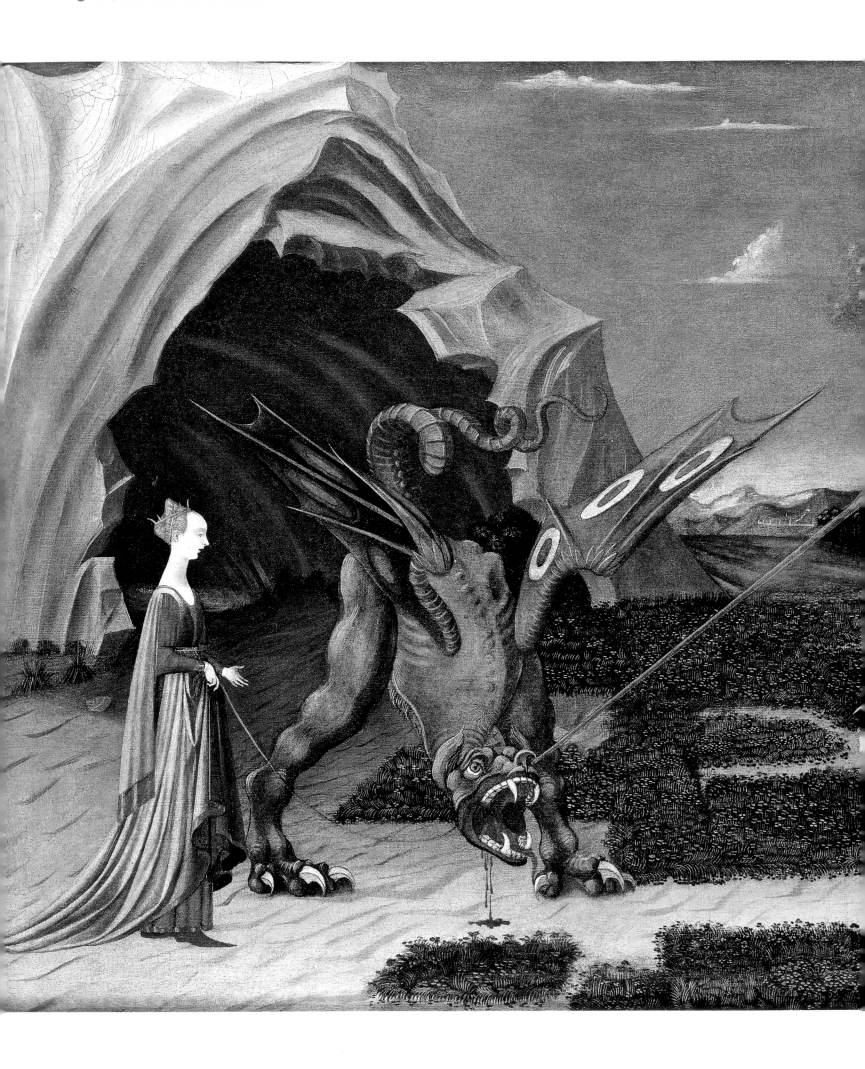

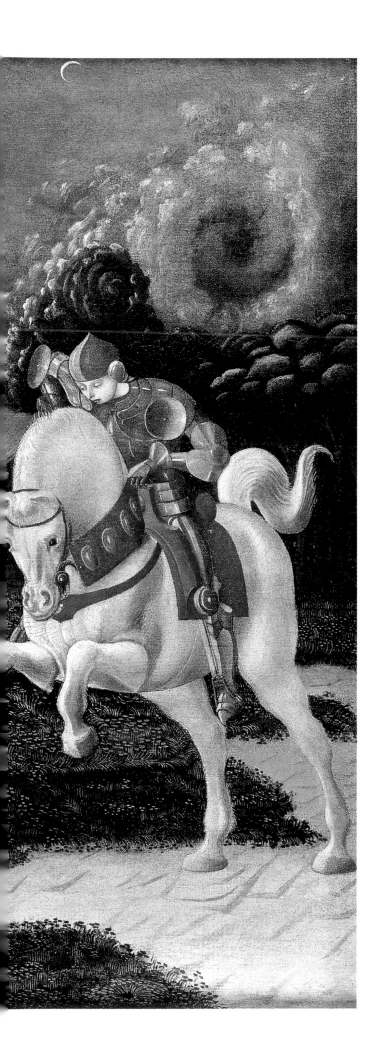

Saint George and the Dragon
Paolo Uccello (c.1397–1475)

This small oil painting probably dates from around 1460. Uccello's depiction of the legend of Saint George and the Dragon is highly decorative: the unruffled cardboard-cutout princess, dressed in the height of fashion, already seems to have the lurid green dragon well under control before Saint George comes charging in on his white horse. Contrasting with the stylized landscape and sky, Uccello's treatment of the horse reveals his trademark interest in dramatic perspective. The impression given by the carefully spaced and balanced figures is of the assured victory of the forces of good over evil, rather than of a life-or-death struggle between them.

KEY ELEMENT

SAINT GEORGE: George is said to have been martyred in Palestine in the early fourth century CE, but no historical evidence of his life exists. Carpaccio's mural cycle in the Scuola di San Giorgio, Venice (c.1505), depicts the legend[1] of George as a soldier who traveled to Libya where a dragon was terrifying the populace. When the king's daughter was chosen as an offering to appease the dragon, George, mounted on his horse and armed with the sign of the Cross, wounded the beast. The maiden's girdle was tied around the dragon's neck and she led it to the city whereupon the king and his people were baptized and George killed the dragon.

See also page 176 [1]*Golden Legend, St. George*

SEE ALSO	PAGE		PAGE
Armor	246	Landscape	242
Dragon	236		

Saint Catherine of Siena Intercedes with Christ to Release Palmerina

Girolamo di Benvenuto (1470–1542)

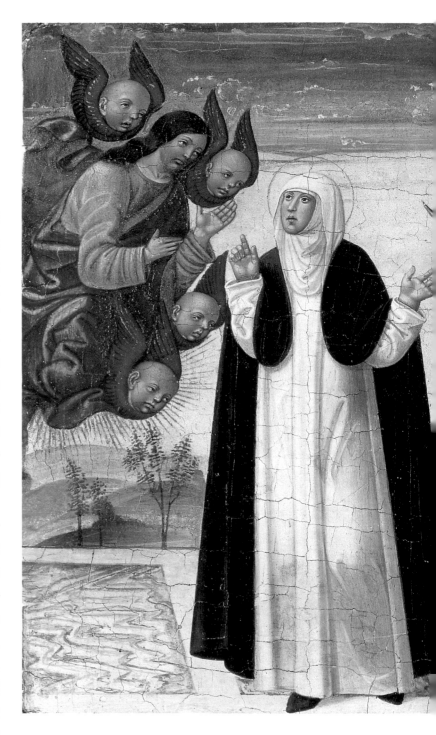

Girolamo di Benvenuto worked mainly in and around Siena, and Saint Catherine, patron saint of the city, is a frequent subject of his paintings. This small panel, the date of which is uncertain, shows an episode from her legend involving another Dominican nun called Palmerina. Despite Catherine's efforts to achieve reconciliation with her, Palmerina nursed an implacable hostility toward the saint, but when she fell mortally ill Catherine prayed that Palmerina should not be condemned to eternal punishment by dying without repenting.

The first part of the panel shows Christ, surrounded by cherubim, appearing to Catherine as she prays, and warning her that Palmerina is doomed; behind the saint is the Devil, who traditionally attended the deathbeds of the unrighteous in order to seize their souls, holding up a long scroll of Palmerina's sins. Catherine's entreaties eventually persuaded Christ not to permit Palmerina to die until she had become truly penitent, thus thwarting the Devil of his prey. The righthand scene shows Catherine and a monk attending the holy deathbed of Palmerina, who eventually made full confession of her sins and died reconciled with the saint.

KEY ELEMENT

SAINT CATHERINE OF SIENA: Catherine (*c.*1347–80) resisted her parents' attempts to make her marry, and joined the Dominican Order to tend the poor and sick. She had many mystical experiences: in one, Christ offered her a choice of two crowns, one of gold and one of thorns, and she took the latter; in another, she received the stigmata; and, like Catherine of Alexandria, she had a mystical marriage with Christ.

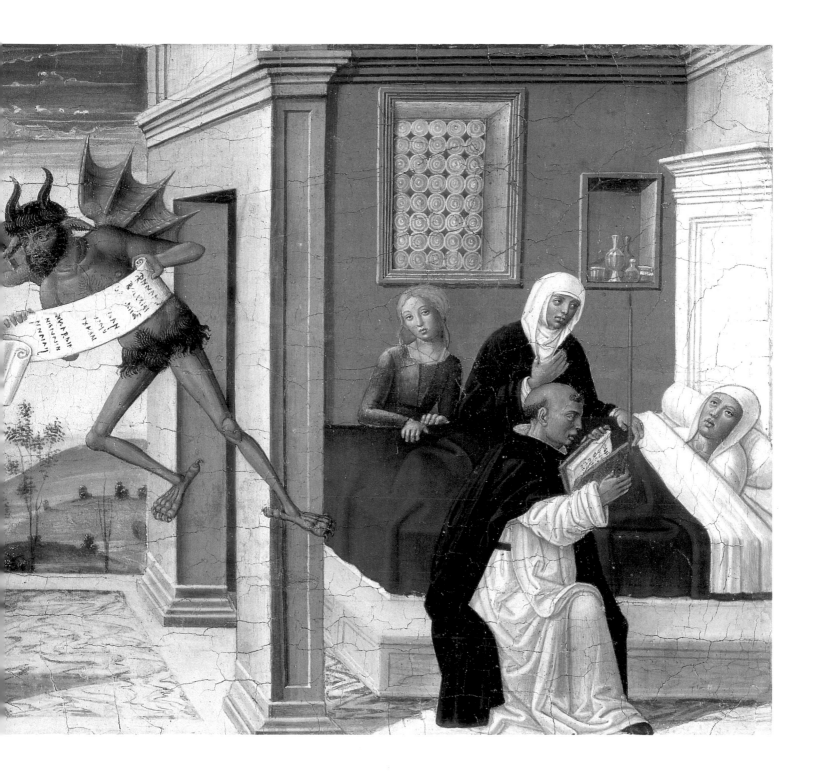

Throughout her life she worked toward the strength-ening and purification of the Papacy. Catherine is now a patron saint of Italy and most highly revered in her native city of Siena, where Domenico Beccafumi (*c.*1486–1551) painted her receiving the stigmata in a white habit, probably to reflect her purity. In other paintings she wears the black and white of her Order and may have a lily or rosary or show her stigmata.

Apostles, Disciples, and Evangelists

After the Resurrection, Christ's 12 disciples became the Apostles, or messengers of his gospel, except for Judas Iscariot (see box, below), who was replaced by Matthias. Risking their lives they are reputed to have traveled to regions as far afield as Spain and India, spreading Christ's teachings.

SAINT JAMES THE GREAT (died 44CE) was the son of Zebedee. He and his brother John were fishermen who, with Peter, were the favorite disciples of Christ. They witnessed his Transfiguration and the Agony in the Garden of Gethsemane, and they are usually shown in paintings of these scenes. According to legend, King Herod Agrippa ordered the martyrdom of James: he was decapitated by the sword.[1]

In the seventh century a legend arose claiming that James went to Spain and was a successful evangelist. This tradition is a relatively late one, but contributed to the growth of his Spanish cult; he became the patron saint of Spain. In the Middle Ages his shrine at Compostela was one of the major places of pilgrimage, where many miracles were said to have taken place; pil-grims wore his emblem, a cockle shell. Saint James is often shown as a pilgrim himself with a cockle shell on his hat or on his cloak.

James's brother, **SAINT JOHN THE EVANGELIST,** (died late first century CE) was the youngest of Christ's disciples. He appears as a young man in numerous scenes of the New Testament. John has been identified as the unnamed "disciple whom Jesus loved," who wept on his shoulder at the Last Supper, and to whom Christ entrusted the care of his mother after his death.[2] In the Acts of the Apostles, John is described preaching with Peter. They were imprisoned together, and eventually John was exiled to the island of Patmos. He is said to have spent his last years at Ephesus, where he died. Poussin painted him as an old man writing (1640), for he is traditionally held to be the author of the Fourth Gospel and the Book of Revelation.

According to legend,[3] John was returning to Ephesus at the same time as the body of his dear friend Drusiana was being carried out for burial. John ordered her bier to be set down and her body unbound; then he said,

Judas Iscariot

JUDAS ISCARIOT appears in numerous cycles of the Passion as the disciple who betrayed Christ to the chief priests for 30 pieces of silver. He sits isolated in scenes of the Last Supper. When Christ announced that he would be betrayed, Judas asked, "Is it I?", to which Christ replied, "Thou hast said."[1] While Christ prayed in the Garden of Gethsemane, and Peter, James, and John failed to keep watch, Judas brought in the priests' soldiers, and singled out his master with a kiss.[2] After Christ's trial, Judas repented, returned the 30 pieces of silver to

the priests, and hanged himself in shame.[3] He is rarely mentioned elsewhere, except to note that he was the group's treasurer.

Caravaggio's *The Taking of Christ* (1602) was one of many treatments of the Betrayal. Judas, usually unattractive, may wear a yellow cloak and his attribute may be a money bag, or the rope with which he hanged himself.

[1]Matthew 26:25 [2]Matthew 26:47–48
[3]Matthew 27:3–5

In Giotto's The Payment of Judas *(detail; c.1305) a demon (left) goads Judas into betraying Christ.*

Rope: see Judas Iscariot

"Drusiana, may my Lord Jesus Christ raise you to life! Arise, go to your house and prepare food for me!" As Filippino Lippi depicted, Drusiana rose as if from sleep and did as he ordered (*c.*1490; Strozzi Chapel, Santa Maria Novella, Florence). John's attribute is an eagle, a representation of divine inspiration, which is found in his Gospel. Also, he often holds a chalice full of snakes, alluding to the poison that he drank without feeling any ill effects. The *Ghent Altarpiece* (*c.*1430) by Jan van Eyck shows him with this attribute.

SAINT PHILIP (died *c.*80CE) appears rarely in the Gospels. He doubted that Christ could feed the 5,000 with only five loaves of bread and five fishes,[4] and he may be shown holding the loaves or in close proximity to them. At the Last Supper Philip asked Christ to "show us the Father," and Christ replied "I am in the Father and the Father in me." Philip participated in the gathering of Christ's disciples after the Ascension.[5] Details of his later life are vague: legend[6] tells of how he preached to the pagans of Scythia who put him in chains and ordered him to make a sacrifice before a statue of Mars. A dragon emerged from the base of the statue, killed the pagan priest's son and two tribunes, and made everyone else ill with its stench. Filippino Lippi illustrated Philip repelling the dragon (1503). Later Philip went to Hierapolis, where he was crucified.

Little is known of **SAINT BARTHOLOMEW**. According to one version,[7] he preached, exorcized demons, and baptized in India, then Armenia. Here he refused to worship pagan gods and was flayed alive. His attribute is the knife with which he was skinned – shown, for example, by Tiepolo (1722).

SAINT THOMAS, or "Didymus" the twin, is known for doubting the Resurrection: he declared that unless "I shall see in his hands the prints of the nails, and put my finger into the prints of the nails, and thrust my hand into his side, I will not believe." Christ instructed him to do so, and he was convinced.[8] The "Doubting Thomas"

In St. Luke Drawing a Portrait of the Virgin *(detail; c.1450) by van der Weyden, Luke sketches Mary as she feeds the Christ Child.*

theme appears in many cycles of stories following the Resurrection, as well as in paintings of the episode in isolation such as Caravaggio's vivid representation in *The Incredulity of Saint Thomas* (*c.*1601), in which Christ draws Thomas's finger to the wound in his chest.

Thomas is also said to have doubted the Assumption of the Virgin, but "suddenly the girdle that had encircled her body fell intact into his hands," and he believed.[9] In 1141 the supposed girdle was brought to the Cathedral of Prato in Tuscany, where relevant scenes were frescoed by Agnolo Gaddi in the 1390s, and Donatello and Michelozzo carved a pulpit for the chapel in which the relic is displayed.

SAINT JAMES THE LESS (died *c.*62CE), so-called in order to avoid confusion with James the Great, was referred to as "the Lord's brother" in the New Testament, and in art he may, therefore, resemble Christ. He was probably the first Bishop of Jerusalem, where the contemporary historian Josephus records that he was stoned to death. However, later legend says that he was instructed to preach about Christ from the roof of the Temple and that for this he was thrown from the roof, stoned, and clubbed to death.[10] One man snatched up a fuller's bat, used for beating cloth, aimed a heavy blow at James's head, and split his skull. James may be shown as a bishop. His attribute is a club, or a flat fuller's bat.

[1] *Golden Legend, St. James the Great* [2] John 19:25–27
[3] *Golden Legend, St. John the Evangelist* [4] John 6:5–7
[5] Acts 1:13 [6] *Golden Legend, St. Philip*

[7] *Golden Legend, St. Bartholomew* [8] John 20:25–29
[9] *Golden Legend, The Assumption of the Virgin*
[10] *Golden Legend, St. James the Less*

Paul and Peter

Paul and Peter, the most important Apostles, traveled widely to bring Christianity to the Jews and the Gentiles, and founded the Church. Images and scenes from their lives may appear paired in painting.

Before his conversion **SAINT PAUL** (died *c.*67CE) was known as Saul and was a strict Pharisee, who conspired in the persecution of Christians. On the road to Damascus he had a vision: "suddenly there shined round about him a light from heaven; and he fell to the earth and heard a voice saying unto him, 'Saul, Saul, why persecutest thou me?'"[1] He was subsequently converted and baptized as Paul. In 1621 Caravaggio painted a dramatic picture of his conversion for the church of Santa Maria del Popolo, Rome. In painting, Paul may have a high forehead and a bushy beard, and hold the sword of his martyrdom or a book, the emblem of his missionary work.

Paul had to escape from his Jewish enemies in Damascus by night and was lowered over the city wall in a basket. In Jerusalem he met Peter and the disciples and began his life as a missionary. Raphael's cartoons for tapestries for the Sistine Chapel in Rome show some episodes from the Acts of Peter and Paul. For example, Raphael shows Paul and Barnabas in Cyprus being summoned by the Roman deputy Sergius Paulus, who wished to hear the word of God. However, the sorcerer Elymas sought to prevent the encounter. Paul struck him blind and Sergius Paulus was converted.[2] In Athens Paul saw a city devoted to idolatry. He disputed daily in the market, where he encountered philosophers who took him to the tribunal in order to hear his doctrine. His sermons won over some of the crowd, including **DIONYSIUS THE AREOPAGITE**.[3] Raphael shows Dionysius's conversion in *Saint Paul Preaching at Athens* (c.1515).

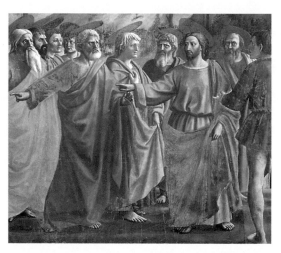

In The Tribute Money *(detail, c.1427) Masaccio places Peter (left) and Christ (right) in the forefront of discussions with the tax-gatherer (far right).*

SAINT PETER (died *c.*64CE) (see also page 147) features in some of the most dramatic episodes in the Gospels, including the Transfiguration and the Betrayal. One of the first to be called, Christ said about Peter: "upon this rock I will build my church."[4] As part of a cycle of the Life of Saint Peter, Masaccio frescoed the story of the Tribute Money (Brancacci Chapel, Santa Maria del Carmine, Florence). At Capernaum the tax-gatherer asked Peter if Christ had paid the tribute money. Christ told Peter to cast his line into the sea: the first fish he hooked would have a coin in its mouth to pay the tax.[5] During the persecutions of Herod Peter was thrown into prison. Raphael's fresco in the Stanza d'Eliodoro in the Vatican illustrates how an angel put the guards to sleep, the chains fell from Peter's hands, and he was led to freedom.[6]

Tradition claims that Peter went to Rome, where he formed the first Christian community. Legend[7] tells of how the sorcerer Simon Magus followed him, and his black arts won favor with the emperor Nero. Simon boasted that he could raise the dead and could fly from the top of a tall tower; Solimena shows him tumbling to his death (1689–90; San Paolo Maggiore, Naples). As Peter was fleeing from Rome, Christ appeared, burdened with his cross. Peter asked *Domine, quo vadis?* ("Lord, where goest thou?"), to which Christ replied "To Rome, to be crucified again." Annibale Carracci shows the surprised saint with Christ pointing the way (*c.*1600). Peter returned to Rome, where he was arrested and imprisoned. He was crucified head down at his request, to differentiate himself from Christ, and was buried in the catacombs directly below the present site of the dome of Saint Peter's.

[1]Acts 9:3–4 [2]Acts 13:6–12 [3]Acts 17:16–34 [4]Matthew 16:18–19 [5]Matthew 17:24–27 [6]Acts 12:1–12 [7]*Golden Legend, St. Peter*

Saw: see St. Simon

Scroll: see Evangelists

According to the *Golden Legend* by Jacobus de Voragine,[1] **SAINT SIMON** (known as the Zealot or the Canaanite) and **SAINT JUDE** (the patron saint of lost causes, also known as Thaddeus) were brothers of James the Less. The stories of Simon and Jude are closely related – they traveled together to Persia where they preached and performed miracles and baptisms, and both were martyred there. The instruments supposed to have inflicted their deaths became their attributes: in Simon's case a cross or a saw; in Jude's a club, halberd (axe) or lance.

Although neither of them was among the original 12 disciples, **SAINT BARNABAS** and Saint Paul (see box, opposite) came to be considered as Apostles. Barnabas preached with Paul in Antioch,[2] and was also a missionary in his native Cyprus, where he is venerated as Father of the Church and where, as Veronese shows (*c.*1556), he apparently cured the sick by laying the Gospel of Saint Matthew over them. He was said to have been either burned alive or stoned to death.[3]

As well as being subjects in their own right, the **EVANGELISTS** (the authors of the Gospels – Matthew, Mark, Luke, and John) may be depicted holding their Gospels or writing them, or they may have scrolls. Like the Doctors of the Church, they conveniently fill ecclesiastical architectural spaces or the frames or wings of paintings when four figures are required.

SAINT MARK (died *c.*74CE) traveled to Rome, where he is thought to have written his Gospel aided by Saint Peter. He then traveled to Cyprus and Alexandria, where he is said to have become the first bishop, and to have been battered and stoned to death. He is depicted as a middle-aged, dark-haired, bearded man, often shown writing his Gospel, and his attribute is the winged lion.

According to legend, Mark was once caught in a storm off the Adriatic coast and was blown onto the islands of the Venetian Lagoon; an angel appeared to him and announced that he stood on the spot where a city would rise in his honor. Some 400 years later, settlers began to drive in the foundations of Venice. In 829CE two Venetian merchants induced priests to let them secretly remove Saint Mark's relics from Alexandria; they managed to conceal them from officials under a consignment of salted pork and transported them to Venice. A basilica was built in Venice, and his relics were enclosed within a column of marble. With the passing of time their exact location was forgotten; but one day, during a fast, stones bounced out of the column and revealed the casket of the saint's relics. Mark is, therefore, particularly venerated in Venice, where scenes of his life were painted by Tintoretto and others, and the winged lion was adopted as an emblem of the city.

The Venetians popularized stories regarding the saint's miraculous interventions on behalf of those who invoked his help.[4] In one, a servant made a pilgrimage to the body of Saint Mark without asking his master's permission. Tintoretto, in his depiction of the tale (1548), shows how, when the man returned, his master wanted his eyes put out, his feet cut off, his legs broken, and his teeth smashed. He was thrown to the ground but, because he had prayed to Saint Mark, the sharp pointed sticks used to inflict his punishment broke into pieces and the iron tools melted or became blunt. Both master and servant repented.

The Evangelist **SAINT LUKE** was a physician and may have traveled with Saint Paul to Italy. Although in medieval tradition it was thought that he was martyred, he probably died of old age in Greece. Legend claims that he was a painter, who produced several portraits of the Virgin. Fifteenth- and sixteenth-century Flemish paintings by artists such as Rogier van der Weyden (see detail, page 167) show him in this role. Luke is the patron saint of painters as well as lawyers, doctors, and pharmacists. His attribute is the winged ox.

Apostles, Disciples, and Evangelists: see St. Andrew (page 148)
Evangelists: see Ezekiel (page 126), St. John the Evangelist (page 166), St. Matthew (page 141)

[1]*Golden Legend, SS Simon and Jude* [2]Acts 15:35
[3]*Golden Legend, St. Barnabas* [4]*Golden Legend, St. Mark*

Fathers of the Church

Whip: see St. Ambrose

Four particularly venerated theologians of the early Church have special status: Saints Ambrose, Jerome, Augustine, and Gregory the Great. Known as the **FOUR LATIN DOCTORS**, they may be depicted in medieval religious painting as a group, engaged in writing.

SAINT AMBROSE (died 397CE) studied law in Rome and was made prefect of Milan, the administrative center of the western Empire. He was later elected Bishop of Milan, even before he had been baptized.

A sixth-century mosaic in San Ambrogio, Milan, shows Ambrose as a middle-aged man in classical dress. However, he is more frequently seen as a bishop, as in the wings of a mid-fifteenth-century triptych by Antonio Vivarini and Giovanni d'Alemagna. He may also appear with the twin brothers, Saints Gervase and Protase, who according to legend[1] were martyred for their faith and revealed the site of their relics to Ambrose in a vision. In the early sixteenth century, Ambrogio Bergognone painted scenes from Ambrose's life, beginning with the saint as a baby in his cradle with bees buzzing over his face, without harming him, and his father predicting his illustrious future.[2] In other paintings he may have a bee hive, symbolizing his future eloquence, and a book with the words, "be nourished by food, but the food of angels not human" – an allusion to his name, since ambrosia is the food of the gods. He may also be shown holding a whip, with which he is said to have driven the Arians, a heretic sect, out of Italy.

SAINT JEROME (*c.*341–420CE) (see also page 151) dedicated much of his life to translating the Scriptures into Latin (the "Vulgate"). He may be depicted as a scholar surrounded by books in his study, a room usually furnished as it would have been in the artist's time; Antonello da Messina's depiction (*c.*1475–76) is an example. Or he may be dressed as a cardinal – although the office did not exist in his time – holding the Bible, or a model of a church to represent his status as a Doctor of the Church. Between 1502 and 1507

Carpaccio painted scenes from Jerome's life in the Scuola di San Giorgio, Venice.

SAINT AUGUSTINE (354–430CE) became Bishop of Hippo in his native Numidia, now Algeria, where he formed a monastic community. In his youth he had been impressed by Saint Ambrose, and he, in turn, became highly influential with works such as *Confessions* and *City of God*. In the church dedicated to Augustine in San Gimignano, Benozzo Gozzoli frescoed scenes from his life in Rome, Milan, and Hippo, emphasizing his scholarly nature (1465). A predella panel by Botticelli (1488; Uffizi, Florence) illustrates the legend that Augustine came across a boy trying to pour the ocean into a hole in the sand. When Augustine commented that this was impossible, the child replied, "No more so than for you to explain the mysteries on which you are meditating." Augustine often appears as a scholar reading or teaching, as a bishop, or in the black habit of his Order; he may have a flaming heart, sometimes pierced by an arrow.

SAINT GREGORY THE GREAT (*c.*540–604CE) – a remarkable administrator and a prolific writer – was elected Pope in 590CE. In the same year, a virulent plague swept through Rome. As Gregory led a procession past Hadrian's mausoleum, he had a vision of the Archangel Michael sheathing his sword to indicate that the plague would cease. A chapel was built and the mausoleum was renamed the Castel Sant'Angelo. Gregory is thought to have been concerned with liturgical music and to have established the Gregorian chant. He is usually shown as an elderly pope, often with the three other Doctors of the Church. He may have the dove of the Holy Spirit whispering in his ear to inspire his writings. Some Flemish and German paintings of the Renaissance recreate the legend of the Mass of Saint Gregory, showing Christ as the Man of Sorrows with the Instruments of his Passion appearing to Gregory above the altar as he conducted Mass.

St. Ambrose: see Bee (page 236); **St. Gregory the Great**: see Dove (box, page 239), Instruments of the Passion (page 133), Man of Sorrows (page 136)

[1] *Golden Legend*, SS Gervasius and Protasius
[2] *Golden Legend*, St. Ambrose

Female Saints of the Early Church

In the three or four centuries after the Life of Christ, Christianity spread throughout the Roman Empire, giving rise to numerous legends of martyrs, both male and female. Female saints were often chosen as subjects in art for their resolve to dedicate themselves to Christ and refuse physical love and earthly wealth despite often horrific consequences.

In the third century CE the noble **SAINT AGATHA**[1] was pursued by Quintianus, the lecherous Roman consular official in Sicily, but nothing would persuade her to give in to his demands, as her resolve was with Christ. Infuriated, Quintianus threw her in prison in Catania, tortured her, and cut off her breasts. Saint Peter appeared and restored her, but she was then rolled naked over live coals, and died in prison. Breasts are Agatha's attribute, and in paintings she is often shown carrying them on a plate. Because of their shape, she was adopted as the patron saint of bell founders.

Like Agatha, **SAINT LUCY**[2] (died c.304CE) was martyred in Sicily. Angered by her Christian faith, her suitor handed her over to the Roman Consul. When she was condemned to a brothel to be violated, she was made miraculously immovable, even by oxen. She survived being drenched in urine and oil and set alight, only to be killed by a sword thrust into her throat. Her name, implying light, explains why her attribute is a lamp. In another legend, one of her suitors ceaselessly praised her eyes, so she tore them out and sent them to him. Consequently, she may be shown with a pair of eyes on a dish. Tiepolo shows her taking her last communion (1748–50; Santi Apostoli, Venice).

Bellini's Madonna and Child with Saints *(detail; see pages 98–99) shows Lucy and Jerome with their respective attributes: a lamp and a book.*

SAINT AGNES[3] can often be identified in paintings by her attribute, a lamb, which she probably acquired because *agnus*, Latin for lamb, sounds like her name. She is generally represented as a young girl with long hair. The son of a Roman prefect fell in love with Agnes but she scorned his promise of wealth, declaring that she had become a bride of Christ. When she refused to worship the pagan goddess Vesta, the prefect had her stripped and taken nude to a brothel, but miraculously her hair grew and covered her nakedness. An angel appeared in the brothel and provided her with a cloak of heavenly light which converted everyone inside. Her executioners were burned by the flames they intended for her. A knife was finally plunged into her throat and she died aged 13. She appears as an elegant figure holding her lamb, for example in Duccio's *Maestà* (see pages 144–45). Emerantiana, her half-sister, was stoned to death and may appear with her in paintings, often with a pile of stones in her lap.

The noble and beautiful **SAINT CATHERINE OF ALEXANDRIA**[4] lived in the fourth century. She argued with Emperor Maxentius that he should cease persecuting Christians. He invited 50 masters of logic and rhetoric to challenge her and Catherine converted them all through her reasoning and faith in Christ. After repeated attempts to punish her, the Emperor constructed a wheel with iron saws and sharp-pointed nails on which Catherine was to be tortured. However, she prayed to God, and an angel shattered the wheel, which became her attribute. Scenes from her life were illustrated by Masolino in about 1420. A popular

St. Agatha: see Breast (page 245)
St. Agnes: see Lamb (page 237)
St. Lucy: see Eyes (page 244)

[1] *Golden Legend, St. Agatha* [2] *Golden Legend, St. Lucy* [3] *Golden Legend, St. Agnes* [4] *Golden Legend, St. Catherine of Alexandria*

episode not covered by Masolino was the story of her mystical marriage to Christ. Apparently, Catherine was converted by a hermit who gave her an image of the Virgin and Child. The image prompted a vision in which the Christ Child placed a ring on her finger. Veronese is one of several artists who depicted the betrothal of the richly dressed saint (*c.*1575).

Frequently pictured with Catherine as an attendant saint in paintings of the Virgin, **SAINT MARGARET OF ANTIOCH** was a Christian maiden harassed by the prefect of Antioch. After refusing to become his concubine, she was tortured and thrown into prison.[1] Here, the Devil appeared to her in the form of a hideous dragon and swallowed her up, but the power of the cross she was wearing split the dragon in two, leaving her unharmed. She was subsequently beheaded, but not before she had prayed that, just as she had been safely delivered from the dragon's belly, so healthy children would be born to all women who invoked her aid when faced with a difficult labor. She consequently became the patron saint of childbirth. A dragon is her attribute, and she may be depicted trampling it underfoot.

Part of a series on her life, Puvis de Chavannes's St. Geneviève as a Child at Prayer *(detail, 1879) shows onlookers marveling at the young girl's devotion.*

Also in Antioch, the sorcerer Cyprian (third century CE) wanted to seduce **SAINT JUSTINA OF ANTIOCH**.[2] He invoked the Devil to win her over, but three times was unsuccessful: Justina made the sign of the Cross and the Devil fled. Realizing that Christ was greater than the Devil, Cyprian was converted and baptized. Justina and Cyprian were martyred at Nicomedia and may be shown together in art. A unicorn, symbol of chastity, is Justina's attribute.

The beautiful **SAINT BARBARA**[3] was locked in a tower – possibly in Egypt in the third century CE – by her heathen father to keep her from her many suitors. She managed, however, to admit a Christian priest, disguised as a doctor, and was converted. She had a third window made in her tower to represent the divine light of the Trinity. On discovering her new faith, her father informed the authorities, who ordered him to cut off her head, but he was struck dead by a bolt of lightning before he could do so, and subsequently it became the custom to invoke Barbara against sudden death. She is depicted as a young, elegant maiden and her attribute is a tower, as seen in Memling's *Donne Triptych* (*c.*1475).

The history of **SAINT URSULA** is uncertain, but she was venerated by the early fifth century and appears in several Italian and German paintings. Legend cites her as the Christian daughter of the king of Brittany, whose hand was sought by Conon, the pagan son of the king of Anglia. She accepted on condition that he should be baptized, that she should be provided with 10 virgin companions, that the 11 of them should each have a retinue of 1,000 virgins, and that all should make a pilgrimage to Rome. Conditions were agreed and the pilgrimage undertaken. On their journey home they were besieged by the Huns who, like wolves ravaging a flock of sheep, slew them all. Their leader tried to pursuade Ursula to marry him but she refused, and he shot her with an arrow. Ursula is usually depicted as a young girl. She may be holding the martyr's palm, an arrow, a pilgrim's staff, or a white flag with the red cross of victory. She may also appear with a ship or, reflecting her royal birth, a crown or ermine-lined cloak, with which she may be protecting her numerous virgins. Scenes from the life of Saint Ursula were painted in the late Middle Ages and Renaissance, particularly in Venice and the Veneto. The most famous example of such a narrative cycle was painted by Carpaccio in around 1495; he set episodes such as the departure of the pilgrims against contemporary

Axe: see St. Cecilia

Basket of Fruit and Flowers: see St. Dorothea

Venetian Renaissance settings. In 1641 Claude Lorrain chose to paint the single scene of *Ursula's Embarkation*, probably because it provided him with a sea-port setting at dawn.

The devotion to God shown by **SAINT GENEVIEVE** (*c.*420–500CE) was noticed when she was only eight years old and tending a flock of sheep. Her prayers apparently repelled the advance on Paris of Attila the Hun. She arranged for food for the starving during the Frankish siege of Paris, and the enemy leader listened to her pleas for clemency. As a result of her efforts on behalf of the city, she became known as the patroness of Paris and may be shown holding its keys. Her story was illustrated in the 1870s by Pierre Puvis de Chavannes (originally in the Panthéon, Paris).

SAINT CECILIA[4] is said to have been a Roman noblewoman of the second or third century, who was raised as a Christian. She revealed that she was a bride of Christ to her pagan husband, Valerian, on their wedding night. Because she converted him, Cecilia and Valerian were given two crowns of permanently fragrant roses and lilies by an angel. When she refused to worship pagan gods, Cecilia was put into a boiling bath for a night and a day but remained unharmed. Three blows of the axe failed to behead her; and, lingering on the point of death for three days, she gave all her possessions to the poor. The Master of Saint Cecilia painted scenes from her life in the late thirteenth, or early fourteenth, century; 300 years later Stefano Maderno carved her lifeless body. Her attributes are musical instruments, particularly the organ, which she may be playing or holding (as in Raphael's image of her from 1514) and the lily of purity.

Like Cecilia, **SAINT CHRISTINA** is believed to have been a Roman noblewoman. Legend[5] tells of the suffering she endured for her faith, including being thrown into a lake with a millstone around her neck.

With Christ's blessing she survived until her martyrdom, when she was shot by arrows. She is venerated at Bolsena in northern Italy, which claims to have her relics. Her attribute is a millstone depicted hanging from her neck, as seen in Signorelli's *Virgin and Child with Saints* (*c.*1515).

The Roman widow **SAINT FELICITY** (died 165CE) and her seven sons refused to worship pagan idols. Felicity watched her children being put to death one by one before she was either beheaded or plunged in a vat of boiling oil. In *Saint Felicity* (1463) Neri di Bicci shows her as a matronly nun surrounded by her children, with the predella panel representing their martyrdom.

SAINT DOROTHEA[6] (died *c.*303CE) was persecuted with other Christians in Cappadocia. Two women, who had abandoned Christianity, were sent to make her recant, but instead she reconverted them, for which she was beheaded. On the way to her martyrdom a man asked her to send flowers and fruit from heaven. Miraculously, a child appeared with a basket of fruit and roses. Dorothea may appear before the Virgin and Child in a garden, with the basket, her attribute – as in an early fifteenth-century painting from the School of Gentile da Fabriano in the Ducal Palace of Urbino.

SAINT THECLA (first century CE) was said to have been converted to Christianity by Saint Paul; breaking off her engagement to a young man, she became a bride of Christ. Persecuted for her faith, she survived torture by fire and exposure to wild beasts in the amphitheater, eventually becoming a hermit. In her old age a chasm opened up to block her persecutors' path. She is honored as the first female martyr by the Greek Church although, as with many early saints, it is not certain that she existed. Churches were dedicated to her in Italy, such as the Cathedral of Este, where a painting by Tiepolo (*c.*1759) shows her interceding on behalf of the town for release from the plague.

St. Cecilia: see Lily (page 241), Musical Instruments (page 207)
St. Margaret of Antioch: see Dragon (box, page 236)

[1] *Golden Legend, St. Margaret of Antioch*
[2] *Golden Legend, St. Justina* [3] *Golden Legend, St. Barbara*
[4] *Golden Legend, St. Cecilia* [5] *Golden Legend, St. Christina*
[6] *Golden Legend, St. Dorothea*

Male Saints of the Early Church

Saint was the title given to the Apostles, the Evangelists, and the numerous martyrs who died during the Roman persecutions. Pope Alexander III (1159–81) gave the Papacy the exclusive right to canonize others, such as popes and monarchs. Both the miraculous exploits and the often hideous martyrdoms of the early saints made them popular subjects, not only during the late Middle Ages and Renaissance, but throughout the history of Western painting.

Pope Clement I (**SAINT CLEMENT**) (died *c*.101CE) is thought to have been a Bishop of Rome, but little is known of his life. While preaching, converting, and baptizing, Clement caused a riot among the pagans, and was sent to join prisoners condemned to hard labor in the Crimea; directed by a lamb, he struck the earth, whereupon a stream of water flowed out to quench the prisoners' thirst. He was thrown into the sea with an anchor tied around his neck, but the sea later receded to reveal a small temple containing his body. Scenes from his life were frescoed from the sixth century in San Clemente, Rome. Giambattista Tiepolo showed the saint as an elderly pope with tiara and triple-armed cross before a vision of the Trinity. Clement's attribute is sometimes an anchor.

Several of the early saints were members of the Roman army. These include **SAINT SEBASTIAN** (see page 155) and **SAINT LONGINUS** – the Roman centurion who pierced Christ's side at the Crucifixion and was immediately converted, saying, "Truly this was the Son of God."[1] His attribute is, therefore, the spear. The weapon is one of the relics of Saint Peter's, Rome, where Bernini's sculpture (1629–38) shows Longinus, arms outstretched, at the moment of his conversion.

According to legend,[2] **SAINT EUSTACE** (said to have died 118CE) was a general in Emperor Trajan's army. While he was out hunting he came across a stag of great size and beauty. Eustace gave chase and, when the stag came to a halt, he saw a crucifix between its antlers, shining brighter than the sun. The stag is said to have approached Eustace, commanding him to convert to Christianity. A similar story is told of Saint Hubert, with whom Eustace is sometimes confused. In *The Vision of*

Saint Eustace (*c*.1430) Pisanello shows Eustace dressed as a young nobleman, stopped in his tracks before the stag while hunting in the depths of a forest.

The noble **SAINT JULIAN** (the Hospitaller)[3] was one day hunting a stag, which turned round and foretold that Julian would kill his parents. To avert the tragedy, Julian fled. He served a prince and married a widow, whose dowry was a castle. Meanwhile his parents, searching for their son, arrived at the castle; Julian was not at home, but his wife gave them the matrimonial bed to sleep in. When Julian returned, he saw the shapes of two people in his bed. Thinking his wife had taken a lover, he unwittingly murdered his parents. To atone for his crime, Julian and his wife founded a hospice for the poor and ailing. Castagno frescoed Julian as a humble young man (1454–55; SS Annunziata, Florence), while Christofano Allori depicted his hospitality (1613). His attribute may be a stag. He is the patron saint of ferrymen, travelers, and innkeepers.

SAINT DENYS, Denis or Dionysius of Paris, is the patron saint of France, sometimes confused with the biblical Dionysius the Areopagite. Although Italian by birth, he worked as a missionary in Gaul and became Bishop of Paris. He was said to have been beheaded *c*.258CE on Montmartre (Martyrs' Hill) and to have carried his own head to his burial place, 2.5 miles (4 km) from Paris. The abbey of Saint Denys, which became the burial place of the kings of France, was built on the site. In around 1416 Henri Bellechose depicted Denys as a young bishop receiving his last communion from Christ, and later being decapitated. In altarpieces the saint may stand holding his severed head.

Legend[4] relates how in Syria the Christian twin brothers **SAINTS COSMAS AND DAMIAN** (thought to have died either *c*.287CE or *c*.303CE) learned the art of medicine and healed men, women, and animals without payment. They refused to make sacrifice to pagan gods and were tortured, bound in chains, and thrown into the sea; but an angel pulled them out and sat them before the judge who had condemned them. The twins were thrown into a huge fire, but they remained unharmed while the flames leaped out and burned the

Anchor: see St. Clement

Saint Nicholas

All that is known of **SAINT NICHOLAS** is that he was Bishop of Myra in Asia Minor during the fourth century. Various legends[1] have grown up around him, including that of a noble but poor man who was thinking of prostituting his three virgin daughters because he was unable to provide them with a dowry; Nicholas threw three golden balls or bags of gold through the window of their house while they slept and withdrew unseen, thereby saving them from their fate. Another legend tells of seamen threatened by a violent storm invoking Nicholas; he appeared, and assisted them with the rigging until the storm died down. These two stories were particularly

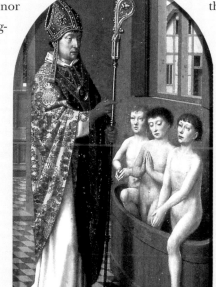

popular, as seen in Fra Angelico's predella to the *Perugia Polyptych*. He is usually painted as a bishop, and his attribute is three golden balls at his feet, as shown in Raphael's *Ansidei Madonna* (*c*.1505). He is patron saint of sailors and of children, and also the origin of Father Christmas, an identification probably derived from his patronage of children and his charitable acts of presenting gifts by night.

[1]*Golden Legend, St. Nicholas*

The right-hand panel of Gerard David's triptych The Legend of St. Nicholas *(c.1500–1510) shows Nicholas restoring three boys whom an innkeeper had killed, cut up, and salted as food for his table.*

heathens. They were then sentenced to be stoned to death, but the stones turned back and wounded the throwers; then arrows were fired at them, but the arrows turned around and pierced the archers. Cosmas and Damian – the patron saints of physicians (along with Luke) and of the Medici family of Florence – are sometimes depicted as young martyrs in doctors' robes, perhaps with a phial or other medical instruments. Scenes from their lives were painted in the predella panels of the San Marco altarpiece by Fra Angelico.

SAINT ERASMUS, Elmo or Ermo (died *c*.303CE) was thought to have been a bishop in Syria. In 1629 Poussin depicted his gruesome martyrdom, showing him lying naked on a stone slab, his vestments beside him, as brutal pagans put him to death by winding his intestines

around a windlass. The windlass became his attribute; and, because similar machines are used on board ship, Erasmus became one of the patron saints of sailors.

SAINT CHRISTOPHER (see also page 159) recruited many converts and was cruelly tortured because of his faith. At one time 400 bowmen shot arrows at him but not a single one touched him; suddenly one turned back and struck his persecutor, the king of Lycia, in the eye, blinding him. Christopher was beheaded, but he had foretold that his blood would restore the tyrant's sight, and when this came true the king was converted to Christianity.

It is known that **SAINT LAURENCE** (Lorenzo) was a deacon and that he was martyred in Rome in 258CE. Legend[5] claims that he was entrusted by Pope Sixtus II

St. Denys: see Dionysius the Areopagite (box, page 168)
St. Eustace/St. Julian: see Stag (page 237)
St. Longinus: see Crucifixion (pages 106 and 134)

[1]Matthew 27:54 [2]*Golden Legend, St. Eustace*
[3]*Golden Legend, St. Julian* [4]*Golden Legend, SS Cosmas and Damian*
[5]*Golden Legend, St. Laurence*

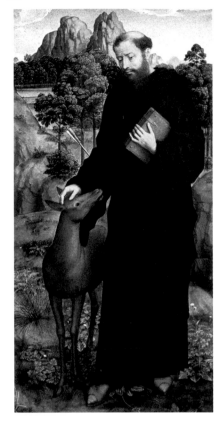

This detail from Memling's St. Christopher *(see pages 158–59) shows St Giles with his attributes: a deer and an arrow.*

with the Church's treasure, which he then distributed among the poor. When Laurence was ordered by the prefect of Rome to bring the treasure, he gathered together all the poor and sick before the prefect and, gesturing to them, said, "See here the eternal treasure, which never diminishes but increases." Laurence was killed by being laid on an iron grid above roasting coals. The martyrdom is shown in Bronzino's painting of 1569. Scenes from his life were also painted by Fra Angelico in the Chapel of Nicholas V in the Vatican. Laurence was one of the patron saints of Florence and of the Medicis; he appears in many paintings commissioned by the family. He is usually seen dressed as a deacon with a censer, or he may be shown holding a plate of coins in reference to the alms he distributed. His most common attribute, however, is the gridiron of his martyrdom.

Little is known of the lives of **SAINTS CRISPIN AND CRISPINIAN** – two brothers who were being venerated in France by the sixth century. Shoemakers by trade, they apparently came from Rome in the third century CE to preach at Soissons until they were martyred for their faith by being beaten, boiled in oil, and flayed. In a fresco painting of the late fourteenth century in the Oratorio di San Stefano by Lentate sul Seveso they are seen as young laymen. They are the patron saints of leather workers and their attribute is a shoe or a shoemaker's model of a foot.

A nobleman of Siena, **SAINT ANSANUS** (died c.304CE) was brought up as a Christian by his nurse, and was openly preaching the faith by the age of 19, in spite of persecutions under Emperor Diocletian. He was whipped, thrown into a pot of boiling oil and finally beheaded. A patron saint of Siena, he appears as a young man with a banner and a cross, primarily in the art of that school. With Saint Margaret, his image by Lippo Memmi flanks the altarpiece of Simone Martini's *Annunciation* (1333), which was originally intended for the chapel dedicated to Ansanus in the Cathedral of Siena, and is now in the Uffizi, Florence.

According to legend,[1] **SAINT ANTHONY** (the Great or Abbot) (251–356CE) gave all his possessions to the poor when he was 18 years old, in order to live as a hermit in the desert near the Nile. Other hermits joined him there; hence he is often regarded as the founder of monasticism. In the desert he suffered countless torments by demons. A popular theme in art was the saint tempted by lust: Veronese painted him struggling with the Devil as a sensual female scratches his hand with her extremely long fingernails; Cézanne concentrated on the enticing voluptuous nudes. As Anthony was apparently over 100 when he died, he is depicted as a bearded old man with a crutch, wearing a hooded robe. Artists, including Pisanello, show him with a pig and a bell – alluding to the fact that monks of his Order had special dispensation to let their pigs graze freely, and that they rang handbells to attract donations.

Little historical evidence exists concerning **SAINT BLAISE** (thought to have died c.316CE). His cult spread during the eighth century, and legend[2] has it that he was Bishop of Cappadocia. He is said to have cured sick animals, and is still invoked to do so. Sano di Pietro depicted a scene in which the saint ordered a wolf to take back a pig that it had stolen from a widow. Saint Blaise also cured a boy with a fishbone stuck in his throat, and hence he is also protector against human illnesses, especially sore throats. He was tortured in various ways, notably with wool-carders' iron combs, which became his attribute; finally, he was beheaded.

SAINT GEORGE[3] (see also page 163) is best known for slaying a winged dragon – a story which represents

 Fleur-de-lys: see St. Martin

 Shoe: see SS Crispin and Crispinian

the triumph of Christianity over evil. Like Christ of the Resurrection, George may hold a white banner with a red cross. George's cult was brought to Europe by the crusaders, and in about 1348 Edward III of England adopted him as the patron of the Order of the Garter. He is the protector of England.

A young officer in the Roman army, **SAINT MARTIN OF TOURS** (*c.*315–97CE) was born in Hungary. While billeted in France, he converted to Christianity. Legend[4] relates that one bitter night Martin came upon a naked beggar and divided his own cloak in two with his sword in order to cover the man; Christ then appeared to him, which led to his baptism. He became a recluse and founded the first monastery in Gaul. Martin hid when the people of Tours sought to elect him their bishop, as he wished to continue the solitary life, but a cackling goose gave away his hiding place. Reluctantly he took up office, but continued to live outside the city walls. Scenes from his life by Simone Martini (*c.*1317) decorate the chapel dedicated to him in San Francesco, Assisi. He is particularly venerated in France. He is depicted as a bishop with the French fleur-de-lys on his cope, or occasionally with a goose, or as a soldier on horseback in the act of dividing his cloak for the beggar.

SAINT SYLVESTER[5] (died 335CE) was one of the earliest popes, elected in 313. Little is known about him for certain, but he is said to have baptized Emperor Constantine. In a dispute with 12 learned Jewish doctors about Christianity he was challenged to restore a dead bull to life. When he did so, the doctors converted. In another story he closed the throat of a dragon whose breath had killed two wise men in the Forum. In 1248, in the Chapel of San Sylvestro (Quattro Coronati, Rome), scenes of Sylvester and Constantine were frescoed as an assertion of papal primacy. Scenes from the life of Sylvester by Maso di Banco (1340) can be seen in the Bardi di Vernio Chapel, Santa

Croce, Florence. Sylvester is usually dressed as a pope; his attributes may be a chained dragon or a bull.

Born in Antioch, **SAINT JOHN CHRYSOSTOM** (*c.*347–407CE), whose name means "Mouth of Gold," was elected Archbishop of Constantinople in 398CE. One story tells how he had a child by a princess, for which he was required to pay penance by crawling on all fours like an animal; this scene was engraved by Dürer. Renowned for his eloquence, John is counted as one of the **FOUR GREEK DOCTORS** of the Eastern Church, along with Saints Athanasius, Basil, and Gregory Nazianzen. He may also appear with the four Latin Doctors of the Western Church – for example, sculpted under Bernini's *Chair of Saint Peter* (1657–66; Saint Peter's, Rome).

The Bishop of Modena, **SAINT GEMINIANUS** (fourth century CE) was a friend of Saint Ambrose and was renowned as a healer. Legend has it that he went to Constantinople to exorcize a demon from the Emperor's daughter, and so he may be shown with a demon at his feet. Attila the Hun had a vision of the saint, as a result of which he halted his attack on Modena. He was depicted by Sebastiano Mainardi as a bishop holding a model of San Gimignano, the many-towered town which adopted his name (*c.*1500; Sant' Agostino, San Gimignano).

Little is known of **SAINT GILES**, who may have been a hermit near Arles, in the south of France, some time before the ninth century CE. He was highly popular in the late Middle Ages, and over 150 churches in England were dedicated to him. The Master of Saint Giles (*c.*1500) shows the best-known episode of his life when a deer, which had been pursued by hunters, came to Giles for protection. Aiming for the deer, one of the hunters accidentally shot Giles instead. Consequently Giles became known as the patron saint of cripples. The deer is his attribute; he may also be shown with an arrow in his arm.

St. Giles: see Stag (page 237)
St. John Chrysostom: see Four Latin Doctors (page 170)
St. Sylvester: see Bull (page 236), Dragon (page 236)

[1]*Golden Legend, SS Anthony and Paul the Hermit*
[2]*Golden Legend, St. Blaise* [3]*Golden Legend, St. George*
[4]*Golden Legend, St. Martin* [5]*Golden Legend, St. Sylvester*

Later Saints and Martyrs

In the late Middle Ages many of the most influential monastic Orders were established. Their founders and most prominent members were commonly portrayed in art – often in paintings commissioned by members of their Order. Individual cities and churches also commissioned paintings of their patron or titular saint.

SAINT BERNARD OF CLAIRVAUX[1] (*c*.1090–1153) expanded and reformed the Cistercian Order – founded in 1098 by two Benedictine monks – and established a successful house at Clairvaux, in eastern France. He attacked the luxury of the clergy and the abuses of the Roman *curia*, and was a great spiritual leader who was heeded by kings of England and France. In the late fifteenth century Filippino Lippi and Perugino painted his vision of the Virgin: he appears as a young tonsured monk looking up from his lectern in the white robes of his Order. Ambrogio Bergognone shows him (*c*.1490) with a dragon chained at his feet to represent his supression of heresy.

SAINT DOMINIC[2] (*c*.1170–1221) was the founder of the Dominican Order. He appears in numerous altarpieces in chapels devoted to his Order. He wears the black-and-white robe of the Dominicans and he may hold the rosary – which it is said the Virgin presented to him in a vision – or a lily of purity. The presence of a black-and-white dog, reflecting the colors of his habit, was a reference to his position as the inquisitor of heretics: the *Domini Canis* or "Hound of the Lord." Such dogs appear in the foreground of Andrea da Firenze's fresco (*c*.1365; Spanish Chapel of Santa Maria Novella, Florence), in which Dominic appears to have sent them out to catch wolves in the same way that the Dominicans set out to convert non-believers.

SAINT FRANCIS OF ASSISI[3] (*c*.1181–1226) was the son of a wealthy merchant. He led an extravagant life until, aged about 20, after several illnesses and a military expedition, he devoted himself to God. In 1224, while praying in the hills, he received the "stigmata," the marks of the five wounds of Christ, which never left him. Francis was also renowned for an episode in which he preached to the birds.

Saint Francis is seen as a tonsured middle-aged man, wearing the brown habit of his Order, and a rope girdle with three knots representing the vows of Poverty, Chastity, and Obedience. He may be depicted barefoot holding the lily of purity or showing his stigmata. In Spanish Counter-Reformation art he is often shown at prayer. Zurbarán represents him kneeling in meditation, holding a skull (*c*.1630–32). Several panel paintings and cycles showing episodes from the life of Saint Francis are displayed in monasteries of his Order.

SAINT CLARE OF ASSISI (*c*.1194–1253) was strongly influenced by Saint Francis. Rejecting her noble family and offers of marriage, she persuaded him to place her in the care of Benedictine nuns. Later she was joined by her sister and widowed mother, and in 1212 they founded their own community. Clare's image, with scenes from her life, was painted 30 years after her death in the church of Santa Chiara, Assisi, where she appears in a grey tunic. Her attribute is the lily or a monstrance: legend claims that while besieged by the infidel she placed one or other of these outside her convent, and the enemy fled.

SAINT PETER MARTYR (1205–52) heard Saint Dominic preach and joined his Order, becoming an

St. Francis Preaching to the Birds (detail; 1296–97) is part of the 28-scene fresco cycle of the Legend of St. Francis painted by Giotto and his assistants for the church of San Francesco in Assisi.

Skull: see St. Francis of Assisi

Black-and-White Dog: see St. Dominic

outstanding preacher in his own right. He became Inquisitor-General and vigorously suppressed heresy. As Bellini shows (see detail), he was assassinated along with one of the friars who accompanied him on his way from Como to Milan.[4] His murderer later repented and became a strict Dominican. An important saint for the Dominicans, Peter Martyr wears the black-and-white habit of the Order and often has an open wound in his head, or a knife firmly planted in his skull, as depicted by Cima da Conegliano (*c.*1504).

SAINT BONAVENTURA (*c.*1221–74) studied, taught, and preached in Paris. He joined the Franciscan Order and in 1257 became its head or Minister-General. In 1273 he was made Cardinal-Bishop of Albano, but maintained a simple way of life. He wrote extensively, including a biography of Saint Francis. In about 1629 Zurbarán showed him addressing the assembly at the Council of Lyons, but he is usually seen studying, dressed as a Franciscan or a bishop; he may have a cardinal's hat.

SAINT THOMAS AQUINAS (*c.*1225–74), one of the great Doctors of the medieval Church, joined the Dominican Order in around 1244. His noble family was outraged that he chose to be a mendicant friar and had him imprisoned for a year, but this only reinforced his resolve. Released, he studied at Paris and Cologne, then devoted the rest of his life to teaching in Paris and several cities in Italy, and also to writing his *Summa Theologica* (1266–73), which became the basis of much of the Catholic doctrine. He is depicted in the Dominican habit, and his importance as a theologian is represented in the chapter house known as the Spanish

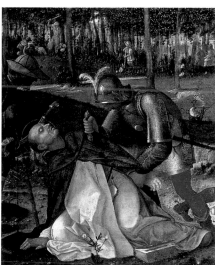

In The Assassination of St. Peter Martyr *(detail; 1509) Bellini captures the ferocity of the ambush on Peter and his retinue.*

Chapel in the Dominican church of Santa Maria Novella in Florence, painted by Andrea da Firenze in the mid-fourteenth century. He may be seen with his books and have a star on his chest, or hold a lily. Velázquez shows him supported by angels in front of a fire (*c.*1631), a reference to the episode in which he used a burning log to chase off a woman who had come to tempt him.

SAINT IGNATIUS LOYOLA (1491–1556) founded the Jesuit Order. He studied at the University of Paris, where he inspired faith in seven students who intended to become missionaries to the Moslems. Membership of the Jesuit Order grew to thousands, and missionaries were sent throughout Europe and further afield to educate non-believers and halt the spread of Protestantism. The Sacred Heart crowned with thorns, the flaming heart, and the monogram IHS, are the Jesuit emblems with which Ignatius is depicted. He wears the black habit of the Order and a biretta. He may be shown in a variety of settings – for example, as a missionary, taking his vows, studying or performing miracles.

SAINT TERESA OF AVILA (1515–82) founded the first of many convents of reformed or "discalced" (barefoot) Carmelites. Teresa frequently had mystical visions, which she recorded. In one an angel appeared: "In his hands I saw a great golden spear, and at the iron tip there appeared to be a point of fire. This he plunged into my heart several times ... and left me utterly consumed by the great love of God."[5] This divine experience was famously sculpted by Bernini (1645–52; Cornaro Chapel, Santa Maria della Vittoria, Rome).

Later Saints and Martyrs: see Christianity (pages 248–49); **St. Dominic**: see Dog (page 237), St. Catherine of Siena (pages 164–65); **St. Francis of Assisi**: see Stigmata (page 136)

[1] *Golden Legend, St. Bernard* [2] *Golden Legend, St. Dominic* [3] *Golden Legend, St. Francis* [4] *Golden Legend, St. Peter Martyr* [5] *Teresa of Avila* 29

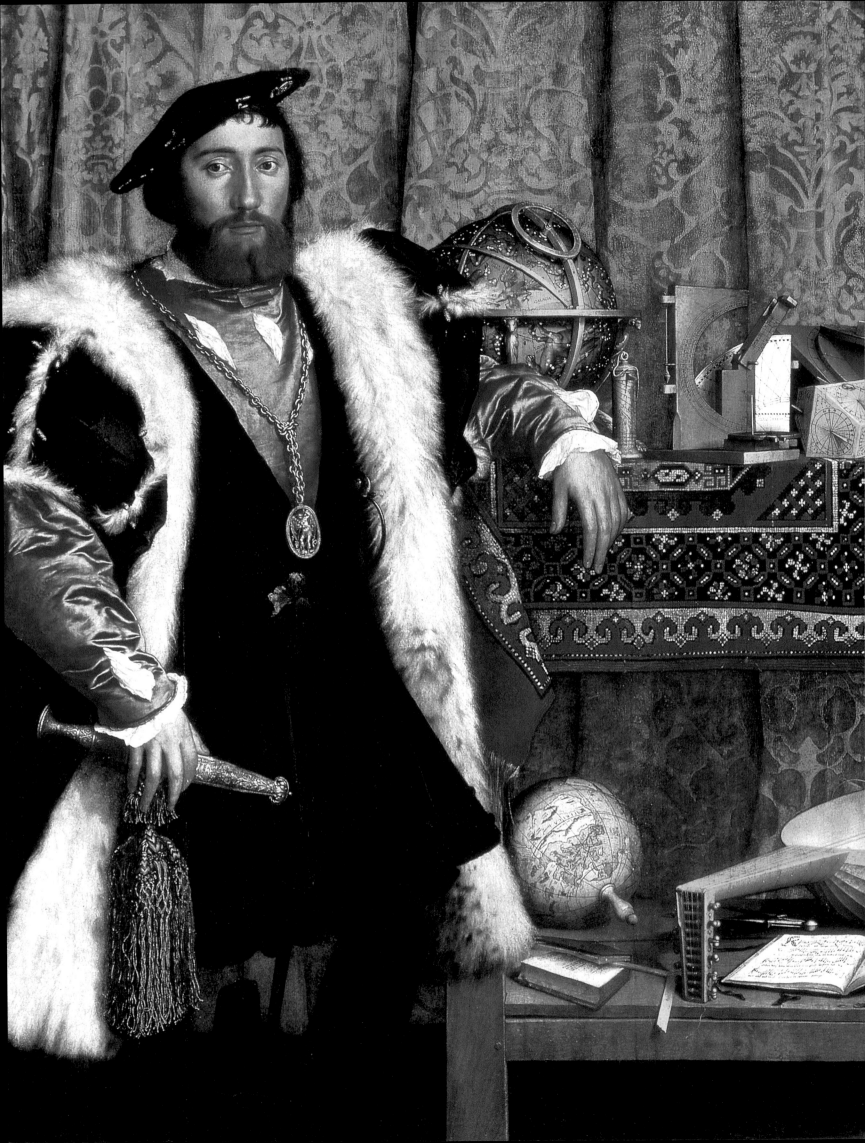

CHAPTER FOUR

HISTORY, LITERATURE, AND THE ARTS

The Classical Age produced real heroes as well as legendary ones – the soldiers, statesmen, scientists, and scholars of ancient Greece and Rome. Their achievements, and those of more recent historical figures, gave artists a rich source of subject matter. This chapter tells the stories that lie behind paintings depicting battles, scenes of victory and defeat, voyages, discoveries, and many other historic episodes. It also explores the ways in which painters and sculptors enriched their works by alluding in them to other art forms, such as literature, architecture, and music.

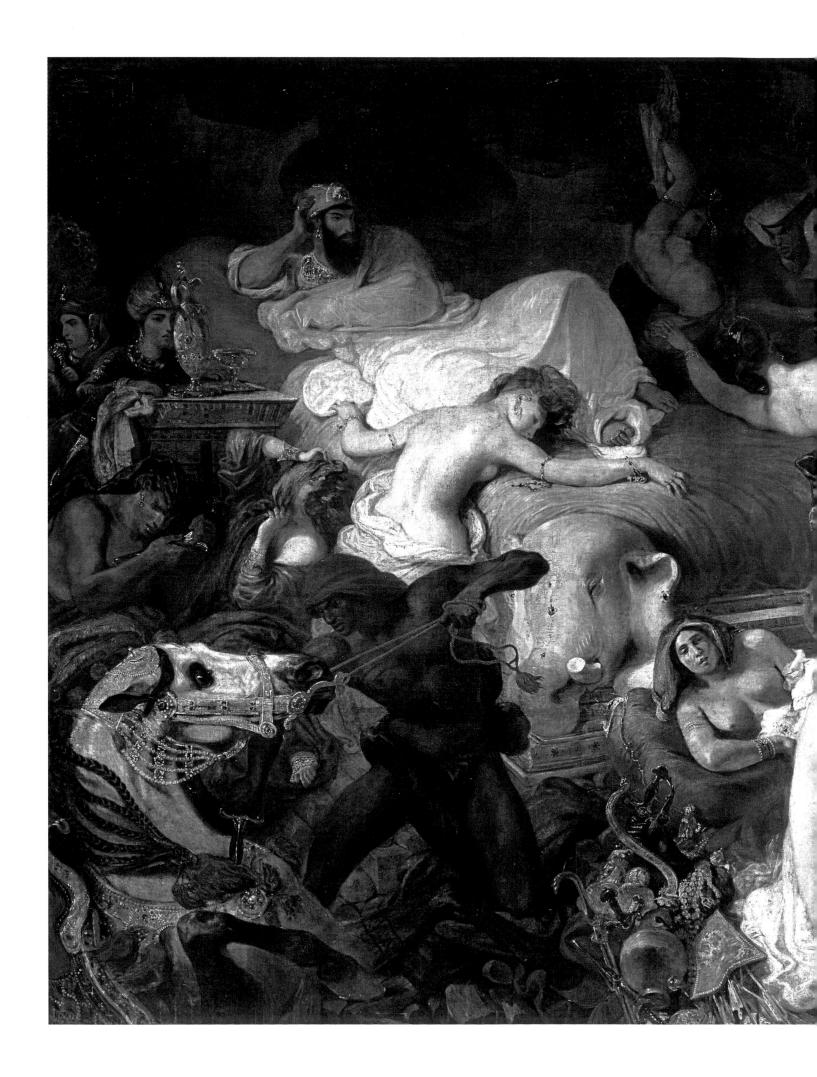

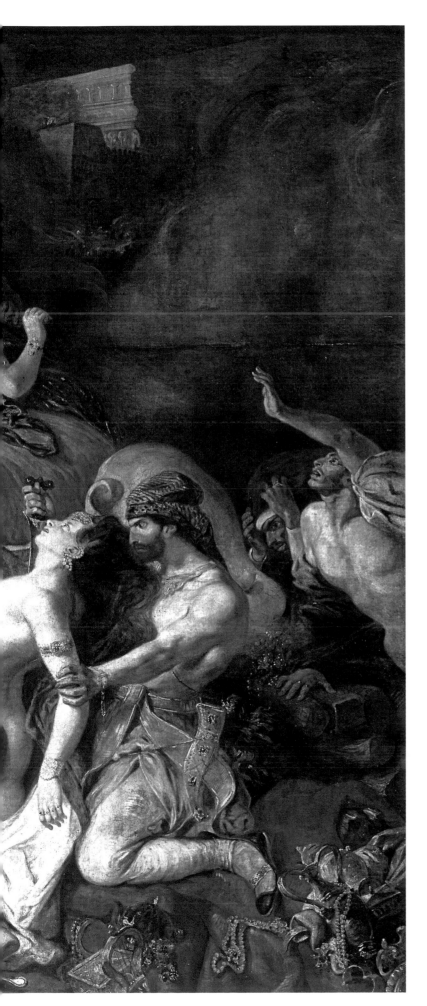

The Death of Sardanapalus
Eugène Delacroix (1798–1863)

In 1821, the poet Byron wrote a tragedy based on the tale of Sardanapalus, which inspired Delacroix to paint this large, dramatic composition six years later. As his enemies prepare to break through a broken wall, Sardanapalus reclines on his bed, contemplating a scene of carnage and confusion. Apart from the meditative king and the servant carrying the poison for his suicide, the figures writhe erotically in an orgy of violence and despair. Delacroix's painting is a landmark of the Romantic movement in early nineteenth-century France; it has dynamic energy, shimmers with gold, pearls, and precious stones and is painted with rich color, applied with a vigorous brush.

KEY ELEMENT

SARDANAPALUS: According to legend, Sardanapalus was the king of Assyria in the seventh century BCE, where he lived a life of luxury and debauchery. When he was besieged in his capital for two years by the Medes, an Indo-European tribe, he determined not to surrender and decided that the city and all its riches should be destroyed. As he prepared to take poison, Sardanapalus gave orders that his wives, his servants, and his treasures be burned with him on a huge funeral pyre, along with his favorite concubine Myrrha – who was to be given the honor of mingling her ashes with his.[1] The resulting inferno burned for 15 days.

[1] Diodorus of Sicily II:27

SEE ALSO	PAGE		PAGE
Elephant	237	Nude	223
Luxury	234		

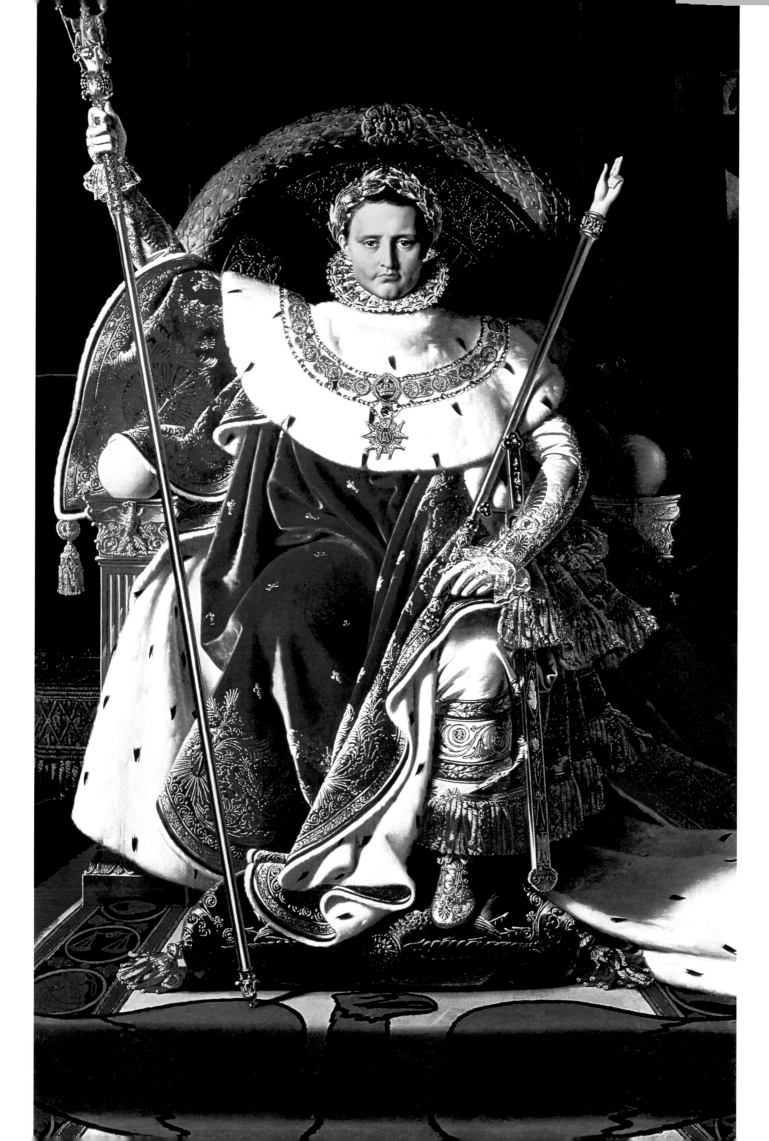

Napoleon I
Jean Auguste Dominique Ingres (1780–1867)

Napoleon sits on his imperial throne in the traditional pose of the supreme god Jupiter, whose eagle is cleverly woven into the carpet – the signs of the zodiac on the edge of the carpet refer to Jupiter's kingdom in the sky. The emperor wears full regalia and a laurel crown, and he holds a scepter, the hand of justice, and Charlemagne's sword. The image (1806) is static and iconic, and contemporaries realized that Ingres had likened the emperor both to Jupiter and to the famous figure of God the Father from Jan van Eyck's *Ghent Alterpiece* (*c.*1432), which had been brought to Paris among the looted trophies of war (the lower half of the central panel is shown on pages 86–87).

It is not known whether Napoleon commissioned this picture or whether Ingres painted it in the hope of gaining official recognition, but when exhibited it was universally criticized. The figure was not considered a true likeness of Napoleon, the painting's style was condemned as archaic, and the image of an absolute ruler was thought to be inappropriate to those who preferred to think of their emperor as a man of the people.

KEY ELEMENT

NAPOLEON I: In 1799, after the French Revolution, Napoleon achieved supreme power and instituted a military dictatorship. He ruled as emperor from 1804–1815. By 1810, he had conquered most of Europe, but his empire began to crumble after a disastrous invasion of Russia in 1812. Finally, on June 18, 1815, Napoleon was defeated at the Battle of Waterloo, when he abdicated and was exiled to the island of Saint Helena.

Napoleon's persistent determination to succeed can be seen in the art he commissioned, which was designed to assert the empire's strength and power. In *The Coronation* (1805–1807), Jacques Louis David combined elements of Italian Renaissance painting and official monarchical portraiture; he also painted *Napoleon Distributing the Eagles* (1810) and *Napoleon in His Study* (1812). Another artist who contributed to the Napoleonic myth was Antoine-Jean Gros (1771–1835), whose paintings often depicted important events in Napoleon's late military career. *Napoleon Visiting the Pesthouse at Jaffa* (1804) is a notable example of the dramatic power of his work.

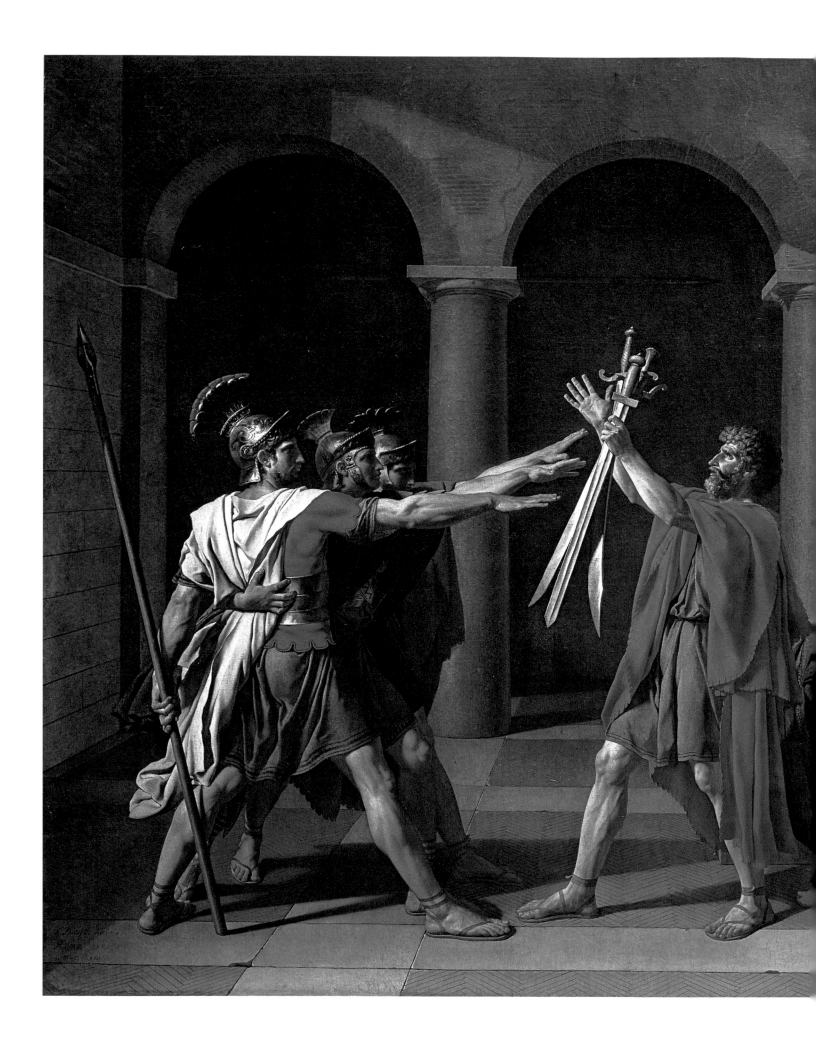

The Oath of the Horatii

Jacques Louis David (1748–1825)

David's first major work (1784) shows a scene from the tale of the Horatii brothers, who were prepared to sacrifice their lives for Rome. The story was also the subject of a tragedy by playwright Pierre Corneille, and David's painting was conceived to imitate actors on a stage. The theatrical stances of the brothers, with legs apart and arms raised, echo one another in single accord as they make their oath and their father presents them with their swords. Their taut muscles and masculine resolve contrast vividly with the emotional poses of their mother and sisters. The Crown commissioned this painting, and the heroic patriotism was intended to improve public morality.

KEY ELEMENT

HORATII AND CURIATII: Two warring families, the Roman Horatii and the Latin Curiatii of Alba,[1] each had three sons equally matched in age and strength. Their kings sought to end hostilities by suggesting that these young men fight, so both sets of brothers took an oath that the losing side would submit peacefully to the other. In combat, the first advantage fell to the Curiatii who, though wounded, killed two Horatii. The surviving Roman fled, followed by the three Curiatii, each of whom ran at a different speed – and it was thus that he managed to fight each in turn, emerging as the victor.

[1]Livy *The History of Rome* I:xxiv–xxv

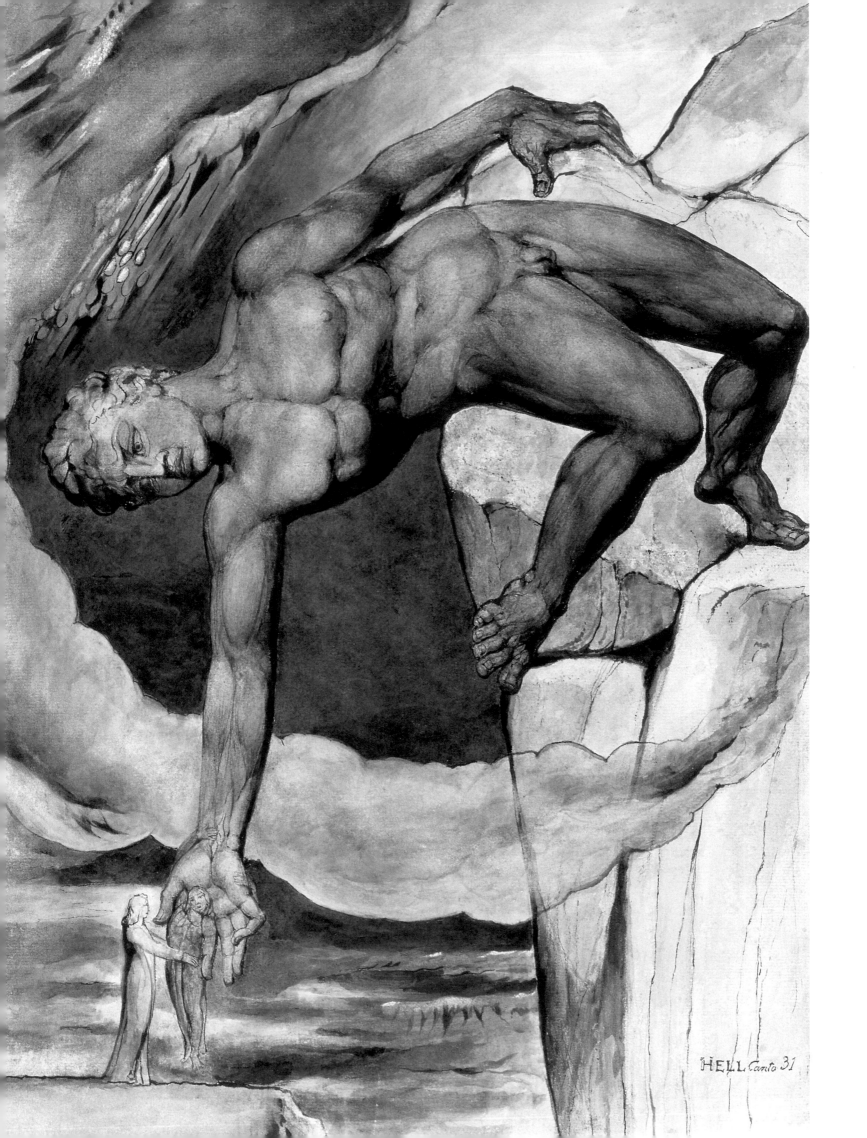

HELL Canto 31

Antaeus Setting Down Dante and Virgil in the Last Circle of Hell

William Blake (1757–1827)

Blake left several projects unfinished at his death, including a set of illustrations for Dante's *Divina Commedia*. In the poem, Virgil leads the author through Hell – described by Dante as a series of circles to which the various types of sinners are assigned. This watercolor (1821–27) illustrates *Inferno* 31:112–43 and shows Dante and Virgil reaching the last circle of Hell – the residing place of the giants whose rebellion against Jupiter represented the sin of pride. Unlike his brothers, the giant Antaeus took no part in the war. He was invincible as long as he remained in contact with his mother Earth, but was destroyed when Hercules lifted him up and squeezed him to death in mid-air. In the picture, Antaeus gently lowers the poets over the edge of an abyss, his size emphasized by the disparity of scale and his awkward pose.

KEY ELEMENT

DANTE: The Florentine writer and poet Dante Alighieri (1265–1321) was one of the founders of the modern Italian language. In *La Vita Nuova* (The New Life) of 1292, he tells of his idealized love for a girl named Beatrice, whom he first saw aged nine, dressed in a delicate crimson dress tied with a girdle. He spotted her again nine years later, walking with two women and dressed in the purest white; she greeted him, "and such was the virtue of her greeting that I seemed to experience the height of bliss."[1] Their last encounter was at a wedding feast – she died prematurely soon afterwards. Inconsolable, Dante continued to contemplate her beauty and goodness while his friends grew concerned at his grief. Rossetti translated *La Vita Nuova* and painted several of its scenes, and his *The First Anniversary of the Death of Beatrice* (1853) shows Dante drawing an angel, oblivious to the presence of others.

Dante is probably best known for his *Divina Commedia* (Divine Comedy), an epic poem describing humankind's destiny on Earth and in the afterlife. The poem has three parts: the *Inferno* (Hell), the *Purgatorio* (Purgatory) and the *Paradiso* (Paradise). The classical poet Virgil leads the author through the first two regions, while Beatrice guides him through Paradise, their journey taking the reader down through the 24 circles of Hell, up the two terraces and seven cornices of Mount Purgatory to earthly Paradise, and finally beyond the planets and the stars to God.

The *Divina Commedia* contains many political and religious allegories and references to Dante's personal experiences. It provided inspiration for numerous artists, including Botticelli. In *The Barque of Dante* (1822), Delacroix shows Dante and Virgil descending into the Underworld, while Raphael followed what is thought to be a contemporary portrait when he depicted Dante with Virgil in *Parnassus* (*c*.1510).

[1]Dante *La Vita Nuova* III:1–11

Landscape with Aeneas at Delos
Claude Lorrain (1600–1682)

The figures in Claude's painting (1672) may seem to be subordinated by his interest in the landscape, but their identity transports us to an idyllic world of antique grandeur. Aeneas sought out Apollo's oracle on the sacred island of Delos during his voyage from Troy; in this scene, the king and priest of Delos, Anius, welcomes Aeneas, his father Anchises, and his son Ascanius. Anius also points to an olive and a palm tree at the center, to which Latona clung as she gave birth to the twins Apollo and Diana. Claude shows Apollo's shrine as that noble and ancient monument of Rome, the Pantheon, where Aeneas was told that his descendants would rule over the Earth's widest bounds. The poetic composition of the scene, with its balance of horizontals and verticals, transparent air and spacious view to the far horizon, evokes the pastoral serenity of the Golden Age.

KEY ELEMENT

VIRGIL: The Roman poet Virgil (70–19BCE) was considered the prince of Latin poets, and is most famous for his epic poem *The Aeneid,* which recounts the wanderings of Aeneas from Troy to Italy. In *Virgil Reading the* Aeneid *to Augustus and Octavia* (1787), Jean-Joseph Taillasson shows him reading a passage to the emperor and his sister. Virgil also wrote pastoral poems.

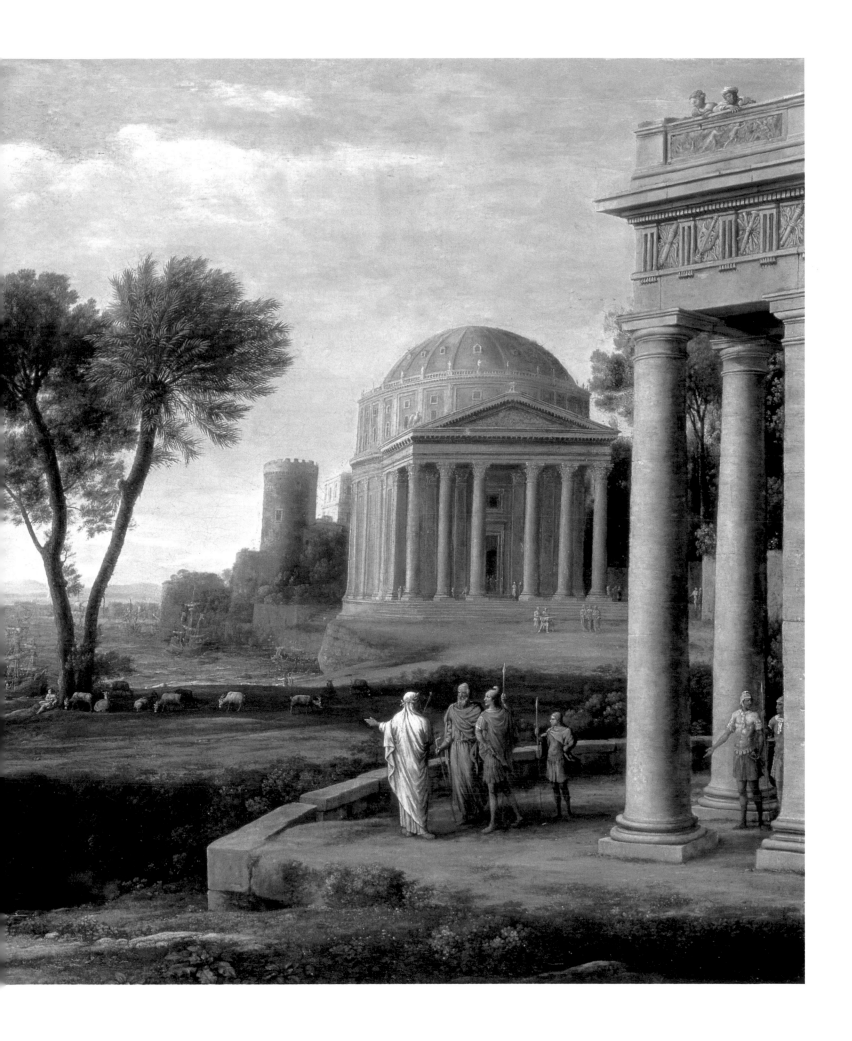

SE · IAI · RIEN · ENTÉDV

DOVROVO · E · PIAINR · DEMOI

De Consolatione Philosophiae

French School (15th century)

The Roman philosopher Ancius Manlius Severinus Boethius (*c.*480–*c.*525CE) was consul under Theodoric, king of the Ostrogoths. Unfortunately, he was imprisoned on a charge of conspiracy and put to death. He wrote his famous treatise *The Consolation of Philosophy* as he awaited his execution, and in it he describes how the allegorical figure of Philosophy appeared to him holding a scepter and a book. In the illuminated page shown here (*c.*1460–70), Boethius seems to be dreaming of Philosophy, who stands beside him wearing a magnificent headdress. Outside his comfortable-looking cell, the figure of Fortune spins her wheel – which Boethius explained was to elevate the fallen and belittle the proud. As the wheel spins clockwise, a hopeful figure rises toward the top, where a man in ermine-trimmed robes sits with other regalia of kingship; but a king's luck may not last forever and, like the figure at the bottom of the wheel, he may be destined to lose his crown.

KEY ELEMENT

PHILOSOPHY: Praised as the highest intellectual pursuit, Philosophy was concerned with the cause and nature of things, investigating these by means of reasoned argument. By applying wisdom, truth, and knowledge, it thus gave rise to true judgment. Philosophy may be personified as a woman enthroned, who may hold a book. It may also be represented by images of the great philosophers of antiquity.

SEE ALSO	PAGE		PAGE
Architecture	206	Scepter	247
Aristotle	208	Socrates	208
Fortune	63	Truth	244

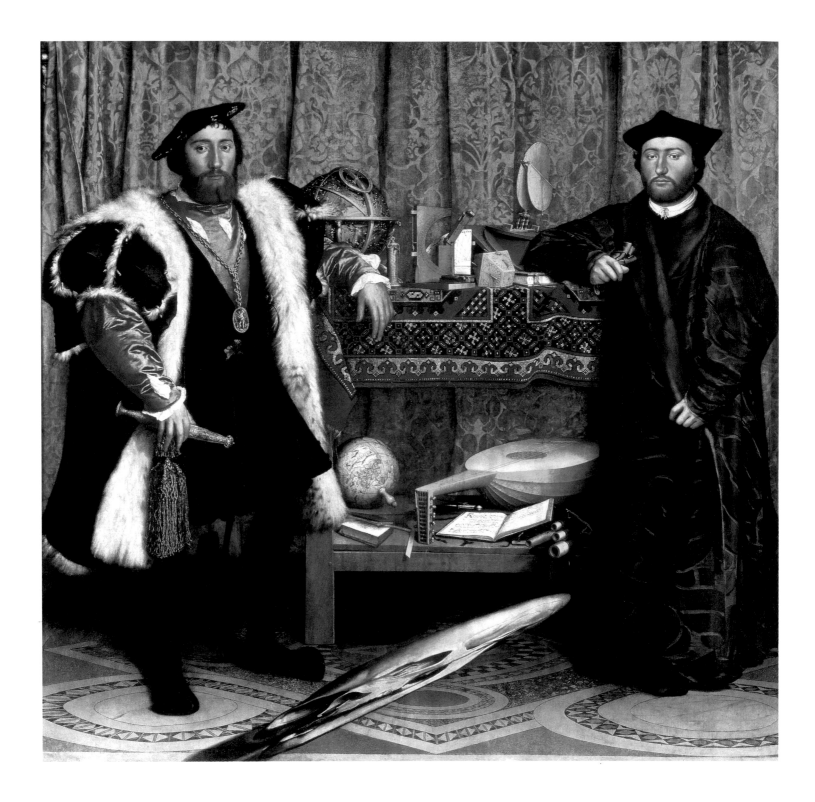

The Ambassadors

Hans Holbein the Younger (c.1497–1543)

One of the most outstanding portrait painters of sixteenth-century Europe, Holbein came to London in search of a post at the court of King Henry VIII, which he finally achieved in 1537. This remarkable double portrait (1533) shows Jean de Dinteville on the left (who was sent by the French king to safeguard relations with Henry), and his friend, the cleric George de Selve. Their luxurious attire reflects their political and religious positions: de Dinteville wears pink satin and velvet, lined with lynx; de Selve is dressed in brown damask. An inscription on de Selve's book tells us that he is 25, while de Dinteville's age, 29, is embossed on his dagger.

Between the two men, shelves littered with objects connected with the Liberal Arts reflect their cultured minds. On the top shelf are items relating to astronomy and instruments for measuring time and space; below, are a Lutheran hymnal, a globe showing the recently discovered America, two instruments for making geometrical calculations, and a lute. The items are painted with a breathtaking realism, yet, as the broken lute string suggests, they belong to the vanities of life. In the foreground, an anamorphic skull – distorted when viewed straight on, but taking shape when seen from below right – hints at inevitable death, while a tiny crucifix in the top left corner suggests there is hope of eternal life.

KEY ELEMENT

LIBERAL ARTS: The seven Liberal Arts were the subjects of secular education in the Middle Ages and the Renaissance. They comprised the *trivium* – grammar, rhetoric, and logic – and the *quadrivium* – astronomy, geometry, arithmetic, and music. The sages of antiquity may represent the subjects or accompany their personifications: Priscian and Donatus are linked with grammar, Cicero with rhetoric, Aristotle with logic, Pythagoras with arithmetic, Euclid with geometry, Ptolemy with astronomy, and the biblical character Tubal-Cain with music. They are pictured in the frescoes by Andrea da Firenze (*c.*1343–1377) in Santa Maria Novella, Florence.

Female personifications of the subjects may have a book and inscriptions to identify them. Grammar, the foundation of all subjects, may be seen with writing instruments, a fountain from which scholars drink, fruit that she offers to a child, or a rod for chastisement; and she may point to the narrow door of knowledge. Rhetoric, a subject studied in adolescence, may hold a scroll, a sword, and the globe of her universal domain. Logic may be shown with a scorpion or snake, perhaps signifying the penetrating nature of the subject. Arithmetic is often seen calculating with her fingers and may hold an abacus or tables covered with figures. Geometry may be pictured with a measuring rod, a set square, a pair of compasses or other instruments of the science. Astronomy may point to the sky and hold an astrolabe or a globe marked with the constellations. Music may be shown playing instruments and singing.

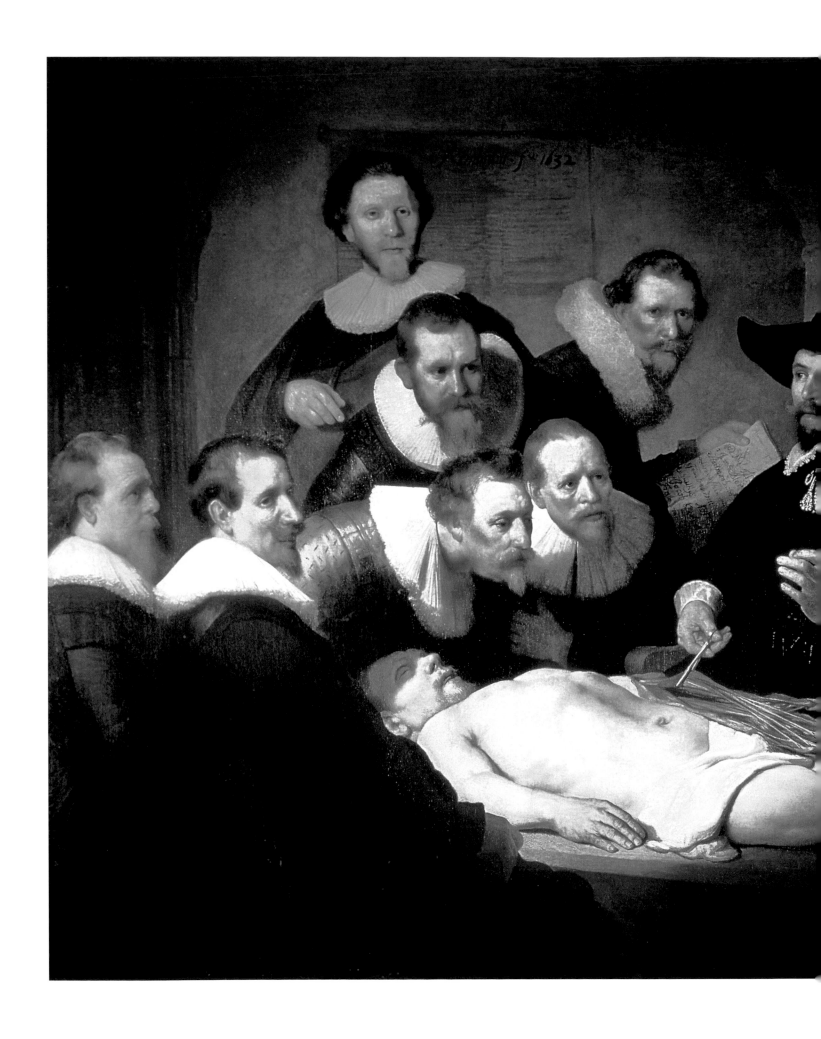

The Anatomy Lesson
Rembrandt (1606–1669)

This canvas (1632) commemorates a dissection by Dr. Nicolaes Tulp, and was Rembrandt's first major commission after he arrived in Amsterdam. Identified by his simple collar, large hat, and saintly expression, Tulp holds the tendons of the arm with forceps; with his other hand, he demonstrates how the muscles bend the fingers – the principal tools of both surgeons and painters. This type of group portrait was popular with brotherhoods and guilds, and traditionally showed the members lined up in a row. Rembrandt's scene is far more animated – the attendants cluster together in a pyramid and, as one holds a list of those present and others look at Dr. Andreas Vesalius's famous treatise in the bottom right corner, they seem engrossed in Tulp's words. Their pale faces and the corpse's skin stand out starkly against the dark background.

KEY ELEMENT

DOCTOR: In the Low Countries, doctors of medicine were sometimes ridiculed, as seen in Bosch's *Cure for Folly* (*c.*1490), which shows a doctor drilling a man's skull to release malign spirits. In Jan Steen's *The Doctor's Visit* (1663–65) – another popular theme – a doctor attends a woman who appears to be either lovesick or pregnant. A piece of ribbon is often evident in such scenes, as a diagnosis was made from the smell created when the ribbon was burned. The doctor may also be seen testing the woman's pulse, which was supposed to quicken in the presence of her lover.

Kings, Queens, and Emperors

From ancient Greece to the present day, artists have been fascinated by figures of authority, depicting the key events in their lives and reigns – their coronations, their triumphs and defeats, and their deaths.

ALEXANDER THE GREAT (see page 183) is often shown helmeted and in armor to indicate his status as a mighty conqueror. His official court painter, **APELLES**, was considered the greatest of classical artists, and one story relates how his painting of a horse was so life-like that it made a real horse neigh. He wrote treatises on art, but neither these nor any of his paintings have survived. He is said to have fallen in love with Alexander's favorite courtesan, **CAMPASPE**, while painting her in the nude; whereupon, Alexander presented her to him.[1] Giambattista Tiepolo painted himself as Apelles and his wife as Campaspe in *Alexander and Campaspe in the Studio of Apelles* (1725–26).

Stories of Persian rulers, whose lands Alexander conquered in the fourth century BCE, were popular subjects for several centuries of painters. Gerard David presented *The Judgment of Cambyses* (1498) as an extreme example of justice: King **CAMBYSES**[2] (sixth century BCE) ordered a corrupt judge, Sisamnes, to be executed and flayed – the seat on which he presided was then covered with strips of his skin as an example to others. In 1827, Delacroix chose the Assyrian king **SARDANAPALUS** as the subject for a dramatic painting of violent despair (see pages 184–85). **CANDAULES**, a king of Lydia, wished to prove that his wife was the most beautiful woman in the world, so he asked **GYGES**, his favorite bodyguard, to watch her undressing. Jacob Jordaens' *King Candaules of Lydia Showing His Wife to Gyges* (seventeenth century) depicts the naked queen about to climb into bed, while the two men peep around the curtain. The story tells how she noticed Gyges slipping away and in outrage made him choose either to die or to kill the king. Gyges chose the latter, thereby usurping the king's wife and territory.[3]

The founder of the Persian Empire was **CYRUS THE GREAT**. Before his birth it was predicted that Cyrus

Equestrian Monuments

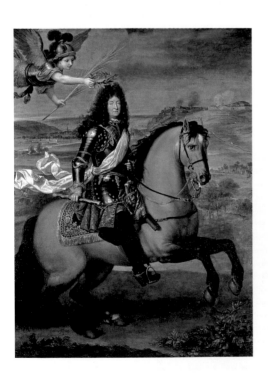

A portrait of a man on a horse expresses power, conquest, and authority. There were countless equestrian monuments in ancient Rome, but few remain. However, the monument of Marcus Aurelius (second century CE), now in the Capitoline Museum, Rome, survived because it was erroneously thought to be a statue of Constantine, the first Christian emperor (see opposite). In the late Middle Ages, the equestrian portrait was used for funerary monuments of military leaders, a tradition that continued with Paolo Uccello's *trompe-l'œil* fresco of the mercenary leader Sir John Hawkwood (*c.*1436). Donatello's statue of Hawkwood in Padua (1443–48) was nicknamed *Gattamelata* (the "honeyed cat") and revived the classical tradition of placing free-standing statues in public areas. Since the Renaissance, numerous European monarchs and illustrious figures in authority have commissioned their portraits on horseback in paintings and statues. A horse striding forward suggests that the horseman is in control; a rearing horse may be used to symbolize the passionate nature of its rider.

In Pierre Mignard's Equestrian Portrait of Louis XIV Crowned by Victory *(c.1692), the palm and laurel wreath signify his conquest of the landscape behind him.*

Bed: see Candaules and Gyges

would overthrow his grandfather **ASTYAGES**, king of the Medes.[4] In an attempt to defy fate, Astyages ordered his faithful servant Harpagus to kill the infant Cyrus. In *Harpagus Bringing Cyrus to the Shepherds* (1706–1708), Sebastiano Ricci illustrated Harpagus, unable to obey the king, giving Cyrus to a cowherd and his wife. When Astyages by chance recognized his 10-year-old grandson, he punished his servant but was persuaded to let the boy live, despite the dream. When Cyrus reached manhood, he usurped the cruel Astyages and inherited the empire of the Medes. He gained control of Asia Minor, captured Babylon and, in 530BCE, caused heavy losses to the Asian tribe ruled by Queen **TOMYRIS**. The queen then marched against Cyrus, slaughtered his army, and searched for his body among the dead. In *Queen Tomyris and the Head of Cyrus* (c.1620) Rubens depicted the episode in which she placed his head in a bowl of blood saying, "Have your fill of the blood for which you thirsted."

A later great queen, **CLEOPATRA** (68–30BCE), has been immortalized in art by numerous painters. Among them, Andrea del Sarto, in *Egypt's Tribute to Caesar* (1521), showed the dues Egypt had to pay to Julius Caesar after he restored Cleopatra to the Egyptian throne. The queen's affair with Caesar was followed by her famous relationship with **MARK ANTONY**, enemy of Caesar's successor **AUGUSTUS**.

Giambattista Tiepolo's frescoes *The Meeting of Cleopatra and Antony* (1750) and *The Banquet of Cleopatra* (1750) show the sumptuous banquet which Antony held to welcome Cleopatra. She told her host, however, that she could produce a dish far more costly than he had provided and, removing a pearl from her earring, she dissolved it in vinegar and drank it. The union of Antony and Cleopatra was opposed by Octavian (63BCE–14CE), who had adopted the title Augustus (meaning venerable) in 27BCE. When he destroyed Antony and Cleopatra's fleet at Actium in 31BCE, the

lovers committed suicide – Antony by the sword and Cleopatra by the bite of an asp concealed in a basket of figs. Her death was the subject of many paintings, such as Guido Reni's *Cleopatra* (c.1630).

Augustus's victory cleared the way for him to become the first emperor of Rome. His successors and their exploits are common subjects in art. **TRAJAN** (98–117CE) was said to have met a widow who demanded justice for the death of her son.[5] The emperor, moved with compassion, saw to it that the boy was avenged. The subject of Trajan and the widow was painted as an example of justice.

The first Christian emperor, **CONSTANTINE** (c.274–337CE), was often depicted at the moment of his conversion. Bernini carved him on a rearing horse in front of the flaming cross in *Constantine* (1654–70). Alternatively, his conversion may be shown as occurring in a dream, as in Piero della Francesca's fresco *The Dream of Constantine* (1455). Giulio Romano painted scenes from the emperor's life in the *Sala di Constantino* frescoes (1520–24); and Constantine was also the subject of a set of tapestries designed by Rubens in 1622.

Just over a century after Constantine, **ATTILA THE HUN** (c.406–453CE), furious that Rome failed to pay tribute to him, invaded Gaul and attempted to capture the city of Rome. Raphael's *Repulse of Attila* (1513) shows Saints Peter and Paul appearing in the sky to halt the invasion on behalf of the Church.

More recent European monarchs, including **LOUIS XIV** (see painting, opposite) and **NAPOLEON I** (see page 187), were often depicted as Roman emperors, and during the Renaissance the Roman custom of **TRIUMPHS** was revived, both in practice and as a subject for paintings. These triumphal marches were an opportunity for victorious leaders to display their booty and captives. Contemporary and classical figures, as well as mythological characters and personifications of the virtues were all represented in triumphal paintings.

Attila the Hun: see St. Paul (box, page 168), St. Peter (page 147 and box, page 168); **Campaspe**: see Aristotle (page 208); **Cleopatra**: see Julius Caesar (page 202)

[1]Pliny the Elder *Natural History* XXXV:85–89 [2]Herodotus V:25 [3]Herodotus I:8–12 [4]Herodotus I 108–129 and 214 [5]*Golden Legend, St. Gregory*

Victory and Virtue in Ancient Rome

Roman soliders and statesmen were noted for their examplary virtue and provided artists in later years with the perfect subject-matter for the exploration of themes of morality.

The legendary founder of Rome was **ROMULUS** who, with his twin brother **REMUS**, was suckled by a she-wolf. Eventually they traced out the city walls on the Palatine hill with a sacred plough, but quareled over the plans. Remus was slain by Romulus, who gave his name to the new city, founded in 753BCE. The she-wolf became one of the symbols of Rome and, along with the intials SPQR – *Senatus Populusque Romanus* ("The Senate and People of Rome"), was inscribed on the standards of ancient Rome and is seen in re-creations of the era, such as Mantegna's *Triumphs of Caesar* (1486–1506).

The **FASCES** – a bundle of wooden rods wound around an axe and fastened with a strap – symbolized Roman authority or power and was carried by lictors (attendants) before superior magistrates. It represented the punishments of whipping and beheading, and was associated with the harsh punitive measures adopted by such statesmen as **MANLIUS TORQUATUS** and Lucius Junius **BRUTUS**. During the war against the Latins in 340BCE, the Roman consuls, of whom Manlius was one, forbade single combat with the enemy.[1] When his son disobeyed the ruling, Manlius ordered his execution. Ferdinand Bol illustrated the event in *Manlius Torquatus Beheading His Son* (1663) for the Council Chamber of the Admiralty in Amsterdam.

Brutus,[2] the nephew of King Tarquinius Superbus, was one of the first two consuls of the Republic along with Tarquinius Collatinus. He led an uprising which ousted his uncle and established the Roman Republic. Two of his sons were plotting to restore the Tarquin monarchy, but their plans were overheard and incriminating letters discovered. Brutus, a man of unbending resolve, condemned them and watched, unflinching, as they were flogged and beheaded. Jacques Louis David's *Victors Bringing Brutus the Bodies of His Sons* (1789) shows Brutus unmoved as the women weep profusely at the outcome of his patriotic deed.

Patriotism was also exemplified by **DECIUS MUS**, a celebrated Roman consul who devoted himself to the service of the state.[3] Rubens made designs for seven tapestries depicting scenes from his life, including the episode in which, in 338BCE, he threw himself into the thickest part of the battle against the Latins to spur on his army. Similar self-sacrifice was shown by the **HORATII AND CURIATII** (see page 189), by **MUCIUS SCAEVOLA** – who thrust his right hand into a fire as a proof of Roman fearlessness – and by **MARCUS CURTIUS**. Misinterpreting an oracle in 360BCE, Curtius, thinking he was saving the city, threw himself into a hole in the Roman forum. The hole immediately closed over his head. Veronese (*c*.1528–88) used the subject in his ceiling decoration *Marcus Curtius*.

Modesty and integrity were regarded as primary virtues of the model Roman citizen. Francesco Salviati (1510–63) painted frescoes depicting episodes from the life of the fourth-century BCE statesman Marcus Furius **CAMILLUS**. Poussin also chose the wise and just Camillus as a subject – in *Camillus and the Schoolmaster of Falerii* (1637) he illustrated the scene in which Camillus, astounded by the treachery of an Etruscan schoolmaster, commanded his men to remove the man's clothes, tie his hands, and let his students drive him back to the city with rods and scourges. The Falerians acknowledged Camillus's act of justice and surrendered their city. Marcus Porcius **CATO** (94–46BCE),[4] a supporter of the Republic, took his own life after the death of Pompey rather than live under the tyranny of **JULIUS CAESAR**: he read Plato's dialogue on the soul twice, and then plunged his sword into his breast. The integrity of Cato was highlighted by Charles Lebrun in *The Death of Cato* (*c*.1646). Caesar's ambition to remain sole ruler of the empire brought about the Republican plot. On March 15th 44BCE he was stabbed to death by Marcus Junius Brutus and his collaborators at the Theater of Pompey in Rome. In his *Triumph of Caesar* (1486–1506), Mantegna chooses Caesar's military prowess, rather than his tragic end, as his subject.

Caesar's ambition was contrasted by the modesty and continence of two earlier Roman figures. The fifth-century BCE consul **CINCINNATUS** was given sole

Wolf: see Romulus and Remus

Roman Wives and Matrons

Rome's women were as much admired for their virtuous acts as were its famous statesmen. During the wars between the Romans and the Etruscans, the noble woman **CLOELIA** was taken hostage by the Etruscan king Porsenna. She escaped and crossed the River Tiber, but was returned to Porsenna. Impressed by her courage, he released her with the companions of her choice. Jacques Stella (1596–1657) shows her on the bank of the Tiber about to transport her companions across.

LUCRETIA, the beautiful wife of

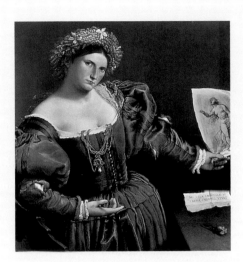

Lorenzo Lotto's A Lady with a Drawing of Lucretia *(c.1530) shows a 16th-century woman pointing to a drawing of the famously faithful Roman wife.*

Tarquinius Collatinus, who served in the army of Sextus, was raped by her husband's commander. Lucretia confessed her disgrace to her husband before plunging a knife into her heart. Titian depicts the violent rape in *Tarquin and Lucretia* (1568–71). Similar marital fidelity was shown by **AGRIPPINA**, who dearly loved her husband Germanicus. After he was poisoned by political enemies in Syria, his grieving wife brought his ashes back to Italy, as Benjamin West showed in *Agrippina Landing at Brundisium with the Ashes of Germanicus* (1768).

leadership when the city fell under siege, but modestly retired to his farm immediately after the battle. The event was depicted by Giovanni Romanelli in *Representative of the Senate Offering the Dictatorship to Cincinnatus* (1655–68). The second-century BCE general Cornelius **SCIPIO** Africanus defeated the Carthaginian leader **HANNIBAL** (247–182BCE) who marched an army reported to consist of 90,000 infantry, 12,000 cavalry, and a number of elephants across the Alps in 218BCE, during the Second Punic War against Rome. In *Snow Storm: Hannibal and His Army Crossing the Alps* (1812) Turner shows how the mighty army, which astounded the Romans, also had to battle with the forces of nature.

Scenes of Scipio's triumph may allude to contemporary victories, and may be used for public decorations to accompany a dignitary's ceremonial entry into a city. The virtuous Scipio also had a bust of the mother

goddess Cybele brought to Rome, as it had been prophesied that the presence of this bust would be instrumental in the defeat of Hannibal. The theme was shown in Mantegna's *Introduction of the Cult of Cybele into Rome* (1506).

Scipio was a popular subject in art.[5] After a victory at New Carthage, he captured a beautiful young girl who was betrothed to the young Allucius. Hearing of this, he restored the girl to her betrothed and requested only that Allucius be a friend to Rome; he gave the girl's ransom to the couple as a wedding gift. The theme was painted to signify self-control, as well as the generosity of a noble and virtuous general toward the innocent. Sebastiano Ricci in *The Continence of Scipio* (c.1695) chose to set the tense scene before Scipio's magnanimous act – when the girl's fate was still in the balance.

Julius Caesar: see Cleopatra (page 201)
Scipio: see Cybele (page 56)

[1]Livy *The History of Rome* VIII:vii [2]Plutarch *Lives, Popicola*
[3]Livy *The History of Rome* X:xxviii [4]Plutarch *Lives, Cato*
[5]Livy *The History of Rome* XXVI:i

Figures of World Literature

Key: see Ugolino

Western literature begins with the Greek epic poet, **HOMER**, the accepted author of the *Iliad* and *Odyssey* who lived some time before the seventh century BCE. In *Parnassus* (*c*.1510) Raphael depicted him with Dante and Virgil as a dignified old man wearing a laurel wreath. Homer was blind, so he is frequently shown dictating his works to a scribe. A legendary predecessor of Homer, the poet **ARION**[1] reputedly played the lyre so beautifully that he would make birds and wild animals halt in their tracks. When he fell overboard while sailing from Italy, he was rescued by a dolphin which had been charmed by his music. Dürer shows him in *Arion* (*c*.1514) with his harp on the back of a curious-looking fish.

The poet **SAPPHO** (seventh century BCE), who lived on the island of Lesbos and was famous for her poetry and beauty,[2] fell in love with Phaon, who refused her, whereupon she threw herself into the sea. Sappho and Phaon are shown together in Jacques Louis David's *Sappho and Phaon* (1809), and Gustave Moreau painted *Sappho Leaping into the Sea* (1880).

The Roman **VIRGIL** (see page 192) and the Florentine **DANTE** Alighieri (see page 191) – both epic poets – were shown together not only by Raphael in his *Parnassus* but also by Delacroix in *The Barque of Dante* (1822). In Dante's epic *Divina Commedia* (1307–21), Count **UGOLINO** was imprisoned with his sons and

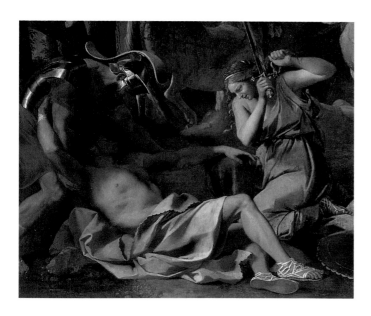

grandsons in a tower, and the key was thrown away. As they starved, his sons cried, "Father, we should grieve far less, if thou wouldst eat of us." They all died of hunger. In *Ugolino* (1882), Rodin shows an emaciated Ugolino kneeling over his dying grandsons. In Dante's poem **FRANCESCA** de Rimini tells the poet Virgil her story.[3] She was the daughter of a friend of Dante and married the deformed Gianciotto, son of the lord of Rimini, but fell in love with **PAOLO**, her husband's younger brother. Their punishment was to drift forever on the wind in the second circle of Hell. This tragic theme was taken up in the nineteenth century. In *Paolo and Francesca* (1855) Rossetti shows Paolo kissing Francesca as they read together.

In around 1483, Botticelli produced a series of panels entitled *The Story of Nastagio degli Onesti*. Painted as a warning to women who scorn their lovers, they tell the story by the poet Boccaccio (1313–75) of the wealthy **NASTAGIO** degli Onesti who fell in love with a beautiful girl of higher birth.[4] She rejected him and, brooding over the cruelty of his beloved, he wandered through the woods. There he saw the ghost of a knight on horseback, who told Nastagio that his love had also been unrequited and that he had taken his own life in despair. His beloved had died shortly afterwards without repenting of her cruelty, so he cut out her cold heart with the rapier he had used on himself. Yet she rose as if unharmed, and the chase began again. Nastagio invited his own love and her family to a banquet in the woods, where they witnessed the scene and she agreed to marry him.

Orlando Furioso, an epic poem by Ariosto (1474–1533), published in 1516 in Ferrara, recounts the legend of Charlemagne, the Saracen invasion of France, and the conflict between Christians and Muslims. The poem takes the form of a parody of medieval romances, with combative knights, damsels in distress, monsters, and witchcraft. **ORLANDO**, or Roland, was driven mad

Poussin's Tancred and Erminia *(detail; c.1635) shows an episode from* Jerusalem Delivered *by Tasso in which Erminia cuts a lock of her hair to staunch the flow of Tancred's blood.*

Hippogriff: see Ruggiero

by his love for the beautiful but fickle **ANGELICA**. She was promised to either Orlando or his cousin, depending upon which of them slaughtered more Saracens.[5] She fled from her suitors, and had many adventures. In *Angelica and the Hermit*, Rubens (1577–1640) shows how a lustful hermit put her to sleep with a magic potion, but when he tried to satisfy his desire with the sleeping maiden he found he was too old to perform. Ingres' *Ruggiero Delivering Angelica* (1819) illustrates how Angelica was chained to a rock on the Isle of Tears to feed the orc, a huge sea monster. She was seen there by **RUGGIERO**, or Roger, a Saracen champion, who flew down on a hippogriff (a mythical creature with the hindquarters of a horse and the wings and head of an eagle) to slay the monster and save her.

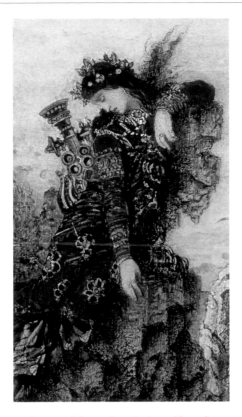

Gustave Moreau's painting of Sappho *(detail; 1871–72) depicted the Greek poet in a tragically elegant pose.*

Another poet of the fifteenth century, the English Sir Thomas Malory (died 1471), provided artists with equally romantic subjects in his *Le Morte d'Arthur* and *Chrétien de Troyes*, which told the legends of King **ARTHUR**. The Arthurian legends embody the chivalric qualities that appealed to English medieval revivalist painters such as William Morris and Dante Gabriel Rossetti in the latter half of the nineteenth century.

The epic poem *Jerusalem Delivered* by Torquato Tasso (1544–95) is a religious work about the First Crusade. It features several characters sometimes depicted in art, including **OLINDO** who chose to die with his love **SOPHRONIA** when she was ordered to be burned at the stake. Friedrich Overbeck's *Olindo and Sophronia*

(1817–27) shows the lovers tied to the stake. Tasso also tells of the Christian hero **RINALDO** who was lulled to sleep by the Saracen sorceress **ARMIDA**, who planned to kill him but was suddenly overcome by his beauty.[6] In *Rinaldo and Armida* (*c.*1630), Poussin shows Cupid holding back the hand in which Armida clutches a dagger; and in another version he depicts her carrying Rinaldo away to her castle.

Another hero from the same poem, **TANCRED**, was loved by **ERMINIA**, a Saracen princess who escaped the besieged city of Jerusalem and fell asleep in the woods. *Erminia with the Shepherds* by Domenichino (1581–1641) shows how she awoke to the sound of a shepherd and his sons singing. Tancred accepted a challenge to fight the Saracen giant Argantes, but although he killed his opponent he was himself heavily wounded. Filled with fear for her lover, Erminia ran to his side with his squire Vafrino. At first they believed him dead, as Guercino's *Tancred and Erminia* (1618–19) shows. Seeing his lips give a sigh, however, Erminia cut off her amber hair to stop the flow of his blood, and they carried him back alive to the Crusaders' camp.[7]

Other literary characters of the sixteenth and seventeenth centuries which have featured in great paintings are Miguel de Cervantes' **DON QUIXOTE**, Giovanni Guarini's **AMARYLLIS** and **MIRTILLO**, painted by van Dyck (1599–1641), and the Dutch playwright Pieter Hooft's **GRANIDA** and **DAIFILO**, painted by Gerrit van Honthorst in 1625.

Arion: see Lyre (page 207)
Homer: see Laurel (page 215)

[1]Ovid *Fasti* II:79–129 [2]Ovid *Heroids* XV [3]Dante *Inferno* V:88–142
[4]Boccaccio *Decameron* 5th Day, 8th Story [5]Ariosto *Orlando Furioso* I:viii–xi and X:Xcii–cxiii [6]Tasso *Jerusalem Delivered* XIV:lxvi–lxx [7]Tasso *Jerusalem Delivered* XIX:ciii–cxii

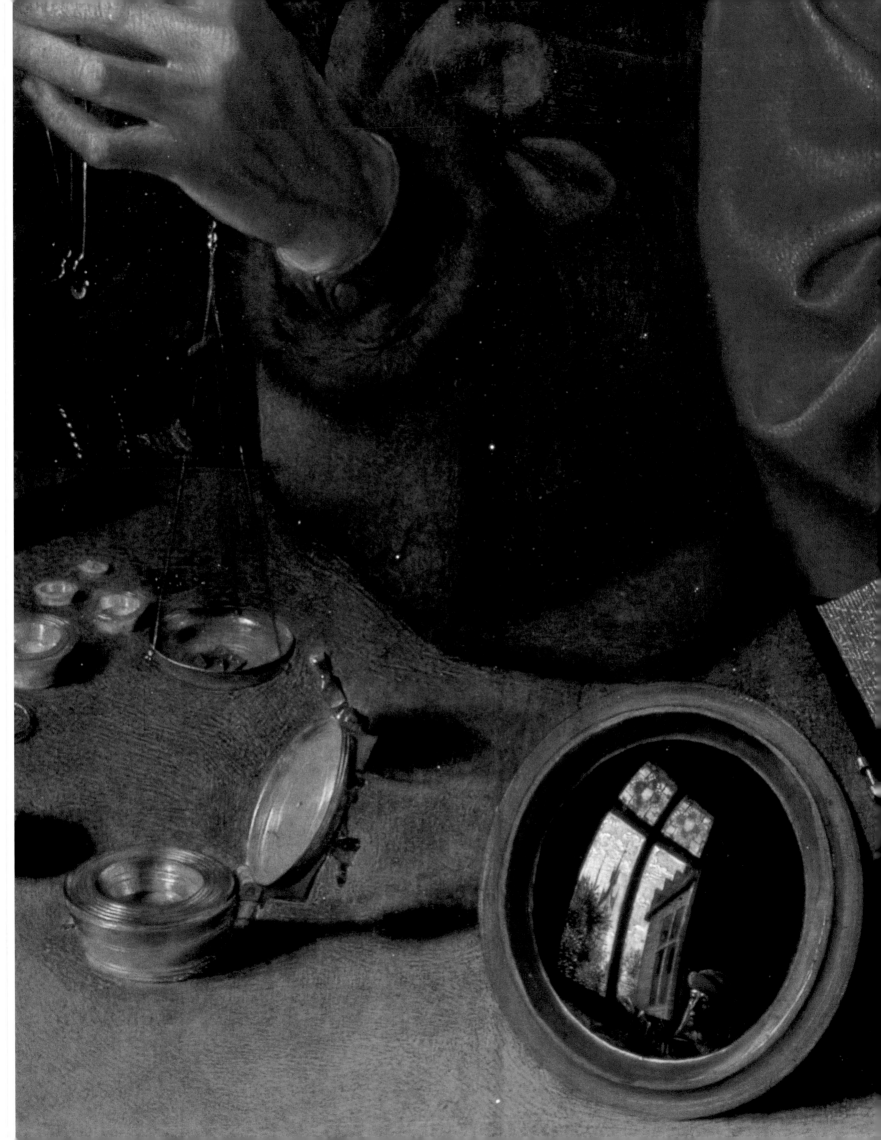

CHAPTER FIVE

SYMBOLS AND ALLEGORIES

This chapter covers the emblematic meanings of images that appear in Western art – from animal symbols such as doves and snakes, other aspects of nature such as flowers and landscapes, to everyday objects such as candles and dice. These symbols were not only deployed in isolation, but were also combined to build up complex visual allegories on subjects such as marriage, the four seasons, and the Seven Deadly Sins. In allegorical paintings, artists often drew upon the gods and goddesses of classical mythology to personify human qualities or natural phenomena.

The Arnolfini Marriage

Jan van Eyck (c.1390–1441)

This small full-length double portrait records not only a couple exchanging their wedding vows but also the interior of a wealthy merchant's home in early fifteenth-century Bruges. The artist has witnessed the union of this couple by inscribing in Latin *Johannes de eyck fuit hic 1434* (Jan van Eyck was here 1434) on the far wall. He has painted objects of the everyday world with such staggering precision that even the convex mirror reflects the room and visitors entering.

The painting may be taken as an allegory of ideal marriage. Prosperity abounds – the glazed windows, oranges, fur-lined clothes, the mirror decorated with tiny scenes of the Passion of Christ, the carved bedhead, the rich draperies, and the carpet are all evidence of this merchant's success. Everything points to a happy marriage – the faithful dog between them, the cleanliness of the room, the rosary hanging on the wall, the groom's gesture of acceptance, the bride's modestly bowed head, and her forthcoming child, which will be born on their comfortable double bed under the auspices of the carved image of Saint Margaret – patron saint of childbirth.

KEY ELEMENTS

DOG: Many diverse qualities are ascribed to dogs in art. Creatures of fidelity and loyalty, they are depicted on medieval tombs lying at the feet of their masters, and in portraits they represent similar qualities. Dogs may also have the role of guardians – in classical myth, for example, the three-headed Cerberus stood at the entrance to the Underworld. They may even be used to express carnal desire or to signify greed – as in the fable of the dog which, holding a cake in its jaws, looked down into water and lost the cake in an attempt to catch its reflection. A dog is the attribute of Saint Roch, and black-and-white dogs in Dominican scenes are, in a pun on the Order's name, depicted as *Domini Canes* or "Hounds of the Lord;" they may be seen chasing wolves, which represent heretics.

MARRIAGE: One of the seven sacraments of the Catholic Church, the ideal marriage is sometimes represented by that of the Virgin and Joseph. Faithfulness within matrimony is often symbolized by a personification of Faith – one of the three Theological Virtues – who may hold a book, a lighted candle and a heart, a cross or a chalice.

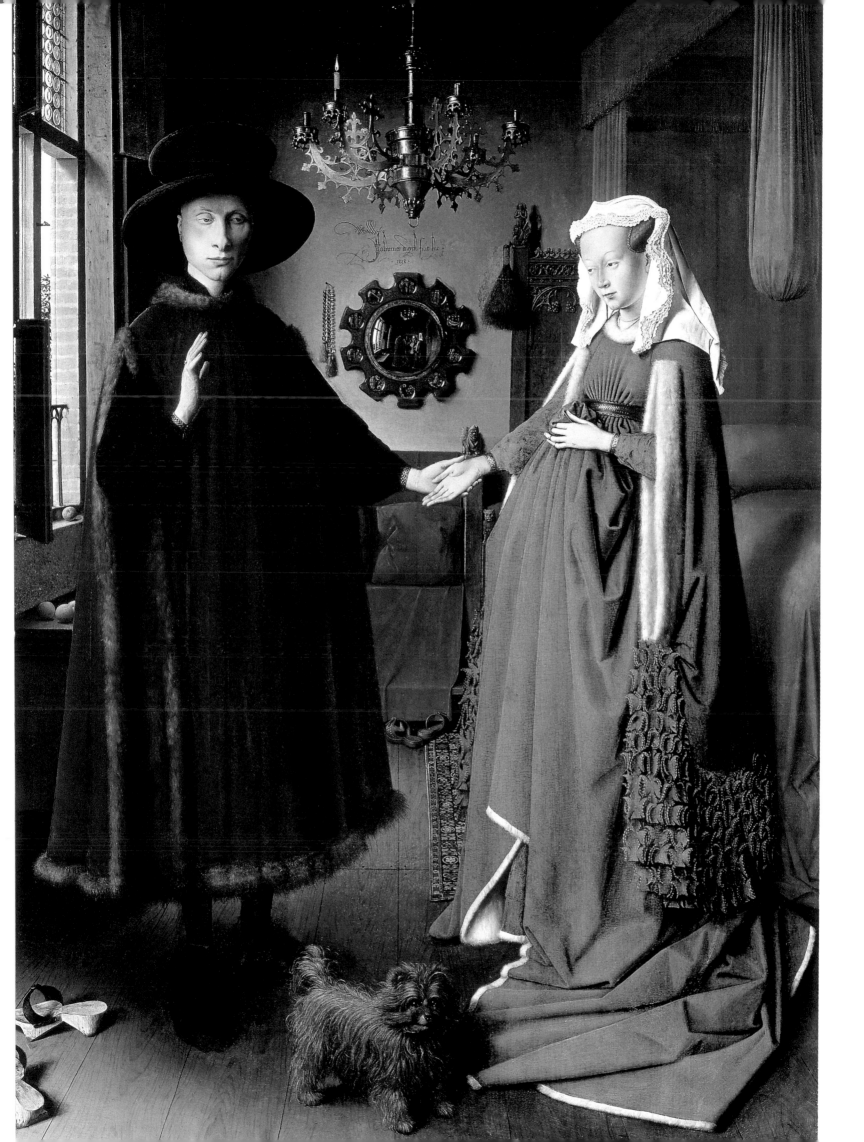

Summer
Giuseppe Arcimboldo (1527–93)

The Milanese artist Giuseppe Arcimboldo was employed as a portrait painter at the court of the Habsburg emperors in Prague. He was also noted for painting a type of "capriccio" – an inventive conceit that was much in demand. These pictures look like heads or figures when seen from a distance but, on closer inspection, are made up of fruit, vegetables or other objects. Arcimboldo created an image of Agriculture from spades, plows, scythes, and other farm tools, while his 1573 figure of Summer is formed from the season's produce. This double imagery, transforming one thing into another, inspired the works of the Surrealist painter Salvador Dali.

KEY ELEMENT

STILL LIFE: The painting of inanimate objects or "still lifes" emerged as a subject in its own right during the seventeenth century, and was particularly popular in Holland, which had a tradition of delight in the everyday world. However, this art form can be traced back to classical antiquity, when the celebrated Zeuxis reputedly painted a bunch of grapes so naturalistically that birds tried to eat them. Carefully arranged, with controlled lighting, the objects may be significant – but above all, these works were a display of the artist's virtuosity. Both humble and extravagant objects were included, the latter often carrying implications of wealth or aspiration.

 # Embarkation for the Island of Cythera

Jean Antoine Watteau (1684–1721)

Cythera was an island paradise where love prevailed. In Watteau's enchanted landscape of 1717, couples act out the stages of love, from persuasion to submission and accord. On the right, a man propositions a girl as Cupid tugs her skirt, another helps a woman to her feet, while his friend draws a lady forward as she hesitates. To the left, beside a gilded boat with oarsmen ready to depart, the women – who appear equally enamored – are shown encouraging the men. Watteau's style was well suited to visions of an idealized world where beautiful women in shimmering fabrics are courted by elegant gentlemen. The autumnal colors give the painting a melancholy air, perhaps reflecting Watteau's recognition of the transcience of life – consumption killed him at the age of 37. Another interpretation suggests that the lovers are already on Cythera and are preparing, reluctantly, to return to the everyday world.

KEY ELEMENT

FÊTE CHAMPÊTRE: Scenes of the wealthy pursuing romantic pleasures in an idealized pastoral landscape were known as Fêtes Champêtres, and were popular in eighteenth-century France. Fashionably dressed couples amuse themselves by dancing, playing music or talking, and an air of gentle ennui may pervade the scene.

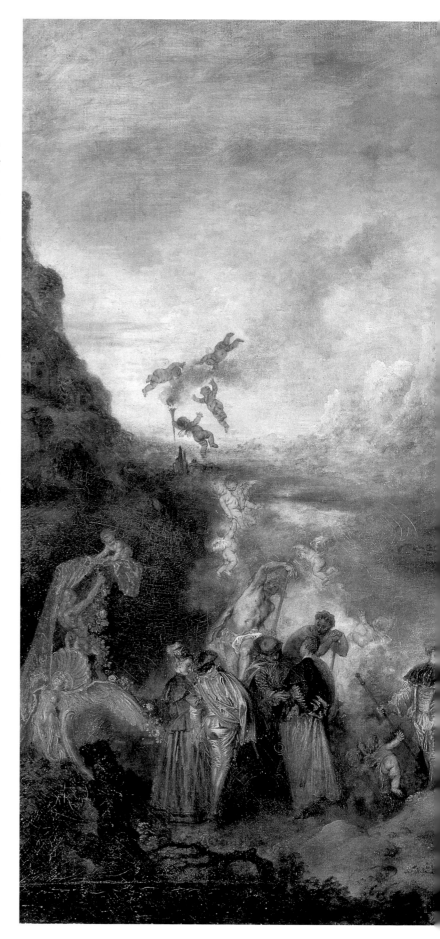

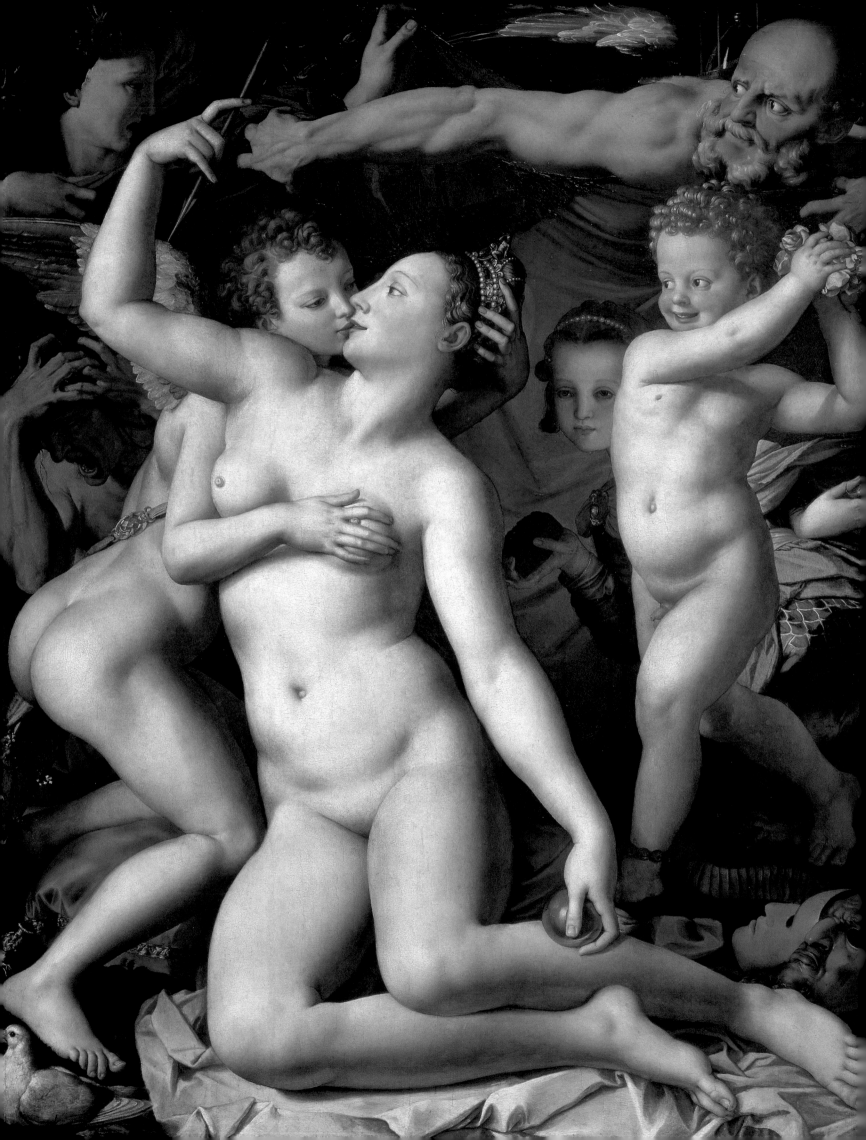

An Allegory with Venus and Cupid

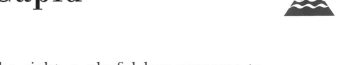

Agnolo Bronzino (1503–1572)

Bronzino served as court painter to Cosimo I, Grand Duke of Tuscany. This painting of around 1540–50 is a masterpiece of variety and intrigue as male and female figures of all ages are arranged in a shallow depth across the canvas, causing the eye to zigzag over the surface of the composition. Together they form an allegory that refers to the destructive power of love.

In the center, a naked Venus clutches her golden apple, the prize that brought about the Trojan War; with her right hand she disarms her son Cupid, who embraces her erotically – almost crushing the dove of peace with his foot. To the right, a playful boy prepares to throw rose petals, seemingly unaware that he has trodden on thorns and that one has pierced his right foot. Behind him a pretty girl holds out a honeycomb – but her sweet gesture is a deception because in her other hand she holds the sting of her reptilian tail.

In the background, Old Father Time, watched by a mask-like figure and carrying his hourglass on his winged back, either tries to cover up the group or to reveal their harmful powers; and on the left, a man clutches his head and screams in agony, tormented by a diseased mind.

KEY ELEMENTS

DECEIT: In Bronzino's allegorical picture, Deceit or Fraud has the face of a beautiful young girl, the lower body and tail of a reptile, and the feet of a lion. Deceit may also be represented by a mask – for example, an old woman wearing the face of a young girl.

FOLLY: From the Middle Ages to the seventeenth century, jesters were the licensed fools of royalty and the aristocracy. Giotto's *Folly* (*c.*1310) is a fat youth wearing a feathered crown and a tattered tunic, holding a club. Bronzino's Folly is the grinning young boy with bells around his ankles like a jester about to throw petals over Venus. In *Das Narrenschiff* (1494) by the German satirist Sebastian Brant (1458–1521), a variety of fools are shipped off to the Land of Fools without a pilot or directions. This satire on human vice and folly inspired allegorical illustrations such as Bosch's *Ship of Fools* (*c.*1495).

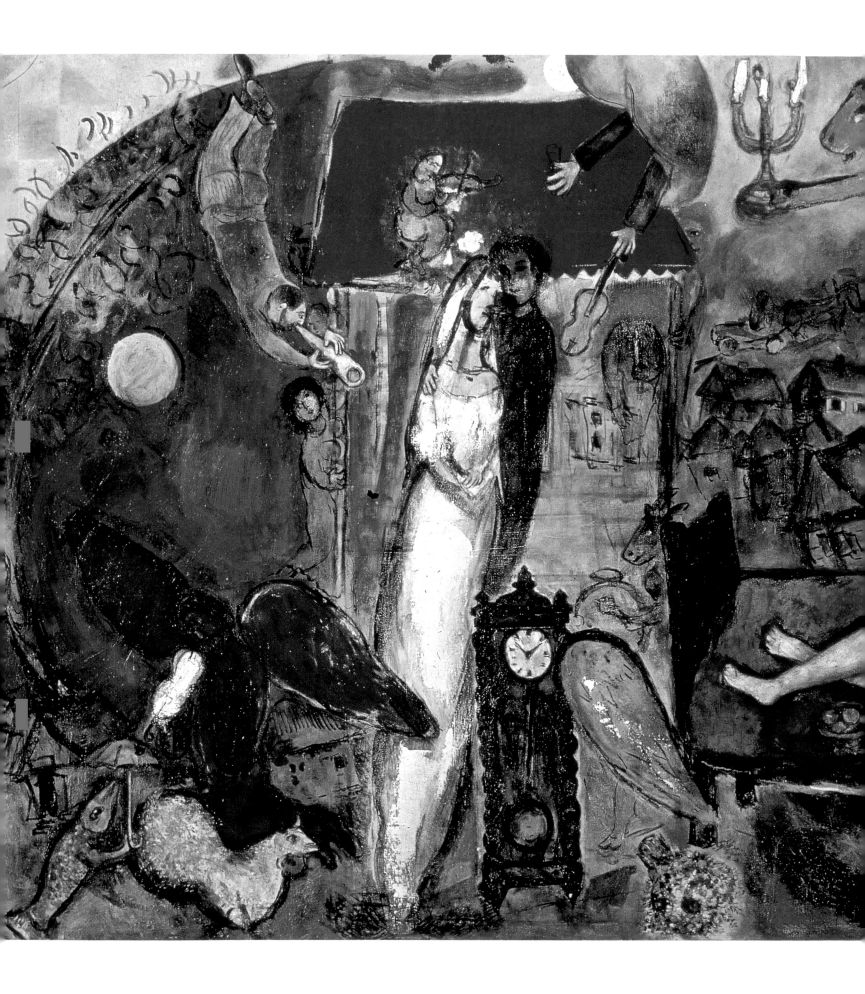

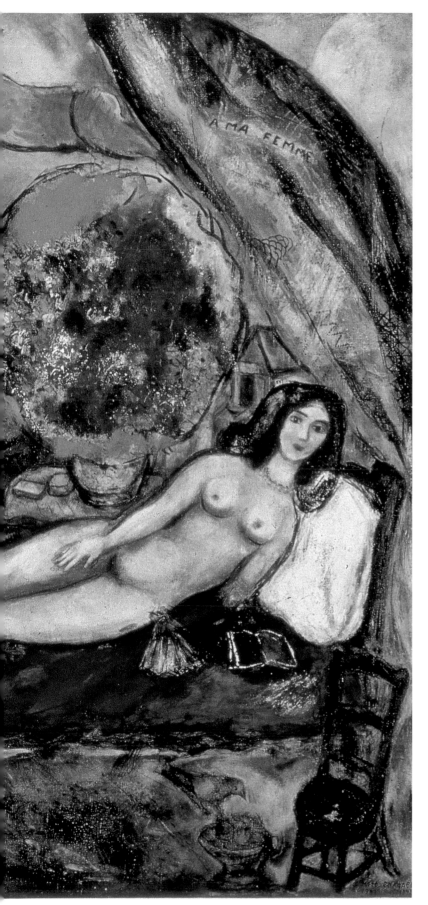

To My Wife
Marc Chagall (1887–1985)

Chagall was extremely prolific and his pictures are steeped in folklore and memories of his Jewish upbringing in Russia. By 1914 his work was internationally renowned, but although its imaginative qualities attracted the Surrealists, he refused the invitation to join them. He met Bella Rosenfeld in 1909 and married her in 1915, celebrating their blissful union in hundreds of paintings, including this one of 1933–44. She was his manager, muse, and guardian angel, and together they fled Moscow, Leningrad, Paris, and Berlin to escape the terrors of Bolshevik and Fascist Europe.

KEY ELEMENT

NUDE: In the mythical Golden Age, humankind lived in harmony with nature and clothes were unnecessary; likewise, Adam and Eve wandered naked in Eden without feeling shame. Nudes can represent power, delight, fecundity, shame, poverty, or truth and were intended to transport the viewer into a world of the imagination. The female form may express the abundance of nature and the source of life and may be endowed with charms that accorded with current taste and fashion; the idealized male may be given strength and grace. Even if the subject warns against the dangers of love, the figures may be profoundly sensual.

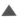

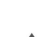

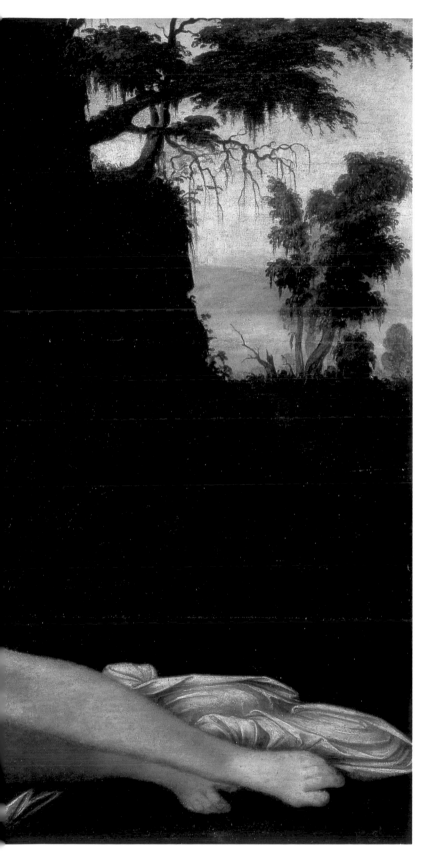

Eva Prima Pandora
Jean Cousin the Elder (c.1500–c.1560)

Few works are attributed to Jean Cousin the Elder, although it is recorded that he designed fortifications, mended a clock, and repaired a statue for the cathedral of his birthplace – Sens in southwest France. He combined influences from Dutch art, the Italian Mannerists, and the School of Fontainebleau in his paintings, and this elongated nude of *c.*1550 unites mythical and Christian themes. In mythology, Pandora brought evil to the world; she is Eve's counterpart and is shown here holding the biblical apple of temptation, while the skull on which she reclines seems to look up as a reminder of mortality. The image is a powerful message of the dangers of women.

KEY ELEMENT

SKULL: Monks and saints used skulls as a meditation aid, for they were a reminder of death, and in Dutch still lifes skulls were included as a *memento mori* – as in Harmen Steenwyck's *Allegory of the Vanities of Human Life* (1612). An old man often holds one in allegories of the Ages of Man, while the skull in Frans Hals' *Young Man Holding a Skull* (1626–28) represents time passing.

Crucifixion scenes may also show a skull, for the site was named Golgotha ("a place of a skull"). And as legend claimed that Christ was crucified on the spot where Adam was buried, Adam's uncovered skull may indicate Christ's sacrifice for the redemption of humankind.

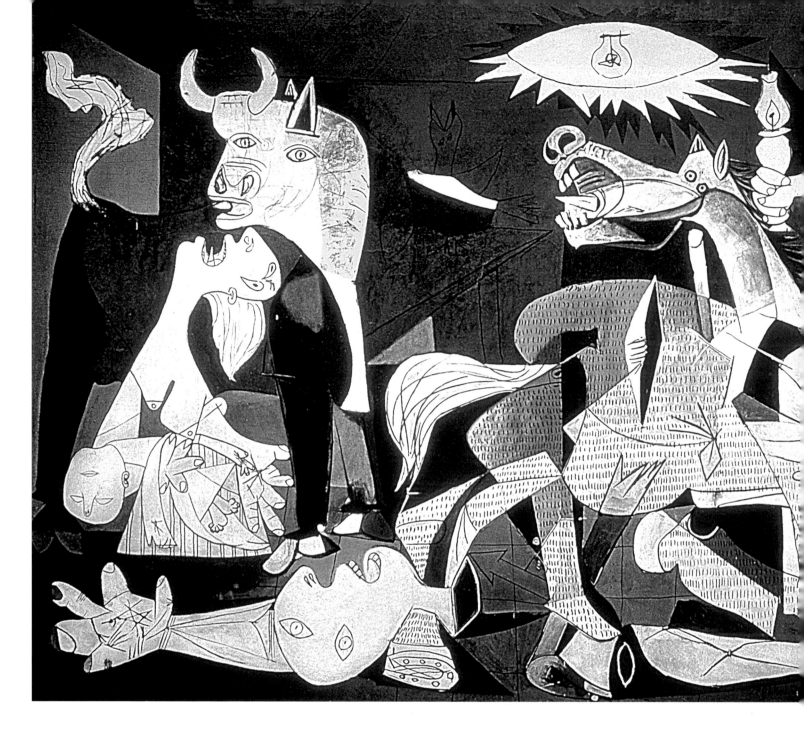

Guernica

Pablo Picasso (1881–1973)

Picasso's emotive canvas of 1937 was a public protest against the Nazi bombing of the Basque town of Guernica in the same year, and it bursts with personal symbols of suffering and violence. To the right, figures flee a burning building from which a woman falls; to the left, a wailing mother holds her child, while a triumphant bull tramples on a fallen warrior. The broken sword, the flower, the dove, the skull (hidden within the body of the horse), and the crucifixion pose of the fallen warrior are all generic images of war and death. The bull represents brutality, while the horse represents the anguish of the innocent. Together, these agonized figures form a kind of collage, silhouetted against the darkness and starkly lit by a woman with a lamp and an eye with a lightbulb for a pupil. The newsprint quality of the monochrome and the stark contrast of light and dark enhance the powerful impact.

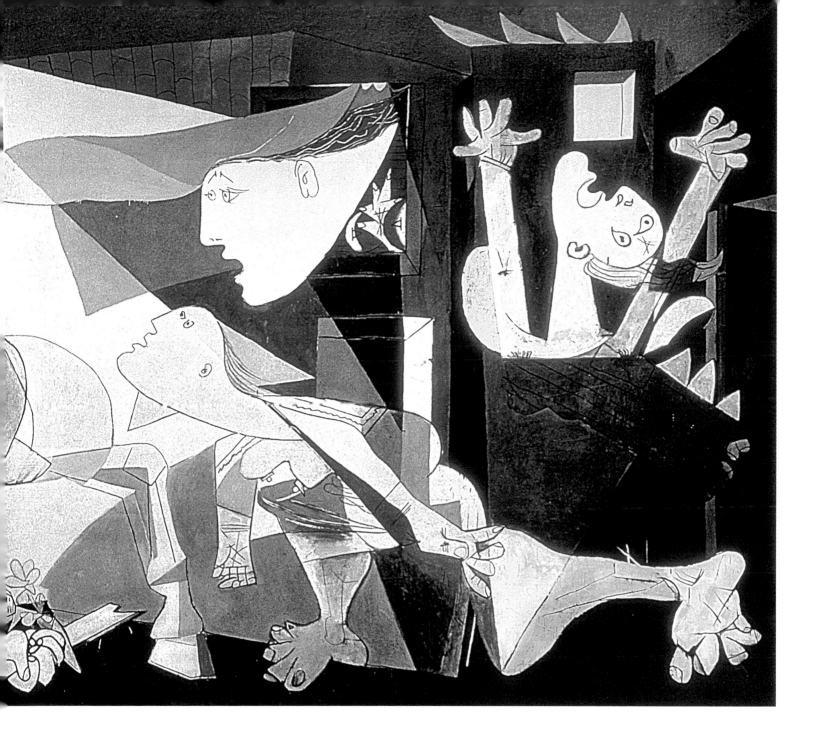

KEY ELEMENT

WAR: Representations of the futility and horror of war include Dürer's engraving *Knight, Death and the Devil* (1513), which shows a warrior riding forth oblivious to his grim companions. Rubens presented his *Allegory of Peace and War* (1630) as an argument against conflict in Europe, while his *Consequences of War* (1638) shows how War, led by Disaster, tramples over the civilized arts. In contrast, paintings may show the missionary zeal of the Crusades or depict a war conducted in the cause of freedom, as in Delacroix's *Liberty Leading the People* (1830).

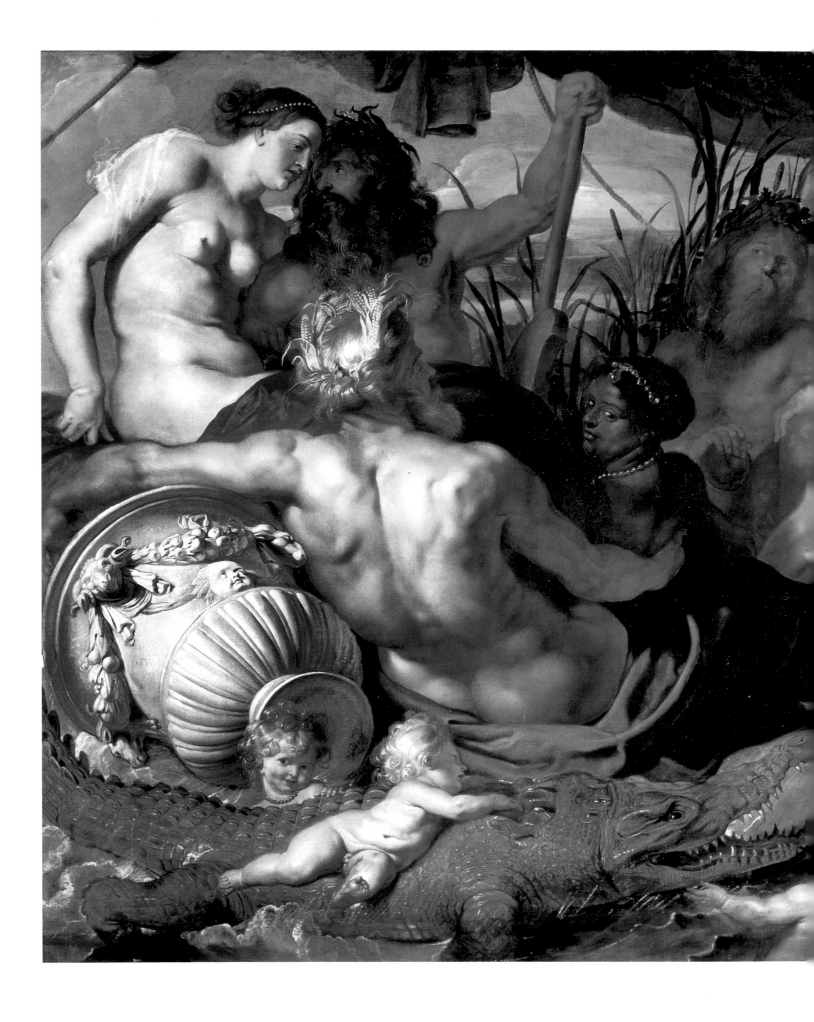

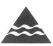

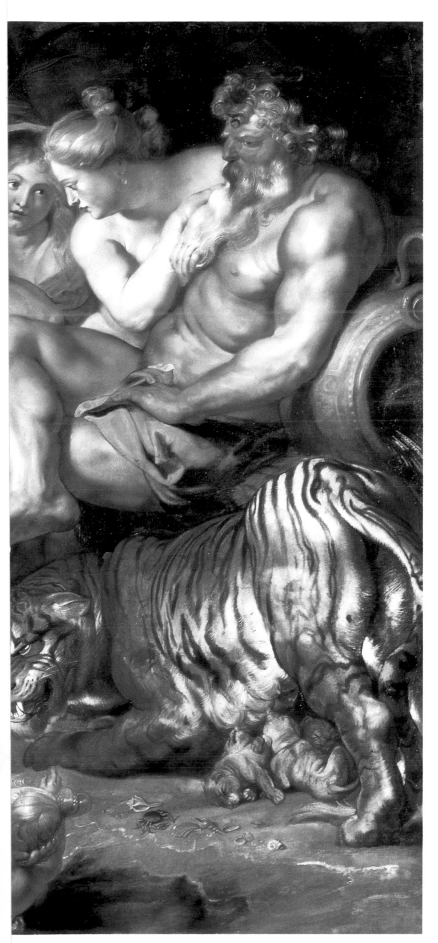

The Four Continents

Peter Paul Rubens (1577–1640)

A prolific artist and an active diplomat, Rubens traveled widely and was friendly with many European rulers – two of whom knighted him. He was also highly educated, often including classical references in his allegorical paintings. This canvas of 1615 is thought to represent the four continents of Africa, Asia, Europe, and America. The upturned urns are attributes of the ancient gods who inhabited the countries' rivers – the gods are seen lazing under a canopy, attended by naked women. A tigress represents the River Tigris, while *putti* play with a crocodile, the symbol of the Nile.

KEY ELEMENT

CONTINENTS: The four continents were popular subjects with Baroque artists – for example Tiepolo's grand ceiling fresco *Apollo and the Continents* (*c.*1750). Jesuits also favored the subject, for it visualized their intention to spread the Catholic faith. The continents were often personified as river gods, and may appear with indigenous animals or recline on urns from which water flows – a veiled head indicating that a river's source was unknown. Africa may wear coral, be shown with a sphinx, a lion or an elephant; the Americas may dress as a hunter with a feathered headpiece, while coins represent rich natural resources; Asia may appear with a camel, a rhinoceros, an elephant, palm trees, jewels or exotic perfumes; Europe may be a bull or a horse, may hold a cornucopia or crown of supremacy, and is sometimes surrounded by figures representing the arts.

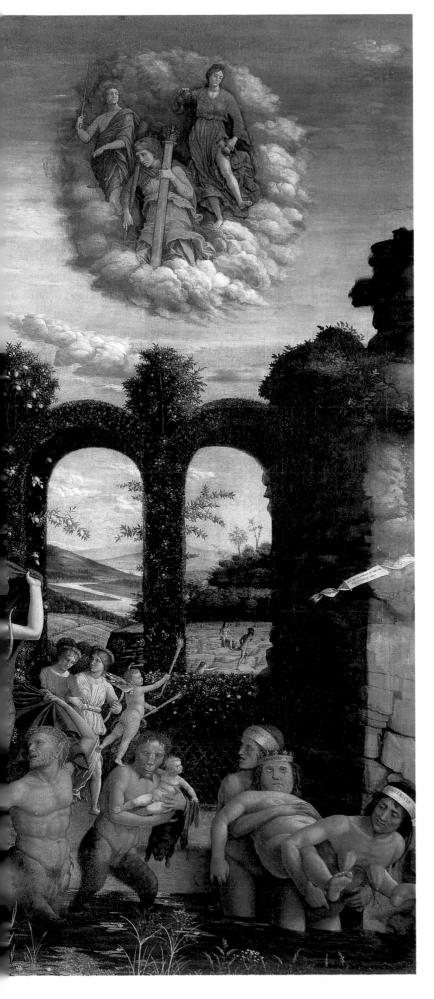

Pallas Expelling the Vices from the Garden of Virtue

Andrea Mantegna (c.1431–1506)

Mantegna painted this canvas (*c.*1499–1502) for the Duchess of Mantua, flattering her by likening her to Pallas Minerva. Pallas rushes in on the left, driving a swarm of cupids and other figures before her and gazing at the sky where Temperance, Justice, and Fortitude float on a cloud. Behind her, a figure turns into a tree, around which a scroll begs the Virtues to banish the Vices. On the right, Ingratitude and saggy-breasted Avarice carry obese Ignorance, followed by a satyr, and a centaur carrying a nude – who may represent sensual love. An ape with bags of evil across his shoulders symbolizes Immortal Hatred, Malice, and Fraud, while Sloth leads armless Idleness on a rope. The women in blue and green with Pallas may be Diana and Chastity.

KEY ELEMENT

BATTLE OF VIRTUES AND VICES: Opposing vices and virtues may be shown in battle, such as Faith against Idolatry, Humility against Pride, and Chastity against Lust; or they may be set against one another in niches – as under Giotto's narrative frescoes. From the Renaissance Minerva, Apollo, Diana, and Mercury may fight for the Virtues, and Venus and Cupid for the Vices, as in Perugino's *Battle Between Love and Chastity* (1505).

Beware of Luxury

Jan Steen (1626–79)

Packed with references to proverbs, Steen's painting of *c.*1663 shows a sleeping housewife surrounded by examples of intemperance and carelessness. Two lovers – indicated by the man's leg over the woman's knee – drink wine, while the man laughs at a remonstrating woman and ignores the man with a duck on his shoulder (a quacker, or quaker). Nor does he heed the sword and crutches – objects of punishment – in the basket above. Wine spills from an overturned pitcher and an uncorked barrel on the left, an unattended child has dropped his bowl, and a dog gobbles up food on the table. In the background, a young boy smokes, a girl steals from a cupboard, a foolish monkey stops the clock, and a roast has fallen into the fire. Meanwhile, a pig sniffs roses dropped by the lover – a Dutch equivalent of "pearls before swine" – and playing cards act as a reminder of the dangers of gambling.

KEY ELEMENTS

LUXURY: Many seventeenth-century Dutch artists depicted luxury, showing richly dressed figures at tables covered with sumptuous objects. These paintings warned of the vanity of earthly possessions and waste-fulness, and Jan van de Velde's *Death Surprising a Young Couple* (*c.*1620) bears the inscription: "We often sit in luxury, while Death is closer than we know."

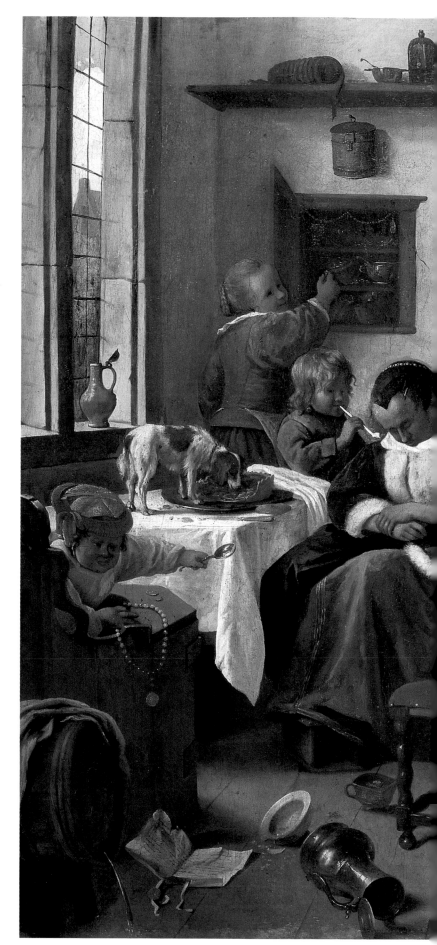

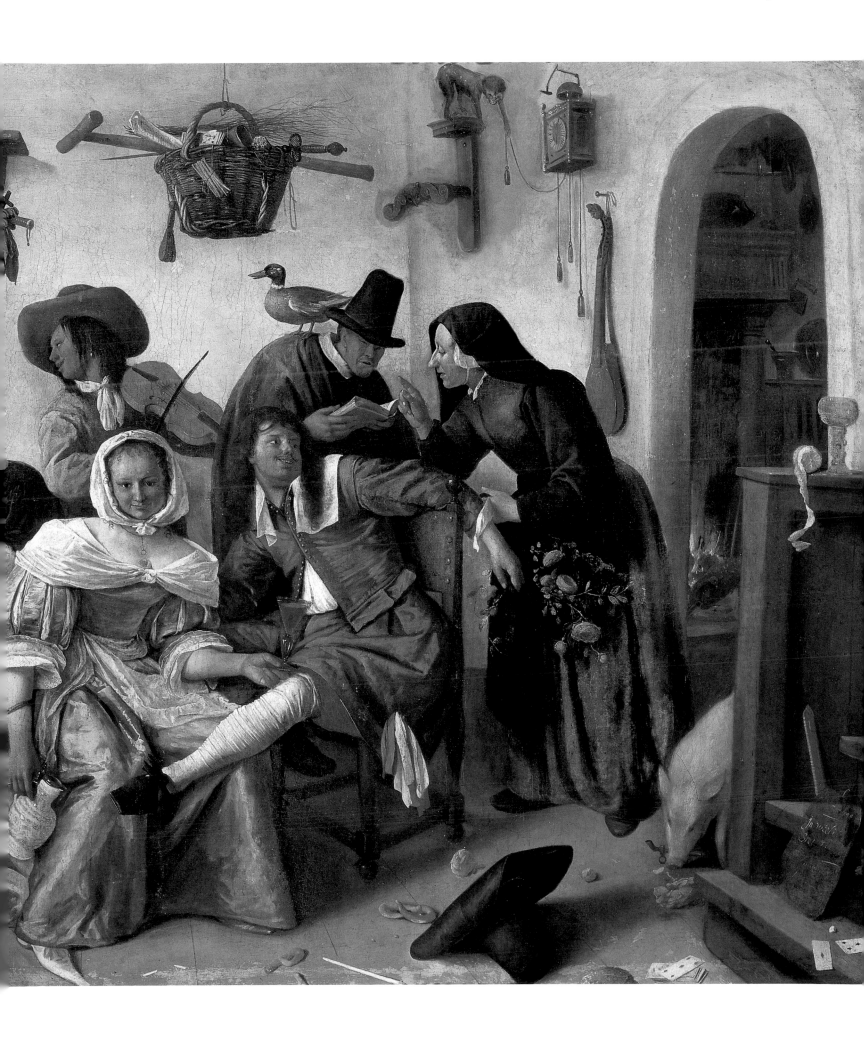

The Animal World

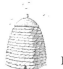

Beehive: see Bee

Across the world and throughout history, animals have been accorded powerful mythological, cultural, and religious significance. In mythology, Orpheus tamed the animals with his music; in the Old Testament, God created the animals in the Garden of Eden, Adam named them,[1] and Noah gathered them in pairs for the Ark.[2] These stories represent a time when humans lived in harmony with animals. And yet humankind has also slaughtered animals on a massive scale in sacrifice to the gods, believing that revenge would follow if they did not give offerings to the divine world.

Medieval bestiaries outlined the characteristics of real and imagined animals, and endowed them with great moral symbolism. The **APE**, or monkey, for example, often represents the base instincts of humans and is used to satirize human affectation, folly, and vanity. In Molenaer's *Lady World* (1633) a monkey slips its paw into a slipper as a representation of lust; in *The Monkey Painter* (1740) Chardin uses the animal to reveal how artists "ape" or imitate nature; and in the nineteenth-century, caricaturists mocked students as apes imitating their masters.

A less satirical but nevertheless comic role is assumed in mythology by the **ASS** who is often considered lazy or stupid. But at the Nativity, it is the humble ox and ass that recognize Christ as the Son of God. An ass with a millstone around its neck implies obedience, as in the stories of the Sacrifice of Isaac, the Virgin on the Flight into Egypt, and Christ on the Entry into Jerusalem.

The **BEE**, the beehive, and honey appear frequently in myth. Cupid was stung by a bee while stealing a honeycomb – the scene is amusingly depicted in a painting by Lucas Cranach (see page 72).

Goya and Picasso are among those painters who have been fascinated by the confrontation between toreador and **BULL**. To the ancient Greeks this animal signified potency and power, not ferocity: the god Jupiter disguised himself as a bull in order to rape Europa – for

Mythical Creatures

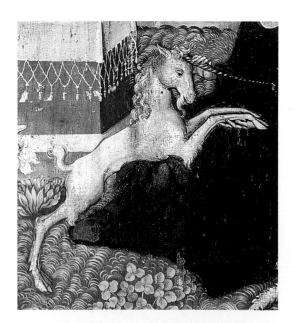

In Martin Schongauer's The Mystical Hunt *(detail; c.1475), the unicorn is depicted with the Virgin Mary, symbolizing her extreme purity.*

The encounters of early travelers with unfamiliar animals fired the imaginations of generations of writers and artists, giving rise to the creation of many fabulous beasts. One such creature is the **DRAGON**, often depicted as a gigantic, winged reptile with huge jaws, a barbed tail, eagle's legs, and sharp claws. In Christian iconography the dragon may represent the Devil, who appeared to Saint Margaret of Antioch in this form. The tale of Saint George and the Dragon was popular in fifteenth-century Italian art, where the beast may represent the infidel vanquished by the Christian knight.

Far less fearsome than the dragon is the **UNICORN** – a magnificent white pony with a goat's beard and a horn in the center of its head. With this horn it purifies waters poisoned by a serpent so that animals can drink. It is strong and swift, but can be caught by a virgin, whose purity it senses and in whose lap it will rest. Tapestries now hanging in the Metropolitan Museum, New York, show it being hunted and captured, while those at the Cluny Museum, Paris, may be an allegory of the five senses. Both series have chivalric references, as the creature was associated with courtly love, and was likened to a man who becomes the helpless servant of the lady he loves.

Dragon: see Perseus (pages 32–33), St. George (pages 163 and 176–77)
Unicorn: see St. Justina of Antioch (page 172)

Star: see Camel

this reason, a bull may represent the continent of Europe. Similar roles are afforded the **CROCODILE**, which is sometimes used to depict Africa or Asia, and the **ELEPHANT**, which appears in Old Testament scenes to evoke the East. The elephant can also symbolize the continent of Africa.

In many paintings a **CAT** may be shown as a peaceful, domestic animal, but a stealthy cat about to pounce suggests that trouble is lurking. In Manet's *Olympia* (1863) a black cat, with arched back and bristling tail, announces an intruder into the courtesan's domain. A black cat, or witch's familiar, is associated with evil. Faithfulness is the virtue most frequently associated with the cat's traditional adversary the **DOG** (see page 212). Dogs can also be guardians or symbolize greed.

Many animals have biblical associations in art, especially the **LAMB**, which was used to represent Christ (see pages 86–87). It may also symbolize one of Christ's flock of followers under the protection of the Good Shepherd,[3] as illustrated in the early Christian mosaics of the Mausoleum of Galla Placida, Ravenna, Italy. In Old Testament scenes a **CAMEL** is often included to give authenticity to the setting. This animal was considered royal, and is seen with the Magi following the star. Saint John the Baptist is often depicted wearing a tunic of camel hair. According to the Old Testament, God told Moses and Aaron to "speak unto the children of Israel, saying: These are the beasts which ye shall eat among all the beasts that are on the earth."[4] The meat of the **PIG** was not included as it was deemed unclean. Pigs were considered greedy animals and prone to lust.

An early symbol of Christianity was the **FISH** because

In van Eyck's The Arnolfini Marriage *(detail; see pages 212–13) the small dog symbolizes the couple's faithfulness.*

the Greek word for fish, *Ichthus*, contains the initial letters of *Jesus CHristos, THeou Uios, Soter* (Jesus Christ, Son of God, Savior). The variety of fish caught in the biblical episode of The Miraculous Draught of Fishes (see pages 148–49) stood for the many types of people who would embrace Christianity.

Another potent symbol in Christian art is the **STAG**, which may drink at the spring of life-giving waters[5] – as seen in mosaics from Galla Placida. The animal is the attribute of Saints Eustace, Giles, Hubert, and Julian. In secular art, Edwin Landseer's aggressive *Monarch of the Glen* (1851) echoes the proud, self-satisfied character of the Victorian ruling class. Stags were also frequently used by royalty and by the aristocracy as a heraldic device – a white hart was adopted as Richard II of England's emblem, and is seen on the badges of the angels in the *Wilton Diptych* (see pages 86–87). In classical mythology, the stag or hart was hunted by Diana.[6] She even changed Actaeon into a stag for intruding on her as she bathed.

Both Christian and mythological significance is also attributed to the **GOAT**. The animal was sacred to the Roman supreme god Jupiter, who was suckled by a she-goat. Goats may also be associated with Pan or Bacchus and his lusty satyrs. In the Christian world, the Israelites sacrificed goats to the Lord, while the scapegoat took the sins of the world into the wilderness.[7] William Holman Hunt painted a forlorn image of *The Scapegoat* in 1854–55. In the Gospel of Saint Matthew, goats are likened to the unbelievers – and when all nations gather before Christ, "he shall separate them one from another, as a shepherd divideth his sheep from the goats."[8]

Ass: see Isaac (page 122); **Bee**: see Saint Ambrose (page 169), Cupid (page 72); **Bull**: see Europa (page 53); **Elephant**: see Hannibal (page 203), Continents (page 229)

[1]Genesis 1:24–25 [2]Genesis 6:19 [3]John 10:11 [4]Leviticus 11:2–7 [5]Psalms 42:1 [6]Virgil *Aeneid* VII:480–500 [7]Leviticus 16:10 [8]Matthew 25:32

Caduceus: see Snake

The **LION** has an ancient and significant role as the king of beasts, representing strength, courage, and fortitude, and has long been included in royal and aristocratic emblems. It is a ferocious beast and to overcome it may be seen as proof of superhuman strength – as in the stories of Samson and David in the Old Testament and the classical tales of the hero Hercules. A lion lying peacefully with other animals suggests a Paradise or Golden Age without conflict; Daniel in the lions' den represents God's redemption of his people.

Vigilance is another of the lion's perceived qualities, as stated in the Old Testament: "the lion which is the mightiest among beasts and does not turn back before any."[1] It may therefore be the guardian of doorways or support church pulpits as a pillar of vigilance.

In mythology, lions draw the chariot of Cybele, the personification of Mother Earth. In Christian iconography a lion is an attribute of Saint Jerome. A winged lion symbolizes Saint Mark, patron saint of Venice; the city therefore adopted this image as their religious and political emblem.

From ancient times it was believed that the **SNAKE** had great tenacity for life and possessed medicinal powers. A serpent coiled around a staff, the caduceus, is the attribute of Aesculapius, god of medicine. Given to Mercury by Apollo, the caduceus remains an emblem of the medical profession to this day. A brazen serpent was also used by Moses to cure Israelites of snake bites.

In the classical world, the snake was also thought to be wise, an idea continued in the Gospels: "Be ye therefore wise as serpents, and harmless as doves."[2] But in the Old Testament, the serpent had been synonymous with evil, and its wisdom was the cunning of the Devil: "the serpent was more subtil than any beast of the field."[3] In representations of the Temptation the snake is often given the head of a woman, because Eve, tempted by the snake, gave the forbidden fruit to Adam, and woman is thus considered to be a temptress. In paintings of the Immaculate Conception, the Virgin may stand on a snake to show triumph over evil.

The snake has been a phallic symbol since the earliest times. The Devil and his demons are often shown with snake-like sexual organs. A snake may be poisonous too, and the attribute of Saint John the Evangelist is a chalice full of snakes, based on the legend that he drank poison without suffering any harm. The idea of "a snake lurking in the grass"[4] suggests hidden danger even in the midst of peaceful nature, such as at the ill-starred wedding of Orpheus and Eurydice.

An asp was the traditional emblem of Egypt, conspicuous on the royal diadem. No one bitten by an asp survived, and it was, therefore, an appropriate symbol of the invincibility of Egyptian rule. Cleopatra committed suicide with an asp's bite.

The **SALAMANDER** was a mythical, lizard-like reptile thought to live in, and be impervious to, fire. It nourished the good and destroyed the bad, and was adopted as an emblem of Francis I of France.

In Carpaccio's St. Jerome and the Lion in the Monastery *(detail; see pages 150–51) the lion follows the saint faithfully.*

Lion: see Daniel (page 126), David (page 124), Cybele (page 56), Hercules (page 68), St. Jerome (pages 151 and 170);
Snake: see Adam and Eve (page 88), Caduceus (page 247)

[1]Proverbs 30:30 [2]Matthew 10:16 [3]Genesis 3:1–14
[4]Virgil *Eclogues* III:92–93

Birds

In Ingres's Jupiter and Thetis *(detail; see pages 36–37) an eagle is the attribute of Jupiter.*

In classical augury, the flight of flocks of birds was read as a sign from the gods. For example the **CROW** and the **RAVEN** were considered unlucky, while the **SWALLOW** and the **STORK** were thought to be lucky. In early Christian art a bird suggested the "winged soul" or the spirit, recalling an idea held by the ancient Egyptians that the soul left the body as a bird at death.

The Christ Child may hold a bird, often a **GOLDFINCH**, as a sign of his Passion. In Raphael's *Madonna of the Goldfinch* (*c*.1506), Christ strokes the bird, but in Michelangelo's *Taddei Tondo* (*c*.1504) he recoils from it.

The **CRANE** represents vigilance and appears in Raphael's *Miraculous Draught of Fishes* (see pages 148–49) on the alert for fish that might slip out of the net. A legendary bird[1] of great beauty, the **PHOENIX** was said to transform in its own fire. In early Christian funerary sculpture, it is a symbol of the Resurrection and the hope of victory over death.

In mythological paintings, a **DOVE** sometimes appears with female deities, especially Venus, as a representation of love. This bird is also associated with funerary cults and was believed to carry souls to the afterlife. In the Old Testament, a dove returned to the ark with an olive leaf in its beak, indicating to Noah that the waters had abated. In Christianity, the bird symbolizes the Holy Ghost.

The **COCK** is associated with the dawn of a new day, because it crows at sunrise. It was thought to be vigilant and is, therefore, shown on weathervanes. With Saint Peter a cock indicates his denial of Christ, who had said to him, "Wilt thou lay down thy life for my sake? Verily, verily, I say unto thee the cock shall not crow, till thou hast denied me thrice."[2]

It was believed[3] that a **PELICAN** nourished its young with its own blood, and the bird was therefore used to represent self-sacrifice and charity. It was likened to Christ, whose blood brought salvation.

With its strength, speed, and soaring flight, the **EAGLE** is appropriately the attribute of the supreme Roman god Jupiter and a symbol of the planet Jupiter. It was adopted as the Roman insignia and was later used to represent the Holy Roman Empire, the United States of America, and other nations and dynasties. The attribute of Juno was a **PEACOCK**. With its sumptuous plumage and decorative qualities, it has been much utilized, especially in the Arts and Crafts and Art Nouveau movements.

One myth tells how Cygnus mourned the death of his friend Phaethon and, mistrusting the skies and hating fire, he chose to inhabit rivers, where he was changed into a **SWAN**. The fabled "swan song" was thought to be sung just before the bird died. Swans are associated with the Muses and with Apollo; one Greek legend claims that the soul of Apollo, and therefore of all good poets, turned into a swan. These magnificent birds may be shown drawing Venus's chariot. Jan Asselijn's *The Threatened Swan* (mid-seventeenth century) was retitled *Netherlands Defending Her Nest Against the Enemies of the State* after the artist acquired the Grand Pensionary of the Dutch Republic as his new patron.

[1]Pliny the Elder *Natural History* X:3 [2]John 13:38 [3]*Physiologus*

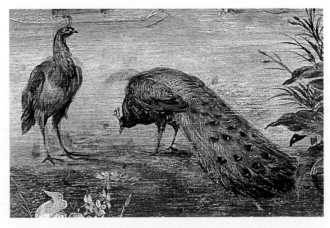

In Jan Brueghel's and Rubens' The Sense of Smell *(detail; early 17th century), peacocks stroll in an ornamental garden.*

The Fruits of the Earth

The bounty of nature is frequently represented in art by a cornucopia or bowl overflowing with flowers and **FRUIT**; such scenes are often accompanied by Ceres, goddess of agriculture, and personifications of Peace, Abundance, and Summer. Fruit may be included in **STILL LIFE** paintings (see page 217) to illustrate the transience of life, while exotic or out-of-season fruits may suggest wealth. Some artists painted fruit purely to demonstrate their skill.

Shells

In mythology, a **SCALLOP** shell was the attribute of Venus, who was born from the sea. Neptune and Galatea may be depicted riding in chariots formed from shells, while tritons and other figures may use **CONCH** shells as trumpets.

In the seventeenth century, **OYSTERS** were considered a delicacy and an aphrodisiac. They often appear in brothel scenes and may denote a prostitute; oyster-selling was regarded as one of the lowest forms of trade. In Jan Steen's *Easy Come, Easy Go* (1661), an old woman shucks oysters for a man as a young girl offers him wine. In Dutch seventeenth-century still lifes, such as those of Abraham van Beyeren (1620/21–90), exotic shells allude to newly discovered territories, and display the artist's skill.

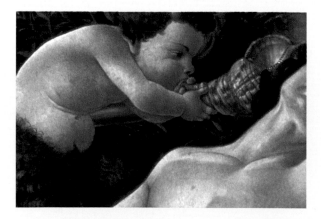

Botticelli's Venus and Mars *(detail; see pages 10–11) shows an impudent satyr trying to wake the god of war with a blast on a conch.*

Although not specified as such in the Bible, the **APPLE** is taken to be the forbidden fruit from the Tree of Knowledge – perhaps because *malus* is Latin for both apple and evil. An apple thus represents the Original Sin and the Fall of Man, and may be the attribute of Eve. An apple may also refer to other sins: in *Past and Present* (1858), Augustus Egg shows an adulterous mother cast out of her home, an apple creating a parallel with Eve's expulsion from Eden. In contrast, the Christ Child may hold an apple to signify salvation and redemption, and in mythological paintings the golden apple of Discord is the attribute of Venus.

A **POMEGRANATE** is the attribute of Proserpina (Persephone in the Greek), who was condemned to stay in the Underworld for half of each year after she ate its seeds. The fruit symbolizes the bleakness of autumn and winter and the regeneration of spring and summer – Rossetti's *Proserpina* (1874) contemplates the restrictions of her life. Christianity adopted the fruit as a symbol of the Resurrection, and the Christ Child is sometimes shown holding a pomegranate – as in Botticelli's *Madonna of the Magnificat* (1480s). Christ may also hold a **CHERRY**, which represents the sweetness of good works.

Other classical figures who have foods as their attributes are Bacchus and Ceres. The **VINE** and grapes are the attributes of Bacchus and Silenus, and of Autumn, while figures drinking wine in seventeenth-century Dutch art are susceptible to lust and sloth. In Christian art, grapes symbolize the wine of the Eucharist. Ears or sheaves of **CORN** are the attribute of Ceres, and may appear with Summer, Peace or Abundance. In Christian art, they represent Christ's body – sheaves of corn appear with grapes in Botticelli's *Madonna of the Eucharist* (1472).

Many foods have allegorical meanings. **BREAD** is the sustainer of life and a symbol of Christ's sacrifice, after he broke bread at the Last Supper.[1] The **EGG** may be a symbol of renewal, but in sixteenth-century Dutch art, an egg with two legs and a knife sticking out of the top is thought to represent a demon. **ALMONDS** may symbolize divine favor, after God chose Aaron as High Priest by causing his staff to produce "ripe almonds."[2]

Narcissus: see Flowers

Ark: see Olive

Heavenly light in an almond-shaped aureole may enclose Christ or the Virgin.

FLOWERS are the attribute of the classical goddess Flora, while various blooms sprang from those who died of unrequited love: anemones from Adonis, narcissi from Narcissus, hyacinths from Hyacinthus, violets from Attis and sunflowers from Clytie. Flowers also denote Paradise, and are used to illustrate the seasons. In Christian art, red flowers represent Christ's blood, white flowers the Virgin's purity. Cyclamen, jasmine, violets, and lily-of-the-valley are also connected with the Virgin, while the columbine may symbolize the Holy Ghost. In still life, flowers may represent the impermanence of life; seventeenth- and eighteenth-century painters also depict them as botanical jewels – perhaps including rare flowers or those from different seasons, as in Ambrosius Bosschaert's *A Vase of Flowers* (1615–20).

The over-ripe fruit in Caravaggio's The Young Bacchus *(detail; see pages 14–15) symbolizes the transient nature of earthly pleasures.*

The **LILY** is the attribute of the Virgin and of those associated with her, especially Gabriel, Joachim, Joseph, the virgin saints and Saint Dominic. It may be seen at the Annunciation, either held by Gabriel or in a vase. The **PASSION FLOWER** was likened to the Instruments of the Passion: its leaves represent the spear, its tendrils the scourges, and its anthers the five wounds; the stem of the ovary is the column of the Cross, the stigmas the three nails, and the filaments the crown of thorns. Charles Collins shows a nun contemplating the flower in *Convent Thoughts* (1850). The **ROSE** was the first flower to bloom when Venus was born, and heralds spring – themes immortalized by Botticelli in *Primavera* (*c*.1478) and *The Birth of Venus* (1484–86). In chivalrous art, rose thorns may

protect a maiden's chastity, while portraits often included roses to enhance a subject's beauty. Rose petals in religious art may represent Christ's wounds, a red rose among thorns signifies the early martyrs and their persecutors, while saints and angels may hold roses to indicate heavenly bliss. In images of the Garden of Eden, the rose may be pictured growing without thorns.

When Adam and Eve were expelled from Eden, "they sewed fig leaves together and made themselves aprons."[3] A fig leaf was thus used to cover the genitalia of classical male nudes. **LAUREL** leaves (see page 215) symbolize honor, while **MYRTLE** was sacred to Venus and signifies eternal love – in Titian's *Sacred and Profane Love* (*c*.1515), it crowns the bridal figure.

Evergreen **IVY** is the attribute of Bacchus, often covering his wand or crowning his head; it may also symbolize immortality. In *The Long Engagement* (1859), Arthur Hughes shows ivy covering the carved initials of a curate and his fiancée. The **OLIVE** tree was a symbol of peace in both the classical and Christian worlds, and was sacred to Minerva. In the Bible, a dove brought an olive branch to the ark to show that God had made peace with man, and the Archangel Gabriel may also carry one, as in Taddeo di Bartolo's *Annunciation* (*c*.1409). **PALM** leaves originally signified victory, and personifications of Victory or Fame may be shown bestowing them upon the illustrious. Christianity later adopted the palm for martyrs who had triumphed over death, and it is also associated with Christ's Entry into Jerusalem.[4] **CYPRESS** trees often grow in cemeteries, so may be associated with the dead – as in Arnold Böcklin's *Island of the Dead* (1880).

Apple: see Adam and Eve (page 88); **Flowers**: see Adonis (page 50), Clytie (page 76), Hyacinthus (page 72), Narcissus (page 75); **Myrtle**: see Venus (page 11)

[1]Luke 22:19 [2]Numbers 17:8 [3]Genesis 3:7 [4]John 12:13

Landscape and the Elements

Grapes: see Autumn

Until the late sixteenth century, **LANDSCAPE** painting in Western art simply provided a convenient backdrop for outdoor scenes. During the Renaissance, however, the details of these landscapes became increasingly naturalistic and since then the interpretation of nature has reflected various aims – either as a subject in its own right or as an enhancement of a particular theme.

Landscapes often indicate humankind's relationship with nature – rural scenes perhaps revealing an intimacy with nature or consciously ignoring the impact of the Industrial Revolution. The pastoral image also recalls the mythical Golden Age, when humans and nature existed in harmony and the rivers flowed with milk and nectar. Cultivated fields and a clement sky may suggest humankind in control of the environment, while stormy scenes usually indicate the superior forces of nature. The time of day depicted and treatment of light are evocative too – dawn often suggesting hope and evening light casting ominous shadows.

Some landscapes are purely topographical, while others may present picturesque views with arcadian or heroic connotations. Watteau was particularly fond of **FÊTE CHAMPÊTRE** scenes (see pages 218–19), showing the wealthy in idealized pastoral settings; the Impressionists were renowned for painting tamed and populated landscapes; Van Gogh, Cézanne, and Gauguin chose to present wild images of nature, more akin to their own temperaments.

The seasons (see box, opposite) help to convey mood: winter communicating bleakness and decay, spring and summer the optimism of renewal and vigor, and autumn the benefits of plenty. A **HARVEST** scene may represent summer and signifies nature's abundance. Jean-François Millet's *The Gleaners* (1857) subverts the usual mood, for his peasants are so poor that they have to collect the remains left by the harvesters.

In the book of Genesis, the **GARDEN** of Eden is described as an earthly paradise where flowers bloom and animals roam free. God expelled Adam and Eve from Eden after they ate the forbidden fruit of the Tree of Knowledge, and the theme was highly popular in medieval and Renaissance art. In life, the medieval garden was confined within the precincts of castles and monasteries; in art it may be shown as a Garden of Love, embodying the pleasures and conventions of a courtier's life. Medieval gardens also appear in illustrations of the early fourteenth-century poem *Le Roman de la Rose*, in which the young poet is led to a Palace of Pleasure to meet Love, only to be obstructed by Danger, Fear, and Slander. The Virgin is also shown in a walled garden with flowers scattered across the ground – the *Hortus Conclusus* – in reference to the Immaculate Conception. The Rhinish Master (fifteenth century) shows this in *Paradise Garden.*

In England, gardens laid out for royalty and the aristocracy reflected the latest fashions, but they were also an indicator of political and social change. Until the 1750s, avenues, terraces, and hedges were used to form geometrical designs and often reflected a hierarchical and authoritarian society. In the eighteenth century, this regularity gave way to the open curves of Lancelot "Capability" Brown, who designed parks modeled on the classical landscapes of the French painter Claude Lorrain, and on literary descriptions of gardens with grottoes, walks, fountains, and statues. With the onset of the Romantic movement in nineteenth-century painting and literature, it became fashionable to imitate wild, remote landscapes, and these were often the settings for contemporary Gothic novels.

The four **ELEMENTS** – earth, water, fire, and air – may be illustrated by relevant objects, such as water pouring from an upturned urn or birds flying through the air, or by figures involved in an appropriate activity. They may also be represented by the gods of antiquity. **EARTH** may be the goddess Ceres or Ops, who may hold a globe or a cornucopia, while other representations include Cybele with her lion, and the bountiful Golden Age. **WATER** may be represented by a seascape, a river scene with reeds and fish, by Neptune, god of the sea, or a river-god, or by the birth of Venus from the sea. **FIRE** may be Vulcan at his forge or the sun, while **AIR** may be represented by Boreas, god of the north wind, Zephyr, god of the west wind, or by Juno's peacock.

Luna was the goddess of the **MOON** and sister of the

 Fish: see Water

The Cycle of the Year

The **SEASONS** are often indicated in paintings by farming activities and weather: Pieter Bruegel the Elder painted panels illustrating two-month periods, such as *Hunters in the Snow* (*c*.1560), which represented January and February. Giuseppe Arcimboldo used agricultural produce to form the figures and faces of the seasons (see pages 216–17).

The seasons are sometimes likened to the four Ages of Man. David Teniers illustrated this in *Spring, Summer, Autumn, Winter* (*c*.1640). Poussin (1594–1665) incorporated scenes from the Old Testament in his series of the four seasons: Adam and Eve in Paradise represent **SPRING**; Ruth and Boaz symbolize **SUMMER**; spies returning from the Promised Land are **AUTUMN**; and the Flood represents **WINTER**.

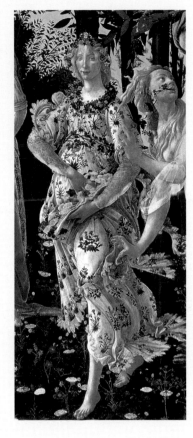

In the tradition of Italian art, the gods of antiquity may also represent the seasons. Spring is the time to plant, so may be personified as Flora, goddess of flowers, or a young girl with flowers, a spade or a hoe. Summer is the time of harvest, and may be Ceres, goddess of the harvest, or a girl with sheaves of corn, fruit or a sickle. Autumn is the time for pressing wine, and may be indicated by Bacchus, god of wine, or a figure with grapes. Winter is often represented by Vulcan, god of the forge, or an old man warming himself by a brazier in a snowy landscape.

Seasons: see Ages of Man (page 245)
Summer: see Ruth (page 128)

Flora's dress and the carpet of flowers on which she walks perfectly encapsulate spring in Botticelli's Primavera *(detail; see pages 20–21).*

Sun. She was connected with the goddess Diana, who is often identified by a crescent moon in her hair or in the sky. The moon may obviously symbolize the night, but it was also a symbol of chastity associated with the Virgin, notably in paintings of the Immaculate Conception. The sun and moon together may refer to the unity or cycle of time, to the universal, or to a marriage of dual natures. Both these heavenly bodies may be shown in the sky in scenes of the Crucifixion. The **MILKY WAY** stretches in a luminous band across the night sky,[1] and various authors describe its origins. In one account, Jupiter held Hercules to sleeping Juno's breast to secure his son's immortality, and after the infant had finished drinking, the flow of milk continued – some falling to Earth as lilies, some splashing upward to create constellations. Tintoretto depicts this scene in *The Origin of the Milky Way* (*c*.1570), showing Hercules waking his unwitting wet-nurse. The **RAINBOW** is associated with the goddess Iris who descended from the sky on a rainbow when she brought messages from the gods to mortals. In the Bible, a rainbow was sent by God after the Flood as a symbol of reconciliation with humankind.[2] It surrounds Christ's throne in the Last Judgment, after the vision in Revelation.[3]

Air: see Winds (page 62)
Moon: see Diana (page 61)
Rainbow: see Last Judgment (pages 92–93)

[1]Hygnus *Poetica Astronomica* II:43 [2]Genesis 9:13 [3]Revelation 4:3

The Body and Soul

In the Middle Ages, the body was believed to contain four humors relating to the **TEMPERAMENTS** (from the Latin *temperare* – to measure), which could be disrupted by planetary movements and diet. The dominant humor determined character: an excess of blood made people sanguine, yellow bile made them choleric, phlegm made them phlegmatic, while too much black bile caused **MELANCHOLIA**, which was associated with intellectual pursuits. Melancholia was Saturn's introspective daughter, and Dürer's *Melancholia* (1524) shows her slumped in gloomy contemplation, a book unopened in her lap and a pair of compasses unnoticed in her hand. The **SENSES** were popular subjects in seventeenth-century art, and may be represented by items such as musical instruments for hearing and flowers or pipe smoke for smell. In his series *Senses* (*c*.1650), Gonzales Coques unusually depicts a man letting blood drain from his arm to portray touch. The senses are also suggested in Willem Buytewech's *Merry Company in the Open Air* (*c*.1620–22) as a reminder of the vanities of the material world. **EYES** often symbolize the eyes of God, for in the Bible "the eyes of the Lord are over the righteous."[1] The Trinity may be shown as an eye within a triangle, while a pair of eyes is the attribute of Saint Lucy. Christ healing the blind is an allegory of spiritual **BLINDNESS**, while Pieter Bruegel the Elder's *The Blind*

Personifications

The representation of concepts and places, including the four **CONTINENTS** (see page 229), in human form has been a popular artistic technique for centuries, with humans of different ages and with different attributes standing for different qualities. **TIME** is often personified as an old man with an hour-glass or scythe, and in Pompeo Batoni's *Time* (1747) he points to a girl while an old woman loses her beauty. The transience of time is shown using items that wither or disappear, such as flowers, smoke or bubbles, or by objects reminiscent of death. Michelangelo interpreted Time as the figures of *Dawn, Dusk, Night and Day* (*c*.1530).

TRUTH is Time's daughter, and she may stand naked with the attribute of the sun's rays or the sun, or a book in which truth is written. She may also stand on a globe to signify her superiority to worldly concerns, an idea used by Bernini in his sculpture *Truth* (1646). The attributes of **PEACE**, another female personification, are an olive branch and a dove; she may hold a

Bronzino's bare-breasted Allegory of Happiness *(detail; 16th century) holds a cornucopia.*

cornucopia, sheaves of corn, or flowers, or be surrounded by the fruits of the earth, which she nurtures. She may celebrate the end of her counterpart, **WAR** (see page 227), or illustrate the benefits of peace. The female figure of **ABUNDANCE** represents the prosperity brought about by peace and justice, and her attribute is usually a **CORNUCOPIA** full of fruit and jewels. She may be surrounded by children and once-wild animals that have been tamed. **CONCORD**, the harmony between people or nations, may also be expressed by a woman with a cornucopia or corn.

A winged female often indicates **FAME** who bore away the illustrious dead on her wings; by the Renaissance she had acquired a trumpet with which to herald the famous. Bernardo Strozzi's *Fame* (*c*.1635) shows her with a gilded trumpet and a plain recorder, representing both the good and bad aspects of her proclamations. Deceit is also often represented as a woman (see page 221), while **FOLLY** is usually a youth (see page 221).

Flowers: see Senses

Pipe: see Senses

Leading the Blind (1568) was inspired by Christ's parable[2] and warns of the perils of choosing an unfit leader. The blindness of secular love may be indicated by a blindfolded Cupid, while other blindfolded figures may personify unprejudiced Justice (usually a female figure with a sword and scales), unpredictable Fortune (if she has a globe or wheel) or Ignorance.

A **HEART** symbolizes divine love and understanding, for "the Lord looketh on the heart."[3] Saints may hold a flaming heart, perhaps pierced by an arrow, and the attribute of Saint Ignatius Loyola is a heart crowned with thorns. A **HAND** often represents the hand of God and may release a dove to the Virgin, while a hand paying Judas or holding coins denotes Christ's Betrayal. A hand also became an Instrument of the Passion after Christ's face was slapped during his mockery, as seen in the fresco by Fra Angelico in San Marco, Florence.

Many early works showed the Virgin offering her **BREAST** to the Christ Child, until the Council of Trent (1545–63) disapproved. Breasts are also associated with Mother Nature and nourishment, while a bared breast can be a sign of humility, grief, or anger. A woman breastfeeding may personify Charity; the Roman tale of Pero feeding her imprisoned father was popular with Renaissance artists. A **NUDE** may represent shame (see page 223), while a nude female figure may represent **FERTILITY**, accompanied by a hen with eggs and chicks, or by hares and rabbits. **BARE FEET** usually indicate Christ and his disciples, who obeyed his command to "carry neither purse, nor scrip, nor shoes."[4]

The span of life is divided into the **AGES OF MAN**. Sometimes there are four, corresponding to the seasons, and sometimes three. Children may play near a dead tree to represent the two extremes of the cycle, youth may be a soldier or a pair of lovers, and a man contemplating a **SKULL** (see page 225) may represent old age. Usually the subject implies the transience of

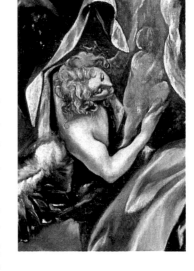

In El Greco's The Burial of Count Orgaz *(detail; 1586–88), an angel in the sky above the funeral party waits to receive the deceased count's soul.*

life, but Titian's painting *The Three Ages of Man* (1510–16) is an allegory of prudence, suggesting that the present should learn from the past.

SLEEP may be personified and shown in a silent cave where poppies bloomed, dispatching his son Morpheus to deliver dreams.[5] Dreams may be depicted as visions of delight or horror – the latter portrayed in Henry Fuseli's *Nightmare* (1781), while in Goya's *The Dream of Reason Produces Monsters* (c.1790) irrational ideas are transformed into owls, bats, and a cat. A man asleep with women often had a lewd significance, and Gerard Terborch's *Women Drinking Wine with a Sleeping Soldier* (seventeenth century) was a warning against sin.

DEATH was the brother of Sleep; they may be shown as dark- and light-skinned *putti*, as in Poussin's *Diana and Endymion* (c.1630). More commonly, Death is represented by a skeleton, sometimes wearing a hooded cloak, and carrying a sword, scythe, sickle, or hour-glass. *The Triumph of Death* was a popular subject, and Francesco Traini's frescoes at Campo Santo, Pisa (mid-fourteenth century), depict three noblemen horrified by decomposing corpses in open coffins. Death may also be a reminder that no one is spared, regardless of age or status, and Edvard Munch's *Death and the Maiden* (1893) shows the fatal embrace of death as the destroyer of beauty. In Christian art, the **SOUL** was usually depicted as an infant, either taken to Hell by demons or carried to Heaven by an angel, as in El Greco's *The Burial of Count Orgaz* (see detail, above).

Eyes: see St. Lucy (page 171)
Heart: see St. Ignatius Loyola (page 179)
Melancholia: see Saturn (page 56)

[1]Psalms 34:15 [2]Matthew 15:14 [3]I Samuel 16:7 [4]Luke 10:4
[5]Ovid *Metamorphoses* XI:592–615

Objects, Pastimes, and Emblems

The activities and objects pictured in a scene often have particular significance. **ARMOR** identifies warriors such as Mars, god of war, his female counterpart Bellona, and Minerva, goddess of war and wisdom. Fortitude and Europe may wear armor too, as may several Christian saints including the Archangel Michael, Saint Liberale, and Saint George, while Pilate and his Roman soldiers may be seen in armor in paintings of Christ's Passion. Armor and weapons also litter Vulcan's forge, Victory and Peace may be seen with a pile of armor, while a *putto* standing on armor or near a sleeping warrior usually represents love triumphant. In fifteenth-century Italy, the ideal career was thought to be dedicated to both arms and letters, and Berruguete painted the Duke of Urbino reading while dressed in armor in *Federigo da Montefeltro* (1480). **CHAINS** are used to denote a captive, in reality or symbolically, and are associated with Saints Leonard and Vincent. Venus and

Color

Ultramarine was made from lapis lazuli and reflects a patron's wealth or the importance of a work. Red was also expensive, while purple – made from two costly pigments – came to be associated with royalty. Other colors rarely have symbolic meaning, except for black, which is linked with death.

The color of peoples' clothes may signify identity, especially if figures appear in a series of events; in Italian art the Virgin usually wears a blue dress, whereas in Northern art she may wear red. Figures may also wear different colors to distinguish stages in their life: Mary Magdalene's red dress indicates her early life as a sinner, and a green one her time as a penitent hermit. From the Renaissance to the nineteenth century, color was mainly used naturalistically, except in imaginative images, such as paintings of the infernal regions. Later artists exploited its decorative and emotive qualities, Kandinsky (1866–1944) likening its effect to that of music.

Mars may also be pictured in a net of chains, forged by Vulcan to expose his wife's adultery.

Cupid has two kinds of **ARROW**: the one "which kindles love is golden and shining … but that which puts it to flight is blunt, its shaft tipped with lead."[1] A bow and arrows are also the attributes of Diana and Apollo, and the belief that Apollo's arrows brought the plague may have influenced the legend of Saint Sebastian, who survived being shot full of arrows and was therefore invoked against the plague. In Renaissance Italy he was often painted bristling with arrows. An angel pierced Saint Teresa's heart with a divine arrow that gave her both intense pain and spiritual ecstasy. **HUNTING** was the sport of rulers and the aristocracy, offering the opportunity to display wealth, power, and dynamic configurations of people and animals in a wooded setting. In Christian art, the unicorn was hunted as a type of Christ, and Saints Eustace and Hubert may be shown as hunters.

Both the upper- and lower-classes enjoyed playing **CARDS** in seventeenth-century Europe, but moralists considered it sinful – so cards usually denote idleness or vice. Jan Steen put cards in the foreground of *Beware of Luxury* (see pages 234–35) and *The Dissolute Household* (*c.*1660) as a reminder that "cards, women, and drink have ruined many a man," and in *Card Players Quarreling* (1664–65) he depicts a fight between gamblers. In his triptych *Past and Present* (1858), Augustus Egg used the image of children building a collapsing house of cards to show a disintegrating home, but Cézanne simply painted card-players as part of the local life of France. If Cupid holds an ace of hearts he refers to love triumphant, but with a blank playing-card, he symbolizes the hazards of love. **DICE** or a single die can represent fate (as in "the die is cast"), and dice used in a game of chance may be the attribute of Fortune. **COINS** usually suggest corruption (see page 230).

A wool-carder's **COMB** is the attribute of the martyrs Blaise and Bartholomew, who were flayed alive; the latter is seen in Michelangelo's *Last Judgment* (1536–41) holding the instrument of his torture and his empty skin – containing a self-portrait of the artist. Degas

Cupid: see Arrow

(1834–1917) painted women combing their hair as part of their daily toilet; but other artists used the image as an indication of vanity, especially if the woman holds a mirror or is surrounded by other worldly effects. Another object owned by women was the **CASSONE**, a wedding chest from the Italian Renaissance. Its panels may be painted with scenes from mythology, the Bible, or ancient history – either suggesting a happy marriage or warning men of the captivating power of other women, or women against disobedience.

SCALES (see page 230) are usually the attribute of Justice, while a pair of **COMPASSES** is associated with Melancholia, and may also be the attribute of astronomers, geometricians, and architects. During the Creation, God "set a compass on the face of the depth"[2] to impose order on chaos – as seen in William Blake's *The Ancient of Days* (c.1794) – so a pair of compasses may also represent the rational. The **CADUCEUS** – a wand entwined with two snakes, perhaps with wings at its tip – is the attribute of Mercury and is carried by messengers as a sign of peace. Aesculapius, god of medicine, may also hold one, for after God cured Moses' people with a brazen serpent, snakes were believed to have healing powers. A **CLUB** is a sign of strength and may be held by Fortitude. It is also the attribute of Saint Jude, Saint James the Less, Hercules, and Theseus – who killed a robber renowned for battering passers-by to death with a brazen club.

A **CROOK** usually belongs to shepherds and may be the attribute of Apollo or of Christ (the Good Shepherd) and his Apostles. Likewise, a bishop's crook-shaped staff or crozier denotes him as the shepherd of his spiritual flock. A **CRUTCH** supports the old or

The single candle in van Eyck's The Arnolfini Marriage *(detail; see pages 212–13) may stand for the all-seeing Christ.*

infirm; it is the staff of hermits, beggars, and pilgrims, and the attribute of Saints Anthony Abbot and Romuald. Salvador Dali, who had his own strange symbolic vocabulary, often painted limp objects supported by crutches, as seen in *The Enigma of William Tell* (1933). A **SCEPTER** is a staff held by a person in authority, especially a monarch or an emperor, and the tip may bear an appropriate emblem or attribute. An **UMBRELLA** or parasol was also used as a sign of sovereignty or protection, and the Holy Roman Emperor may be pictured holding one over the Pope to indicate their alliance.

In the Old Testament, a **LAMP** signifies divine light and wisdom.[3] Caravaggio may include an external light source to suggest divine illumination, and Christ's words[4] also inspired William Holman Hunt's *The Light of the World* (1853–56). But a landscape bathed in a golden glow, such as Albert Cuyp's *Milkmaid and Cattle Near Dordrecht* (c.1650), evokes a rural idyll where mankind is in harmony with nature. **CANDLES** play an important part in many religions. In Christian art, the Eucharist candles represent Christ's presence at communion, the Paschal candle the risen Christ at Easter, while the Menorah or seven-branched candelabrum represents Judaism. A candle in Dutch seventeenth-century still life, however, suggests the transience of life.

A full **SAIL** or billowing drapery may illustrate the winds or suggest prosperity and success, especially in works depicting triumphs. But the winds are variable, so a sail may also be the attribute of Fortune, representing her fickleness. In Christian art, a **SHIP** may represent a safe haven for the faithful, symbolized by Noah's ark or the Navicella: the ship in which the disciples were sailing when Christ walked on the waters.[5]

Armor: see Mars (page 59), Michael (pages 84 and 118); **Arrow**: see St. Sebastian (page 155); **Club**: see Hercules (page 68); **Crook**: see Crozier (page 249)

[1]Ovid *Metamorphoses* I:469–72 [2]Proverbs 8:27 [3]II Samuel 22:29 [4]John 9:5 [5]Matthew 14:24–27

Christianity

Globe: see Salvator Mundi

Symbols of Christian thought and practice abound in art from the Middle Ages onward. The seven **SACRAMENTS** of the Catholic Church – Baptism, Confirmation, Ordination, Matrimony (or **MARRIAGE**, see page 212), the Eucharist, Penance, and Extreme Unction – are often represented. Rogier van der Weyden's *Seven Sacraments Triptych* (*c*.1451–53) is a rare depiction from the Renaissance, while Poussin painted two series entitled *The Seven Sacraments* (1644–48), in which John the Baptist and Christ represent Baptism; Confirmation is set in the catacombs and evokes the early Christian age; Ordination is Christ giving the keys of Heaven to Saint Peter; Matrimony is the marriage of the Virgin and Joseph; the Eucharist is the Last Supper; Penance is Mary Magdalene washing Christ's feet; and a man receiving the Sacrament is Extreme Unction.

Religious objects, including books, are often present even in paintings of a secular theme. A **MISSAL**, or book of the Mass, contains services and prayers for the liturgical year; it may be decorated with scenes of the Crucifixion, Christ in Majesty or other episodes from Christ's life. A **BOOK OF HOURS** contains daily prayers for the laity; the hours may be illustrated with religious scenes, the months with seasonal farming activities, astrological charts or the pursuits of the aristocracy. The **ANGELUS** is the prayer for giving thanks for the Annunciation, and Jean-François Millet's *Angelus* (1859) shows peasants praying in the fields at the sound of the Angelus bell; the scene became widely known through reproductions and was perversely reinterpreted by Dali. The **ROSARY** – a string of beads used to keep count during prayers – may appear in paintings of the Virgin, as in Bergognone's *Virgin and Child* (*c*.1490), or in portraits of Saint Dominic, who instituted its use.

A **CROSS** has represented Christ's Crucifixion and the Christian faith since the fifth century. The Latin cross is the traditional form, a double-armed cross is the sign of a bishop, a triple-armed cross is the sign of the Pope; a Greek cross is symmetrical, while Saint Andrew's cross is X-shaped. The **CRUCIFIX**, an image of Christ on the cross, specifically represents Christianity. Many hermits and penitents are shown contemplating one; but it appears most often with Saints Francis, Jerome, John, Gualbert, Nicholas of Tolentino, and Scholastica, and between a stag's antlers before Saint Eustace. The letters **IHS** – an abbreviation of the Greek word for Jesus – may appear on the cross, and in 1424 the monogram became Saint Bernardino's attribute after he decided the initials signified "*Jesus Hominum Salvator.*" It is also the emblem of the Jesuit Order, gloriously celebrated in Baciccia's *Adoration of the Name of Jesus* (*c*.1685). **INRI** stands for *Iesu Nazarenus Rex Iudaeorum* (Jesus of Nazareth, king of the Jews), while **CHI RHO** consists of the first two letters of the Greek *Khristos* (Christ).

Many ceremonial objects have religious significance and relate to particular sacraments, incidents or figures. A **CHALICE** is the cup of the Eucharist, after Christ "took the cup, and ... they all drank of it;"[1] it features in paintings of the Eucharist and with saints or priests. A chalice with snakes is the attribute of Saint John the Evangelist. A **CORPORAL** is the cloth on which the chalice is placed before consecration; a **CIBORIUM** is a cup with an arched cover, reserved for the Host (or a canopy covering an altar or shrine). Ornate containers called **RELIQUARIES** hold holy relics and were used to perform miracles; they appear in the *Stories of the Relic of the True Cross* (*c*.1496) by Bellini and his studio.

SALVATOR MUNDI was the name for an image of Christ holding a globe, as in Carpaccio's painting (*c*.1510). Christ may point above to the divine, make the sign of benediction, or wear a crown of thorns. A **HALO** is the light shining around the head of the divine and is usually circular, although those of Christ or God may be triangular to represent the Trinity; Christ may also have a cross behind his head for a halo. A larger **AUREOLE** is reserved for God, Christ or the Virgin.

Christianity: see Life of Christ (pages 132–37), Virgin Mary (130–31), Saints and Their Miracles (Chapter Three)

[1]Mark 14:23–25

Religious Orders and Clothing

Members of religious Orders and ministers of the Church can be identified by their clothing – ministers usually being depicted in the highest office they attained.

Saint Anthony is thought to have founded monasticism in the third century. Different **HABITS** distinguished the Orders that evolved, while an abbot or abbess carried a **PASTORAL STAFF** to signify office. The **BENEDICTINES**, founded by **SAINT BENEDICT** (see page 161) in around 529, are the oldest European Order, and the abbey built at Cluny in 910 became a major religious center in the Middle Ages. The habit of the original Order was black. Reformations of the Order created the Cistercians, Carthusians, and Camaldolese, who all wear white, and the Vallombrosians, who wear pale grey. The Olivetians and Oratorians are also reformed Benedictines.

In about 1060, Saint Augustine founded the **AUGUSTINIANS**, stressing communal living and care of the poor; their habit is black. When Saint Francis of Assisi founded the **FRANCISCANS** in 1210, he called his friars *frati* (brothers) instead of *padri* (fathers) to emphasize their humility. They took vows of chastity, poverty, and obedience, renounced all forms of ownership, and were noted as missionaries and preachers. Initially, their hooded habit was grey, hence the term "grey friars," but it later changed to brown, bound at the waist with a knotted cord, and they are shown barefoot or wearing simple sandals. Saint Francis also established a community for poor women: the Poor Clares. The **DOMINICANS** place emphasis on study and teaching, and were founded by Saint Dominic in 1216; they wear a white gown with a black hooded cloak. The Jesuits believe in charity, education, and moderation. They achieved special status in 1540 when

Spinello's The Heavy Stone (*detail; see pages 160–61*) *depicts Benedictine monks building the first monastery at Monte Cassino.*

the Papacy approved them as the Society of Jesus; their habit is black with a high collar.

The dress of ministers denotes their rank, distinguishing bishops from priests and deacons. The Pope has a **TIARA** (a conical hat with three crowns) or wears a white **CASSOCK** (a long tunic) with a short red cloak. Cardinals wear a scarlet cassock and a scarlet broad-brimmed hat with a low crown. Bishops wear a **CHASUBLE** (a highly decorated outer garment) and a **MITRE** (a tall decorated head-dress with a cleft) and carry a **CROZIER** – the original staff of the Apostles, which became highly elaborate. Deacons may carry a **CENSER** (an incense burner), while the regular clergy wear the habit of the Order to which they belong. Dress also reflects the office ministers are performing. When celebrating Mass they wear a chasuble, a **STOLE** (an embroidered band worn around the neck and crossed over the chest) and a **MANIPLE** (a silk band worn on the arm). A **COPE** (a large semi-circular cape with a deep collar) is worn on special occasions and in processions, otherwise a cassock and **BIRETTA** (a square, ridged hat) are worn – usually black for priests and purple for bishops and deacons. Some elements of the liturgical dress were common to different ministers – for example, a bishop's mitre is also worn by the Pope as Bishop of Rome.

PILGRIMS journeyed to sacred places out of religious devotion or as a penance – sometimes on orders from the Inquisition. They were expected to return with evidence from their destination, such as a cross and palm from the Holy Land or a **COCKLE SHELL** from the shrine of Saint James at Santiago. A cockle shell in the hat denotes a pilgrim, who may also wear a simple cloak, carry a staff, and be barefoot as a sign of humility or poverty.

Virtues and Vices

Scales: see Justice

The four natural or **CARDINAL VIRTUES** of Temperance, Justice, Prudence, and Fortitude are the "hinges" on which all other Virtues hang. They are often personified as women. **TEMPERANCE** is a figure of moderation; she can be seen with an unsheathed sword, a bridle for enforcing restraint or a pitcher of water with which to dilute her wine. **JUSTICE** usually holds the sword of power and scales of balance, and in the sixteenth century was shown blindfolded to symbolize her impartiality and incorruptibility. She may also punish the wicked or give alms to the righteous. **PRUDENCE** may be seen with a book of wisdom or a serpent,[1] and may hold up a mirror to reflect truth. She often has more than one head, signifying that she learns from the past and has foresight. **FORTITUDE** is a figure of strength and may be shown with a shield, a lion or a column (see detail, opposite) – a reference to the biblical character Samson, who pulled down the columns of a building in which he was ordered to entertain the Philistines. She may be represented by the courageous widow Judith or by the mythical hero Hercules, who was renowned for his strength.

The three **THEOLOGICAL VIRTUES** are Faith, Hope, and Charity; they were sanctified by the medieval Church as specifically Christian virtues, imparted by God through Christ. **FAITH** is resolute and majestic, and may hold a book, a lighted candle, and a heart, a cross or a chalice. **HOPE** may be a winged figure reaching up to a crown and looking to the future in expectation. **CHARITY** often holds a cornucopia or bowl of fruit and may be seen giving alms, emphasizing the bounty that she distributes and her kindness. She is "mother of the virtues," and in many Renaissance paintings she is depicted as a loving mother with children, perhaps nursing one of them – as in Cranach's *Charity* (*c*.1540). She also provided an example for ideal citizens to follow, living their lives according to the seven acts of mercy: "For I was hungered, and ye gave me meat; I was thirsty, and ye gave me drink; I was a stranger, and ye took me in. Naked, and ye clothed me; I was sick, and

The Seven Deadly Sins

Anger, **PRIDE**, Envy, Lust, **GLUTTONY**, Sloth, and Avarice are the seven deadly sins. Those guilty of these sins are condemned to Hell, where demons inflict punishments related to the crimes. The sins are personified with various attributes: **ANGER** may be a woman tearing her clothes, while **AVARICE** often holds a purse; in the *Inferno* (fourteenth century) Dante places usurers in the seventh ring of Hell. **SLOTH** may be represented by scenes of idleness – these were popular in seventeenth-century Dutch art, and Sloth may be shown as a woman dozing or daydreaming, as in Nicholaes Maes' *Interior with Sleeping Maid and Her Mistress* (1660s). Other artists suggested that **LUST** brought on slothful sleep, and some used the ass or pig as symbols of lust. According to Ovid, **ENVY** lived in a filthy, sunless house; she was wasted and sickly and her tongue dripped venom. In *The Battle of the Sea Gods* (*c*.1470) Mantegna depicts her as a scrawny old woman.

In The Table of the Seven Deadly Sins *(detail; c.1480–85), Bosch depicted the sins around the central figure of Christ; the complete circle represented God's all-seeing eye.*

Pitcher: see Temperance

Pig: see Lust

ye visited me; I was in prison, and ye came unto me."[2] The seventh act is burial of the dead. In the seventeenth century, charitable brotherhoods often commissioned paintings representing these acts.

Chastity, Poverty, and Obedience are the monastic vows and may appear as women. **CHASTITY** often wears a veil or holds the palm of the virgin martyrs, and may be locked in combat with Lust or stand in triumph on a symbol of lust. She also appears as Diana, goddess of Chastity, and may carry a shield to deflect Cupid's arrows and a chain for binding love. Chastity may also be represented by virtuous Roman women such as Tuccia, or by biblical characters such as the demure Susannah or Joseph, who refused Potiphar's wife. In Christian art, Saints Benedict and Francis may throw themselves into thorny bushes to quell their desires, Saint Anthony may be seen controlling erotic dreams through prayer, while virtuous female saints may hold a lily.

Other minor virtues include Humility, Hospitality, Innocence, and **FIDELITY**, the secular counterpart of Faith, who may have a dog sitting at her feet and hold a key that signifies her trustworthiness. **ABSTINENCE** is usually illustrated by figures famous for their self-restraint, such as King Seleucus, Alexander the Great, and the Roman general Scipio, who refused a young girl betrothed to another. In allegories of Abstinence, a wise Minerva may take an adolescent Cupid from the arms of a naked woman, as in Pietro da Cortona's fresco in the *Rooms of Venus* (*c.*1640; Pitti Palace, Florence). Justice may be portrayed as Zaleucus, the magistrate of a Greek settlement in Italy (sixth century BCE) who was once required to find his own son guilty of adultery. The punishment for the adulteror was to lose both eyes;

De la Hyre's Allegory of the Regency of Anne of Austria *(detail; see pages 214–15) shows a winged figure representing Virtue or Fortitude.*

and even though the people were compassionate and intervened, Zaleucus had one of his own eyes taken out and one of his son's rather than defy the law.[3]

A **BATTLE OF VIRTUES AND VICES** (see page 233) shows the virtues fighting the vices and defeating them. All kinds of wrongdoing may be personified in these paintings, including Cowardice, **DECEIT** (see page 221), Idolatry, Inconstancy, Infidelity, Injustice, Folly, **LUXURY** (see page 234) and Vanity.

CALUMNY, or Slander, was painted in antiquity by Apelles. The painting was described by the Greek prose writer Lucian (first century CE) as depicting a man with big ears receiving evil counsel from Ignorance and Suspicion, while the figure of beautiful but crafty Calumny holds a lighted torch in one hand and drags her victim by the hair with the other.[4] Calumny's guide is pale and filthy Hatred, her handmaids Envy and Fraud, and behind the group stands Penitence dressed in funeral robes, followed by the young and modest Truth. Botticelli reconstructed the picture in the fifteenth century on the basis of Lucian's literary description.

In seventeeth-century Dutch art, **INTEMPERANCE** may be a figure who has fallen asleep after too much smoking and drinking. Jan Steen's *Effects of Intemperance* (1663) shows the folly of such disorderly behavior: a young boy steals from the drinker's purse, a maid gives drink to a parrot, children feed a cat on food meant for adults, and a boy casts roses before swine. As a reminder of the fate of those who lack self-discipline, the birch of punishment is placed in a basket above Intemperance.

Chastity: see Joseph (page 123), Susannah (page 129); **Faith**: see Heart (page 245); **Fidelity**: see Dog (page 212); **Fortitude**: see Samson (page 128), Judith (Page 129), Hercules (page 68)

[1]Ephesians 6:11 [2]Matthew 25:35–36 [3]Valerius Maximus 6:V
[4]Lucian *Slander* 4–6

Index of Artists

Index of Key Words

Acknowledgments

All the photographs reproduced in this book were supplied by The Bridgeman Art Library, London, with the following exceptions: pages 82–83 National Gallery Photographic Library, London; pages 148–49 Victoria & Albert Museum Photographic Library, London.

The author and publishers would like to thank the following individuals, museums, and galleries for permission to reproduce works from their collections (see page 252 for a list of the abbreviations used):

Page 2 PM; 6 NGL; 8–9 Casino dell'Aurora Ludovisi, Rome; 10–11 NGL; 12 LP; 15 UF; 16–17 FMC; 19 LP; 20–21 UF; 22–23 Casino dell'Aurora Ludovisi, Rome; 24–25 LP; 26–27 NGL; 29 UF; 30–31 Musée Picasso, Paris © Sucession Picasso/DACS 2000; 32–33

UF; 34–35 Manchester City Art Galleries; 37 Musée Granet, Aix-en-Provence; 38–39 PM; 40–41 pc; 42 Musée Gustave Moreau, Paris; 44–45 VF; 46 VF; 48–49 FMC; 50–51 PM; 52–53 Museo de Bellas Artes, Bilbao; 54–55 LP; 57 VF; 58 PM; 59 LP; 60 WCL; 61 Musée des Beaux-Arts, Nantes; 62 Manchester City Art Galleries; 63 LP; 64 UF; 65 LP; 66 National Gallery of Victoria, Melbourne; 68 KMV; 69 PM; 71 NGL; 72 Christie's Images, London; 73 Phillips, The International Fine Art Auctioneers, London; 75 KMV; 76 NGL; 77 VF; 78 PM; 80 NGL; 82–83 NGL; 84–85 Musées Royaux des Beaux-Arts de Belgique, Brussels; 86–87 Bavo; 89 KMV; 91 PPF; 92–93 MSM; 94–95 NGS; 96–97 PM; 99 SZV; 101 LP; 102–103 Villeneuve-les-Avignon (Hospice), Anjou; 104–105 UF; 106–107 Musée d'Unterlinden, Colmar; 108–109 pc; 110

NGL; 112–113 Southampton City Art Gallery © Southampton City Art Gallery; 114–15 NGL; 116 UF; 118 KMV; 119 VR; 120 MSM; 121 NGS; 122; KMV; 123 FMC; 124 LP; 126 NGL; 127 Musée du Petit Palais, Avignon; 128 NGL; 129 LP; 130 Acc; 131 UF; 132 SZV; 133 pc; 134 MSM; 135 LP; 136 ACP; 137 Musée d'Unterlinden, Colmar, 138 LP; 140–41 San Luigi dei Francesi, Rome; 142–43 LP; 144–45 Museo dell'Opera dell'Duomo, Siena; 146–47 Brancacci Chapel, Santa Maria del Carmine, Fl; 148–49 V&A; 150–51 Scuola di San Giorgio degli Schiavoni, Venice; 152 Museo de Santa Cruz, Toledo; 154–55 UF; 156 UF; 158–59 Groeningemuseum, Bruges; 160 San Miniato al Monte, Florence; 162–63 NGL; 164–65 Fogg Art Museum, Harvard University Art Museums; 166 ACP; 167 HSP; 168 Brancacci Chapel, Santa Maria del Carmine, Florence; 171 SZV; 172 Fogg Art Museum, Harvard University Art Museums; 175 NGS; 176 Groeningemuseum, Bruges; 178 San

Francesco, Upper Church, Assisi; 179 CIL; 180 NGL; 182 AM; 184–85 LP; 186 Musée de l'Armee, Paris; 188–89 LP; 190 National Gallery of Victoria, Melbourne; 192–93 NGL; 194 WCL; 196 NGL; 198–99 MH; 200 Château de Versailles; 203 NGL; 204 The Barber Institute of Fine Arts, University of Birmingham; 205 V&A; 206 PM; 207 LP; 208 V&A; 210 NGL; 213 NGL; 214 Château de Versailles; 216–17 Ex-Edward James Foundation, Sussex; 218–19 LP; 220 NGL; 222–23 Georges Pompidou Centre, Paris © ADAGP, Paris and DACS, London 2000; 224–25 LP; 226–27 © Succession Picasso/DACS 2000; 228–29 KMV; 231 LP; 232–33 LP; 234–35 KMV; 236 Musée d'Unterlinden, Colmar; 237 NGL; 238 Scuola di San Giorgio degli Schiavoni, Venice; 239 above Musée Granet, Aix-en-Provence; 239 below PM; 240 NGL; 241 UF; 243 UF; 244 UF; 245 S. Tome, Toledo; 247 NGL; 249 San Miniato al Monte, Florence; 250 PM; 251 Château de Versailles